HITLER'S LAST
HOSTAGES

—— MARY M. LANE ——

HITLER'S LAST HOSTAGES

Looted Art *and the* Soul *of the* Third Reich

PUBLICAFFAIRS
New York

PublicAffairs
Hachette Book Group
1290 Avenue of the Americas
New York, NY 10104
www.publicaffairsbooks.com
@Public_Affairs

Printed in the United States of America

First Edition: September 2019

Published by PublicAffairs, an imprint of Perseus Books, LLC, a subsidiary of Hachette Book Group, Inc. The PublicAffairs name and logo is a trademark of the Hachette Book Group.

The Hachette Speakers Bureau provides a wide range of authors for speaking events. To find out more, go to www.hachettespeakersbureau.com or call (866) 376-6591.

The publisher is not responsible for websites (or their content) that are not owned by the publisher.

Print book interior design by Amy Quinn.

Library of Congress Cataloging-in-Publication Data

Names: Lane, Mary M., author.
Title: Hitler's last hostages : looted art and the soul of the Third Reich / Mary M. Lane.
Description: First edition. | New York : PublicAffairs, 2019. | Includes bibliographical references and index.
Identifiers: LCCN 2019003411| ISBN 9781610397360 (hardcover) | ISBN 9781610397377 (ebook)
Subjects: LCSH: Art thefts—Germany—History—20th century. | Art treasures in war—Germany—History—20th century. | Gurlitt, Hildebrand—Art collections. | Hitler, Adolf, 1889–1945—Political and social views. | World War, 1939–1945—Destruction and pillage—Germany. | Art—Mutilation, defacement, etc. —Germany—History—20th century. | Germany—Cultural policy. | Germany—History—1933–1945.
Classification: LCC N8795.3.G3 L36 2019 | DDC 364.16/2870943—dc23
LC record available at https://lccn.loc.gov/2019003411

ISBNs: 978-1-61039-736-0 (hardcover), 978-1-61039-737-7 (ebook)

LSC-C

10 9 8 7 6 5 4 3 2 1

For the Pack
Stella, Blake, Jex, and, of course, David
"In many a strife, we've fought for life"

Art will always remain
the expression and the reflection
of the longings and the realities of an era.

—Adolf Hitler

CONTENTS

Photo insert located between pages 150 and 151

WAKE-UP CALL

"This Nazi shit will consume your life for the foreseeable future. Get used to it."

—Senior Editor for the *Wall Street Journal* to the author,
November 2013

A T AROUND 4 A.M. ON Wednesday, 6 November 2013, I was sleeping in a Manhattan hotel when I was awakened by one of my phones for the *Wall Street Journal*. The night before, I had been covering the annual Impressionist and Modern Art Auction at Christie's—a night during which dealers, speculators, and private collectors had bought just shy of $144.3 million worth of art in roughly the amount of time it takes to watch a feature film. The auction had included works by artists whose careers I had grown accustomed to analyzing for both their artistic merit and their market value—a cold but critical balance in covering the world's largest legal but unregulated industry. That night, Christie's had sold a Vincent van Gogh work on paper for $5.49 million, a Claude Monet for $8.12 million and—its top lot—a portrait by Pablo Picasso of one of his mistresses for $12.2 million.

On the phone, a Europe-based editor told me to return to Berlin immediately. This, he said, was bigger than New York's November Auction Week, the most lucrative time annually for the global art market.

What exactly was "this," I asked groggily. Though I was the chief European art reporter, editors had told me to concentrate on New York's relationship with Europe that week rather than events in Europe itself. My editor told me that *Focus* magazine, a German cross between America's *Newsweek* and *People*, had just revealed that an octogenarian recluse named Cornelius Gurlitt had been hiding approximately 1,200 works of art in his small Munich apartment—works by the same artists I had just covered at Christie's.

Focus said that Cornelius had inherited them from his father, Hildebrand Gurlitt, who had been one of the main art dealers for the Führermuseum, the museum Adolf Hitler planned to build to house Nazi-approved masterpieces, many looted from the Führer's victims and from European museums. German government officials had confiscated the trove in early 2012 as part of a never-ending tax investigation. Yet they had concealed the trove's existence for almost two years.

If the works were real, the collection was clearly worth tens of millions of dollars. There were pieces by Pierre-Auguste Renoir, Pablo Picasso, Edgar Degas, Henri Matisse, Max Liebermann, and dozens of other artists whose names the German government refused to release. Germany's hiding of this find represented an egregious violation of the Washington Principles, a set of international regulations agreed to by Germany in 1998 intended to facilitate the return of Nazi-looted property to Hitler's victims.

The *Journal* asked me to investigate the case and write a Page One article on the lives of Hildebrand and Cornelius Gurlitt within seventy-two hours, ten of which would be consumed by travel. On the airplane, I contemplated the implications this story would have for Germany, the art world, and my career. I dozed in my cramped coach seat, preparing for several nights' slumber under my desk in the *Journal*'s bureau, located across from the German parliament. I had recently turned twenty-six years old. Little did I know that I was embarking on a five-year project that would confirm that the wounds of World War II were hardly healed and clearly demonstrate that the

German government was ill prepared to deal with this problem of international proportions.

———✦———

On 9 November 2013, I published my first Page One article on the Gurlitt family for the *Wall Street Journal*, focusing on Hildebrand Gurlitt, the man who had been part of the elite group rounding up art across Europe in the 1940s. What I uncovered for that article and over the next several months was so bizarre, so cinematic, that even hardened Manhattan editors expressed astonishment at the Gurlitt family's history—and consternation at the German government's blasé response.

In February 2012, Hildebrand's son, Cornelius Gurlitt, an elderly, reclusive bachelor, had been resting in his apartment in Munich when he heard a sharp rap on the door. Within minutes, German tax investigators raided his house. Cornelius had caught their attention months before while transporting €9,000 in crisp €500 bank notes on a high-speed train from Switzerland. Because this amount was under €10,000, he was not required to declare it, but Cornelius's use of €500 notes, commonly used for money laundering in Europe, had aroused suspicion.

Raiding Cornelius's apartment, authorities were astonished to find roughly 1,200 artworks piled up like old newspapers in every nook and cranny. Cornelius had taken one Matisse painting, *Woman with a Fan*, a portrait of a pale-skinned brunette, and shoved it into a crate of tomatoes. On his living room wall hung Liebermann's *Two Riders on the Beach*, a charming depiction of two equestrians and their horses on sun-dappled sand.

Officials confiscated all of the artworks but did not disclose their existence to the international community. German public servants' callous lack of transparency with the press and public about an issue as delicate as art looted during the Holocaust was impossible to ignore.

After my New York flight landed in Berlin, I learned that the government's tax prosecutor, Reinhard Nemetz, had given the government's one and only press conference about the Gurlitts in a provincial Bavarian town while I and many other journalists were still in transit. He had argued that

determining whether these works had been stolen from museums or Jews was not his job; he only aimed to have them appraised to ensure Gurlitt paid taxes.

German officials bucked the question of whether it was ethical to ignore the fact that many of the artworks had probably been looted from museums or Holocaust victims, stating that this was not germane to their predicament. They pointed out in a shockingly tone-deaf manner—echoing the views of many enablers of the Nazis—that their behavior was legally proper. Its morality was irrelevant.

This approach was not the exception among German public servants; it was the rule.

When I contacted federal officials, including Chancellor Angela Merkel's primary spokesman, they refused to comment or even nominally address the worries of the Jewish community leaders with whom I was in touch, declaring the finding of the largest trove of art belonging to one of Hitler's henchmen "a local issue."

The scandal subsequently spilled into the international art world as it became clear that a professor from Berlin's prestigious Freie Universität was researching the artworks at the government's behest. Yet the government did not ask her to determine if they were Nazi-looted art but rather to identify them for taxation purposes; this gave credence to the oft-whispered suspicion in the elite art world that German academics were out of touch with research into the cultural consequences of World War II—far more so than their counterparts in the United States or other European nations.

Over the next fifteen months, I reported how German officials continued to bungle the confiscation of the Gurlitt art trove. The government consistently refused to release high-resolution images of the artworks, increasing the odds that the grainy photos taken at the press conference—representing less than 1 percent of the total trove—would not be published abroad. This made it difficult for Holocaust survivors and their descendants to prove that the works in Gurlitt's trove were indeed theirs.

For my subsequent Page One exposés and a flurry of shorter articles for the *Journal*, I began interviewing and working with two Jewish families of European heritage who immediately identified two paintings that belonged to their ancestors: Matisse's *Woman with a Fan* and Liebermann's *Two Riders on the Beach*.

Both families now lived in Manhattan.

The matriarch of the wealthy Rosenbergs, from whom the Nazis had stolen *Fan*, was Elaine, a steely eyed, tight-lipped octogenarian. Her father-in-law, the art collector and Matisse dealer Paul Rosenberg, had escaped France in the summer of 1941 after the Nazis had invaded his homeland. Remarkably, Rosenberg had preserved proofs of purchase for many of his artworks, including *Fan*. He learned after the war that the Nazis had stolen that piece and over one hundred others from his bank vault in September 1941, and he had tried in vain to find the artworks until his death in 1959.

The Nazis stole *Two Riders* from the Toren family. David Toren, a soft-spoken Holocaust and 9/11 survivor, had fled Poland to Sweden as a child on one of the last *Kindertransport* missions; his parents were murdered at Auschwitz. David and his London-based brother, Peter, were the heirs of *Two Riders*, which David, a budding equestrian before Hitler's rise, had long admired before the Nazis stole it.

Upon learning of the Gurlitt art trove, the Rosenbergs and the Torens immediately contacted German officials and provided proof of ownership. The government declined to help. Astoundingly, German law did not require Cornelius Gurlitt to return looted works: Germany had allowed the statute of limitations for those from whom Hitler had stolen art to expire in the 1970s.

Much to the outrage of Israeli and US officials, Angela Merkel's government remained mum even when Cornelius proudly and publicly declared that he would not return art looted from Jewish Europeans, adding, "No! Never!"

Until his death, Cornelius Gurlitt maintained that his father, Hildebrand, had simply done his job in working for Hitler—a perfectly legal job at that. Yet, in spring 2014, he realized that the revelation of his art hoard

had tarnished his family's reputation. Bowing to pressure from the Justice Ministry in Bavaria—the lone governmental institution in Germany that saw the scandal from a moral perspective—he agreed to return *Fan* to the Rosenbergs and *Two Riders* to the Torens, even though he was not legally obligated to do so.

On 6 May 2014, six months after his art trove became public, Cornelius died of heart failure in his bare Munich apartment, which the government had emptied of his secret art stash. Though a tax investigation was now a moot point, Merkel's government nevertheless declared that protecting the privacy of the deceased Cornelius Gurlitt took precedence over transparency regarding the return of looted art.

On 20 November 2014, I broke the news in the *Journal* that a small art museum in the Swiss capital of Bern would be taking possession of Gurlitt's trove. A full year after Cornelius died and roughly five months after the Kunstmuseum Bern accepted the odd bequest, the German government finally chose to return *Two Riders* to the Torens and *Fan* to the Rosenbergs.

On 23 June 2015, the Torens sold their treasured painting at a Sotheby's London auction for $2.95 million, five times the low estimate of $540,000. David and Peter Toren originally planned to keep it, but Peter had recently died and left his share of the painting to multiple heirs, complicating its ownership to the extent that selling it became the only option.

The Rosenbergs had *Fan* restored and kept it.

———✦———

Despite how scandalously the Gurlitt case had played out, how callous it had made German officials appear, it was clear to me, now an august twenty-seven years old, that the battle to hold "future Gurlitts" accountable was in danger of being forgotten by the same experienced art dealers, collectors, enthusiasts, and newspaper readers who had breathlessly followed the case from fall 2013 to fall 2015.

I worried that this was the German government's hope. The nation's public servants showed no interest in changing the laws that allowed private citizens to keep Nazi-looted art even when Holocaust survivors and their heirs could prove they were the rightful owners. The federal government had

finally set up a provenance research center but did not require government-funded museums to use it to clear their collections.

Unsurprisingly, many did not volunteer to do so.

Moreover, most of these museums still refused to digitize their records, showing when and how they had acquired their collections. Elderly Holocaust survivors and researchers of all ages who desired to access the archives of these institutions would need to book appointments, secure permission from German institutions, and travel to Germany.

The story of art in Germany is vexed, not only because of the theft and damage that occurred during and before the war but because art was central to Hitler's political project from its inception. The stories of art and Nazism become quickly and inextricably entwined as one looks further back historically.

In contrast to all other Western dictators except Napoleon Bonaparte, Adolf Hitler was genuinely obsessed with art. His actions fundamentally and permanently altered the West's cultural landscape. Hitler regarded himself as an artist first and a politician second. He was actively involved in determining what he considered to be ideal Aryan art, while snuffing out the careers—and often the lives—of artists, collectors, or dealers he considered "degenerate."

Even trapped in the bunker in spring 1945, Hitler had obsessively looked at the model of the Führermuseum that his assistants had brought down to his subterranean kingdom, the halls of which he had decorated with carefully curated artworks. Even as he faced his impending suicide, he still discussed art—his passion since childhood.

Over the past several decades, publishing houses have released thousands of books on Adolf Hitler and World War II. Only a small minority of these focus on the impact of the Third Reich on culture, and a smaller subset still has honed in—as this book does through the story of Hildebrand and Cornelius Gurlitt—on how the complicity of ordinary Europeans enabled the regime to perpetrate its cultural and genocidal annihilation.

Germany has much to do in terms of saving and restituting Nazi-looted art. Yet the mood and politics of the country in 2019 make it less and less likely that this will happen swiftly or at all in the years ahead. For this reason,

historians, Hitler's victims, and their heirs often refer to "lost" artworks—those still separated from their lawful historical owners following the events in Germany in the 1930s and 1940s—as "Hitler's Last Hostages." Because of Germany's refusal to change the laws that protected the Gurlitt family, were a "new Gurlitt" to appear now, victims of Hitler's Third Reich would still have no more rights to demand the return of their possessions.

As this book demonstrates, many of Hitler's Last Hostages have yet to be rescued.

PORTRAIT OF THE DICTATOR AS A YOUNG MAN

"I collected the paintings in the collections I have bought over the years, never for private purposes, but always exclusively for enlarging a gallery in my hometown of Linz on the Danube. It would be my most fervent wish for this legacy to be realized."

—Adolf Hitler, dictating his will, hours before committing suicide on 30 April 1945

O N Valentine's Day 1945, Hildebrand Gurlitt stood outside what had once been his family's stately home in Dresden, trying his best not to panic. The imposing iron gate guarding the house and its impressive garden had done nothing to stop the over 770 Royal Air Force bombers that had dropped 650,000 firebombs over the roofs of Dresden, transforming the picturesque city and his childhood home into a blazing hellhole. The air raid destroyed 80,000 houses and buildings, and 25,000 people had died. The Gurlitts had been comparatively lucky; after the sounds of bombs reverberated through the chilly night, Hildebrand, his elderly mother, his wife, and their two children raced to an underground shelter in the garden, where they slept until Hildebrand came up to survey the damage. Looking around,

Gurlitt was glad that he had made one last sentimental effort the night be-fore to sit for a few minutes on his late father's stool, listening to the bombs as they fell around him. Now, although his childhood home's walls were in-tact, the insides were gutted. The stool was now a smoldering pile of embers.[1]

Though angry over the bombing, the forty-nine-year-old Gurlitt felt overcome with panic for a far different reason: he secretly was in posses-sion of well over 1,000 artworks, artifacts, paintings, sculptures, and sketches that he had acquired while working as an art dealer for Adolf Hitler's covert "Führermuseum Project." Once Germany won the war, Hitler planned to establish a museum to house and display thousands of masterpieces acquired throughout Europe through looting or shady deals. The latter had been Gur-litt's specialty, and as long as a Nazi victory seemed possible, it had afforded the art dealer a protected and prosperous life unheard of for most Germans.

Yet the bombing of Dresden now made clear to Gurlitt that an Allied victory was a foregone conclusion. He had heard rumors about the so-called Monuments Men, a group of mostly American art experts tasked with pro-tecting artworks and other cultural objects from theft or destruction. Most disturbing to Gurlitt was the remit given to the Monuments Men by Allied forces to investigate individuals who could have used the war to their advan-tage. Working with a select group of German and French dealers to assemble the Führermuseum's collection, Gurlitt had not cared whether they acquired the pieces legitimately or whether they had been looted or stolen from perse-cuted Jewish European collectors and dealers.

In addition, Gurlitt had engaged in side deals to augment his secret col-lection. In early 1944, sensing that Allied victory was possible, he had moved around forty boxes of this stash to a secret location outside Dresden. Gurlitt still had between one hundred and two hundred artworks with him, however, and he was convinced that his reputation as one of Hitler's art dealers would arouse suspicion among the Monuments Men, were they ever to find him.

Implementing an escape plan he had devised weeks before, Gurlitt gath-ered his family from the garden bunker and loaded them into a truck with the boxes of remaining artworks. He raced to Schloss Weesenstein, an eight-hundred-year-old manor fourteen kilometers from Dresden, where a col-league and fellow art looter was already hiding. Shortly after Gurlitt's arrival,

however, this colleague convinced him that they should all travel together to a manor four hundred kilometers westward into Bavaria to the estate of a fellow Nazi sympathizer, Baron von Pölnitz. The nobleman's large house and grounds were far away from the Russian forces approaching Berlin and Dresden from the east. Gurlitt reasoned that if he escaped attention for long enough, perhaps the Allies would assume he was dead.

Surveying his family and his artwork, Gurlitt knew that his mother was too frail to make the trip. Leaving her behind would put her at risk of whatever violence the Russians brought with them, including sexual assault. After weighing the value of his art and alibi against the welfare of his mother, Gurlitt decided that the benefits of leaving her behind outweighed the risks, and he arranged for his mother to return to Dresden to the family's bombed-out basement.

As the rest of the family chugged slowly along bomb-cratered roads in a truck fueled by wood chips, Gurlitt's son and daughter, Cornelius and Benita, jostled for space with the part of their father's collection that he planned to present to the Allies if he was captured. He would pretend that this was the entire collection when in fact more than 90 percent was hidden—and Gurlitt hoped would remain so. Gurlitt knew that, were the Monuments Men to find him, they would probably surmise that he had worked in some capacity as a dealer for Hitler, so he had carefully curated a mix of inexpensive items from non-European cultures and a selection of European masterpieces. Before the Dresden bombings, he had made sure to take no steps to preserve the artworks' provenance—any documentation indicating previous owners of the works. African and Mexican decorative masks, statues from New Guinea, bronze Nepalese statues of Buddha from the 1500s, and even a Peruvian vase in the shape of a duck were nestled among artworks by famous European artists. Those included a portrait of the holy family by Jean-Honoré Fragonard, a portrait of a woman washing herself by Edgar Degas, a statue of the Greek Titan Atlas by Auguste Rodin, and a landscape by Gustave Courbet.

Also in the stash were several works by Germans whom Hitler had labeled "Degenerate Artists." He considered these "subhumans" to include not only Jewish Germans but also Christians who created artworks with themes

that were too sexual, too primitive, or insufficiently reverent of the "Aryan race." Among them were a pietà by communist artist and feminist Käthe Kollwitz, a self-portrait by Otto Dix, two scenes of wild Berlin life by George Grosz, and a depiction of a fishing village by Max Pechstein.

In the back of the truck, Hildebrand's twelve-year-old son, Cornelius, had no idea that two of the looted works he was sitting with would come back to haunt him as an old man in the twenty-first century: *Two Riders on the Beach* by Jewish German Impressionist Max Liebermann and *The Lion Tamer*, a vibrantly colored portrayal of a dramatic circus act by Max Beckmann.

<center>———◆———</center>

The Führermuseum was hardly a whim; it was a goal of Adolf Hitler's since his childhood. The circumstances in which the future Führer was born and reared were hardly the product of traditional family circumstances. Both his father, Alois, and his mother, Klara, came from lower-class Austrian families mired in disfunction. Twenty-three years Klara's senior, Alois was born out of wedlock in 1837. Adopted by the brother of his mother's eventual husband several years later, he took the last name "Hiedler," which he later legally changed, for unknown reasons, to "Hitler."[2]

Alois, a customs officer, was a promiscuous man with a complicated relationship history. While married to his first wife, fourteen years his senior and the mother of his first child, he impregnated a teenager, causing his first wife to divorce him. His first wife died soon after obtaining the divorce. Shortly thereafter, he married his teenage mistress, who died several months later after giving birth to his second child. Alois subsequently impregnated and then married Klara, twenty-three years his junior, whom he had admired since her childhood. Klara, a dark-haired woman with blue eyes and about five feet, six inches tall, had grown up across from Alois in the Bohemian town of Spital, and even as an adult, she continued referring to her husband as "Uncle Alois."[3]

Adolf was born four years into the marriage, on 20 April 1889 at 6:30 p.m. He was Klara's fourth child and her first to survive infancy. She nicknamed him "Adi," doting on him even after the births of his younger brother

and sister, Alois and Paula. Filling out their household was Klara's sister Johanna, who suffered from kyphosis, or severe curvature of the spine, and also was mentally handicapped.[4]

Although corporal punishment was not unusual at the time, the Hitler family's neighbors noticed that Alois was particularly brutal. He would beat Adolf up to thirty times on his spine, and Alois Jr. once saw his older brother in such bad shape that he worried Adolf was dying. Klara compensated by showering her children with kisses in public, unheard of in such a stoic society.[5]

Adolf considered his mother, with her soft, dark hair, wide, mournful eyes, and willowy frame, to be infallible and angelic. When his father was away, he shadowed her constantly. When Alois returned, Adolf would dash outside to engage in his favorite childhood sport: shooting small animals with the family handgun. In 1895, Alois impulsively uprooted the family to a remote farm in Hafeld, Upper Austria, but after two years he relocated the family again to the nearby town of Lambach, where Adolf joined the local Benedictine Boys' Choir. Adolf admired the priests and found comfort in the Catholic Church's strict, repetitive rituals. While Klara admired Adolf's newfound devotion, Alois considered it unmanly; whereas Klara regularly observed mass, Alois only attended once a year on the emperor's birthday so that he could wear his official civil servant uniform.

Any stability that the Catholic Church provided Adolf was curtailed when the Hitlers moved yet again in 1898 to a town outside Linz, where they occupied a cheap house next to the cemetery; the location, also favored by a burgeoning rat population, provided ample targets for the now nine-year-old Adolf's pistol.[6] Because the family was poor, Adolf attended the local school tuition-free. Despite this charity, he was generally indifferent to his grades, repeating a year because he had failed math and natural history.[7] After school adjourned each day, he was mostly preoccupied with avoiding nightly assaults from Alois, by now a chain-smoking alcoholic. Adolf regularly escorted his father home from the local bar, where he was a predictable fixture from 10 a.m. until closing.[8]

Attempting to divert his son's attention from choir and toward more virile hobbies, Alois encouraged Adolf to peruse books on war in the family

library. As he looked at pictures of battle and death, particularly those depicting the Franco-Prussian War, Adolf began feeling the emotional uplift he had experienced at mass. "Before long that great heroic campaign had become my greatest spiritual experience," Adolf wrote later in *Mein Kampf.* "From then on I raved more and more about everything connected with war or with militarism."[9] The effects were noticeable. Adolf's teachers became alarmed by his increasingly bellicose nature. "He lacked self-discipline, being notoriously cantankerous, willful, arrogant and irascible. He had obvious difficulty fitting in at school," his French teacher, a Dr. Huemer, noted, adding, "Moreover, he was lazy."[10]

When Adolf turned twelve, he announced to his parents that he would become an artist famed for painting battle scenes. He began neglecting his schoolwork altogether, and his grades plummeted as he focused on his drawings, which he hid from his increasingly enraged father who had no tolerance for his son's artistic ambitions, war scenes or not.

The need for furtiveness ended abruptly on 3 January 1903 at around 10 a.m. when Alois, then sixty-five, slumped to one side while drinking wine in the local tavern. Other drinkers carried him into an adjacent room, where he died of pulmonary bleeding before the priest and doctor arrived.[11]

After her husband's death, Klara moved the family again, this time closer to Linz's city center. Adolf's grades remained horrific, his attitude as antagonistic as ever, but Klara hoped that his reentering the Catholic fold via confirmation would provide him with structure and purpose. She selected as his godfather Emanuel Lugert, not because he had any personal connection to the family but because Lugert commonly mentored belligerent boys. Adolf was more virulent than anyone Lugert had sponsored. "I had to almost drag the words out of him" in conversations, noted his godfather. "It was almost as if the whole business, the whole confirmation was repugnant to him."[12]

Adolf's confirmation failed to revitalize his waning interest in Christianity. Instead, he became enraptured by the nationalistic rhetoric of one of his schoolteachers, Leopold Poetsch. At this point in Adolf's youth, a nascent movement to unite Germany and Austria in a single state was gaining ground. Austrians, skeptical of their empire's stability, were concerned that the aging Emperor Franz Joseph I was too feeble to manage it.[13] Poetsch

voiced one of the popular alternatives for the crumbling empire to his students: creating a united Austrian-German state based on their mutual, "pure" Germanic culture. Hitler and his peers were a rapt audience, but this rhetoric raised a larger question: Exactly who was culturally and ethnically qualified to be considered "purely" Germanic?

Anti-Semitic sentiments were rare at the time in Linz. Jewish Austrians comprised about 1 percent of the city's population, and though Hitler and his classmates knew who was Jewish because they did not attend mass, they did not target Jewish kids for bullying. Jewish Austrians were active in the local workforce, particularly in education and medicine, and regional politicians awarded the local rabbi the prestigious Emperor Franz Joseph Medal of Appreciation for his work on the school board.[14] Overall, the community rejected the rhetoric coming from a tiny minority of anti-Semites. When a local anti-Semitic newspaper made posters with racial slurs for readers to plaster on the windows of Jewish-owned shops, the Jewish worker's union successfully sued for damages with the support of the Christian community.[15]

Despite Poetsch, Adolf's grades plummeted, and he began to alienate himself from classmates, addressing them with the formal German version of "you" (*Sie*) as opposed to the informal version (*Du*) that children use with each other.[16] From this point forward, Hitler socialized only with his mother and began inventing illnesses as excuses to stay home with her. When he announced in his mid-teens that he was quitting school to dedicate himself full-time to art, Klara acquiesced. Thus ended Adolf's formal education. He adopted a dandyish mien and began walking around town, swinging a black ivory-tipped cane. At the family dinner table he refused to converse with his siblings or the boarders to whom his mother rented rooms to bring in extra income.[17]

In May 1906, Klara and Adolf decided he would benefit from a two-week visit to Vienna for artistic inspiration. After a six-hour train ride, Hitler first arrived in the city that he considered the epitome of high culture. It was loud and chaotic, simultaneously traditional and modern. He went to see a performance of Richard Wagner's *Tristan und Isolde*, a tragedy about forbidden love between a Cornish knight and an Irish princess, staged at the opera house located a few steps from the Ringstraße. The Ringstraße, or "ring

road," was the most significant change to Vienna's layout since the Middle Ages. In 1857 Emperor Franz Joseph had ordered the drab medieval walls that encircled the innermost part of the city torn down. A wide boulevard was constructed in its place, and chic townhouses for the nouveau riche were built in the remaining free space on both sides of the boulevard.

Adolf was mesmerized. "For hours on end, I would stand in front of the opera or admire the Parliament Building; the entire Ringstraße affected me like a fairy tale out of the *Arabian Nights*," he wrote.[18] Hitler visited the Kunsthistorisches Museum, an institute that had opened in 1891 and already contained one of Europe's best collections of Old Masters. It was a ten-minute walk from the Akademie der Künste, the Austro-Hungarian Empire's most prestigious art academy and one of the world's most revered. By the end of his trip, Hitler knew he had to apply. He was certain he would be accepted.

Returning to Linz, he told Klara his plan and even began taking piano lessons in October 1906 to diversify his "self-education," an unsuccessful endeavor that caused his piano teacher to cringe for decades afterward when recalling his rehearsals. Adolf soon decided to move to the Austrian capital to prepare for the art academy's admission test. "I went to Vienna with a suit-case containing some clothes and my linen in my hand and an unshakable determination in my heart. I, too, hoped to wrest from Fate the success my father had met fifty years earlier; I, too, wanted to become 'something'—but in no event an official."[19]

There Adolf settled down in Mariahilf, a district just a few steps from the academy.[20] The academy's ceiling was painted by Anselm Feuerbach, a Rhineland-born classical painter who had died in 1880 at age fifty. Adolf revered Feuerbach along with Ferdinand Waldmüller, Karl Rottmann, and Rudolf von Alt, all of whom depicted the German people as mighty and flawless. Such old-fashioned painters were unusual heroes for a young man in 1907, but the academy suited Adolf's artistic predilections. Historical painting was still the dominant style—tradition was advocated over adventurousness—but other young artists were beginning to push back. Oskar Kokoschka, a student at the academy's sister institution, the Arts and Crafts Academy, griped that the teachers at the academies were frozen in a stagnant historical style.

Thirty years later, the Nazis would actively target Kokoschka as degenerate.

Adolf embarked confidently on the elaborate application to the Akademie der Künste. "Armed with a thick bundle of drawings, I was convinced I would find the examination mere child's play," he predicted. "In secondary school, I was by far the best draftsman in my class. Since that time my ability had only improved. My own satisfaction in my ability lead me to hope for the best," he noted. Around 110 hopeful students submitted artwork of their choosing to the academy, followed by two days of exams lasting six hours: three in the morning and three in the afternoon, with a lunch break in between. The applicants chose from a list of forty-six themes, ranging from the rather nebulous "peace" and "joy and moonlight" to specific Bible stories, including "Adam and Eve Discovering Abel's Body" and "The Binding of Sampson."[21] "I waited for the results of my entrance exam as I was filled with excitement, impatience and proud confidence," said Adolf.[22]

Nevertheless, an unfavorable verdict soon arrived: the academy deemed Adolf and the majority of the other applicants inadequate candidates. It admitted only twenty-eight students.[23] "I was so convinced of my success that the announcement of my failure came like a bolt from the blue," Hitler noted.[24]

The academy's director met with a devastated Adolf, advising the young man that while he utterly lacked talent as a painter, his rigid, regimented measurements in drawing would suit him well as an architectural draftsman. Yet, having failed nearly all his classes and dropped out of school, Hitler lacked the necessary academic background to pass an architectural exam.

Angry and adamant that he had been wrongfully rejected by the academy, Adolf returned home in late October only to discover that his mother had terminal cancer, diagnosed by Linz's respected Jewish doctor, Eduard Bloch, a few months after he had removed a tumor from Klara's breast. Within six days, Klara was bedridden and too weak to move.[25] In early November, Dr. Bloch started prescribing her morphine and placing cloths containing iodoform on Klara's open wounds with the intention of "burning out" the cancer, then a standard practice. Klara submitted stoically, barely showing signs of the searing pain.

Klara knew she would be leaving behind eleven-year-old Paula and her mentally handicapped sister Johanna, but she told Dr. Bloch that she was most concerned for Adolf. Her eldest son tended to her devotedly and accompanied her to the iodoform sessions even though he would openly squirm at seeing the treatment applied to his mother's skin. Dr. Bloch wrote in his notes that it was unusual for a boy Adolf's age to come to such a session with his mother and that, in decades of medical experience, he had never seen a mother and teenage son so codependent. "To a very large extent this boy lived within himself. What dreams he dreamed I do not know," Bloch observed.[26]

Klara Hitler died on 21 December 1907. She was forty-seven years old. Adolf felt rudderless, furiously sketching his mother before the undertakers removed her body. They buried her a few days later in an expensive polished coffin with metal ingots that Hitler had chosen. The elderly Bloch was accustomed to witnessing mourning, but Hitler's behavior stood out. "In all my career, I have never seen anyone so prostrate with grief as Adolf Hitler," he noted.[27] On Christmas Eve, Adolf and Paula visited Dr. Bloch at his home to thank him for trying to save their mother. Hitler followed up by painting a Catholic monk in watercolor and sending it to Bloch with the inscription "My very best wishes for the New Year. With Eternal Gratitude, Yours, Adolf Hitler."[28]

On hearing of Klara's death, the post office in Linz offered the now orphaned Adolf a secure job with a solid salary. He rejected it, however, explaining that he was going to become a world-famous painter. When the postal workers pointed out that he did not have the financial means, he retorted, "Makart and Rubens also worked themselves up from impoverished conditions!"[29]

One local resident felt so moved by the teenager's earnestness that she wrote to a friend in Vienna who knew Alfred Roller, a famous stage designer at the opera, who also taught at the Arts and Crafts Academy. On being asked to meet with Adolf, who would soon be returning to Vienna,[30] Roller swiftly wrote back, "Do tell young Hitler to call on me and bring some of his works so I can see how he is doing," listing the best times to call.[31] Hitler was

thrilled, aware that Roller's powerful connections within the art world could open doors for him. Yet he was deeply shy and prideful. Back in Vienna, the eighteen-year-old loitered in front of Roller's office with the prestigious man's letter of invitation in his hand and dithered over whether to cross the threshold. He went into the building once, then turned around. He went in again—all the way to the staircase—before dashing outside. He went in a third time, and someone approached to ask if he needed help. Hitler mumbled an inaudible excuse and left, never to return.[32]

Thereafter, Adolf determined that he should limit his human fraternization to a bare minimum so that he could focus on his art. He cut off contact with his sister, Paula, who eventually assumed he had died. "I'm an entirely non-familial being, a non-socializing man by nature," Hitler asserted. "I only belong to the German people."[33]

While Hitler's sense of his own national identity was intensifying, the position of Jews in the racial politics of the day began to come into question. By the time Hitler moved to Vienna in 1908, Jewish Viennese were integrating and prospering more than ever before, thanks in large part to an 1867 edict from Emperor Franz Joseph giving Jewish Viennese citizens equal rights. Though some highly conservative Jewish Austrians still maintained noticeably separate lives in parallel societies, most lived bourgeois lifestyles, routinely married into established Catholic families, and heavily influenced the Austrian art world by sponsoring artists and buying their works.

Within this social context, Hitler began grappling with three questions: What defined the pan-German race? What type of culture should pan-Germans produce? What specifically—if anything—made certain races inferior or even dangerous to others?

The intensification with which Hitler and right-wing intellectuals began contemplating these questions in 1908 was particularly galvanized by the work of Charles Darwin.

In 1859, Darwin had published *On the Origin of Species* in English. A German translation followed the next year. Darwin postulated that through natural selection, *homo sapiens* had evolved from other species. Inspired by Darwin's research, a growing number of Europeans began espousing "social Darwinism," the belief, predicated on Darwin's scientific studies, that certain

ethnic groups, or races, were intellectually, culturally, and physically superior to—more evolved than—other races and cultures. Though not supported by Darwin himself, the ideology gained traction because the movement's interpretation of the revered scientist's research, however misguided, gave it an air of scientific respectability.

Theories circulated throughout western Europe as to how to identify "degenerate" strains of humans and what should be done about them. In France, for example, increased mobility led young women from the countryside to migrate to Paris in the late nineteenth and early twentieth centuries in search of better lives. Some prospered, but many failed and took up prostitution. The wave was so great that these women filled streets and brothels to an extent unseen elsewhere in Europe. French social Darwinists began asserting that economically supporting these women or providing them with other jobs was futile because they belonged to "degenerate," or inferior, strains and were thus predisposed to engage in "abhorrent" behavior such as sex work. Social Darwinists also noted how Darwin had observed that different breeds within the same animal species compete with each other for space and resources. Consequently, they posited, different races of humans would compete so that one race—with its particular customs and culture—would ultimately dominate and eventually eradicate the others.

When European artists began to portray the French prostitutes in their artwork, reflecting the social reality around them, social Darwinists began to argue that their art was "degenerate"—that like the women it depicted, it was lower and less evolved. Deliberating this became particularly popular in Hitler's Vienna due to the writings of Max Nordau, who had been the Paris correspondent for Austria's respected *Neue Freie Presse* newspaper. Nordau argued that so-called Degenerate Artists posed as great a threat to superior human races as disease-infested, possibly violent criminals.

Viennese-based artists at this time, including Gustav Klimt and Egon Schiele, were highly sexual and fond of creating boldly erotic art. At times their techniques were measured and precise, but often they used jagged lines and crude brushstrokes to evoke primal feelings in viewers. "They draw and paint like children," wrote Nordau damningly.

The best art, Nordau preached, should be uplifting, wholesome, and aesthetically gentle. He protested that Degenerate Artists were abusing the freedom that came with modern society. Nordau stopped short of advocating for formal censorship, however, arguing that Degenerate Artists should be discouraged through social pressure and the refusal of upstanding citizens to purchase their works. Moreover, as a Jewish journalist, Nordau rejected the belief held by many social Darwinists that the "Jewish race" was a degenerate strain of humankind.[34]

Nevertheless, anti-Semitic art critics took up the phrase "Degenerate Art," which Nordau had made popular. Houston Stewart Chamberlain, a Briton who had moved to Vienna the year Hitler was born, lectured that European history was primarily one of racial struggle. If pure-blooded Europeans allowed inferior races to reproduce with them, European culture, including Austria's vaunted art scene, would become tainted and eventually extinct.[35] Chamberlain's British nationality was not problematic for those who believed in a racial pecking order. A Viennese right-winger named Guido List told the members of his eponymous List Society that God had revealed to him the mystical secrets of the race superior to all others, Aryans, which he said comprised Germans, Danes, Swedes, Norwegians, Brits, and the Dutch. The success of the Jewish Viennese signaled a crisis, argued List, who preached that Jews possessed a toxic combination of inferior racial makeup and cunning craftiness for breeding with superior races in order to sabotage them and their cultures.[36] Hitler and List never met, but Hitler followed List's writings and particularly admired his society's eye-catching symbol: the swastika.

The right-wing newspaper *Alldeutsches Tagblatt* began to warn readers, of whom Hitler was one, that modern art was "Jewish through and through."[37] If pan-Germans did not fight back, they would have no one to blame but themselves. "Woe unto the nation that doesn't have the strength to fend off the alien invasion but apathetically watches as legions of cunning Jews penetrate all areas of public life, tear the bread out of the nation's mouth, and economically subjugate it," a journalist for a similar paper, the right-wing *Deutsches Volksblatt* admonished.[38]

Around this time, Hitler began realizing that Vienna was not as perfect as he initially had thought, a grim reality that became clearer as his artistic career failed to blossom. The "relentless struggle" of aspiring entrepreneurs in Vienna "kills all pity," wrote Hitler in *Mein Kampf*. He described the city as a place where "glamorous wealth and repulsive poverty were mixed in sharp contrast."[39]

The Ringstraße, though sparkling with wealth at first glance, also contained nooks and crannies where thousands of unemployed Austrians lived on the street, even congregating below the Burgtor, the imperial gate on the Heldenplatz, or Hero's Square, outside the Hofburg Palace. While Hitler was still new to Vienna, an influx of women, many ethnic minorities from across the empire, moved to the city in hopes of escaping abusive men, economic restriction, and the threat of forced marriages, much like their Parisian counterparts in previous decades. Many succeeded, but as in Paris, a large number of naïve and economically vulnerable women became trapped in low-level, forced sex work. Hitler noticed how child prostitution was also rampant: prepubescent girls realized that it was far more profitable than begging. The middle class pejoratively branded the young women as "whores" while unabashedly paying them to "educate" young men before marriage. A medical journal surveyed middle-class doctors and learned that 75 percent had lost their virginity with prostitutes, 17 percent with family maids, and only 4 percent with women they considered "marriage material."[40]

One prominent writer, Jörg Franz von Liebenfels, concluded that because the majority of poor beggars appeared to be from minority ethnicities or mixed-ethnic families, these strains of the human species must be intrinsically tainted biologically. Several journalists advocated a triage of sorts: identify and aid the fair-haired, fair-skinned beggars over their darker-skinned counterparts.[41] Many members of established Viennese society responded to the wave of poverty by holding lavish balls to fund-raise for charity, using the misfortune of others as an excuse to host parties. The irony of this was not lost on journalist Emil Kläger, who observed how it was fueling the growing class disparity. Poor people would often come to the gates of the galas, hoping in vain for food. "They appeared to me like a bad dream image, those

vast crowds of believers who wait out there in the barren darkness outside the bright gates of our rich life, utterly blinded by its external beauty," wrote Kläger of such beggars.[42]

As extravagant as these wealthy fund-raisers were, they were necessary because the government was too disorganized to handle the homeless crisis. The galas funded the building of *Wärmestuben*, shelters known as "warming stools," where the homeless could briefly sit and rest before venturing out into the cold again. Because the *Wärmestuben* closed in the early evening, the poor slept on the stools by day and then wandered around by night, looking like dazed vampires. "As if under a spell, people remained motionless within the quadrangle of the benches, looking like a ghostly gallery of the dead whom someone had put one next to the other as if for some horrible amusement," observed Kläger. A few fortunate beggars took shelter on the outskirts of Vienna in abandoned stables that had been deemed unfit for animals. It typically took several sleepless nights to adapt to the bug infestations. On squalid mattresses, babies and impoverished widows cuddled with sex workers and alcohol abusers for warmth.

"Sunshine, incidentally, will soon become one of Austria's most favorite meals," quipped one magazine reporter.[43]

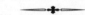

In autumn 1909, Hitler's orphan stipend from the government and his meager inheritance from Klara both dried up. The aspiring artist, now twenty years old, became one of the homeless unfortunates himself. He often sought refuge at a shelter in the working-class Meidling district, built behind a cemetery so that locals would not protest. Since there were so few Viennese shelters, beggars lined up to stay at night, a cruel mirror of the lines to enter Vienna's chic restaurants; there were even bouncers to deal with rejected beggars who became obstreperous. The institution, supported by the left-leaning Socialist Democratic Workers Party along with private donations, had one of the best job-placement centers among Viennese shelters. Yet, rather than seek employment, Hitler spent his days copying his own sketches of monuments and voraciously reading right-wing newspapers and tracts. Daily wear turned his only suit from blue to a dingy mauve.[44]

Hitler quickly became keenly aware of the pecking order that the home-less established for themselves. Even as the rich saw themselves as superior to the homeless in their Darwinian struggle for dominance, the homeless jock-eyed among themselves for power and limited resources. Young to middle-aged men crowded out single women, sex workers, mothers with children, orphans, the old, the sick, and the meek. Xenophobia was also a factor: homeless Austrians generally believed they took priority in the *Wärmestuben* over foreigners.

Responding to the crisis, numerous Jewish synagogues mobilized their congregations to build additional shelters. Jewish philanthropists partnered with Vienna's Christian Association of Soup and Tea Institutions to create *Wärmestuben* where soup, warm milk, and cocoa powder were distributed for free, and vegetables could be bought at cost.[45] These *Wärmestuben* efficiently distributed small treats meant to help the homeless socialize with each other and feel human again. The homeless, including Hitler, prized these new and improved refuges.

In February 1910, Hitler secured a spot at a privately funded hostel in Brigittenau, an industrial district. The smartly built residence at Medemann-straße 27 was lit up by a bright electric lamp. Its large foyer was heated by a modern steam system, and up the stairs was a large, clean dining hall. There were also small kitchenettes so the men themselves could cook. Each resident slept in an individual compartment measuring 4.6 by 6.9 feet, and there was a room where the men could shave.

Two reading rooms—one for smokers, one for nonsmokers—contained pulp fiction and popular newspapers.[46] In these reading rooms, debates en-sued that reflected the increasingly radical political environment. Discussions centered on the high price of groceries and meat, the increasingly frequent ri-ots, and the rising homeless population. The reading rooms at Hitler's shelter began to host their own lively debates, which widened to broader discussions about sex. Men shared stories about women as Hitler usually sat silent.

Hitler began trying to articulate his political views through energetic speeches while simultaneously pursuing his art career.[47] Typically, he painted in the corner of the men's hostel, eavesdropping on the discussions of other residents. Whenever he disagreed, he would jump up, throw a pencil or paint

brush across his table, and try to convince the others of his views by yelling, eyes ablaze. If Hitler felt his speeches extolling pan-German culture were falling flat, he would stop mid-sentence and abruptly return to his painting.

Hitler's speeches were not yet explicitly anti-Semitic, but he increasingly expressed admiration for Karl Lueger and Georg von Schönerer, noted anti-Semitic politicians who advocated policies for "managing Jews."[48] Nevertheless, Hitler seesawed between denigrating and admiring Jews. While he openly admired the talent of Jewish artists like the romantic composer Felix Mendelssohn-Bartholdy and befriended a one-eyed Jewish Austrian homeless man in the hostel, he was beginning to suspect that Jews had "a different smell" because they were a different human "breed" and began believing with increasing intensity in the pan-German movement while repeating Lueger's view that no measure was too great to preserve the pan-German people.[49] "Should the Jews threaten our Fatherland, we will know no mercy," declared Lueger in a speech to thunderous applause, adding, "I do want to put out a warning."[50]

By the spring of 1910, one hostel resident, Reinhold Hanisch, had grown curious about Hitler's artwork, despite the fact that holding a conversation with the future Führer was next to impossible. "He was awkward," Hanisch would later recall.[51] After Hitler said that he had attended the Akademie der Künste and would one day become a great artist, Hanisch suggested that Hitler paint postcards and sell them in local taverns, where there was a market for such cheap trinkets. After Hitler admitted that he was too shy to approach tavern owners, Hanisch proposed that he could do the footwork and take a commission while Hitler focused on his craft, and Hitler agreed.[52]

Hitler wrote to his sister asking for help, and she sent him fifty Kronen; it was enough to buy a coat for twelve Kronen and spend the rest on art supplies.[53] Emboldened, he rapidly began painting hundreds of postcards of Vienna's iconic monuments: St. Stephen's Cathedral, the city hall, the parliament, and the Scottish Church. In addition to selling postcards in taverns, Hitler created larger works and sold them to framers, who could sell ready-made frames more quickly when they contained art. His best customers were two Jewish Austrians: Samuel Morgenstern and Jakob Altenberg. "They were

the cheapest items we ever sold. The only ones who showed any interest in them were tourists who were looking for inexpensive souvenirs," noted the latter's daughter, Adele Altenberg. Adele was a young girl when Hitler began coming into the store on his own, increasingly without Hanisch. She noticed how Hitler kept his eyes on the floor, refusing to look at her. Once he tried discussing the pan-German movement with her father, who quickly told him to stop such divisive nonsense.

About two months after he began postcard painting, in summer 1910, Hitler made a new friend at the men's hostel, Josepf Neumann, a copper cleaner who was eleven years older, single, and Jewish. Hanisch grew jealous of the pair after Neumann and Hitler went on a vacation together for a week. When they came back, Neumann asked Hitler to move with him to Germany. Hitler declined and stayed in Vienna to paint, but to Hanisch's dismay, Hitler's artistic output diminished as he missed Neumann's presence. Hanisch promptly bought his own art supplies and began copying Hitler's works, placing himself in direct competition with Hitler, causing their friendship to quickly collapse.[54]

Hitler was scraping together a living by selling his artworks, but his income was meager. He considered asking his aunt for more money only to discover that she recently had died, at just forty-eight years old.[55] Pressing on, Hitler continued for one more year on his own, bickering with Hanisch and sulking around the men's hostel, ruminating over the possibility of leaving Vienna for Munich not only to continue his artistic "self-education" there but also because his deadline to enroll for compulsory military service in the Austrian army was fast approaching. He wanted to dodge the call-up.

In the next few months, Hitler befriended Rudolf Häusler at the men's hostel. Häusler and Hitler met in the reading room and bonded over their similar backgrounds. Both had doting mothers but distant, austere fathers, and it was in the company of Häusler that Hitler moved to Munich.

After five and a half years in the Austrian capital of high culture, Hitler left Vienna broke and an artistic failure. Yet he would later argue to his supporters that he had moved to Munich because he had accomplished as much as he could in Vienna and was now ready to move to Germany's center of culture.

In May 1913, Hitler and Häusler packed their bags and headed to Schwabing in the north of Munich, a place of bohemians, artists, anarchists, and self-proclaimed "intellectual thinkers" who frequented the lively, cheap bars there. The move to Munich, Germany's cultural capital, as opposed to Berlin, its political capital, was a clear indication that Hitler's primary focus was culture, not politics. Hitler and Häusler moved into a flat rented from a local tailor. Vladimir Lenin had lived just down the street at Schleißheimer Straße 106 a decade before. While Hitler was there, Paul Klee, Franz Marc, and Wassily Kandinsky also lived in the neighborhood. Yet Hitler showed no more interest in getting to know them than he had Vienna's elite artists. He mainly spent his days alone in bars and cafés or at the Hofbräuhaus, occasionally making sketches and returning home reeking of beer and smoke. Back at the flat, he specialized in being the roommate from hell. He forced poor Häusler to listen to hours-long speeches until 3 or 4 a.m., during which Hitler would become increasingly passionate and even start to spit.[56]

Unfortunately for Hitler, by the summer of 1913 his compulsory military service was unavoidable; with tensions rising across the continent, Austria was mobilizing its eligible citizens for training. Begrudgingly, Hitler went from Munich to Salzburg for physical fitness testing. The result for the future Führer, who prized the physical ideal of a strong and muscular male, was humiliating. "Unfit for military and auxiliary service; too weak. Incapable of bearing arms," read his military inspection report. He returned to Munich to discover that Häusler had moved out while he was gone.

Everything changed for Germany and the Austro-Hungarian Empire on 28 June 1914, when the fifty-year-old Austrian Archduke Franz Ferdinand and his forty-six-year-old wife Sophie were assassinated in Sarajevo. Hitler was excited by the prospect of conflict, since it would provide the perfect opportunity for the Aryan race to show its superiority. On Odeonsplatz in Munich on 1 August 1914, Hitler cheered with the roaring crowd as Germany declared war on Serbia. Within days, Russia, France, Belgium, Montenegro, and Great Britain were also embroiled in the conflict. Hitler submitted a petition to fight for Germany on 3 August. Though Hitler had moved to Munich in part to avoid military service in Vienna, at that time there had been no imminent global war. Now he sensed the opportunity not only to

experience firsthand what he genuinely believed to be the romantic side of war but also to become a hero and prove the superiority of the pan-German race. Hitler's zeal was rewarded: the day after he submitted his petition to fight for Germany, he opened a letter to find he had been accepted. That same day British Foreign Secretary Edward Gray looked out his office window in London at dusk and, seeing men lighting the street lamps, declared, "The lamps are going out all over Europe. We shall not see them lit again in our lifetime."

CHAPTER II

ENIGMA OF WAR

"War freed many an individual from the environment he hated and the slavery of his everyday routine. Beliefs? Ha, ha! In what? In German heavy industry? In the big capitalists? In our glorious generals?"

—George Grosz

HALF A YEAR AFTER ADOLF Hitler joined the German army, he was working as a courier in Belgium. Enamored of the structure of the job, the sense of identity that the army gave him, and the solitary nature of his position, he refused to take any leave, a choice that stupefied his supervisors. Many other soldiers were in utter despair; mental breakdowns were common enough that the army did not investigate which were real and which were ruses.

One man discharged from the army for such alleged mental instability was Wieland Herzfelde, who had served a brief stint as a medical assistant in Flanders before the army discharged him after he attacked his commanding officer. Orphaned when he was young, the working-class veteran was a poet and aspiring art publisher, determined to make his mark on the art world

once he found an artist to work with who suited his own gregarious and sarcastic personality.

In the summer of 1915, while lounging in the art studio of his eccentric friend Ludwig Meidner one afternoon, the two commiserated on the pointlessness of the war and strategized how to organize protests and drum up publicity for a publishing venture that Herzfelde was planning. Unexpectedly, a dapper gentleman with ash-blonde hair, wearing a spotless grey suit, popped his head around the open door; he had eavesdropped on their conversation. Introducing himself as a Dutch entrepreneur, he began casually chitchatting before mentioning his hope that the war would drag on indefinitely and aid his latest entrepreneurial endeavor: collecting shell splinters from battlefields and employing maimed soldiers to paint them with the Iron Cross and emblazon them with slogans like "God Gave Us and Saved Us" and "Every Shot Hit the Spot." He intended to sell them as paperweights and ash trays; the longer the war dragged on, the more money he would earn.

A silence fell over the studio as the man strutted out, leaving everyone dumbfounded and wondering what had just happened. "An odd duck," Herzfelde said to Meidner, adding, "He must belong to us somehow." Herzfelde surmised correctly that the man had played a prank to illustrate a point about war profiteers.[1]

The man was George Grosz, who would soon become one of the most incendiary and famous artists in Germany, with a reputation that would eventually reach the United States. Herzfelde and Grosz would bond over their nearly identical senses of humor, and Herzfelde would not only become the artist's publisher but also his closest friend for life.

While the "Dutch merchant" impression was a prank, it was also part of a coping mechanism for the twenty-two-year-old Grosz, who, like most Germans, was undergoing a crisis of national identity. The army had discharged him in early May on the grounds of physical and mental instability. Grosz's art was unflinchingly critical; this took an emotional toll on him, however, and he suppressed his fractured personality in role playing, wild parties, and copious quantities of liquor. His friend and fellow artist Meidner was in on the prank against Herzfelde; the trio began attending parties and drinking in

bars and burlesque clubs. "Deliberately, we wore unkempt clothes, our hair awry," Herzfelde would later recall.[2]

Meidner viewed the war as a disaster from the outset. Over several years, Admiral Alfred von Tirpitz had advocated a modernization and expansion of German naval power to rival the United Kingdom, further aggravating the pan-European arms race, with which few Germans had concerned themselves. Meidner, however, had paid attention and painted his *Apocalyptic Landscape*, which showed with gloppy paint and wide brushstrokes a typical German city exploding with blue fire, the sun slinking into the mountains, the ground swirling like lava and evoking the darker works of Vincent van Gogh created weeks before the Dutchman shot himself. "I trembled, all that high summer through, in front of canvases that seethed with the fuming anguish of earth, in every patch of color, in every scrap of cloud and in every cascading stream," Meidner wrote of the works he created between 1912 and 1916. "I could see nothing but a thousand skeletons jigging in a row."[3]

Unlike Meidner, Grosz had not seen the skeletons coming. Grosz, like Hitler, had romanticized war since childhood and volunteered for the army in November 1914 out of a sense of patriotic duty. The two shared numerous childhood similarities: hard-drinking fathers who died early, abysmal school records resulting in expulsion, an admiration of militarism, and a desire to paint battle scenes. Yet these similar backgrounds would result in wildly divergent views on German culture.

Born in Berlin on 26 July 1893, Grosz lived above a restaurant run by his parents until he was five and the family moved to Stolp, a small town in Pomerania, 250 miles northeast of Berlin on the Baltic Sea. Grosz and his father had a happy relationship, and the two spent time drawing soldiers and horses together, bonding over both creative pastimes and national pride. Yet Karl Grosz died when George was six years old, and Karl's widow Marie moved her family back to Berlin, where she worked as a seamstress. Though struggling after the death of her husband, Marie would take Grosz and his sister to Aschinger's, a beer saloon at Oranienburger Tor, as a treat; the

children delighted in sitting near the crystal and mirrored pavilion where they ate wurst, while waitresses in white checkered outfits bustled around them.[4]

Living in Berlin, Grosz scuffled with schoolyard bullies, rousing an awareness of the violence latent within humans and animals.[5] This leitmotif entered Grosz's art after he started seriously drawing at age nine; he created a bloody hunting scene, which the owner of an art supply shop framed and sold to a farmer, earning the aspiring artist his first commission: four marks and eighty-five pfennigs. The little victory encouraged him to press on. He began at this early age to develop the sardonic humor that would become the hallmark of his adult work. He incorporated the dark wit found in the caricatures of nineteenth-century illustrator and author Wilhelm Busch, who wrote the best-selling *Max und Moritz* children's book about a pair of naughty boys whose bodies get ground to bits and fed to ducks.[6]

Grosz's grades at school were abominable, and he was prone to conflicts with his teachers, typically met with corporal punishment. The head teacher changed the name of his class whip based on the student who had been its latest victim; it was usually named "Grosz."[7] After his expulsion from school, Grosz began to focus on becoming a famous artist, determined to acquire fame through hard work and rigorous self-criticism and by earning the respect of experienced artists. He sought inspiration for his art by biking around Stolp and soon discovered a new hobby triggered by his nascent libido: peeking into portly women's windows to check out their breasts— the more voluminous their bosoms the better. It awakened in him a lifelong fascination with female sexuality that was unique among German artists: Grosz's depictions of women from various walks of life did not deride them for their erotic drives and preferences.

Grosz challenged himself by precisely copying the works of Old Masters and popular German artists in order to understand their composition and, crucially, in order to craft his own style and learn to break the rules so rigorously instilled in and followed by traditional German artists. Dreaming of adventures in a metropolis, Grosz readied his application for the revered Dresden Academy of Fine Arts. "This prize always hovered before me like the Holy Grail," he wrote of his chances for artistic fame.[8] After traipsing

through freshly fallen leaves as a mist spread across Dresden's Elbe River on the testing day, Grosz and the other candidates entered an exam room with a large skylight through which streamed cold German sun. They looked nervously at one corner, where a few antique statues stood like sentinels against the wall, one raising a dusty arm in greeting. Some hopefuls brandished expensive paint boxes, while others sharpened cheap charcoal pencils; the academy required the applicants to complete the same test using whatever materials they could afford to bring.

To Professor Robert Sterl, a middle-aged native of Dresden with a radish-colored face, innate talent mattered more than the economic backgrounds of the students. Watching Sterl, Grosz considered him the kind of man with whom he could split a bottle of red wine over an amicable chat. Grosz's laborious studies over the preceding months bore fruit during the entrance exam as the young applicant showed off a technique that was unique but still rooted in tradition. His lines appeared flat and dense, indicative of a newer style, but also proportional, something traditionalists admired. As Sterl curtly complimented him, Grosz's adrenaline spiked. "So! I was going to pass!" he thought.[9] Indeed he did, matriculating in 1909.

Grosz fit in well with the other students, particularly a boy who introduced him to the art of Norwegian artist Edvard Munch. Munch's 1893 *The Scream* made an impression on Grosz, with its eerie orange and blue hues and the main figure's unalloyed expression of angst, but Grosz was also quite taken with Munch's lithographs, not only for their impeccable craftsmanship but also for Munch's almost mystical portrayal of female sexuality and emotions.[10] In Munch's black-and-cream 1896 work *On the Waves of Love*, a woman with a serene expression floats in water, her long, unbound curly hair mixing with the waves. In the 1895 lithograph *The Alley*, Munch portrays a prostitute with the symbols typically used for a Venus or the Madonna; floating in the air, the woman hovers among the men nude, with a tranquil, almost holy countenance.

Grosz and his classmates engaged in various antics, including lively food fights.[11] In class, however, the students labored to create art that meticulously mimicked real life, a style that hardly resembled that of the mystically minded Munch. Grosz considered the realist exercises pedantic and pointless.

"If we were painting the head of a model, then every hair of the eyebrow had to be counted," noted Grosz. "Our crayons, numbering one to five, had to be sharply pointed—truly a symbol of order and discipline."[12] Just as the artist Oskar Kokoschka had noted of his art academy—the very one that had rejected Hitler months before—the regimented nature of the Dresden school was at odds with the zeitgeist engulfing its students outside the classroom.

The young Grosz respected the traditional subject matter of the Old Masters: biblical allegories, battle scenes, and calming landscapes. He worried that artists of his generation would neglect proper artistic techniques: "One of the fashionable bywords of the day was 'individuality.' It was preposterous! Everyone thrust his head back and painted without looking in order to titillate a 'deeper' individuality, to encourage the expression of the unconscious. Many of us just took the thick paint into our mouths and spat it onto the canvas."[13]

Grosz decided that in order to break with tradition, he first had to understand it. He approached tenured professor Raphael Wehle, regarded by other students as a loner and defender of the archaic style. At first Wehle refused to see Grosz, convinced it was a prank. Yet Grosz convinced Wehle of his sincerity and valiantly attempted to master the fastidious traditional techniques, such as the particularly German practice of cramming three hundred detailed figures into biblical scenes.

At this point in western Europe, artwork created by students at prestigious academies like Dresden's were considered demonstrations of nationalism—a way literally to illustrate an almost sacred national pride. When he broke with tradition, Grosz believed he was doing something exhilarating yet bordering on sacrilegious. It made him melancholy: "The noble, classic, religious ideals were just not in me because they were not of my time."[14]

The risk catalyzed an epiphany, however terrifying. "Yes, real life was not just made of plaster casts," Grosz exclaimed, referencing the plaster models that Wehle had him use to portray the hundreds of figures in traditionally crowded biblical scenes. "Life was more like a rag completely smeared with a riot of color."[15] Hesitantly, Grosz stopped trying to paint in the style that Professor Wehle taught in his dusty studio and went out into the city to

observe life itself. He began depicting rising class disparity; in an untitled work, he showed a tubby, moneyed man with his ostentatiously dressed female companion, trailed by a peg-legged beggar on crutches holding a frayed cap that contrasted with the garish plumage of the lady's hat.

Grosz was fascinated with the experimentation of young artists but unsure whether his art was compatible with their goals. One prominent movement of the time, Die Brücke, took its name from the German word for "bridge" to indicate that members aimed to bridge the gap between literal depictions of objects and pure abstract expressions of emotions; they aimed to create artworks that used strong colors and somewhat distorted forms but still made obvious to viewers what objects were being depicted. Founded in 1905, the group consisted of mostly German artists, including Emil Nolde, the oldest and most respected member.

One of Grosz's classmates brought a book to class about Nolde, then in his early forties. Nolde was skilled with paint brushes but also enjoyed using rags, which he dipped into color and slapped onto canvases with calculated precision that nevertheless exuded a primal quality. In his 1906 etching *Company at the Table*, Nolde depicted a group of German farmers socializing in a darkly colored style with crude lines that instantly evoke van Gogh's *The Potato Eaters*, created twenty-one years earlier. In his 1909 work *Young Oxen*, Nolde paid homage to his home region of Frisia in northwestern Germany using the broad, short strokes of the Impressionists to create a portrait of cattle in a field. Though the cows appear charming, looking directly at the viewer, Nolde's serious purpose was to honor the farmers of Frisia for their arduous, often unappreciated work—something Grosz admired.

Yet academy professors disdained what they interpreted as Nolde's spurning of hard work and succumbing to primordial passions. "Such a fellow sticks his finger in his ass and smears it on paper!" said Grosz's professor Richard Müller. "He sketches like a drunken pig with a dung fork!" Nolde's infamy had even spread to local Dresden parents. "Look, I'm going to tell Nolde. He'll pick you up and smear you all over the canvas!" was a popular admonishment to children.[16] Grosz acknowledged that Nolde's technique was less precise than that of the Old Masters, but he believed that this did not make Nolde's work less significant. "The expression of one's inner self was all

that mattered," Grosz felt.[17] Sometimes feelings are brutal, he thought, so the way they are expressed also should be. Yet this raised a question for Grosz: Where would such brutality lead? "Frequently, I unconsciously felt something menacing that lay behind the peaceful things around me, inexplicable and mysterious," he later wrote. Yet, caught up in the emotional high emanating from the shock of the new, he pushed his qualms aside.[18] "Down with rules, maulsticks, and finely pointed lead pencils and crayons!" he declared.

After graduation, Grosz moved to Berlin in 1911, determined to make his mark. He lived with his roommate from Dresden, Herbert Fiedler, and the pair stayed up late drinking sherry and discussing art and sex. When they depleted their governmental and familial stipends, they would plod to Aschinger's, where Grosz had gone with his mother a decade prior. Now he appreciated it for its cheap beer and overflowing bread baskets. "How wonderful those hot, little rolls, that seeded rye bread and those salt sticks tasted," remarked Grosz, who conspired with Fiedler to line their pockets with them to take home.[19] Berlin was cheap enough that the pair could enjoy a diverse array of nighttime adventures. "The ladies of pleasure would stand in the doorways like sentinels, dangling their handbags, the sign of their guild," Grosz observed.

Fur-adorned operagoers and streetwalkers converged on Friedrichstraße and Berlin's other main thoroughfares, providing ample fodder for sketches; the artists found it titillating that it was often impossible to distinguish between fashionable wives and high-class escorts, an ambiguity that respectable Germans found disconcerting. This allure of Berlin drew artists away from Dresden and into the German capital. The Bavarian-born Ernst Ludwig Kirchner, a founder of the Brücke movement that Grosz had admired in Dresden, moved to Berlin at the same time as Grosz. Thirteen years Grosz's senior, Kirchner had earned a degree as an engineer in case his artistic dreams failed him. However, increasing interest in his works throughout Germany, including from the revered Nolde, led him to relocate to the fashionable area of Wilmersdorf in West Berlin, where he founded an art school with fellow avant-garde painter Max Pechstein.

Kirchner's studio in Berlin quickly became known for its nude cavorting and fantastical orgies, reflective of Kirchner's art, in which he celebrated

female sexual liberation but also considered women primarily as beings intended to play out the sexual fantasies of men. In one lithograph he produced, *Love Scene*, two women embrace and kiss; yet their bodies are awkwardly turned in such a way as to expose their breasts and buttocks to the viewer; in the pastel work *Two Nudes on a Bed*, Kirchner uses complementary blues, reds, and yellows to depict a pair of voluptuous women lounging together. Like Grosz, Kirchner began venturing out onto Friedrichstraße at night to observe the diverse array of sex workers that Berlin had to offer, ranging from gritty streetwalkers to glamorous, high-class escorts. Grosz, with his working-class background, gravitated toward the former group; Kirchner, who came from a respected family of academics, gravitated toward the latter. After gleaning inspiration from observing the escorts, Kirchner employed his own friends to serve as models for one of his most successful artworks, *Five Women on the Street*. By using professional models, Kirchner emphasized the fantasy of working as an escort rather than the reality that actual escorts experienced. In the painting, five high-end sex workers wear elaborate black hats with exotic plumage and slinky black coats. Four of them stare into a department store window, themselves objects available to buy for cash that they can subsequently use to fuel their glamorous lifestyles.

Though Grosz admired Kirchner's work from an artistic perspective, ethically speaking he sensed something eerie and empty, even nefarious, in the fascinations of his burgeoning creative class. "I think it's the moth instinct that attracts us to bright lights of the streets and cafes," he said of their propulsion into hedonistic self-destruction, aware that he shared this impulse.[20] Moreover, he felt that his artistic career exacted a personal toll on himself. Having settled into a life of drinking and drawing, he increasingly found it difficult to observe this world without participating in it. "A dreary semi-conscious state between squalid work and alcohol. A Mess!" he summarized in a letter he wrote, admittedly, while inebriated.[21]

Grosz studied in Paris from August to November 1913 in a studio specializing in teaching artists to sketch scenes in five minutes, a skill that was critical for capturing the rush of city life. Grosz honed his artistic style by mixing simplicity derived from children's art with Berlin's popular street graffiti techniques, crafting an uncanny new style to depict these hedonistic

times. He did not particularly like the French, vexed by what he considered a tendency among French artists to avoid depicting society's problems and opt for frivolously facile subjects. His friends and classmates in Paris did not agree. The painter of the moment was Henri Matisse, famous for creating aesthetically pleasing paintings of dancers and portraits of creamy skinned young women, works that featured vibrant colors and soft, arabesque lines. Yet twenty-year-old Grosz was unimpressed, believing that Matisse, then forty-four, was concerned with promoting a "pleasant" visual style over considering whether his content was meaningful.

In marked contrast to French artists who were his age, Grosz in Paris created grisly scenes that included double suicides and even, in one instance, a man preparing to blow the head off a naked woman crouched on her bedroom floor; these were several in a series of "Lustmord" drawings that seemingly straight-laced members of Germany's educated classes bought as lurid escapes from the burdensome rigidity of traditional morality. One of the most iconic of these gruesome images was *The End of the Road*, a black-and-white fantasy of a double suicide and an infanticide: a paunchy mother, her stomach slumping down toward her crotch, indicative of a recent pregnancy, has hung herself while her tiny baby and partner lie below her. No more changing diapers, no more sticky summer nights of failed postnatal eroticism. Just death.

These "Lustmord" drawings both fueled and reflected Grosz's queasiness about Germany's widespread and growing militarism and political bellicosity, movements that Grosz considered gravely deleterious. Rampant sex, alcohol, and drugs or religious fanaticism seemed to be the unsustainable responses. Eventually something would twist, break, and explode. Grosz began experiencing fantasies during which water swaddled him and lulled him into a trance—even as pressure from above was slowly crushing him. "It was as if I were going somewhere very, very slowly—but where I could not say," he described. "It was gloomy but mysteriously beautiful and dreamlike at the same time."[22]

When drinking or smoking in bars, eventually stumbling home in the cockcrow hours, Grosz was struck not with paralyzing despair but with the assumption that daily life would soon return to a reassuring, humdrum normalcy. As simplistic as it sounded, the theory seemed probable to him:

things could not fully shatter for the Germans, because they had never done so before. "Through the mad whirl of parties and balls there crept persistent rumors of oncoming war, but we did not take these rumors too seriously," Grosz wrote in regretful retrospect. When Germany declared war and Hitler reveled with other war-hungry Germans 360 miles away in Munich, Grosz realized how Berliners were vastly underestimating the havoc it would unleash. "Those who were not enjoying life craved war. I was not one of them."[23]

While they also did not crave war, many other young artists welcomed it once it became inevitable, convinced that serving in the military would lead to exciting adventures that could provide the type of artistic inspiration that would jump-start their nascent careers. Max Beckmann, a thirty-year-old artist and etcher from Leipzig who admired the French Impressionists and was frustrated that his career had yet to bloom, volunteered for the medical corps. The sinking of the *Titanic* in 1912 had fascinated Beckmann, who thought of it not as a humanitarian tragedy but as the perfect, opportune subject matter for an epic-sized painting that romanticized an adventurous struggle between mankind and nature. Beckmann's mammoth oil painting *The Sinking of the Titanic* focuses on three boats crammed with passengers from various social classes dramatically battling to stay afloat. Several passengers in the water around them struggle to straddle pieces of wreckage while, in the background, the gargantuan ship sinks into the Atlantic. The idea that he could now participate in a war on the front lines thrilled Beckmann, who viewed it as a chance to experience "something intoxicating, wanton and savage—cruel, exuberant life."[24]

Otto Dix, twenty-two, was a student at the Dresden Academy of Fine Arts when the war broke out. He had created one promising work at the academy, *Landscape with the Rising Sun*, but, frustrated with his studies, volunteered as a soldier. Heading to the front, Dix carried with him a Bible and a well-worn copy of Friedrich Nietzsche's 1882 book *Die fröhliche Wissenschaft* (originally *The Gay Science* in English but translated now as *The Joyful Wisdom*), famed for containing the German philosopher's statement "God is dead." Dix hoped to reread the two books after battles to compare his combat experiences with the texts.

Everyone Grosz knew seemed to have embraced the war. As his friends voluntarily enlisted, Grosz, initially wary, ultimately reckoned that the war could provide interesting source material for his art, so he enlisted also.

Yet what he experienced was not merely biblical: it was apocalyptic.

—◆—

Several months after his enlistment, Grosz, now back in Berlin after having been discharged in spring 1915, began contemplating the mass enthusiasm for war that had swept up conservative and liberal Germans, including his artistic friends. Why exactly had they joined? What had been the consequences? What would the future bring?

By enlisting, these men had voluntarily relinquished their wild sex parties, cocaine binges, and alcohol-fueled evenings. They had hoped for artistic inspiration, which now seemed humiliatingly naïve. They had been utterly unprepared for the psychological seriousness of war, not to mention the reality that the combination of military technological development and international involvement made this a war of immense proportions and lethality, unprecedented in world history.

Major German artists with whom Grosz was friendly, having indulged in these fantasies of a romantic war devoid of gore, were rapidly discharged from duty and returned to Berlin psychologically damaged. Beckmann had suffered a nervous breakdown, and Dix, still on the front lines as a machine gunner and platoon leader, was consumed with self-loathing for having foolishly thought the war would be an artistic experience. At Halle an der Saale in the central-east German region of Sachsen-Anhalt, Kirchner trained as a member of the cavalry, working well with the horse he was assigned but apparently suffering a serious mental breakdown nonetheless. His riding instructor arranged for a provisional discharge until he made a full recovery, and he returned to Berlin. Though not physically wounded, Kirchner was mentally ill; mixing drugs and alcohol, he created *Self-Portrait as a Soldier*, an intentionally hyperbolic portrayal of himself as a severely maimed veteran.

Initially after his own discharge, Grosz had felt elated. "Hey, I'm free!" he wrote to a friend. "Free from the Prussian military!" Yet elation gave way to a wrenching depression, a sense of purposelessness, compounded by the

collapse of the art market. Grosz felt rudderless at home, filled with a grow-
ing disdain for the monarchy, the generals, and German society in general.
"I had utter contempt for mankind in general. I drew drunkards; puking
men, men with clenched fists cursing at the moon; men who had murdered
women, sitting on their coffins," he later reflected of this nihilistic phase.[25]

His mood continued to sour as the summer of 1915 came to an end.
"I'm abysmally depressed," he wrote in September 1915, realizing he was
creating personalities like the "Dutch merchant" he had used with Wieland
Herzfelde and Ludwig Meidner to escape from himself. "I've ripped three
different personalities out of my imaginary lives, I myself am beginning to
believe in these imaginary alter egos."

Grosz felt complicit in furthering the war's pointless violence by having
volunteered to serve. "When war was declared there was mass intoxication,"
he reflected, adding, "The appeal of gun and helmet soon wore off and war
represented only the grim and the horrible."[26]

The vast majority of Hitler's artwork at this time showed war eerily
devoid of humans—buildings, empty battlefields, or lifeless nature. Grosz
sketched soldiers with their noses blown off, war cripples with crustacean-like
steel arms, a pair of medical soldiers suppressing a struggling infantryman
with a straitjacket fashioned from a horse blanket, a colonel having sex with
an army nurse, a medical orderly casually dumping a pail with assorted hu-
man body parts into a trash can. To maintain sanity, Grosz depicted the
painful reality. Hitler, by contrast, sketched a bizarre calm.

Grosz became depressed by what he deemed pointless heroism. Hero-
ism was noble when tied to a noble cause, but by 1915 what was the point
of all this heroism? He felt convinced that Germany had entered the war
too deeply, too quickly, too tenaciously. Moreover, the unelected officials
who supported the war viewed it as a game, a social experiment, while the
common soldier trudged on. "I saw heroism but it seemed to be blind," he
lamented. "What I saw more was misery, stupidity, hunger, cowardice and
horror" from military superiors, he added.[27]

Once discharged from the army, Grosz spiraled into an alcohol-fueled,
manic state of artistic creativity. Like Grosz, Berlin had come unhinged. The
pallor of death appeared on the faces of mothers who had lost their sons. The

frenzied nightlife persisted, but what was once drinking to reminisce became bingeing to forget the loss of innocence. Soldiers, sex workers, grieving parents, and war profiteers all mixed at the same clubs. It struck Grosz as grisly; yet he felt compelled to take part.

One typical work he created at this time showed a cross section of a tenement house. In one window, a man is beating his wife with a broom; in another window, an enraptured couple is having sex; in a third window, a man who has committed suicide is hanging stiffly with flies swarming around his corpse, his neighbors oblivious to his passing. Other drawings showed puking drunkards or men with clenched fists ranting to themselves under moonlight.

Berlin felt like a ghost town, the prosperity of the early 1900s drained by the war. In its place were the elderly, the decrepit, and contumacious military rejects like Grosz. "What I see around me, now that there are no more foreigners living in Germany: unkempt, fat, deformed ugly men and women," he wrote. "It's hard to remain within the bounds of decency when one begins to draw."[28]

"Being German always means being tasteless, stupidly hateful, fat, inflexible," he criticized. "Being German means being reactionary of the worst sort."[29]

———◆———

Little wonder that, weeks after being discharged, Grosz was in danger of plummeting into nihilism. He began feeling a despair he would never fully shake regarding the purpose of artists. "What do we artists, we insignificant little ants, have to say? We, who are nothing more than blown up frogs?" he mused. "Do we change the general picture in the slightest?"[30]

Yet, when he met Herzfelde at Ludwig Meidner's studio that summer, Grosz found a friend whose business acumen and philosophical mind-set made him consider possible constructive purposes for his art. Herzfelde wanted to establish a publishing company for art portfolios with Grosz as his main talent, which gave the artist a goal toward which to work.[31]

Grosz's drawings were not mere visual diatribes: by sketching murder fantasies, laymen and policemen ignoring suffering and crime, right-wing

bullies provoking it, and children influenced by it, he was exposing the emotional origins of the war into which Germany had entered. It was this aspect that would make his work so politically inflammatory in the years to come.

In one such work, the oil painting *Suicides*, a wealthy man in olive green pants and a cobalt blue jacket lies dead on the ground, his bowler hat askew, a gun by his side. Another man has dropped his gun before slinking off the canvas under the watchful eyes of a stray dog in the street, while a third man has hanged himself from a lamppost. A topless sex worker is standing at the window, her lips as red as her nipples, while her obese elderly customer leers at her backside. Only after taking in this spectacle does the viewer notice, far in the background, a dull-colored church with its lights off: Grosz felt that at the time the church, which was encouraging the war, was neglecting to preach against the vices that had triggered it.

Grosz's distribution and sale of his artworks began to escalate once Herzfelde graduated from Grosz's drinking buddy to become his business manager. After buying *Neue Jugend*, a two-year-old newspaper with an anti–Great War slant, Herzfelde quickly turned it into an efficiently run, profitable publication popular with both disillusioned veterans and an increasingly antiwar section of the working class. The June 1916 edition included two drawings by Grosz, while the August 1916 edition promoted portfolios of Grosz's drawings that were affordable for the middle and working classes. Soon Grosz's work was rising in value despite the war's overall dampening effect on the art market.

Grosz's increasing commercial success was interrupted when the army called him back up in the first week of January 1917. His service did not last long; army officials admitted him to a hospital after he suffered a mental breakdown within hours of entering service and was discovered partially buried in a pit of feces. Grosz found ample fodder for his disturbing drawings in the amputees who had devised a lurid pastime: throwing cigarettes into each other's mouths. His roommate, a coachman who had been shot in the abdomen, died beside Grosz muttering, "Where are my legs? I left them somewhere," before crumpling in on himself. Grosz flashed back to the battlefield, attacking a medical sergeant in his ward whom he mistook for an enemy.[32] Exasperated by his war-triggered mental instability, the army finally

sent him back to Berlin in late January and declared him permanently unfit for service.

After his return to civilian life in 1917, Grosz produced his greatest paintings to date—those that would become his most famous posthumously, work that explored the social factors leading up to the war and the reality that these issues were still unresolved. "Everything in me was gloomy protest," he noted.[33]

Germany, a Winter's Tale shows a regular German worker, middle-aged and balding, sitting down to eat a stereotypical German meal of wurst and beer. Like his napping pup, he seems indifferent to the chaos surrounding him: buildings teeter, a church surreally flies through the air, people scamper everywhere. At the bottom of the work is a triptych, evoking Catholic iconography, showing portraits of a priest, a general, and a schoolmaster. The priest, clutching a prayer book, is gesticulating wildly out a window, where the city is in flames. The old general wears an Iron Cross, while the schoolmaster appears ready to stride out of the painting to attack an unruly student. In a telling move, the general holds his sword in repose, all but the hilt off the canvas. Instead, it is the schoolteacher who is brandishing a weapon: the cane with which he plans to beat his students. The experience, tolerance, and even love of violence, Grosz seems to say, starts in childhood.

Meanwhile, riots due to food shortages were becoming rampant, and German cooks reluctantly began innovating with an increasingly despised root: the turnip. "It was obliged to do duty as cake, roast hare, and malt beer," noted twenty-five-year-old writer Richard Huelsenbeck, a friend of Grosz. The war dragged on, depleting Germany of resources. "Military trains carried loads of fresh meat—human and porcine—to the front," noted Huelsenbeck. By 1918, as the cities emptied and the soil became barren, confidence in the monarchy and the military began to wither, engendering a stifling atmosphere that triggered frequent knife and fist fights to which the jaded police turned a blind eye.

—◆—

In late autumn 1918, a naval mutiny in Kiel and Wilhelmshaven lead to wider mutinies, and on 9 November Kaiser Wilhelm II abdicated. Soldiers began running rampant and attacking their officers. The kaiser's abdication

did not particularly shock Grosz or Huelsenbeck, who had become good friends after Huelsenbeck moved from Zurich to Berlin several months earlier. Since early 1918, Grosz had been immersed in Dada, a group that Huelsenbeck had started in Zurich in 1916. Unlike an artistic school, which aims to propagate specific techniques or technical trends, Dada was an artistic movement that aimed to reflect the chaos of the times through whatever thematic and technical approaches its supporters preferred. Dadaists, like most Germans, believed the old European order had been obliterated and felt that confidence in Germany's artistic tradition equally had been shattered. "Something startlingly new for the first time in history has been drawn from the question: What is German culture?" the group wrote in a statement, adding "(Answer: Shit)."[34] Many Berliners whom Grosz observed had entered a state of defeated torpor; Grosz and his friends moved in the opposite direction, exhibiting surges of open anger and rage.

"We simply mocked everything," said Grosz of the Dadaists. "Nothing was holy to us. Our movement was neither mystical, communistic nor anarchistic," said Grosz. "We spat on everything, including ourselves."[35] They also defecated, at least metaphorically. In February 1918, Grosz gave a performance where he pretended to have a bowel movement before a Lovis Corinth painting while shouting, "Kunst ist Scheiße" (art is shit), to a dumbstruck audience.

Corinth, thirty-five years Grosz's senior, was a leading figure of the Berlin Secession, founded by Jewish German Impressionist Max Liebermann as an edgier, privately run alternative to the government-run Association of German Artists. After the association closed down a Berlin exhibition of Edvard Munch in 1892 on the grounds that Munch was morally offensive, many German artists became alarmed that it had no privately run rivals, effectively meaning that the German government had the power to censor and dictate what constituted German art worthy for the public to see. Liebermann and Corinth, who took inspiration from French artists, differed wildly from Munch stylistically. Yet in the late 1890s they feared that complacency about government censorship could have dangerous consequences.

By 1918, however, both men had grown weary of resistance; instead of being avant-garde, Corinth and Liebermann had become part of the old guard. Much of the sixty-year-old Corinth's inactivity was due to a

mild stroke he had suffered in 1911, but it angered Grosz nonetheless that he had become so apolitical during a time when German artists were in such a crisis.

Liebermann, then seventy and in good health, had long been admired by German art collectors, critics, and curators; like the French Impressionists, he used short, quickly executed strokes to create outdoor scenes that emphasized natural sunlight. Rather than asking models to pose, Liebermann portrayed their natural movements after observing them at length. In *Bathing Boys*, a painting from 1900, he depicted nine young boys gallivanting on a beach off the Dutch coast. Fascinated with the equestrian paintings of Edgar Degas, one of Impressionism's founders, Liebermann created the 1901 painting *Two Riders on the Beach*, depicting two equestrians on lithe, chestnut horses as they prance on pristine sand in front of lightly frothing waves. He took great care in creating the work, also making a pastel version of the scene. Works like *Two Riders* were so popular that German art enthusiasts had lobbied for Liebermann to represent Germany at the 1904 Saint Louis World's Fair in Missouri. Kaiser Wilhelm vetoed the idea, however, stating that Liebermann's work looked too "French" and was thus "gutter art," a dispute reported by the *Washington Post* at the time.[36]

As the Great War dragged on and the Germany that Liebermann had once loved was in decline, he relinquished the streak of curiosity that had inspired him as a younger artist. After the kaiser abdicated, Liebermann also gave up his position as the leader of contemporary German art, retreating to his studio to paint anodyne garden scenes. When asked by a Parisian art newspaper why he did not seek to help rebuild German culture and serve as a mentor for young artists reeling from their country's defeat, he replied that he had "already become too old" to take up the responsibility of reacting to the "disturbed epoch" that was the Great War. "I regret that the good old days before the war, and my old friends in France and Belgium, are lost for me," he said.[37]

This defeatism from the older generations caused Grosz and his friends to adopt an attitude that Grosz summed up in two words: "Screw it." He paraded around the semideserted streets of Berlin wearing a monocle, frock coat, and gloves and tapping a cane with a skull on it to parody a Prussian

army general. He wanted to shock the public in this pallid corpse of a city into feeling anger at militarism. "I was disappointed, not because the war was lost, but because the people had tolerated it and suffered it for so long a time, refusing to follow the few voices that were raised against the mass slaughter," Grosz lamented. It was an anger and shame felt by veterans from all sides of the conflict. D. H. Lawrence, the future author of *Lady Chatterley's Lover*, had fought against Germany but shared Grosz's anger that Europeans had been too cowardly to call for the fighting to stop and referred to the war years as "the years when the world lost its real manhood." Yet Lawrence and citizens of every country involved in the war, save for Germany and Austria, considered themselves victors. The Germans and Austrians could not. The kaiser's abdication and the armistice made it undeniable for them that they had lost not just the war but their old monarchial order. The fate of that fallen regime now rested in a glistening, gilded, sun-drenched room, the Hall of Mirrors at Versailles, where the postwar terms would be settled.

The stakes were high, exerting crushing pressure on the Germans, who burned with a hope that drove them into frenzied anxiety. "If peace and orderly economic conditions can be upheld, Germany will emerge from defeat stronger and happier than before. But if the entente reduces us to wage slaves, that will mean a fresh war," warned one friend of Grosz, Harry Kessler, a noble-born German diplomat based in Berlin who spent his leisure time cultivating and appreciating German art.[38]

Kessler, who worked a few blocks from the imperial palace, made periodic visits there to take notes during the winter of 1918. A close friend and new patron of Grosz's, he could not have been more different from the artist. Grosz, now twenty-five, felt comfortable in burlesque clubs, hosting wild parties, admiring buxom women, and swilling beer. Kessler, who demurred when Grosz invited him to his parties, was shy and discreetly gay, preferring to drink in moderation. Yet the two formed a friendship based on extreme respect, a love of the styles invented by Grosz and his artistic compatriots, both male and female, and a mutual desire to see Germany learn from the disastrous mentality that had enabled the war.

Kessler visited the ruined palace on Christmas Eve and observed how its windows gaped like the eye sockets in a skull. Looters had smashed the

balcony from which the Emperor had made his call to arms in August 1914. A grenade had landed in the Hall of Pillars and damaged a painting by Franz Skarbina, a German artist who had died in 1910 and whose street scenes were popular with the middle classes. Kessler was shocked that the paintings on the walls were so banal that looters had not even bothered to take most of them. The monarchy had neglected to nurture German culture for decades, and now the nation had not just a power vacuum but also a cultural one. "The Emperor's and Empress's mementoes and artworks are so insipid and tasteless, so philistine, that it is difficult to feel much indignation against the pilferers. Only astonishment that the wretched, timid, unimaginative creatures who liked this trash and frittered away their life in this precious palatial haven, amid lackeys and sycophants, could ever make any impact on history," he wrote in his journal.[39]

Dada's nihilism had given Grosz a voice for his grieving as the war drew to a close, but he realized toward the end of 1918 that he needed to transition from nihilism into developing a concrete set of principles. Both Grosz and Herzfelde began considering the idea that Grosz's art and Herzfelde's publishing house should promote communism, particularly the form that German communists espoused, which emphasized the separation of church and state, basic human rights, freedom for adult men and women to express their sexuality with other consenting adults, career equality for women, and both distrust of and disgust for moneyed individuals, particularly those who had inherited their wealth.

In the weeks leading up to Christmas 1918, the gun violence that had played out on the battlefields was brought home to German cities, whether on the streets or in popular hangouts like Grosz's favored Romanisches Café on Kurfürstendamm. Gun violence was commonplace enough that urban Germans began referring to it as "this shooting business." Firefighting lit up the night sky. Still, the telephone system functioned and the trams ran punctually.[40] Yet Germany incrementally was entering a period in which a disdain for and distrust of establishment politicians would become the new normal.

A disorganized communist putsch in Berlin on 6 December left several dead. Karl Liebknecht and Rosa Luxemburg, both forty-seven-year-old communists and activists for social and women's rights, harnessed sympathy

for the victims with a demonstration. Pallbearers carried the victims' coffins, while several thousand men and women clad in gray in orderly rank and file carried red banners high. It was a well-timed and aesthetically striking spectacle. Only a few minutes' walk away, the Emperor's abandoned palace was, quite literally, a crumbling symbol of absent political authority.

Inspired by the demonstration and searching for political meaning, on 31 December 1918 Grosz and Herzfelde joined the Communist Party and rang in 1919 together as a year of hope, receiving their membership cards from Rosa Luxemburg herself.

The German communist movement's push for broader labor rights and women's rights proved controversial for many Germans. If one believed in traditional, conservative family values, communism represented a moral threat. Elfriede Friedländer, an acquaintance of Grosz, did little to assuage this fear of the moderates by writing in her 1919 book *Sexual Ethics of Communism* that the sacrament of marriage was nothing short of the "evil spawn of capitalism." Communism, Friedländer argued, would eradicate stigmas against abortion, homosexuality, and bigamy and legitimize incest for men and women of all social classes.[41]

Just days after Grosz joined the Communist Party, members of the Social Democratic Party (SPD), then leading the country, began fighting on the streets with the communists. The absence of a moderate middle had given way to vicious conflict among factions of the Far Left and smaller groups on the Far Right, in particular anticommunist supporters of the military. It became impossible to tell who represented which group during brawls. "Berlin has become a witches' cauldron wherein opposing forces and ideas are being brewed together," said Kessler, observing one altercation.[42]

On 15 January, Waldemar Pabst, a commander in the Freikorps, a Far Right, anticommunist paramilitary group backed by SPD leader Friedrich Ebert, carried out his personal plan to assassinate Communist Party leaders Luxemburg and Liebknecht. Government-backed paramilitary soldiers drove Liebknecht to a spot on a highway in the respectable western Berlin district of Charlottenburg and ordered him to take a step forward. He complied, and a soldier promptly shot him, registering Liebknecht as "shot while trying to escape." A military official struck Luxemburg unconscious with a

rifle butt, and another subsequently shot her repeatedly in the head in the back of a government car, dumping her body into Berlin's Landwehr Canal; it was never recovered. Many Germans, including Grosz's patrician friend and patron, Kessler, were unsympathetic to the communist cause, viewing it as destructive, distracting, and disorganized. This violence, however, particularly toward a woman, shocked them. More broadly, it fueled distrust of the establishment because government officials had assassinated the pair for political purposes without due process and in complete disregard for the rule of law.

Herzfelde felt that Grosz's cold, incising, and jagged lines were perfect for creating images depicting these feelings in a work on paper that could be easily reproduced. He created *In Memory of Rosa Luxemburg and Karl Liebknecht*, depicting the pair's corpses wrapped in shrouds and placed in open coffins. A menacing judge, with the face of a demon, hovers like a ghost above them. Grosz used ink and a tinted wash to create an eerie, soft effect in transparent haunting lines. Grosz's use of a judge in traditional German robes was tactical. In not showing a policeman or military official, Grosz was drawing what many Germans were thinking: it was not just the police and the military that were rotten—the nation's problem extended to the justice system itself.

Grosz was quickly becoming one of the most prominent artists who supported the communist cause in Germany, but he was not the only one. Longtime communist supporter Käthe Kollwitz, who had joined the Berlin Secession with Corinth, created her own homage to the assassinations that paired well with Grosz's artwork.

Born in 1867, Kollwitz had grown up with progressive parents who encouraged her academic and artistic education. Before the war, she pioneered the notion of creating artwork specifically intended to portray the plights of workers and women to empower them, while also informing the government and higher economic classes so they could enact change. Kollwitz's series *A Weavers' Uprising*, created between 1893 and 1897, humanized the consequences of increasingly industrialized factory and agricultural technology for both urban and rural workers. The series even had appeared in the prestigious 1898 Great Berlin Art Exhibition at the Lehrter Bahnhof in central

Berlin, making Kollwitz the first woman and one of the first leftist artists to gain exposure among both academics and ordinary museum visitors. Kollwitz's series was in the running to win the exhibition's top prize, but Kaiser Wilhelm II, who privately derided it as "gutter art," declared that a woman could not be eligible to win.

Kollwitz faced opposition not only from the conservative establishment but also from the growing Communist Party, which was angered that while the artist supported their views, she did not want to join their movement because she saw herself as a politically inclined artist rather than a political activist. Long before communism became popular in Germany following the Great War, Kollwitz had been advocating for labor rights and increased exposure of the plight of the forgotten man and woman. After the deaths of Luxemburg and Liebknecht, she produced a woodcut of workers gathering around Liebknecht, whose face can be seen still possessing the solemnity that had been his trademark expression during speeches. A male worker bends over him in the style of a pietà, a trope used in classical art to depict female mourners of Christ.

By the end of the Great War, however, Kollwitz had retreated from the public eye and from her artistic social circle after her eighteen-year-old son Peter was killed in battle, her pain compounded by a feeling of responsibility for his death: she and her husband had given him permission to enlist— he could not have joined the military otherwise. Even before Peter's death, Kollwitz had been intensely sensitive to the pain of mothers who lost their children, mainly due to disease and malnutrition. Her emotional 1903 work on paper *Mother with Dead Child* shows a lower-class German woman cradling her dead child in the manner of classical depictions of the Virgin Mary cradling a recently crucified Jesus Christ. At the war's end, however, despite the popularity of her tribute to Karl Liebknecht, Kollwitz retreated into her mourning. This left Grosz as the communists' primary artist, one whom the party particularly supported because he was an actual member.

* * *

Grosz, twenty-five, childless, and still partying, industriously worked on his career in daylight hours, recognizing the necessity of building his public

reputation while also nurturing private connections with influential liberals who could sponsor him and give him constructive criticism. Herzfelde, as Grosz's publisher, was still working ambitiously to promote the artist's work, lunching with Kessler, the German diplomat who was Grosz's patron, to show him political drawings by Grosz that the artist and Herzfelde soon distributed through vendors to students, soldiers, and universities. Grosz and Herzfelde hoped that Kessler could convince his fellow bureaucrats to reject their increasing cynicism about the new republic in favor of working to craft specific policies to enact positive change.

As cynical as they could be, Grosz and his compatriots still believed that something good could come of the Great War. "We hope that a socialist republic not only will make the situation in the art world healthy, but will create a unified art epoch for our generation," said Max Pechstein, noting that he and Grosz hoped they could "breathe new life into the dead ideals of our age."[43]

Vast swaths of the German people shared this tentative optimism: Germany's military invincibility had been exposed as a fraud and its monarchy had collapsed, but perhaps the success of a new republic and increased civil rights for its citizens were still possible. Yet their hope acquired a foreboding sheen when the Allies chose to open the peace conference in Versailles on 18 January 1919, the anniversary of the day the German Empire had been proclaimed in 1871. Germans were stung, considering it a sophomoric jab.

Meanwhile, the postwar government continued to quash protests with violence rather than welcoming debates to establish the new republic's goals. In Berlin, the newly appointed Defense Minister, General Gustav Noske, responded to a minor strike on 3 March 1919 by the communists by unleashing 40,000 troops who used machine guns, mortars, and howitzers and left 1,200 dead communists in their wake. As after the murders of Liebknecht and Luxemburg, even Germans who found communism abhorrent viewed this as excessive government force. Grosz responded to Noske's massacre in his new magazine *Die Pleite*, which technically translates as "The Bankruptcy" but was also contemporary slang for "Shot to Shit." Grosz showed the works to Kessler, who was beginning to disdain the very government that he was paid to represent.

Such drastic political mistakes meant artists were primed to skewer the nascent German republic. Artist Hannah Höch, four years older than Grosz and an open bisexual, already had created a major parody of the new President and Chancellor. That work, using a photo-montaging technique Höch invented and popularized, mocked an already notorious photograph of the two flabby-chested men in swimming trunks. Höch added childlike drawings of dolls and bouncy balls to make the men seem like oversized babies, incapable of building Germany up from the Great War's rubble. Höch's complicated montages, unlike Grosz's simple drawings, were harder to mass produce, so it was Grosz's parody of the President lolling in an easy chair, his crotch bulging and a steaming pile of dung on top of his head, that became better known.

The popularity of Grosz's works incensed the new republican government, which jailed Herzfelde even as violence in the street escalated. The Chancellor exacerbated the situation by announcing that anyone caught in armed conflict with government forces should be immediately shot rather than given the chance to surrender and be processed according to the rule of law. He also supported rooting out and arresting peaceful protestors for objecting to the government, including artists who protested through their work. To this end, soldiers tried apprehending Grosz on the basis of his critical drawings alone. Grosz began to use false papers to sleep in different locations every night. Upon finally returning to his studio, he gratefully accepted money from Kessler and reunited with the recently released Herzfelde.

Undeterred, Herzfelde and Grosz began plotting their new issue of *Die Pleite* while celebrating their intrepidness with hefty doses of alcohol. On 3 May 1919, they distributed roughly 12,000 copies of *Die Pleite*. By this point, Grosz had decided that abstract art was irrelevant and that artists should create "message-based art." Unlike propaganda, which tells its viewers what to think about societal problems, Grosz felt that art should expose these quandaries to prompt discussion of solutions, while also employing artistically innovative techniques.

He did not have long to wait for further inspiration. Even before its signing, it was clear that the Treaty of Versailles was designed to crush Germany's

spirit and humiliate its people for their role in the war. French Premier Georges Clémenceau led the condemnation of Germany. Nicknamed "Le Tigre," he interrupted, shushed, and talked over representatives from smaller nations and brushed aside Woodrow Wilson's idealistic rhetoric.

On 20 April 1919, Hitler's thirtieth birthday, the entente summoned Germany to receive the conditions on which it had decided, a move that horrified German citizens, who had believed that their leaders would play an active role in the negotiations. The victors dashed the hopes of millions, including Kessler and Grosz, that the newly democratic Germany would join the League of Nations. Students burned the French tricolor in front of the statue of Friedrich the Great in Berlin, but the German politicians complied with French demands. On 28 June 1919, Herman Müller and Johannes Bell, the two men comprising the German delegation, arrived in the Hall of Mirrors visibly beset with jitters. There, they compliantly came forward to a table, signed the treaty on behalf of the German people, and meekly returned to their seats. Nothing was said about Germany's future role in an increasingly globalizing world. It would not have one.

Moreover, nothing was said about the roughly ten million soldiers and eight million civilians who died during the war, observed the Irish painter, William Orpen, as he sketched the scene for a painting of the signing. In the finished work, Bell and Müller huddle over the treaty, Bell sitting in a wingback chair and facing Clemenceau and Wilson with his torso slouched over the document in a gesture of supplication. Wilson and Clemenceau both appear utterly bored, with Wilson only partially looking at the German delegation as he prioritizes reading a newspaper. It was a deliberate insult—and accurate observation—by Orpen. "Why upset themselves and their pleasures by remembering the little upturned hands on the duckboards, or the bodies lying in the water in the shell-holes, or the hell and bloody damnation for the four years and odd months of the war, or the men and their commanders who pulled them through from a bloodier and worse damnation and set them up to dictate a peace for the world?" noted Orpen.

Germans expected that the treaty would be contractually harsh. Indeed, its terms were similar to those Germany had given to other defeated nations.

Still, Germans were flabbergasted by the humiliations that were deliberately integrated into the terms of the treaty: just as the Allies had required that the conference open on 18 January 1919, the German Empire's anniversary, they required that the Germans sign the treaty on 28 June, the anniversary of Archduke Franz Ferdinand's assassination, which had triggered the war. Moreover, their location was the Hall of Mirrors, where the German Empire's birth had been celebrated in 1871. To top it off, the victors added a clause into the treaty, Article 231, that placed "sole moral guilt" on Germany for starting the war—meaning no other countries bore responsibility for joining in or prolonging the fight.

The treaty reduced the status of the infant republic in the eyes of other nations to that of a bastard born out of shame and sin. Germany's standing among nations that were once her peers was crushed in perpetuity. While two politicians, Chancellor Philipp Scheidemann and Foreign Minister Count Ulrich von Brockdorff-Rantzau, resigned in protest, other leaders of the fledgling German government acquiesced. The republic became synonymous with defeat, humiliation, and injustice, and the German public perceived its leaders not only as spineless but as unwilling to put the needs and interests of their constituents first.

It was a republic that no one wanted.

This is what devastated Grosz and his artistic compatriots. During the months before the war ended in November 1918, they, along with millions of other Germans, had known defeat was inevitable. Yet they never thought that this defeat would be so humiliating or that so many other nations would respond with praise to this shunning of Germany from the international community of influential nations, an ostracism that had no end date. "My friends and I believed in a future of progress as if there were some preconceived international agreement upon that score," Grosz lamented.

The right-wing *Völkische Beobachter*, which would later support Hitler, summed up the treaty in two words with which people of many political persuasions would agree: it was a "syphilitic peace" that, like the dreaded disease, began with a small sore but would slowly attack the limbs and joints, even all the flesh, down to the heart and brain of the new German government.[44]

In his diary, Kessler jotted down a passionate but prescient line about the long-term consequences of the treaty: "A terrible time is dawning for Europe, a sultriness before the storm which will probably end in an even more terrible explosion than the World War."[45] Grosz was more succinct, summarizing the years from 1914 to 1919, the resulting government, and the state of German society with the words "this shit show."

ECLIPSE OF THE SUN

"We wanted something more, but what that 'more' was we could not exactly say. Though we could find no solution in the purely negative, we denied all existing values. . . . I thought the war would never end, and it never really did end."

—George Grosz

ONE MORNING DURING THE EARLY days of the Weimar Republic, Erwin Blumenfeld, a rather louche Jewish German photographer, roused himself from a groggy sleep only to find himself severely hungover. The twenty-one-year-old Blumenfeld, a gaggle of women, and eleven men, including Wieland Herzfelde and Richard Huelsenbeck, had split sixty bottles of wine with the pack's leader, George Grosz. It was the latter who had advertised the costume party around Berlin with a poster reading, "Well-built young society girls with film talents invited to a studio party, Studio Grosz, 8 p.m."

About fifty women arrived, many stripping and drinking with the men. After realizing he had been slumbering for a full two days while curled up in Grosz's bathtub, Blumenfeld discovered he was missing his new blue suit. Drinking more to forget this loss—and the throbbing in his head—seemed

the sensible solution.[1] This was the attitude exuded at Grosz's parties. As Grosz put it, "It was contentment and suicide in high style."[2]

The fourteen years between the empire's fall and Adolf Hitler's rise saw a dazzling diversity of sexual preferences, social perspectives, artistic approaches, and political convictions to an extent never before been seen in Europe. Like the elaborate costumes worn at Grosz's infamous parties, German opinions on sex, art, feminism, violence, and spirituality were myriad. German political views were communist, apolitical, feminist, and racially prejudiced; it was as if Germans were playing some version of ideological hopscotch.

Grosz's friends garnered admiration and derision from both art world elites and regular Germans for their morally, sexually, and politically charged creations. Yet it was Grosz who became a household name for combining all three aspects into easily distributable works on paper that were instantly recognizable for their trenchant, often sparse style of jagged, taunting lines. "I know no one who has grasped the modern face of the holders of power right down to the last alcoholic veins as Grosz has. The secret: he not only laughs, he hates," asserted prominent Jewish German playwright Kurt Tucholsky.[3]

Grosz's widely distributed works reflected his seething hatred of corrupt government officials, unchecked crime, and Germany's neglect of its wounded war veterans. Though he descended into a near nihilistic despair during frequent bouts of depression, Grosz always retained the blend of wit and cynicism that he had honed since art school.

Harry Kessler, the diplomat who was Grosz's patron, wrote after a postwar studio visit that Grosz rejected abstract art as irrelevant and advocated making visually striking, politically motivated artwork to trigger talk about the republic's flaws and thus galvanize change. There "are complex events of an ethical character which perhaps art alone is capable of conveying," noted Kessler.[4] Grosz considered his work to be a blend of reporting and opinion, a visual version of political punditry.

After the Treaty of Versailles's ratification, Grosz and his friends spent 1919 and the beginning of 1920 unsuccessfully trying to reverse the traumatic effects of the Great War. Determined not to become a lost generation, they deliberately careened between productivity and hedonism, assiduously documenting the republic's chaos by day and passionately partying by night.

Grosz and his friends published a manifesto outlining their goals for both their lives and their art. In it, the group of twenty acknowledged that the majority of young Germans were traumatized and had retreated to the insularity of their homes, wary of political activism. "All these are characteristic of a young generation, which has never understood how to be young," they wrote. Grosz and his companions aimed to be a vibrant minority pushing forward a wilder notion of a new German culture, declaring an end to Expressionism, which they now considered outdated.[5]

At art school in Dresden, Grosz had grown to admire the Expressionists, including Oskar Kokoschka. Yet now Kokoschka, at only thirty-four, had moved away from the revolutionary and populist ideals that had imbued his early paintings. On the eve of the Great War, in 1914, Kokoschka had created his last masterpiece, *The Bride of the Wind*, a portrait of the artist embracing Alma Mahler (née Schindler), the widow of the Jewish Austrian composer Gustav Mahler, who had died three years earlier. After losing her husband, Mahler had connected with Kokoschka, and the two had embarked on a passionate, loving affair. The work was the epitome of the Expressionist style that Grosz, as a student in Dresden, had admired in Kokoschka: the couple embrace, their legs and bedsheets intertwining in swirls of soothing dark green and navy brushstrokes, floating in a dreamy atmosphere. Now, however, Grosz accurately suspected that Kokoschka, instead of nurturing young artists or creating his own works expressing Germany's turmoil, had stagnated after becoming a professor in Dresden at the end of the Great War.

Grosz's suspicions were confirmed following a 15 March 1920 rally in Dresden that turned bloody when the Reichswehr fired on aggressive workers demonstrating for better employment conditions. In an op-ed published in *Die Aktion*, Kokoschka ignored the fact that 59 people were dead and 150 wounded due to a government-provoked attack. Instead, he focused on how bullets had flown through the window of the centrally located Zwinger Gallery and damaged a painting of Bathsheba by Peter Paul Rubens. Kokoschka suggested, without irony, that the workers arrange duels with the Reichswehr outside town. Grosz was incensed, particularly because *Die Aktion*, a cultural periodical founded in Berlin in 1911, had been vital to legitimizing the

Expressionists. Kokoschka's response seemed proof to Grosz that the Expressionists had grown complacent.[6] Grosz was furious that Kokoschka, once passionate about creating art that angered the authorities, was insouciant now that his works were so prized by the government-sponsored academic establishment from which he had received tenure. Grosz lashed out, publishing a paper mocking establishment painters who created "securities" that "aesthetic fops" could buy as investments. "We're all familiar with the cult of stars," he wrote. "Your brushes and pens, which should be used as weapons, are nothing but hollow straws."[7]

Across the country, tensions between the military and civilians only increased. In the Ruhr region, fighting erupted in April between communists and the Freikorps, the civilian paramilitary group that had murdered Rosa Luxemburg and Karl Liebknecht. Traumatized veterans were not ready for the adrenaline rushes of the Great War's battles to dissipate. "We shoot even the wounded. The enthusiasm is terrific," wrote one fighter, describing how he and his comrades shot ten Red Cross nurses. "We shot those little ladies with pleasure, how they cried and pleaded with us to save their lives. Nothing doing!" he bragged.[8]

In this turmoil, Grosz considered it crucial to imbue his art with political significance. In summer 1920, he featured the title work from his new portfolio in a show of several Dada artists held on Lützowufer 13. The work featured the title *God with Us* in three languages—German, English, and French—picked because they were the primary languages used in diplomatic exchanges in the Great War. *God with Us* portrayed three fat, zombie-like soldiers striding forward, the slogan on the belt buckles of German soldiers giving the work its name, a deliberate provocation meant to spur debate within society.

Kurt Tucholsky, the eminent playwright and journalist who had praised Grosz's ability to craft acerbic sketches criticizing the new government, considered Grosz's work the best of the 174 pieces on display. "His portfolio 'God with Us' shouldn't be missing from any citizen's family table—his grimaces of the military majors and sergeants are infernal, true, haunting horror," wrote Tucholsky. "The others scratch. He kills."[9]

The new government, despite its faltering political and economic plans, nonetheless decided to try to silence the tide of criticism coming from

artists, especially George Grosz. The German army took him to trial over *God with Us*. Grosz and his publisher, Herzfelde, had the opportunity in court to attack the military, but they demurred, saying their artwork was a commentary on what some, but not necessarily they themselves, thought of the military. Tucholsky was openly disappointed. "That was your defense? You 'didn't mean it like that'?"[10] The government destroyed the printing plates and transferred the copyright to the army. Though the case increased the German people's awareness of Grosz as an artist, it also clarified for him and his fellow citizens that, in the young republic, freedom of expression was hardly a civil right.

Grosz's exploration of sexual mores increasingly contained political undertones. Dozens of sketches he made after visiting seedy clubs at night showed obese black-market dealers enjoying high- and low-class hookers, fine alcohol, and cigars. Such men were earning increased profits in currency speculation in 1922, as the gap between the rich and the poor began to widen. Citizens blamed the government for this growing wage gap fueled by illegal side deals. They specifically aimed their ire at the Jewish industrialist and German Democratic Party founder Walther Rathenau, who advocated the Fulfillment Policy, pledging Germany would pay war reparations, which by late January 1921 had been set at roughly 130 billion gold marks to be paid back by 1963. The Fulfillment Policy angered most Germans, who still felt the Treaty of Versailles was ruinously unjust.

Kessler worried about growing anti-Semitism targeting Rathenau, a good friend who, he observed, was being attacked as "too Jewish" at home and "too German" abroad.[11] On 24 June 1922, two right-wing army officers assassinated Rathenau in his car, convinced that his Judaism meant he was trying to sabotage Germany in his diplomatic negotiations. Rathenau's murder ended hopes of better diplomatic relations abroad and helped Grosz realize that anti-Semitism was growing.

By this point, Grosz was enjoying a sustainable income from Herzfelde's efficient distribution of his art with an innovative pricing scale that was affordable for the working class but still profitable. *Die Räuber*, a portfolio of Grosz works, had four editions: five copies costing 300 marks were bound in vellum with hand-laid Japanese paper; thirty-five copies costing 150 marks were printed on lower-grade paper bound in silk; fifty-five cloth-bound

copies cost 100 marks; and an unlimited run of unsigned editions in a paper folder sold for 3 marks each.[12]

Grosz's political ideology was still in flux, but by the end of 1922, he no longer believed that communism was a plausible political option for Germany. Many German communists believed that Russia was a utopia, espousing an almost religious reverence for the blue-collar worker. Grosz was increasingly bothered by this following a brief visit to Russia during which he realized that implementing communism through governmental force did not eliminate class differences; moreover, Russia's one-party system did little to promote free thought or artistic creativity.

"There are rich and poor just like there are everywhere else," he decided.[13] Disillusioned, he left the Communist Party. As communism jostled with other viewpoints to establish itself as a dominant movement, the young republic in October 1922 began grappling with an alarming economic issue: hyperinflation. "One had to buy quickly because a rabbit, for example, might cost two million marks more by the time it took to walk into the store," said Grosz of the toxic combination of a disrupted supply chain and a sinking currency.[14]

Millions of Germans responded by descending into a pernicious form of nihilism triggered by oversaturation with everyday problems and heated political discussions. "There was universal hatred," explained Grosz, citing the key targets of this wrath: Jews, capitalists, communists, militarists, home owners, workers, the Reichswehr, the Allied Control Commission, corporations, and politicians. "A real orgy of hate was brewing and behind it all the weak republic was scarcely discernible. An explosion was imminent," Grosz predicted.[15]

Concurrently, Grosz's position in the art world became more lucrative and publicized after he signed with Alfred Flechtheim, a well-known Jewish German dealer fifteen years older than Grosz who became a personal friend. "Nature made an exception in this case, just as it does from time to time in the relations between cats and dogs," Grosz quipped about the rarity of an art dealer befriending an artist whom he represented.

Signing with Flechtheim not only marked thirty-year-old Grosz's entry into the established art world that the artist long had loathed but also made

him more familiar with the growing hatred in Germany of both French art and those who admired it. At Flechtheim's home, he enjoyed sumptuous dinners paired with lovely Rhineland wine. Gazing up at Flechtheim's walls, Grosz noticed, much to his chagrin, that Flechtheim had covered them with French, not German, paintings. Grosz quipped that Flechtheim treated the paintings by Germans that he personally owned as "stepchildren," compared to his more "legitimate" French artworks.[16] Those Germans who were aware of Flechtheim's prestige in the art world increasingly saw the Jewish German dealer's preference for foreign artwork as evidence of something nefarious in his "blood."

Meanwhile, among Berliners, it became a sardonic joke that those too old to have served in the war, particularly those who had profited from it through arms dealing and speculation, were now quite literally tripping over the Great War's casualties. Grosz created one well-distributed work with the sarcastic caption *Caution, Don't Stumble*, showing a wealthy man and his fur-clad wife about to trip over an amputee's leg. For the 80,000 amputees who came back to Germany without support from the military that had sent them off to war, Berlin was a place to flock for the chance to beg and, if lucky, elicit some cheap or free sex.

———◆———

As Grosz began seeing unprecedented success after signing with Flechtheim, his artist compatriots during the wartime years also worked to establish themselves in the uncertain postwar market while simultaneously grappling with their personal demons.

Ernst Ludwig Kirchner, now in his forties, struggled the most both psychologically and professionally. After doctors admitted him to a Swiss sanatorium in 1917, numerous medical professionals observed his dependency on Veronal, a powerful sleep-inducing drug, contrasted with "nervous excitation" when experiencing withdrawal; his service as a soldier caused him now to exhibit increasing signs of paranoia, though his doctors said that much of this "excitation" likely had been present long before the war. Kirchner struggled to lift himself out of depression, an endeavor he dubbed "grasping all the lovely things" as he moved into a new home in Davos to

stay close to his doctors.[17] It was a maxim he repeated to himself as he tried creating artworks that seemed moving but still positive; yet he struggled with making this his natural style, given the emotional turmoil he was fighting. In *Winter Landscape in Moonlight*, Kirchner portrayed the snowy alpine land-scape around his home in fantastical hues of fuchsia and turquoise. Residents of the small town, then quite provincial, were impressed by his gramophone and readily came to socialize at his house, where he sketched them as they danced.

Still, he suffered from a dependency on morphine, which doctors con-sidered a safe drug to prescribe for a patient to self-administer at home. "If I manage to stop taking the drug [morphine] in the spring, then we shall be on quite a different plane and can make decisions," he wrote a friend. Increasingly, Kirchner created artworks such as *Sick Man at Night*, in which a man closely resembling Kirchner, with the sickly pallor of a drug addict, sweats in a nightshirt under his bedcovers even as an open window above his bed reveals an Alpine snowscape outside.

Max Pechstein, Kirchner's cofounder of the Berlin art school during the war, now struggled to find a place in postwar Berlin without his friend, par-ticularly as the art school was shuttered, given that Kirchner was unable to help teach. Rather than dwell on his unpleasant wartime experiences, Pech-stein created scenes of the Palau Islands, a former German colony that he had visited in 1914. Disturbed by his military service in Somme, Pechstein found solace in rekindling his Christian faith, though he worried that the church was not sufficiently reaching out to jaded veterans. To counteract this, he created twelve woodcuts illustrating the Lord's Prayer's major tenets, using a primitive style with thick, jagged lines inspired by his trip to the Pa-lau Islands.

Living in Berlin after the Great War, Grosz's friend Otto Dix was in a far more stable emotional state than his rival Kirchner; yet Dix still strug-gled with the consequences of having spent more time on the front lines than any other artist of note. After his career as a machine gunner on the Somme, in Artois and in Flanders, the twenty-eight-year-old Dix now scoffed at his younger self for having been naïve enough to think that going to war could be an academic exercise, laughing at the fact that he had brought the Bible and

Friedrich Nietzsche's writings into the trenches. Yet he had still found time to make some preliminary sketches on which he now hoped to expand, though he first focused on depicting the chaos he observed around him in Berlin.

Dix's 1920 oil painting *The War Cripples* shows four crippled veterans walking past a bourgeois shop selling fancy footwear. Bitterly, the impoverished former soldiers trudge on, one in a wheelchair, one missing one leg, and another hobbling along on crutches with sticks attached to the stumps where his legs once were. Concurrently with *The War Cripples*, Dix created *Skat Players*, which shows three severely disfigured war veterans with horrifically burnt faces playing the popular card game in the corner of a dimly lit café. Two of the men lack legs, though one still wears his Iron Cross, struggling to play his cards with a new prosthetic hand. Dix had quietly sketched the scene while observing the men in a bar, and though the work was a masterpiece, this brush with the reality he experienced in the trenches made him temporarily turn to observing the burgeoning sex industry in Berlin, particularly its seedier aspects; though also an unsavory topic, it was easier for Dix to focus on nonconsensual sex work and the exploitation of young girls than on the unforgiving brutality of his wartime experiences.

He quickly created two of the most iconic and incendiary works of his career: *Leonie* and *Girl Before a Mirror*. In *Girl*, a prostitute appears young and beautiful from the back, wearing a classically simple white corset that appears to be in impeccable condition on her youthful skin. Gazing into the mirror, however, the viewer can see the front of her body is actually aged, gaunt, and decrepit; her sagging breasts droop out of the corset, and her ribcage protrudes prominently. The reflection reveals to the viewer that her corset is actually ragged; faded pink ribbons and tattered lace are the only signs of a once glamorous piece of lingerie. *Girl* was a brazen commentary on the reality that, even as he was creating the work, young girls were being forced into the world of child prostitution, a business in which they would most likely be trapped for the rest of their lives. Like his compatriot Grosz, Dix created the piece in order to trigger changes in the government to protect these young children. Although the government did not deny the veracity of the work, the Berlin police confiscated *Girl* nonetheless and charged Dix with indecency. The painting disappeared forever.

For many homeless men, particularly veterans, brothels like those de-
picted by Grosz and Dix provided not just a place for sex but also a tempo-
rary shelter. Jewish Austrian journalist Joseph Roth, a distinguished reporter
for the respected *Frankfurter Zeitung*, covered the horrifying conditions at
a typical homeless shelter in Fröbelstraße, a center in the eastern district of
Prenzlauer Berg. Grotesque figures, "as though hauled from the lower depths
of world literature," shivered on wire-mesh iron beds, he observed. Women
in brown rags slept apart from men, though that didn't stop the place from
crawling with sexually transmitted diseases. Hundreds of injured and dis-
placed veterans were turned away at the gates, prompting riots.[18]

The government, Roth also observed, publicly displayed images of the
anonymous corpses of the physically vulnerable who perished on the streets
from disease, suicide, or murder. Tidy rows of photographs in cabinets on
the ground floor of the police headquarters showed snapshots of the bodies
as they had appeared when found. White slime oozed from eyelids; drowned
bodies encrusted in slime were puffed up, resembling, Roth thought, poorly
mummified pharaohs. "They stand there open mouthed, their dying screams
are still in the air, you can hear them as you look," he wrote, noting that this
"anonymous misery" was redacted from newsreels for cinemagoers who did
not want their entertainment sullied.[19]

Germany's moral divide was widening, with citizens crowding toward
the financially extreme ends of society. The middle class generally did one
of two things to survive: ignore the news or look for those whom they could
blame for the increasing chaos. Grosz picked up on this phenomenon, cap-
tioning a sketch of a middle-aged German man "Juden raus!" or "Jews, Get
Out!" Grosz's work was prescient. Rather than a social outcast, the man in
the work was a member of the bourgeois, sporting spectacles and a proper
suit and a tie. Right-wing politics and anti-Semitism, Grosz was warning,
were becoming acceptable among all economic classes.

Adolf Hitler was in his early ascendancy, his influence growing. Grosz
recognized the threat. He created a drawing that took aim at the aspiring
dictator's obsession with Teutonic warriors and his belief that he alone could
"fix" Germany. In *Hitler the Savior*, a pen-and-ink drawing, Grosz drew Hitler
with his head held high and his arms behind his back. Puffing out his chest

to appear more muscular, Hitler wears a one-shoulder, fur-lined tunic, complete with the sword and chained belt of a Teutonic folk hero. It was a hyperbole of the archetypical Aryan warrior. Grosz gave Hitler muscular arms that the skinny, petite politician clearly lacked; he even mockingly adorned Hitler's right bicep with a tattoo of a swastika over an olive branch. Grosz took the title *Hitler the Savior* from Hitler's own supporters, who, disillusioned with the state-sponsored church, brazenly began comparing him to Jesus Christ. "He shatters fetters, sweeps the rubble heaps back into order, scourges stragglers home," described Hitler follower Stefan George, predicting that Hitler would usher in an era of "Lord once more Lord. Rule once more Rule."[20]

Scoffing at Hitler's virility was also a tactic that Dix employed this same year in his own work *Pimp and Prostitute*, which showed Hitler with a cigarette hanging out of his mouth, a buxom topless prostitute lounging in the background. There was no evidence of Hitler's ever visiting prostitutes, but the work was a metaphor: "pimping" was contemporary German slang for the promotion of dangerous, misleading ideas.

It was clear that art had become a critical commentary on the state of Germany, its politics in particular. This set up a conflict that Hitler, artist and ideologue, would pursue relentlessly.

———✦———

Hitler the Savior and *Pimp and Prostitute* were circulating at a time when Hitler was gaining infamy for his failed Munich Putsch, which took place on the night of 8–9 November 1923. Leading up to the putsch, the thirty-four-year-old had continued voraciously reading newspapers, in which the coverage of Grosz's trial for *God with Us* and continued presence as a provocateur were omnipresent. Yet, despite Grosz's efforts, the Nazis had become the most prominent nationalist party by the end of 1923.

Hitler now held large rallies, and although his party was only one of roughly fifty other Far Right groups, he achieved political dominance by homing in on voters disenchanted with the government's continued inability to craft policy and solve key issues. Hitler argued that Germany was suffering from a lack of national unity due to the "niggerizing of the Germans" by nonwhites, the rise of the communists, and a dangerously widening income

gap.[21] Even those who rejected the first two points could easily observe the third: economic disparity.

Anti-Semitism was now a common rhetorical theme. Hitler argued that "Jewry" was a pernicious disease quite literally bred into Jews, an "inbred race" unwilling and unable to defend any nation and its culture; it was consequently dangerous for national security that they possessed full voting and civil rights. Hitler argued that a judicially enforced "opposition to and elimination of the privileges of the Jews" was warranted and would ultimately lead to the necessary extinction of Jews themselves.[22]

The majority of Hitler's opponents confidently believed that his movement would founder due to a lack of momentum and organization. Yet they underestimated how strategic Hitler was in marketing his new party, particularly as an antidote to communism. In early 1920, he adopted red as the official color of the party, now officially named the Nationalsozialistische Deutsche Arbeiterpartei (NSDAP), or National Socialist German Workers' Party. It was a shrewd move that siphoned power away from the communists, Hitler's main antiestablishment rival. Hitler railed that communism was a product of anti-German Jews, simultaneously arguing that democracy was also a Jewish plot to take over Germany.[23] "The Jew destroys and must destroy because," Hitler argued, within "himself he carries those characteristics, which Nature has given him, and he cannot ever rid himself of those characteristics."[24]

Hitler increased the frequency of his Nazi rallies after recognizing their propaganda power. He arranged for security at each, and his security teams calmly and routinely removed protesters to the jeers of the raucous crowds.[25] By 1922, Hitler was holding up to twelve rallies in a single night to satisfy demand, sweating so much that his underwear soaked up the moisture from sweat and spilt beer. The electrifying rallies fueled the party's rapid growth, but Hitler retained control by allowing the NSDAP to establish chapters only in locations where he found leaders personally loyal to him and who could proselytize not only to the working class but also to the bourgeoisie. Hitler recognized that previous radical right-wing parties had failed to succeed because they had appealed exclusively to one group or the other.

The academic classes generally preferred to discuss politics behind closed doors, in reserved tones, so Hitler began courting them in their parlors. In such sophisticated surroundings among trusted friends, the intellectuals felt comfortable entertaining controversial notions, including eugenics, anti-Semitism, social Darwinism, and censorship of controversial art. To them, the graphic, provocative art of Berlin's avant-garde was morally disturbing, and they agreed with Hitler that that these works were inspired by a break-down of and declining pride in German culture.

Crucial to legitimizing Hitler as a serious thinker was Catherine Hanf-staengl, an urbane American married to a German, who invited him to speak in her home. Catherine and her friends were amused by the quirky politician's obsequious behavior, finding him to be an entertaining breath of fresh air. Particularly bemusing was how Herr Hitler would arrive sporting rather odd color combinations; one memorably arresting outfit included a blue suit, a purple shirt, a brown vest, and a crimson tie.[26] Despite not arriving by horse, Hitler would routinely set down a riding crop after entering the house, even placing a holster with a gun in it on the coat rack. He would bring vast bouquets of flowers, bow low, and kiss the women's hands dramatically before ranting against the "Jewification" of art and culture. He used politically offensive rhetoric that the women would never use themselves, infusing the discussions with seemingly harmless excitement.[27]

Hitler was thrilled that the wife of Houston Stewart Chamberlain, the English racist whose books he had read in Vienna, attended these salons. He was also impressed by Catherine's son Ernst, nicknamed "Putzi," a dapper Harvard graduate who spoke native German and English. He noted to himself that Putzi would be perfect for a future NSDAP role and began ruminating over what it should be. Kurt Ludeke, a jet-setting rake born in 1890, described Hitler's draw for young sophisticates like Putzi and himself, employing religious language as many others did. "His appeal to German manhood was like a call to arms, the gospel he preached a sacred truth," Luedeke explained. "I was a man of thirty-two, weary of disgust and disillusionment, a wanderer seeking a cause, a patriot without a channel for his patriotism, a yearner for the heroic without a hero."[28]

France soon provided Hitler with a tragic incident that allowed him to argue that Germany was still under attack from foreign powers and he was the hero behind whom Germans should unite to reclaim their lost national sovereignty. After Germany repeatedly defaulted on paying war reparations, French troops occupied the Ruhr region in January 1923. This was the center of German coal, iron, and steel production, and the French aimed to intimidate Germany into resuming reparation payments. After fighting with a crowd of workers at the Krupp steel plant in Hessen, however, the French began shooting into the crowd, killing three and wounding over thirty. Enraged by what they viewed as a French invasion of their country, half a million Germans participated in funeral demonstrations. The German government's tepid response to the shootings disgusted many Germans, making the Nazis appealing to many who had previously been wary of the upstart party. Hitler harnessed the incident to his advantage; within a few weeks Hitler-backed paramilitary groups stole weapons from the government, which limply asked for them back but did not pursue the theft further. The Sturmabteilung (SA), the NSDAP's paramilitary wing, accordingly gained support from Germans who saw the incident as proof that the government was impotent and interpreted Hitler's brazen act as a sign of competence and strength.

By autumn 1923, Hitler felt emboldened to attempt a putsch. His initial plan had been to march into Munich's center on 11 November and declare a dictatorship, but he expedited his plot after learning on the evening of 8 November that a rival in the party, Karl Lossow, was making a speech in the Bürgerbräukeller, the cavernous basement beer hall where the Nazis routinely congregated for rallies. Incensed that Lossow might take attention away from him, Hitler rushed to the Bürgerbräukeller, grabbed a beer stein, took a gulp, and dramatically threw the stein to the floor. He brandished a pistol, jumped on a table, and, as beer glasses went crashing down, fired a shot into the ceiling. Absurdly, he announced that he had overthrown the national and Bavarian governments.

"I have four bullets in this pistol; three for my collaborators should they desert me and the last bullet for myself," he said glancing down at his top three rivals. The room went quiet. Karl Alexander von Müller, an academic who had attended salons that Catherine Hanfstaengl had hosted for Hitler,

was in attendance. He was shocked and horrified; when Hitler had first rushed in, Müller had mistaken him for a disgruntled waiter. Yet, once Hitler began to speak, Müller became mesmerized. Hitler transformed "the mood of the meeting completely inside out, like a glove, with just a few words," he noted.[29]

Hitler was convinced that his rivals were now behind his plan for a putsch, and they separated, ostensibly to prepare forces for that very night. Yet, once out of Hitler's sight, they shrank away. A light, wet snow began to fall. After midnight, Hitler realized his confidence in his fellow conspirators had been misplaced. Furious, he nevertheless roused supporters for a demonstration at Odeonsplatz in central Munich. The group began attacking policemen, and Hitler's arm was wrenched from its socket when a fatally wounded man fell on him. The police killed sixteen Nazis, and Hitler fled to the residence of Putzi Hanfstaengl and his wife, Helene.

"There he stood, ghastly pale, hatless, his face and clothing covered with mud, the left arm hanging down from a strangely slanting shoulder," Helene would later recall. Distressed, Hitler took out his revolver to shoot himself, but Helen convinced him otherwise. "What do you think you're doing?" she admonished him. "They're looking for you to carry on!" she said of his devout followers. Hitler reluctantly backed down from suicide and was soon arrested after convincing the officer to pin his Iron Cross on his chest before he faced the public.[30]

During his trial in February 1924, Hitler maintained that he had not committed treason because the new republic was not a legitimate government. The senior judge openly sided with him on this point, and the junior judges, responsible for issuing a verdict, only did so after the senior judge promised that it would not be enforced. They sentenced Hitler to five years in prison, but made him eligible for parole after only six months. Though he was Austrian, they spared him from deportation, saying his love of Germany was admirably ardent.[31]

Politically observant Germans who opposed Hitler assumed that the scandal would break Hitler's successful streak. George Grosz, for his part, was not fooled for a second.

———◆———

After the failed putsch, the government chose not to focus on far-right uprisings or the issues that led people to join them. Instead, they launched a second, extremely public investigation into Grosz, prosecuting him for obscenity. Grosz countered that he was not creating works of obscenity in their own right; rather through his artwork he was exercising his freedom of speech to comment on corruption that in his view was undermining the government's political legitimacy. The judiciary found Grosz guilty and confiscated several of his printing plates.

Undaunted, Grosz continued producing critical images of both the government and the Nazis. Grosz created and actively promoted his 1924 work *For the Fatherland, to the Slaughter House*. While the Nazis were portraying themselves as the positive alternative to war profiteers in league with the current government, this work argued that both groups were equally bad for Germany: in the black-and-white pen-and-ink drawing with soft, broad lines, a Nazi militant and an amoral war profiteer lead the masses into a new world war. The works resonated with ordinary Germans and sold widely throughout the country. "George Grosz's cartoons seemed to us not satires but realistic reportage: we knew those types, they were all around us," political theorist Hannah Arendt would later write.[32]

Berlin was now home to the Western world's largest variety of sexual mores and practices, including a new emphasis on sexual autonomy and pleasure for women. For artists, this provided opportunities to portray female sexuality that were unprecedented in Western history. Grosz had recently married Eva Peter, who had caught his eye on the campus of Berlin's Universität der Künste, where she briefly took classes. "Between ourselves, I shit on the idea of depth in women," he had once written to a male friend.[33] Yet courting Eva and then as her husband, he came to respect her mind while also encouraging her to express herself sexually with him as an autonomous, sexually unique individual.

Female artists aiming to chronicle both the benefits and pitfalls of this sexual revolution were freer to do so in the mid-1920s than at any previous time in the history of Western art, facing an unprecedented lack of resistance from male artists in the avant-garde. Hannah Höch, who had been part of the Dada movement with Grosz during the Great War, resolved in the 1920s

to earn an independent income as a single woman after two illegal abortions due to a relationship with Raoul Hausmann, a fellow Dada artist who was married. Still pained by her decision to terminate the pregnancies, she created the oil painting *Imaginary Bridge*. In the work, painted in dark browns and blues, she and Hausmann, represented only by their heads, open their mouths to kiss only for a tiny infant to fall out of Hausmann's mouth, terrified and clutching itself. Despite her pain, Höch considered herself fortunate that, unlike Hausmann's wife, she could escape her destructive relationship with him. After breaking with Hausmann, she blatantly stated, "I would like to blur the firm borders that we human beings, cocksure as we are, are inclined to erect around everything that is accessible to us," adding, "I paint pictures in which I try to make this evident, tangible."[34] She began creating collages from photographs and illustrations cut from German fashion magazines to comment on women's fashion and sexuality. Though several of these pieces celebrated women's sexual empowerment, many others reiterated the warning in *Imaginary Bridge*. In *The Coquette*, a woman in a fashionable flapper dress sits staring down at a group of men leering up at her, their human bodies replaced via collage by those of rotund animals.

Jeanne Mammen, a German-born artist, had grown up and studied in France before fleeing for The Hague during the Great War to avoid internment by the French government, which confiscated her father's property due to his German citizenship. Mammen subsequently moved to Berlin in 1916 at the age of twenty-six. There, she developed a far more positive view of female sexuality and women's empowerment than she had experienced before. She focused on sensual depictions of strong women thriving in traditionally male realms. Mammen's watercolor and pencil on velum work *At the Shooting Gallery* depicts a fashionable woman in a chic cardigan confidently selecting a rifle at a shooting range. The man overseeing the transaction, by contrast, is hardly the paragon of a masculine, skilled shooter; he has weak, flabby skin and tired eyes, in contrast to her strong cheekbones and steely gaze.

Living near the Kurfürstendamm, with its myriad clubs, cafés, and cabarets, Mammen prided herself on seeking out adventurous female dancers and singers and convincing them to pose for her. One of her most popular portraits depicts the famous Jewish German cabaret artist and silent cinema

star Valeska Gert. Though a trained and talented dancer who often gave wild, frenetic performances, Gert was also known for stunts such as "Pause," in which she simply went onto the stage and stood there, seeing how uncomfortable she could make the audience as they waited for something to occur. Her costumes were equally bizarre. In Mammen's portrait, Gert's short, spiky black hair mirrors her outlandish high-necked collar, which fans out behind her scarlet dress with its plunging neckline. Mammen admired how Gert was a self-made woman who designed her own acts down to the tiniest details and successfully managed her own finances.

———◆———

At the same time that Berlin-based female artists such as Höch and Mammen were creating their artworks exploring female sexuality in all its complexity, ordinary middle-class Germans based outside Berlin simply craved stability and a return to what they considered the prewar status quo. Normalcy finally seemed attainable for the first time since the Great War had broken out twelve years before. Though hardy ideal, life was far less hellish than in the months following the signing of the Treaty of Versailles. The Dawes Plan was functioning, ensuring that Germany could receive foreign loans and make its reparations payments in installments.

Otto Dix finally published the most significant series of his career, *The War*, in the midst of this optimistic wave of economic recovery that was sweeping the nation. In contrast to most other artists who served in the Great War, Dix downplayed his wartime experiences in both his professional and private lives. By 1923, he had settled down with his partner, Maria, with whom he had a child in 1923. Dix found it unsettling that the more he nurtured a happy home life, the more his nightmares about his service in the Great War increased. He frequently awoke from nightmares in which he was crawling through the wreckage of bombed and burnt-out buildings. "The rubble was always there in my dreams," he told a friend.[35]

In 1924, Dix finished the fifty etchings that comprised *The War*, based on over four hundred preliminary sketches. He meticulously planned the technique for each etching in advance of its execution in order to produce a myriad of textures, from gentle and soft to harsh and jagged. In *Horse Cadaver*, the corpse of an equine rots on the battlefield, her ribcage prominently

exposed as her chest decomposes. In an eerily similar work, *Corpse in Barbed Wire*, a soldier rots in a trench, his body hopelessly tangled in metal cords. On the battlefield, Dix argues, there is little difference between the bodies of man and beast.

The works were well received by art world elites, not only for their content but due to Dix's mastery of so many intricate types of etching. "No creation in contemporary art has depicted the apocalyptic face and the naked grimace of war with such intensity and immediacy," wrote a critic for the respected *Süddeutsche Zeitung*.[36] Yet the works met largely with extreme discomfort from ordinary Germans, and the portfolio made little money with which Dix could support his new family.

Politicians were also eager to suppress Dix's depictions of wartime, considering them bad for postwar morale. Shortly after Dix created *The War*, the Wallraf-Richartz-Museum in Cologne bought *The Trench*, a painting that Dix had concurrently created. Upon learning this, Cologne's mayor, Konrad Adenauer, forced the museum to return the artwork, finding its topic too depressing for his newly peaceful and prosperous city. Twenty years later, Adenauer would become the first Chancellor of West Germany after the war, responsible for cleaning up the havoc that Hitler would wreak. He would say little of his censorship of artwork in the years before Hitler took power.

In spring 1925, Germans elected Paul von Hindenburg, a revered seventy-seven-year-old general and statesman who embodied the prewar conservative family values for which most Germans yearned. Hindenburg even allowed the imperial flag to be used on diplomatic missions abroad, trips that had regained some of their prewar legitimacy as Germany was finally admitted to the League of Nations. Germans began to feel proud to be German again.

Hitler was alarmed by Hindenburg's rise. After founding his paramilitary force, the Schutzstaffel (SS) on 9 November 1925—the second anniversary of his failed putsch—the aspiring dictator continued to spout the same hate-filled rhetoric as before but now knew that he needed another crisis to gain traction. While Hitler was biding his time, the press and most Germans began to see his radical movement as a thing of the past.

Grosz, however, worried that Hitler was continuing to proselytize to middle-class Germans in hopes that a crisis, whether genuine or manufactured, would soon arise. The artist doubted that the elderly Hindenburg

could handle such a volatile political situation. His angst only increased when he began journeying to remote areas and observed how entrenched the Nazi message was there.

On a trip in July and August 1926 to Osteseebad Leba, Poland, a favored resort for artists and the bourgeoise located 1,100 miles from Hitler's base in Munich, Grosz observed several flag poles bearing official German flags with swastikas painted over them. Anti-Semitic comments were openly accepted; anti-Semitic publications littered the tables of mainstream bars and cafés, where patrons openly worried that the tolerance of legally assimilated Jewish Germans had tainted German culture, particularly the art world. "I wouldn't come here if I were Jewish; who knows why from time to time some of them have the boldness to defy the medieval-style ostracism they face," Grosz wrote a friend.[37]

Grosz aimed to work harder to combat the growing threat that not only the Nazis but also complacency about politics represented to his country. The task was daunting; he drank more, worked harder, and succeeded in creating some of the most trenchant works of artistic political commentary to come out of the Weimar Republic. Uniquely, they criticized not only the growing Nazi movement but also the violent Far Left and the political incompetence of the establishment that enabled the rise of these polarized groups.

In response to this growing anti-Semitism, Grosz created two detailed works in 1926 that came to define his career in the eyes of both his supporters and his detractors: *The Pillars of Society* and *Eclipse of the Sun*. *The Pillars of Society* took its name from an 1877 play by Norwegian writer Henrik Ibsen. The protagonist in Ibsen's controversial *Pillars* gets away with murder because of his power and influence in society. Grosz chose the title to posit that corruption and collusion were similarly dominant in Weimar Germany. Representing the press, which Grosz argued had grown complacent and was in the pockets of politicians and businessmen, was the archetype of a reporter: a journalist clutches the most popular newspapers of the day but is falling asleep with his pen in his hand. Next to him, a parliamentarian for the Social Democrats, the party of Hindenburg, waves the prewar imperial flag that Hindenburg had reinstated. On his head is a steaming pile of dung. Dominating the picture is a Hitler supporter, sporting a tie with a swastika

pin at its knot. Behind the trio of societal "pillars," a clergyman looks at the pandemonium and raises his hands high, inciting his congregation to join in at worst, allowing them to turn a blind eye at best.

Whereas *Pillars* was a commentary on the contemporary state of modern Germany, *Eclipse of the Sun* symbolized its future. President Hindenburg presides over headless bureaucrats taking notes at a table painted in red and green, colors then associated with blood and money, respectively. A donkey—the "jackass" representing the typical uninformed German—wears blinders and rushes toward a manger full of food perched over a pile of skeletons. A child, representing Germany's future, looks out in horror beside them. Hindenburg's advanced age shows in his wrinkled face as he sits in front of a funereal cross in the imperial German colors—Grosz's reminder to viewers that a love of war will only result in more bloodshed. Clad in his old military uniform crammed with medals, Hindenburg receives orders from a war profiteer who is standing behind him and clutching modern weapons.

Both paintings are a frenetic mix of symbols painted in bold colors that mock the Expressionists and Brücke artists like Oskar Kokoschka and Emil Nolde, whom Grosz had once admired. Grosz was tremendously proud of these works, but they failed to sell. It immediately became clear to him that in this increasingly toxic political atmosphere, he needed to revert to creating works on paper that could be easily duplicated, sold at affordable prices, and hidden from the authorities when necessary.

Grosz completed *Pillars* and *Eclipse of the Sun* at the same time that President Hindenburg chose Max Liebermann, the Jewish German Impressionist artist who created *Two Riders on the Beach*, to paint his official portrait. Unlike Kaiser Wilhelm, President Hindenburg considered Liebermann a respectable German artist; the normally stingy Hindenburg, who abhorred wasting coal to warm up his office rooms, instructed his secretaries to heat up his official residence so that Liebermann would be comfortable during the sittings, a gesture that the artist greatly appreciated.[38] Yet Liebermann, the same age as Hindenburg, found it curious that his new President had accepted the position at such an advanced age—and had asked a fellow septuagenarian to create his official portrait. "The two of us sat like old donkeys across from one another and I tried to keep him awake," wrote Liebermann

of the experience, admitting that he was also exhausted because the sessions took place after lunchtime, when he typically napped. Attempting small talk, Liebermann asked Hindenburg what books he was reading. "I read nothing. What should I read?" Hindenburg retorted. Liebermann suggested Goethe, the nation's most famous and revered writer. "No, he is too immoral for me," scoffed Hindenburg.[39]

In the portrait that Liebermann created and Hindenburg authorized, the President appears alert and statesmanlike, sitting upright in a chair, glancing away from the viewer with a dignified expression. Yet, as images of the portrait circulated, Liebermann received scorn from both the Communists and the Nazis due to his Jewish heritage. Communists were furious that a member of a persecuted community would paint a member of the military, irrationally believing this probably indicated that Liebermann was secretly a "National Socialist Jew." The Nazis, by contrast, spread rumors that Liebermann was part of "the most sinister international conspiracy" against German artistic tradition. Rather than seeing this as a warning sign, Liebermann was puzzled, scoffing at a Nazi tract circulating throughout Germany at the time and condemning him as an artist. "A thing like that only makes me laugh," he said, noting that President Hindenburg was well aware of his background. "I am only a painter after all, and what has painting to do with being a Jew?" Liebermann asked.[40]

In 1927, Hitler was developing a sinister answer to just that question. Aware of this, Grosz created his most provocative set of etchings yet, a portfolio that he titled *Background*. Through the works Grosz aimed to illustrate how Germany had remained in such a state of uncertainty and insecurity. Though he had only alluded to it in *The Pillars of Society*, Grosz warned that the state-sponsored church was advocating war rather seeking ways to encourage peace. In *Dividends of the Holy Ghost*, a clergyman with prominent cheekbones and a snout-like nose preaches to a group of scoundrels standing below his pulpit; bullets spew from his mouth. In the most inflammatory work of his career, *Keep Your Mouth Shut and Do Your Duty*, Grosz shows Jesus Christ on a tilting cross, a shining halo above his head, a small cross in his left hand; his right hand is nailed down, and he is forced to wear a gas mask from the Great War. Christ's feet, in combat boots, are nailed to the cross.

The controversy surrounding Grosz's depiction of Christ in *Duty* spread rapidly, even reaching the United States. A prominent American magazine for Quakers, hardly active participants in the global art world, picked up on the scandal and defended Grosz's push for pacifism, a crucial tenet of their own faith.

German government officials, however, were livid. Grosz already had two strikes on his record: his 1921 conviction for insulting the German army via *God with Us* and his punishment for creating obscene art in 1924. This time they charged Grosz with slander, initiating a three-year brouhaha that proved exactly what Grosz feared: the government was more preoccupied with persecuting those pointing out the Nazi threat than with combatting the Nazis themselves. In December 1928, a Berlin court fined Grosz and Wieland Herzfelde—who was still his publisher—2,000 marks each for slandering Jesus Christ. The government argued that they represented Christ on Earth and so had standing to bring a case against Grosz.

Grosz and Herzfelde appealed. A regional judge overturned the verdict, emphasizing that citizens in a free society had the right to criticize the government and religion of any creed, provided that they did not advocate violence.[41] Within hours, the government appealed Grosz's appeal.

The case dragged on. Finally, the national court in November 1931 followed the government prosecutor's recommendation to convict Grosz and Herzfelde, ordering that the printing plates be destroyed.[42] The whole saga, lasting four years, was a disorganized embarrassment for the government, church, and judiciary—all of which backed the prosecution of Grosz.

Their persistence only fueled international demand to see and buy copies of *Duty*, making Grosz even more famous. Simultaneously, the expensive and protracted public scandal, unheard of in the days of the emperor, legitimized the fears of many Germans that an elected government was a ridiculous, unsustainable notion. Much to Grosz's horror, his case resigned many Germans to the idea that single-party rule, under a compelling leader, might be the best and most stable method of government.

After his failed Munich Putsch, Hitler quietly took stock of his party and the nation, hoping for a moment when the weary German electorate would crave his authoritarian style of leadership. Serving time in prison only emboldened him. Admiring guards gave Hitler special privileges, including a reserved table in the canteen, situated under a swastika. Despite his emphasis on physical fitness and his assertions that the German race depended on men "as hard as Krupp steel," the guards exempted Hitler from the prison's athletic requirements.

He received numerous letters of support, which he read in his cell when he took breaks from writing his memoir, *Mein Kampf.* Houston Stewart Chamberlain, his ideological hero whose wife had attended Catherine Hanfstaengl's salons, wrote him encouraging epistles. "The fact that in the hour of her greatest need, Germany should produce a Hitler, is a sign that she is yet alive," wrote Chamberlain to Hitler.[43]

Hitler also opened a letter from a recent PhD recipient in literature, who lauded him for his stirring, religious-sounding rhetoric. "What you stated is the catechism of a new political creed coming to birth in the midst of a collapsing, secularized world," wrote Joseph Goebbels. "To you, a god has given the tongue with which to express our sufferings," he gushed.[44]

Leaving prison, Hitler realized that he needed to gain power via legal means, causing his supporters to dub him "Adolphe Légalité." The Nazi Party had floundered in his absence, which encouraged him as it made clear how dependent his followers were on his guidance. Soon Hitler's acolytes increasingly referred to him by a term that surpassed "Adolphe Légalité" in reverence. Hitler was now "Der Führer" (the leader).

Emboldened, the Führer began crafting a strategy to reconcile his doomsday rhetoric with Germany's increasing prosperity. Germans, he acknowledged, needed a new reason to need him. He rented a rural retreat on the Obersalzberg in Bavaria, close to the border with Austria, a chalet with a gorgeous view and modest furnishings. Hitler increased his efforts to appear statesmanlike, kissing babies and even spontaneously bringing flowers to a man who was accidentally injured during one of his frenzied political rallies.[45] Goebbels attached himself to Hitler, sharing his love of art and demonstrating a talent for generating propaganda. "This is how he is: like a child,

good and merciful. Like a cat, cunning, prudent and agile; like a lion, roaring, great and gigantic," wrote the obsequious Goebbels. "My kindly friend and master!" he added submissively.[46]

Goebbels, a Catholic, created rituals for Nazi rallies that Catholics, disillusioned with the church but missing the predictable rhythm and inspiring mysticism of mass, would find reassuring. This nod to religion resonated particularly well with women, who in the 1919 general election were newly exercising the suffrage they had acquired the year prior. In May 1928, a new Reichstag was elected, and the Nazis won 12 seats out of 491, an impressive showing for a grassroots party.[47]

Hitler's worries that Germany's growing prosperity would thwart his ambitions were dissipated on 24 October 1929 when the New York Stock Exchange crashed. Creditors withdrew short-term foreign loans that had underwritten Germany's reentry into global markets. Demand for German exports plummeted, unemployment grew, and entrepreneurial optimism was crushed once more. "Never in my life have I been so well disposed and inwardly contented as in these days," noted Hitler.[48] He had his crisis. The financial crash helped the NSDAP make huge inroads into Germany's eighteen- to thirty-five-year-old male demographic, which was hit the worst psychologically by the economic downturn. Rather than talking down to them as many elderly politicians did, Hitler spoke like an inspiring older brother.

Art remained a critical part of this inspiration, as Hitler considered it the ultimate physical manifestation of pure Aryan culture, a point he made repeatedly in speeches. On 21 May 1930, Hitler spoke to a large crowd at the Hotel Sanssouci in Berlin. Instead of focusing on politics or the military, he delivered a long polemic on the importance of German art. He reiterated his belief that Berlin's leading artists, a group that certainly included Grosz, were promoting a pernicious movement; the only pure art, he insisted, was Aryan art that promoted Nazi values.[49] Hitler still thought of himself as an artist who had become a politician to stop the false "revolution" of art that by now was underway. "No age can claim to free itself from its duty to foster art," he repeated in his speeches, adding that under the Nazis, "blood and race will once more become the source of artistic intuition."[50]

The 14 September 1930 elections were critical for the NSDAP. Hitler hoped for eighty seats though ordinary Nazis considered this a long shot. In the end, the NSDAP won an astounding 107 seats. Weimar officials were blindsided when the newly elected Nazis began stonewalling parliamentary negotiations, even walking out when rival parliamentarians took the floor. Goebbels began encouraging more open anti-Semitism within the party, and SA singing sessions provided the opportunity for wary members to ease into this bigotry by rowdily singing jingles, including "The Storm Troops stand at ready, the racial fight to lead, until the Jews are bleeding, we know we are not freed!"[51] On 13 October 1930, as the parliament opened in Berlin, roughly three hundred Nazis ran through the streets around Potsdamer Platz shouting, "Death to Judah!" and "Heil Hitler!"[52]

<p style="text-align:center">———◆———</p>

While German officials made time to continue their interminable legal action against Grosz and other cultural critics, they still paid scant attention to the growing number of Nazi supporters outside large and mid-sized cities where Hitler held his rallies. In August 1931, Grosz took another vacation to the Baltic Sea and saw that anti-Semitism was increasing. At the local train station, boys and men with swastika flags harassed anyone in traditional Jewish dress or who even "looked" Jewish. "When one of them came," wrote Grosz of an unlucky Jew, "this guy nearby went to him and, in this audacious and totally racist rage, barnstormed him with loud, commando-like comments that ripped into Judaism." Traveling further through the region, he realized that even average voters were embracing Nazi ideology. Mainstream Germans had become gloomy, agitated, and "extremely, extremely politically right-wing," wrote Grosz.

Nazism had succeeded in tapping into man's basest fears about the economy, the nation, and culture. Hitler, realized Grosz, was doomed to succeed if nothing was done to counteract his movement. "Behind it all is a creepy, animalistic, devout sincerity, that one in no way should be allowed to disregard," he wrote to a friend.[53]

Even non-Germans now picked up on Hitler's religious tenor. Political journalist Hubert Renfro Knickerbocker, who attended an NSDAP rally around this time, called Hitler the "Billy Sunday of German politics,"

referencing the sixty-nine-year-old former Philadelphia Phillies player turned American evangelical preacher. Observing how Hitler's rallies seemed to be menacing versions of Billy Sunday's revival meetings, Knickerbocker wrote, "His converts moved with him, laughed with him, felt with him." Remarking on the size of Hitler's base, he said, "No one can number them precisely today, but the threatening tones of their mass defiance" made the passionate minority a significant force with which to reckon.[54] Polite society now responded to criticism of the NSDAP with insecure silence, observed both Kessler and Grosz. "We have been living, after all, in a permanent state of war since 1914 and, naturally, this has brutalized us—we're hardly capable of noticing real brutality and nuances anymore," Grosz ruefully observed.[55]

Given the negativity and hostility brewing in Germany, Grosz decided it was time to explore the metropolis he had admired since childhood: New York. His family stayed in Berlin as he sailed to America on 26 May 1932, arriving on 3 June. Grosz was well known in New York's art and media circles because his art portrayed specific politicians, such as Friedrich Ebert, Hitler, and Hindenburg, about whom American newspaper readers were inquisitive; he had gained further notoriety because of the protracted legal battles against him, something with which American artists did not have to grapple due to the First Amendment. Reporters met his boat hoping for a colorful story, only to be disappointed that he was courteous and appeared unremarkable.

Grosz quickly found eager drinking partners curious about Weimar culture and charmed that he endeavored to pick up English as best as he could. Harold Ross, editor of the *New Yorker*, met him for drinks at the Algonquin and invited him to contribute cartoons. Frank Crowninshield, editor of *Vanity Fair*, bought his drawings, as did many other New Yorkers. Over the summer, Grosz made about $2,000 in private sales, roughly $33,000 in current dollars.[56] The Art Students League at 215 West 57th Street sponsored his visa, and he taught a class there, becoming an instant hit with the students; Grosz's classes were the best attended in the school.[57]

Exploring New York's nightlife, Grosz went to burlesque shows, which he found more graphic than those in Germany despite Berlin's reputation as a sex mecca. He sketched stripteases at the famous club Minsky's twice or more a week, but he also indulged in more wholesome American pastimes, mostly attending baseball games. He was thrilled to meet George Gershwin,

who gave him a private mini-concert in exchange for an autograph of his personal copy of Grosz's work *Der Spießer Spiegel*.[58] Grosz reveled at the fashions, architectural styles, and customs that provided fresh fodder for his artistic output, which had waned during his trial. He jotted down his impressions: "Lots of women in light summer clothing, emphasizing hips, stomach and bosom (if they have one)," he wrote. "A lady, old and criss-crossed with wrinkles, with two Scottish Terriers; two broken down tramps drift along from the direction of Central Park; you can see they've spent the night there wrapped up in newspapers and are now out hunting for a nickel."[59]

Throughout his career, Grosz had accepted many diverse viewpoints and people, including homosexuals, sexually liberated females, and career women. Visiting New York meant encountering a population of black people astronomically larger than any in Europe, and Grosz initially expressed many derogatory views about them, opinions he would recant in later years. "The Negro has no thoughts of his own—they're all imitations from the whites," he wrote a friend in Germany. "For me he stands a step lower—he has no Euclid, no Plato, only a barbaric, superstitious concept of nature," he wrote, adding that black people "are, however, wonderful actors, musicians and dancers." At the same time, Grosz admired New York's egalitarianism compared to that of Berlin. "A former cabaret singer can become mayor," he lauded in a letter, while adding that New Yorkers tolerated controversial political viewpoints without violence. "Here, around the corner at Columbus Circle, every evening communist orators speak—no one bothers them," he wrote.[60]

Grosz kept tabs on the mood in Germany via the German consulate. In late August, a cultural attaché took him on a tour of Wall Street and the Woolworth Building, and he also attended an embassy stag party. At the event, a rabbi, stroking a long beard, whispered to Grosz that apparently the controversial "Professor Grosz" was in attendance. Upon learning that he was speaking with Grosz himself, the rabbi expressed incredulity that the dapper dandy he was talking to, despite the artist's penchant for alcohol, was so polite. Chatting with the rabbi, Grosz's mood changed from bemused to alarmed when he observed a man a few steps away who was violently puffing on a cigarette while raucously praising Hitler and cursing France.[61]

Grosz viewed the cursing Nazi sympathizer as isolated evidence in America of what already was true in Germany: Nazism was now mainstream. In

February 1932, Hitler had finally obtained German citizenship and was thus eligible to become Chancellor. In April, German voters reelected Hindenburg with 19.4 million votes, but Hitler received 13.4 million, mainly due to his sustained ability to court the bourgeoisie and maintain his base among workers. In early January 1932, he had made a pivotal speech to the Düsseldorf Industry Club, where he sported a dark pinstriped suit and gave a two-and-a-half-hour presentation laying out general plans to make Germany prosperous again. Rather than ranting and raving, he remained calm and composed, even while delivering ominous ultimatums. "Either we will succeed in once more forging out of this conglomerate of parties, leagues, associations, ideologies, upper-class conceit and lower-class madness an iron-hard national body, or Germany will finally perish," he told the industrialists.[62]

Hitler's ascendency was not a foregone conclusion in the autumn when elections were set for 6 November 1932. Economic forecasts predicted that Germany was stabilizing. Foreign nations, particularly America and Great Britain, showed increasing respect for Germany. The improvement made both Hitler and Goebbels nervous.

The NSDAP publicly argued that, if the party were to fall, the communists might take over, a fear that resonated with numerous Germans. Still, it was not enough to prevent the NSDAP from losing 4 percent of the vote. Many optimists in Germany saw this as a sign that the Nazis had peaked, but Grosz was not fooled. Hindenburg, by now eighty-five, was clearly in significant physical decline. Though he enjoyed his titular role, he was not fit for the demands of daily governance. "So, Wiz, let me know what's going on over there—when is Hitler coming to power?" Grosz wrote to his publisher and friend Wieland Herzfelde.[63]

Grosz and Eva made the decision to emigrate to America after years of harassment by the Nazis and Hitler's supporters. The family had already received death threats before Hitler's election. Once, Grosz had picked up an iron pipe in front of his door, recognizing it as the kind that the Sturmabteilung used to beat Jewish Germans on the streets. A note fell out of it reading, "This is for you, you old Jew-Pig, if you keep going with what you're doing." The artist knew that it would not matter to the perpetrators that he was not Jewish. On another occasion, a group of SA men called his home, threatening to come beat him up. Grosz warned that both he and Eva were armed

with pistols and had no problem shooting them. "Come then," he dared. They never did. Yet clearly one day they would.[64]

A life in America for himself, Eva, and his children was the answer, Grosz decided. "Everyone's advising me to stay here and bring my family over," he wrote back home. He began signing his letters bilingually with "Umamung and Kisses," combining "kisses" with the German word for "hug."[65] The Museum of Modern Art's director, Alfred Barr, told him he would help Grosz's career in New York if the artist wished to emigrate permanently. His popularity both as a teacher and as an artist ensured he would be able to earn a steady income, perhaps even more money than in Berlin. "I think America is a fine and astonishing land and full of virile self-sufficiency. I hope to make my home here," he told a reporter for *Americana Magazine*.[66] Grosz returned to Germany and quickly packed with Eva, sailing back to America on 12 January 1933. By now, the couple had a five-year-old, Peter, and a one-year-old, Martin. Knowing that taking the boys would arouse suspicion, they left them with family members so that they could be sent after the school year ended. George and Eva took only three crates and three suitcases. The artist rolled up two of his greatest masterworks, *Eclipse of the Sun* and *The Pillars of Society*, and hid them in a basement in Berlin.[67]

Leaving behind the boys was far worse, but Grosz also mourned this loss of his masterpieces. To protect their friends, the couple did not tell any of them that they were leaving, writing to them in euphemistic terms only once they had reached the safety of America. Grosz journaled that it felt like he was "dismembering" his life, limb by limb.[68] Escaping Germany was vital, Grosz noted, not only for the safety of his family but also to avoid complicity with the growing Nazi power. Still, he knew this sacrifice would permanently damage his career and livelihood. The East Coast would become Grosz's home for the next twenty-five years. When he finally did return to Germany, he would do so as an American citizen.

<div align="center">——◆——</div>

The eighteen days after Grosz left Berlin were a blur of political machinations. Six days after Grosz and his family sailed, Hitler was demanding to replace Franz von Papen as Hindenburg's Chancellor. A meeting took place

in which Hitler took Oskar von Hindenburg, the President's son, into a different room. Whatever transpired in the confidential talks, the younger Hindenburg came out agreeing that Hitler would become Chancellor and von Papen would be Hitler's Vice-Chancellor. Hindenburg was confused and disgruntled, but von Papen was confident that Hitler could be manipulated and his ambitions contained. The Nazis considered the appointment a triumph. Goebbels quickly organized the assembly of a crowd on Wilhelmstraße, the street where government buildings were located. Twenty-five thousand Hitler adherents, carrying torches, marched through the Brandenburg Gate as Hitler watching contentedly out a window.

A few days later, Nazi troops invaded and ransacked Grosz's studio, looking in vain for the artist and his family.

From the start of his chancellorship on 30 January 1933, Hitler saw the promotion of "Great German Art" as a top priority. For years, the forty-three-year-old had spent large amounts of time drawing images and plans for a new party headquarters and the artistic revamping of Berlin.[69] "He has a marvelous nose" for sniffing out and planning new projects, recollected Goebbels, praising his boss's "genius instincts."[70] Hitler declared that he would first rebuild the chancellery to make it more artistically and architecturally reflective of the might of German culture instead of the "mere cigar box" it was.[71]

For many German artists who also felt German culture had been marginalized, Hitler's ascent represented hope. One such artist was one of Grosz's childhood heroes, Emil Nolde, who was busy working to establish himself as a supporter of Hitler. Nolde sought out help at the highest echelons, from Joseph Goebbels himself.

In this new German order, the stakes were clear: artists were either revered or reviled. Within months, Nolde would learn his fate, and he was determined to be on the powerful side of history.

CHAPTER IV

ADOLF'S SILVER HAMMER

"You know, I don't particularly like this exaggerated anti-Semitism. . . . I can't say the Jews are my best friends, but I believe you cannot rid the world of them through cursing and polemics or even through pogroms. And even if you could, it would be demeaning and beneath human dignity."

—Joseph Goebbels, 1919

ADOLF HITLER'S PROPAGANDA MINISTER, JOSEPH Goebbels, vehemently disliked discussing the weather in general conversation. For the thirty-five-year-old, it was a pedestrian topic that offered scant room for wit. Yet, on 15 October 1933, he noted with relief that the sunny skies boded well for a major political relations event: that day, only nine months after ascending to power, Hitler was preparing to lay the cornerstone of Munich's House of German Art.

The building was to replace the Glaspalast, a striking iron-and-glass exhibition space that had burned down on 6 June 1931, victim to an unknown arsonist. The fire destroyed 3,000 works, including a masterpiece by Caspar David Friedrich, whom Hitler and many Germans revered for his nineteenth-century paintings glorifying nature's mystical power and, within

it, man's dominant position. Friedrich's lost work, portraying the crumbling ruins of an ancient Catholic cloister, now seemed to be a metaphor for Hitler's broader plans for the House of German Art: state-controlled culture would usurp Christianity as Germany's spiritual compass. "We ourselves will become a Church," summarized Hitler.[1]

Goebbels, like Hitler, had been confirmed Catholic but began believing in a divine supremacy within himself once he became a Nazi: "If God has made me in his image, then I am God like him," he concluded.[2] Both he and Hitler referred to the new museum as a "temple," part of the move to accustom Germans to the Nazi plan to become the country's dominant authority on spiritual matters. Already over the summer, the Nazi administration had revamped student textbooks to include religious language when discussing the Führer and German culture. To undermine respect for the church, Goebbels arranged leaks of previously ignored sex scandals involving pedophile priests and their young victims; he also scheduled particularly entertaining Hitler Youth outings to conflict with more staid youth events organized by the Catholic Church.[3]

Goebbels planned for the House of German Art to displace the financial and cultural influence within Germany of artists like George Grosz, Otto Dix, Max Beckmann, and Käthe Kollwitz. In doing so, the nexus of the art world would shift from independent individuals to government-controlled ministries financed by corporate sponsors and taxpayers. While previous ministers had raised paltry sums to refurbish the Glaspalast by hawking lottery tickets, Goebbels assembled a package of incentives: a fund-raiser on 4 August at which famous entertainers performed, tax rebates for donations above 25,000 reichsmarks, and a well-designed English-German promotional book illustrating the completed museum plans. His efforts raised an astounding three million reichsmarks by September 1933.[4] Eager to ingratiate themselves with the new regime, the heads of Bosch, Opel, Siemens, and Krupp—whose steel Hitler routinely praised in speeches as analogous to the Aryan male ideal—contributed copious funds.

At the opening of the museum, Hitler's remarks were intended primarily for the donors and the press. "May a new German art blossom from the flame that destroyed the old Glaspalast on 6 June 1931, and may the new

house offer a sanctuary for centuries!"[5] he exclaimed before grasping a com-memorative silver hammer to tap three times on the foundation stone to signal the coming of the Third Reich. It was the propagandistic triumph that Goebbels had been anticipating for months. Yet, as the first ping of Hitler's silver hammer sounded and the cameras rolled, the hammer head wobbled. With the third and final ping, it flew off the handle.

So did Hitler. Descending into a raging tantrum, Hitler ordered film-makers to cut the scene and demanded that the press self-censor the debacle.[6] The German press, independent only a few months before, unanimously cowed to pressure, reporting that "the Führer had completed the act of laying the foundation stone with three sharp, silvery strokes."[7]

Though not an ideal outcome, the Foundation Stone Ceremony's comic end became a triumph of sorts for Goebbels, proving to the Propaganda Min-ister how once-independent institutions were now complying with policies that he and Hitler had introduced a mere eight months before. Only days before the event, Goebbels had required journalists to join his Reich Press As-sociation, which banned non-Aryans or those married to non-Aryans. In one fell swoop, it transformed journalists into civil servants who could be held le-gally responsible for tarnishing their government's reputation. There were few protests.[8] Employing his sly sense of humor, Goebbels referred to this as the "Neue Sachlichkeit," German for the "new reality," which also was the name of the art movement to which George Grosz and Otto Dix had belonged.[9]

Ordinary Germans underestimated Goebbels, a misperception that Goebbels was happy to indulge so that the nation could unify behind the single figure of the Führer. Those within Hitler's inner circle, however, long had observed how Goebbels shaped the Führer's social and cultural policies. Many resented the Propaganda Minister's success, albeit quietly. Other than Hitler, observed Goebbels in his diary, "everyone is jealous of me. Nobody likes me," adding, "Ugh, shit!"[10]

—————◆—————

Since boyhood, Goebbels had cultivated specific qualities that now made him indispensable to Hitler. A talent for manipulating established social and legislative systems, a genuine belief in German cultural superiority, an

objective brilliance as a wordsmith and political strategist, and a slowly developing anti-Semitism all coalesced to make Joseph Goebbels the most reliable and dangerous enabler of the Führer.

Born on 29 October 1897 in the center-west German town of Rheydt, Paul Joseph Goebbels was the fourth of six children. His father, Fritz, was a clerk in a wick-making factory, while his mother, Katharina, was a homemaker. As a child, he frequently suffered from lung inflammations and had a malformed right foot, hampering his ability to roughhouse with other boys. Yet Goebbels had a knack for socializing and still made friends fairly easily. Studying German history and literature awakened in Goebbels an awareness that soaring rhetoric and German romanticism could stoke passionate emotions that lay dormant in ordinary Germans.[11] In April 1917, he began studying at the University of Bonn, undertaking an eclectic curriculum of art history, German folklore, psychology, and the causes and preventions of venereal diseases. His hobbies were drinking beer and bowling, the latter being an interest he would come to share with Hitler.[12]

As a child and a young adult before the Great War, Goebbels did not display any signs of anti-Semitism. For his PhD advisor, Goebbels's first pick was the Heidelberg-based Jewish German historian Friedrich Gundolf. The renowned literary professor was inundated with research, however, and referred the candidate to fellow Jewish German historian Max von Waldberg, who accepted his application. Goebbels made his PhD relevant to Germany's volatile political climate by arguing that romantic author Wilhelm von Schütz's work signaled a desire in Germans for a political and cultural leader who drew on German Romanticism. "All these little people, the smallest, are crying out for leaders, but no great man appears who will embrace them all," Goebbels argued.[13] After receiving his doctorate in 1921 at just twenty-four years old, Goebbels resolved to search for just such a leader.

Soon, while working as a journalist for the *Westdeutsche Landeszeitung*, Goebbels entered into a sexual relationship with Else Janke, a schoolteacher from his hometown, which British, Belgian, and French troops had occupied after the Great War. "I need to write this bitterness out of my soul," he complained to her. Sensing his angst, Else gave him his first diary, and he embarked on a habit that he maintained assiduously until his suicide

twenty-one years later.[14] Goebbels dedicated his first entry of 17 October 1923 to Else, writing, "My dear, kind love! You raise me up and give me new courage when despair threatens. I cannot express how indebted I am to you."[15]

When Else mentioned that her mother was Jewish, however, Goebbels recoiled, describing his "enchantment" with her as "ruined."[16] Goebbels was confused by his own intolerance; he had never considered himself anti-Semitic, but now, on realizing he was having sex with a Jewish woman, he felt an unease he could not explain. Even as he refused to break things off, he had a nagging feeling that he was "someone sent by God to await His word" to assist a modern-day Messiah figure to lead the Germans back to greatness, just as John the Baptist had done for his cousin, Jesus.[17]

On 13 March 1924 Goebbels first wrote in his diary about Adolf Hitler by name. His initial reservations about Hitler's unsophisticated rantings at large rallies evolved as he realized that he could be of unique service to Hitler by helping him appeal to a wider audience.[18] Goebbels identified with Hitler's views on German cultural supremacy, including the Führer's conviction that "blond, blue-eyed" Aryan immigrants had made ancient Persia, Greece, and Egypt into superpowers.[19] Two weeks after he first wrote about Hitler, his view of Else definitively soured. Goebbels began referring to her as "a human dumpling" and "mood killer" with the "curse of Jewish blood" and concluded that his loyalty to Hitler, whom he still dreamed of meeting, necessitated his severing ties with Else.[20] "I'd love to make her my wife, if only she weren't a half-breed," he concluded in his journal shortly before ending the relationship.[21]

On 12 July 1925, Goebbels finally met Hitler in person at a conference in Weimar. "What a voice, what gestures, what passion; just as I wished him to be," he wrote, praising Hitler's "large, blue eyes, like stars" and anointing him "the coming dictator," adding, "I'm ready to sacrifice everything for him."[22] The two immediately became close. For Christmas 1925, Hitler gave Goebbels a leather-bound copy of *Mein Kampf.* Goebbels, by then a cultural policy reporter for the NSDAP's propaganda newspaper, the *Völkische Freiheit,* privately noted that Hitler's writing was "ungainly" and "sometimes unbearable." Still, he tirelessly promoted the book in public.[23]

Despite its best-seller status, most Germans who bought *Mein Kampf* did not actually read it and were consequently ignorant of how it explicitly outlined Hitler's agenda a full nine years before Germans elected him into power. In his book, Hitler argued that historic wars between Europe's Catholics and Protestants had been instigated by Jews to divide Aryans.[24] Jesus was not Jewish and was himself anti-Semitic, Hitler maintained.[25] "The Jew," Hitler argued, throughout history was "always only a *parasite* in the body of other peoples," adding, "He always looks for a new feeding soil for his race."[26] "In the course of the centuries," Hitler wrote, Jews living in Europe had evolved so that "their external appearance had become European and human," but they actually were "degenerate" strains of humanity that produced moral and cultural abscesses in "civilized" societies.[27] "When carefully cutting open such a growth, one could find a *Jüdelein*, blinded by the sudden light, like a maggot in a rotting corpse," he wrote, using the German equivalent of the English slur "kike."[28]

Goebbels's reaction was rapturous. "What drives an ideological movement," Goebbels argued, was not a set of facts but rather "faith," and he further compared Hitler's writings and speeches to Jesus Christ's Sermon on the Mount. "Self-evident truths do not have to be proven," he argued.[29] Goebbels now was so powerful in the NSDAP that he answered only to Hitler; a token of their deepening friendship was the bouquet of dark red roses and a six-seater Mercedes Benz that Hitler spontaneously gave to Goebbels around this time.[30]

In late 1930 Goebbels met his future wife, Magda Quandt, whom he had employed as his secretary. Cultured, educated, and poised, twenty-nine-year-old Magda had recently divorced wealthy industrialist Günther Quandt, with whom she had a nine-year-old son, Harald. Hitler, who adored Magda, teared up when the pair announced they were engaged. Goebbels privately considered Hitler "too soft" and effeminate to marry and reproduce, so they told Hitler that they would give their future children names starting with *h* in his honor.[31] On 19 December 1931, the pair married on the estate of Magda's ex-husband; Hitler was the best man. By January 1933, the couple had a four-month-old named Helga and planned to give Helga's "Uncle Adolf" many more surrogate offspring.

After the NSDAP's January 1933 victory, Goebbels began crafting cultural, racial, and political policy ahead of October's Foundation Stone Ceremony to break ground on the House of German Art. To assuage the concerns of foreigners who worried that cultural censorship portended sinister political and military ambitions, Goebbels commissioned a compact book of Hitler's speeches, titled *The New Germany Desires Work and Peace*, accompanied by a foreword he wrote himself. In flawlessly translated English, Goebbels asserted that Germany was not the sole aggressor of the Great War and emphasized a politicized Christianity then popular among both liberals and conservatives in Great Britain and the United States. Warning of a spiritual vacuum that could occur if communism or atheism were to triumph, Goebbels argued that Christian Germans "regard Christianity as the foundation of our national morality, and the family as the basis of national life." He added that Germans wished to be industrious and self-sufficient and had, he stressed in italics, "*no aggressive intentions whatever.*"[32]

During meetings inside the chancellery, Goebbels urged Hitler to secure permission via legal means to conduct cultural censorship. If Hitler skipped these steps, Goebbels warned, the government risked becoming incapacitated by protests that the NSDAP was breaking the law. Goebbels also encouraged Hitler to more forcefully reiterate his party's desire to combat the Communist movement, a talking point that resonated with middle-class Germans.

"The parties of Marxism and those who went along with them had fourteen years to see what they could do. The result is a heap of ruins," Hitler declaimed in his first official address. "Now, German people, give us four years and then judge and sentence us."[33] In volunteering a deadline for himself, Hitler assuaged the anxieties of those who feared that he aimed to become a dictator for life.

Within a month of Hitler's ascension to office, a terrorist attack provided Hitler and Goebbels with an organic and plausible reason to seize more power from the citizenry. On the evening of 27 February, Marinus van der Lubbe, a Dutchman who had attempted unsuccessfully to burn three other buildings in Berlin, set fire to the Reichstag. The Führer's strategist, Putzi Hanfstaengl, the Harvard man whose mother, Catherine, had organized

the salons in Munich that expanded Hitler's bourgeois base, saw the flames nearby. Hanfstaengl quickly telephoned Goebbels, with whom Hitler was dining.

"Tell him the Reichstag is burning," he uttered breathlessly.

"Is that meant to be a joke?" Goebbels asked.

Once Goebbels had independently verified the fire, Van der Lubbe's execution was a foregone conclusion. The arsonist had broken with the Dutch Communist Party in 1931, but Goebbels used the connection to propose emergency legislation "for the protection of people and state." The Nazis indefinitely suspended the freedoms of speech, association, and the press, as well as the right to uncensored postal distribution and to unsurveilled telephone calls.[34] The government also took 25,000 individuals whom they deemed terrorist threats into "protective custody" at a makeshift, purpose-built prison. The public was grateful. A large number of the 10,000 potential terrorists rounded up in March and April were denounced by their own neighbors or colleagues.[35] Seventy-two hours after the law passed, Hitler's storm troopers marched into the offices of the *Frankfurter Zeitung*, warning its editors that their newspaper would be banned if they didn't cease negative coverage of the Führer. The editorial staff resigned in protest, but the board of directors capitulated to the Nazi threats. It was another promise fulfilled from those that Hitler had outlined a decade before in *Mein Kampf*, in which he had raged against the "hellish press" as dominated by Jews who were pitted en masse against him and the NSDAP, writing articles replete with "unctuous assertions" and "spiritual pestilence" that were worse for Europe than the black plague had been for the continent.[36]

The Reichstag fire and the fear of another terrorist threat helped the Nazis obtain 43.9 percent in the 4 March vote that Hitler had asked the elderly President Paul von Hindenburg to schedule. The 10 percent increase still did not produce a majority in the Reichstag, but it weakened the other parties to the point of making them impotent. On 23 March, Hitler requested that parliamentarians pass the Enabling Act, allowing his cabinet to pass laws without their involvement. When 444 representatives approved with only 94 opposing, the German parliament officially and legally made itself irrelevant.[37]

Spring and summer plans to streamline power went smoothly for Hitler. On 7 April 1933, the cabinet agreed that the NSDAP would now enforce federally mandated Nazi policies at the previously independent state level; it passed the Professional Civil Service Restoration Act, permitting the party to fire non-Aryan government employees and requiring all civil servants to use the *Hitlergrüß*, or "Heil Hitler" greeting. The message was clear: government employees now had to pledge their loyalty to Hitler, not to the citizen or the rule of law.[38]

Like those of most European countries, Germany's Culture Ministry oversaw the nation's museums; the supervision and stability this had granted the institutions now backfired as the Nazis were able to easily fire twenty museum directors and curators over the spring, summer, and early autumn of 1933.[39] The moves aligned with Hitler's agenda outlined in *Mein Kampf* to combat supposedly Jewish-driven "cultural signs of the political collapse" that had occurred during the Weimar Republic. "It is the responsibility of government to prevent its people from being driven into the arms of intellectual insanity," he had written.

Hitler and Goebbels began regulating reproductive rights through the July 1933 Law for the Prevention of Hereditarily Diseased Offspring, which authorized sterilization of children and adults whom the government considered at risk of producing flawed progeny. Catholic vice-chancellor Franz von Papen, now fifty-three, proposed that those whom the government flagged for sterilization should give consent or at least have a guardian provide consent. Goebbels, thirty-five, and Hitler, forty-three, simply ignored him.

Germans with darker skin were swiftly targeted. Hitler claimed in *Mein Kampf* that nonwhites lacked inherent intelligence and could only be programmed for "tricks" as one teaches a dog. It "is training, exactly as that of the Poodle, and not a scientific 'education,'" wrote Hitler.[40] Goebbels concurrently published a five-point manifesto titled "What German Artists Expect from the New Government," which in reality laid out what the government expected from them. Museum directors promoting "un-German" art would be fired, and, at a future date, the Nazis would confiscate and display Degenerate Art, then burn it, just as they had burned controversial books on 10 May 1933.

It was a swift reverse for a country that had acquired a reputation after the Great War as a bastion of vibrant contemporary art. Goebbels began asking German artists to help perpetuate his propaganda, effectively melding the once-free German art world with the government's goals. The Nazis widely distributed a poster promoting a badly needed "yes" vote on 12 November to confirm the nation's withdrawal from the League of Nations, showing Hitler with Papal Nuncio Alberto Vasallo di Torregrossa, present at the ceremony to lay the foundation stone for the House of German Art. Quoting Torregrossa the poster read, "'I did not understand you for a long time. But I have tried for a long time. Today, I understand you.' Every German Catholic, too, today understands Adolf Hitler and votes 'Yes!' on 12 November."[41] Torregrossa worked with Hitler to assuage the fears of cultured Catholics. They succeeded: 95 percent of Germans voted yes. There was no evidence of vote tampering. Even if there had been, the press was now in no condition to report it.

———⁕———

Despite the success in co-opting the Catholic clergy, Goebbels knew he needed to win over the minds of the German people through culture as well. He aimed to curate a show around the theme of Great German Art for the opening of the House of German Art, not only to honor the museum's opening but also to define the entire genre of Great German Art.

The artist with the most at stake was Emil Nolde, who was monitoring the political situation as intensely as other German artists were monitoring him. Nolde, now in his mid-sixties, was one of Germany's most academically respected artists. Younger artists viewed the government's treatment of him as the bellwether of their own futures.

Nolde's personal background and artistic philosophy aligned closely enough with Hitler's to give the elderly artist reasonable optimism that he would find a place within Hitler's nascent stable of "Great German Artists." Like Hitler, Nolde had been rejected from art school and supported his budding art career painting postcards for tourists. Though Nolde, unlike Hitler, had established a lucrative artistic career, his rejection from the Munich Art Academy in 1898 convinced him that Germany's art establishment lacked a

confidence in Aryan art's superiority.[42] Nolde turned thirty-nine in 1906 and joined Die Brücke, publishing his works in the portfolio that Grosz and his friends had admired in art school and during the Weimar Republic.

Nolde's artwork seemed to many, including Goebbels, to embody the strong, silent Nordic spirit underpinning the Aryan culture for which Goebbels and Hitler advocated. In his 1911 etching *Children of the Forest*, children dance naked in a circle in the woods; they could be nymphs, pure Nordic youth, or a mystical combination of both. The work reflected the Nordic spiritual belief that all Nordic souls and spirits were ethereally intertwined and were most present in nature. Nolde had invented watercolor techniques designed to evoke and celebrate the mystical qualities of German landscapes. On one cold spring day in 1908, he had marveled at how his wet watercolors crystalized on the special, highly absorbent paper he set directly on the ground outside. "Sometimes, I would paint in the freezing twilight and enjoyed seeing how the frozen colors had crystallized into stars and radiating lines," he wrote.[43] In *Flood, Evening* a watercolor on special Japanese paper that the Kunsthalle in Kiel purchased, Nolde used dramatic shades of black and gray pigments to portray the night sky on the low horizon of his home province of Frisia. The murky waters of flooded rivers seem to flow off the page, depicted with swirling greens and dark yellows.

Despite admiring Hitler's Weltanschauung, Nolde expanded two sections of his art portfolio that would prove problematic for Nazis: the humanization of non-Aryans and a deviation from classical depictions of Christianity. In 1913 Nolde had traveled to New Guinea; rather than viewing the natives as scientific specimens, common at the time, he portrayed villagers with genuine personalities, including clothing preferences, expressions, ages, and poses. On a subsequent trip to Manila, he questioned whether Europeans were inherently superior. "Are we so-called cultivated ones really much better than the people here?" he mused.[44] In one work, *The Dancer*, a native woman spreads her legs and squats while dancing and flipping her dark brown hair, her brown skin glistening. Though she is topless, her face is earnest; Nolde does not fetishize her.

His largest religious work, 1912's gargantuan *The Life of Christ*, had injected life into what most of Nolde's contemporaries considered a tired

theme for paintings: Christianity. Nolde designed a triptych, the traditional format used for Catholic altarpieces in which one large work tells the main story, flanked by two narrower paintings telling ancillary stories. Nolde updated the format, however, by creating a center panel flanked by two sets of four small paintings telling the whole story of Christ's life. The middle panel depicting the crucifixion follows the classical "triangle" format: Christ is at the center, his mourning mother at the bottom left, and Roman soldiers gambling for his possessions at the bottom right. Yet rather than appearing serene, Nolde's Jesus reflects the corporeal agony of crucifixion. With blood leaking from his hands and feet, Jesus struggles and fails to support the weight of his hanging body, his chest heaving and muscles bulging torturously. On either side of him hang two criminals, one of whom has asked for and received Christ's salvation. Rather than appearing elated and oblivious of his torture, as traditionally depicted, the newly Christian criminal appears to be in excruciating physical pain. Eight small panels on either side of the crucifixion scene emphasize the biblical characters as humans with complex emotions. In the Nativity scene, Jesus's mother, Mary, holds him up, still bloodied. When the Magi visit, she is happy but clutching her hips in postpartum discomfort. In another scene, when the apostles meet Jesus for the first time after his resurrection, they are visibly confused and uncomfortable.

In the mind of Nolde and his supporters, these more realistic portrayals of famous Bible stories kept Christianity relevant rather than ossified. Detractors considered them crude at best and sacrilegiously primitive at worst, but in 1912 they did not yet feel emboldened to call on the government for outright censorship.

In the spring of 1934, however, as the government was decreasing the powers of the states and passing legislation to legally restrict the rights of German citizens, one art institution, the Kunsthalle Mannheim, was eagerly supporting Hitler's censorship of art. Previously, curators would have considered it anathema to create an exhibition with the sole purpose of condemning the artists featured in it. Now, however, curators and museum directors who aligned with Hitler's views felt emboldened to condemn Degenerate Art, the term the Nazis increasingly used for works they considered unpatriotic,

lascivious, too reverential of non-Aryan cultures, or even simply aesthetically ugly. The Kunsthalle Mannheim opened its exhibition titled "Cultural Bolshevist Images," featuring sixty-four paintings, two sculptures, and twenty graphic works crammed into two rooms. The artworks were taken out of their frames and hung in deliberately amateur ways by curators who knew full well how to hang them properly. They were labeled with the name of artist, the year of acquisition, the artist's race, and the purchase price. Artists represented unsurprisingly included Grosz, but more unexpectedly the curators also targeted Nolde.

Nolde was shocked that his work was included in the Mannheim show, particularly given that his Berlin dealer Ferdinand Möller simultaneously was holding a Nazi-lauded show titled *Thirty German Artists*, in which Nolde was included, organized in tandem with Joseph Goebbels and his assistant Hans Weidemann. Goebbels and Weidemann had also sent Nolde's artworks to the Chicago World's Fair and promoted him in a private show at the Propaganda Ministry.[45] This humiliating discrepancy made clear that Nolde's status as a revered older member of the German art world was in jeopardy and that the Nazi government needed to more clearly define what constituted Degenerate Art.

One of Germany's preeminent Aryan female collectors, Gertrud Stickforth, wrote to the Nazi newspaper *Völkische Beobachter* to advocate for Nolde as an anti-Semite and early opponent of the artistic preferences of Max Liebermann, the Jewish German Impressionist. At this point, Liebermann was a frail retiree in his late eighties, living in Berlin and attempting unsuccessfully to maintain a discreet profile so as not to attract the attention of anti-Semitic art world insiders such as Stickforth. Nolde, Stickforth wrote the *Völkische Beobachter*, had for years "risked his name and reputation" to advocate for the exclusion of Jews from the German art world. "He set the Jewish pack against himself by this manly deed. He's actually the Germans' German!" she exclaimed.[46]

Though an early member of the Danish branch of the NSDAP, Nolde had maintained a public neutrality regarding Hitler's rise. "I'm pretty helpless when it comes to politics. I don't know myself whether I'm a German nationalist or a leftist," he mused privately.[47] Now, however, Nolde realized

he would have to decide what stance he would take publicly, thereby staking his career, on the "Jewish question." The need for him to do so was urgent. By the time of the October 1933 Foundation Stone Ceremony, Goebbels had become unsure of whether Nolde was a Great German Artist or not. "Is Nolde a Bolshevik or a painter? Theme for a dissertation," he wrote.[48]

It became clear to German artists that the Nazi cultural elites were about to name some of them Great German Artists; this title would bring not merely admiration from Goebbels and Hitler but permission to create and display artworks in an increasingly censored society. The careers of those who did not gain government approval would end and their means of supporting themselves and their families would be snuffed out. Nolde realized that he needed to more actively embrace anti-Semitism, retreat into silence, or speak out against discrimination.

With this toxic atmosphere brewing in the art world, Nolde began targeting Max Pechstein, a fellow member of Die Brücke who was his age and had garnered popular acclaim for combining old and contemporary techniques to capture the strong spirit of a New Germany. Pechstein had always been a threat to Nolde. Not only did Pechstein have the added benefit of being a Great War veteran, but his depictions of the residents of Palau, made within three years of Nolde's portfolio of portraits of the natives of Manilla, were decidedly easier to look at for the common connoisseur than Nolde's similar works. Similarly, Pechstein's woodcut series *The Lord's Prayer*, though executed with primitive-looking lines inspired by the works of the native islanders, contained none of the pain and grimacing of Nolde's *The Life of Christ* that put off so many regular Germans interested in buying works to display in their homes.

Commercial success thus came far easier to Pechstein than to Nolde. In February 1913, at just thirty-one, Pechstein had begun working with an influential family of art dealers and curators: the Gurlitts.[49] His large solo show of forty oil paintings and three stained glass windows at Fritz Gurlitt's gallery led to a coveted contract with Wolfgang Gurlitt, who sold his art on commission and gave him steady monthly advances.[50] The Gurlitt family provided Pechstein with generous space—both physical gallery space and mental room—to take artistic risks. Pechstein's portrayal of Adam and Eve's

expulsion from paradise displayed in Wolfgang Gurlitt's gallery used the artistic medium of the mosaic developed in ancient Greece and Rome, the pinnacle of ancient Western culture. The aesthetically appealing image showing bodies with soft bellies and curves, yet primitive faces similar to those in Nolde's works, was featured in the prestigious *Das Kunstblatt* a year later.[51] This in turn lead to an exhibition of Pechstein's work at the Kunstmuseum Zwickau curated by director Hildebrand Gurlitt, Wolfgang's cousin. Pleased by the director's progressive approach and refusal to bend to right-wing conservatives, Pechstein hoped that through Hildebrand Gurlitt "there may grow an oasis in this desert" of the German art world, which was growing increasingly stagnant now that the Nazis were intent on censorship.[52]

Yet, despite this Nazi interference in the art world and the NSDAP's antagonistic approaches to Pechstein's Jewish and female colleagues, Pechstein yearned for power and influence and thus aimed to ingratiate himself with the Nazis. So he stayed silent. He was aware he was leaving weaker artists susceptible to persecution by not advocating for them, writing to Grosz in New York to describe how he and the other members of the new Reich Association of German Artists had acquiesced as Nazis purged the group of undesirables. "Well, what shall I tell you, among these few hundred members no-one objected," he wrote. "You see, that's how we are! Snappy, what?"[53] When present at a meeting in which Käthe Kollwitz was expelled from the Prussian Academy of Arts during a Nazi purge of opponents, he declined to defend her. Pechstein justified this passivity by saying that he was a male Aryan, under no pressure to risk his stable career.[54]

This behavior backfired for Pechstein, whose career began to decline while Nolde's seemed to ascend. By autumn 1933, Pechstein knew why: Nolde had told a civil servant during a meeting at Goebbels's office that Pechstein, with his surname ending in "stein," was Jewish and lying about it. Nolde had decided to fully embrace explicit anti-Semitism in his efforts to preserve his status in the art world. Pechstein was furious, demanding that Nolde retract the accusation and providing Goebbels with documents asserting his Aryan heritage. Nolde refused to back down, and Goebbels refused to take the risk of investigating the matter. Due to the growing rumors that Pechstein might not be a full Aryan, the artist's career began to suffer.

German collectors grew wary of buying his pieces or promoting him.[55] Outraged, Pechstein wrote to George Grosz in New York that the Nazis now considered him a cultural Bolshevik and Jew, which was ruining his livelihood. The irony seemed lost on Pechstein that Grosz had uprooted his entire family and fled to New York due to accusations that he was a Bolshevik himself. Instead of fleeing as Grosz had done, Pechstein remained silent, hoping that the Nazis would eventually welcome him back, even as they persecuted his former friends.[56]

Nolde's power play over Pechstein worked. Goebbels invited Nolde to the inauguration of the Reich Chamber of Culture in November, and he and his wife, Ada, also received invitations to the tenth-anniversary celebration of the Beer Hall Putsch. Visiting Berlin, the Noldes stayed with Putzi Hanfstaengl, Hitler's Harvard man. Putzi hung several of Nolde's works in his Berlin flat in solidarity. Having Nolde in attendance was crucial for Goebbels, who was drafting his list of artists for 1937's Great German Art Exhibition. Supporting Nolde, the Propaganda Minister recently had hung several of the artist's works in his own home. Hitler had seen them, however, and found them unpleasant.[57] Knowing Nolde's work could be difficult to process, Goebbels surmised that meeting the artist might be the best option for the Führer.

Listening to Hitler and sitting in proximity to cultural figures of whom Hitler already approved fully converted Nolde into a Hitler supporter. "We saw and listened to the Führer for the first time without the intermediation of radio," he wrote a friend, adding that he had been enchanted by Hitler's soaring rhetoric. Though many of the military officers seemed boorish, Hitler's speech was cultured. "The Führer is great and noble in his aspirations and a genius man of action," said Nolde, who heeded Hitler's warning that the Jews must be controlled. "He is still being surrounded by a swarm of dark figures in an artificially created cultural fog. It seems as if the sun will break through here and dispel this fog in the near future," he wrote.[58]

Nolde was determined to help cut through that fog. Setting aside his brushes for a pen, he channeled his effort into pandering to Hitler, feverishly writing a memoir published in 1934 that Nolde titled *Jahre der Kämpfe* (Years of Struggle), an overt homage to *Mein Kampf.*

As Hitler had in *Mein Kampf*, Nolde expressed reverence for his mother but a wariness of female sexuality. Mentioning his wife, Ada, he worried publicly that sexual desires in wives had the power to "kill the artists in men."[59] This despite the fact that, for years, Ada had submitted to her husband's creative demands and insecurities. "He had, apparently, in his nature something ponderous and dull, timorous and awkward; she was delicate and fine, charming, natural, of an almost fragile physicality, but there flowed between them an uninterrupted quiet harmony," one of Nolde's longtime collectors once observed.[60]

In his memoir, Nolde mimicked Hitler's discussion of nature's mystic powers, with descriptions using archaic German phrases that bordered on maudlin: "It pained me, when in autumn the woodcutters came, hewing, sawing, and brutally felling the most beautiful of trees. Roaring, they fell directly over my path and lay dead, the majestic towering trunks with lost crowns," he wrote of the apparent trauma he suffered when witnessing how logs were made.[61] The artist took a less charitable view, however, in describing Jews. Though less virulent than Hitler in *Mein Kampf*, he described at length the first Jewish German he had met, at the age of eighteen in Flensburg, as "akin to a phenomenon."[62] Nolde also claimed to have met a Jewish researcher in Berlin who allegedly maintained that he was compelled to bed every young girl with whom he was left alone; Nolde wrote that this was proof that Jewish men were sexual deviants by nature. Nolde also targeted Pechstein yet again in *Jahre der Kämpfe*, calling him the "darling" of the "Jewish-controlled" media. He also attacked the once-revered German impressionist Max Liebermann, warning that he and other Jews have "great intelligence" but "little soul and little gift for creativity."[63]

In *Jahre der Kämpfe*, Nolde also advocated for enforced governmental regulation, including eugenics programs, for the sake of cultural purity. "Some people, particularly the ones who are mixed, have the urgent wish that everything—humans, art, culture—could be integrated, in which case human society across the globe would consist of mutts, bastards and mulattos," warned Nolde.[64] As a final flourish, Nolde mimicked Hitler and Goebbels's assertions in their publications that their views were divinely inspired, writing that he had "God in me, hot and holy as the love of Christ."[65]

The bold manifesto shocked more reserved anti-Semites, including Ernst Ludwig Kirchner, still living in Switzerland and struggling with depression and a lengthy unproductive streak. Kirchner privately believed that every Jew lacked creativity and thus a true German "cannot be friends with him," but he found Nolde's public bigotry untoward. "It is very sad that he is such an opportunist [*Conjunkturjäger*], but he was always that way," Kirchner commented to a friend, adding that Nolde had been supported by Jewish Germans far more than most artists.[66]

————◆————

The publication of *Jahre der Kämpfe* was, in effect, the throwing down of a gauntlet. Goebbels clearly now needed to issue a ruling on Nolde, one, Goebbels realized, that would not only influence the outcome of Nolde's career but also test the Propaganda Minister's seemingly indestructible relationship with the Führer. Goebbels was leaning toward a relatively tolerant interpretation of what constituted a Great German Artist, a standard by which new and even radical artistic techniques would be accepted, provided that the artist was Aryan and the content conformed to Nazi ideology.

Before becoming involved with the Nazis, Goebbels had once attended a lecture on Vincent van Gogh, praising the Dutchman as "one of the most modern men in new art." Goebbels even romanticized the mental illness that had contributed to van Gogh's suicide. "All modern artists—I'm not talking here about half-hearted snobs and epigones—are to a greater or lesser degree insane—like all of us who have active minds," he had noted.[67] As a young man, Goebbels also had become interested in Ernst Barlach, a leading sculptor and lithographer whose figures were similar to Nolde's in evoking primal emotions. His bronze statue *Christ and John* shows Jesus embracing his cousin John the Baptist, an evocative piece that celebrates familial love and vulnerable emotions in the two young men. Barlach, a Great War veteran born near Hamburg, also had two sculptures in the *Thirty German Artists* exhibition that Nolde had been in and that Goebbels had supported.[68]

The debate about the cultural limits of Nazism took place in an atmosphere of bloody party purges that culminated in a rampage between 30 June and 2 July 1934, known as the Night of the Long Knives or the Röhm

Putsch. A small but boisterous faction of the paramilitary Sturmabteilung (SA) began causing trouble for Hitler shortly after he became Chancellor in January 1933. While most Nazis immediately settled down to the task of governing, Ernst Röhm, the SA's forty-six-year-old cofounder, brazenly declared that the "German Revolution" was ongoing. Hitler, never a fan of revolutionary language, which he felt sounded communist, had insisted to Röhm, Goebbels, Hermann Göring, and other top officials that the revolution was complete: they were now actual lawmakers.[69]

Röhm remained defiant, demanding in February 1934 that the SA should control national defense.[70] Röhm had become so bellicose by summer 1934 that Hitler realized that the hothead was jeopardizing the NSDAP. Fearing a putsch, Hitler and his entourage made a surprise visit to the Hotel Hanselbauer in the Bavarian lake town of Bad Wiessee on Tegernsee, where Röhm was staying with supporters. Barging into their rooms at 6:30 a.m., where they were sleeping off a hard night of drinking, Hitler brandished a pistol and declared Röhm a traitor. Hitler's loyalists then found Röhm's deputy, Edmund Heines, in bed with a younger Nazi man. This, combined with the fact that Röhm was an open but discreet homosexual, proved politically expedient. Neither Hitler nor Goebbels was particularly homophobic, but Röhm's indiscretion provided them with a convenient slander palatable to the general public: the SA was bursting with repugnant homosexuals and therefore had to be purged.[71] Hitler's faithful took Röhm and five other SA men to Stadelheim prison in Munich.

Back in central Berlin, Goebbels called Göring with the secret password to begin a wider purge: "Operation Kolibri" or "Operation Hummingbird." Vice Chancellor von Papen, whose concern about potential judicial overreach was an increasing annoyance, was too prominent to be assassinated. Instead, Nazi hit men killed his press secretary, Herbert von Bose, to send a sinister message[72] and murdered Edward Jung, von Papen's speechwriter, and dumped him in a ditch. They subsequently put von Papen under house arrest. Youthful Nazis wearing coordinating trench coats and fedoras entered former chancellor Kurt von Schleicher's home while he was on the phone; they shot him and gunned down his wife, Elizabeth.[73] Hours later at a garden party, while mingling with his ministers' wives, Hitler announced that

Röhm's death was necessary and that Röhm needed to do the deed himself. Nazis in Stadelheim gave Röhm a revolver with a single bullet in the cylinder and left his cell. Ten minutes later, when no shot was heard, they reentered the room and shot Röhm themselves.

By the time the killings ceased on 2 July, the Nazis had assassinated at least two hundred people. Generally, Germans were grateful that their Führer had taken decisive steps to protect them from forces that could have unseated their first stable government in decades. With journalists consenting to Hitler's control and the Protestant and Catholic churches remaining silent, laymen remained unaware that some of those killed were merely vocal objectors to some of Hitler's more bigoted policies.[74] Ordinary Germans gave little thought to the violation of the rule of law—with deadly results—that occurred during the Night of the Long Knives.

The increasing trust Germans placed in their Führer came at a time when President Hindenburg's health was fading, causing increased anxiety among ordinary Germans, who revered him. Hitler asked Germans on 1 August to vote on whether, when Hindenburg was no longer fit to serve, Hitler should take up Hindenburg's responsibilities. Within hours, Hindenburg died at age eighty-six due to complications from cancer. After a pomp-filled funeral, Germans voted 89.9 percent to make Hitler the sole executive head of the country, as the military took oaths pledging loyalty to him rather than the nation.[75]

Invitations for a rally at Nuremberg sent two weeks later featured what would become a favorite artistic theme for Hitler: muscular, naked young men bearing the party standard. Five hundred trains carried 225,000 people to cheer on the Führer with cries so genuine that even cynics, including American journalist William Shirer, were impressed. "They reminded me of the crazed expressions I saw once in the back country of Louisiana, on the faces of some Holy Rollers," he recorded.[76]

The Nazis legalized territorial expansion and anti-Semitism in 1935. In January, when French control of the Saarland expired under the terms of the Treaty of Versailles, the region's half million voters cast ballots on whether to join France or return to Germany; 91 percent volunteered to join Hitler's dictatorship.[77] Two months later, when Hitler announced to foreign

embassies that he was creating a new Wehrmacht with thirty-six divisions, Great Britain and France were too divided to react forcefully.[78] The Führer's confidence reenergized once-hesitant anti-Semitic hooligans, who now had a growing Jewish population to terrorize: many Jewish Germans who had fled discrimination came back to Berlin for the summer, encouraged by Germany's financial stabilization and underestimating the NSDAP's anti-Semitic prejudice. As bullying increased, Hitler decided that the most efficient action to take was no action at all. "There's no point in artificially creating additional difficulties," he reasoned.[79] Moderate Germans began raising concerns with the government about the violence, not because it was immoral but because it was illegal. Recognizing this, the government simply legalized discrimination.

Hitler and Goebbels went on a brief summer vacation in mid-July to relax before further legislative overhaul. "Eating together. Then walks and a boat trip by moonlight. Wonderful atmosphere. I steer. Back and forth across the Baltic. Führer very happy. I enjoy giving him joy," journaled Goebbels, enraptured.[80] Back in Berlin, the NSDAP declared that future marriages between Jewish and non-Jewish Germans were forbidden, Jewish Germans couldn't employ women under forty-five to work in their houses, and the government would soon determine the status of "partial" Jews.

After visiting an independently organized Dresden exhibition of Degenerate Art in August, Hitler was encouraged by the fact that Aryan elites in the art world were beginning to spontaneously denounce art that conflicted with the traditional styles and patriotic themes that their Führer preferred. He made "the future of German art" the major theme of the 1935 Nuremberg rally. So confident was Hitler of the universal truths in his speech that he ordered his Propaganda Ministry to translate it and publish it in English. Speaking to the crowd, he argued that by relinquishing so many rights to the government, Germans had shown the world how much they trusted their Führer to protect their cherished culture. "At some future date, when it will be possible to view those events in clearer perspective, people will be astonished to find that just at the time the National Socialists and their leaders were fighting a life-or-death battle for the preservation of the nation, the first impulse was given for the re-awakening and restoration of artistic vitality," he

declared.[81] The cultural and political programs of the NSDAP were increasingly aligned, he said, in order to rid Germany of "facile smearers of paint." Nazi Germany was showing its character—determining who was and was not worthy of inclusion.

Hitler fervently explained that a nation's art reflected the genetic purity of its citizens. Privately, Hitler told his inner circle that inferior artists should be "'reeducated' in concentration camps." Publicly, however, he argued simply said that he was challenging artists who aimed to "wallow in filth and rubbish for the sake of filth and rubbish" and glorify the "moral and physical decomposition" of inferior humans in order to sully German culture. He was merely protecting German safety as any good leader should.[82] "Just as nobody would claim that, in order to uphold the sacred right of personal liberty, the assassin should be left free to inflict physical death on his neighbor, for the same reason nobody has the right to be allowed to inflict spiritual death on a people, simply because he claims full liberty for the exercise of his obscene and distorted fancy," Hitler argued.[83]

After the rally, Hitler enacted the Law for the Protection of German Blood and German Honor, creating separate citizenship levels for Jews and giving the state increased control over the lives of "deficient" humans.

The law was drafted by the party's advisors and presented to the Führer in short summaries because Hitler "disliked reading files," recorded his adjunct, Hans Wiedemann.[84] Hitler set the broad principles of what he wanted—a process dubbed "working toward the Führer." Individual pieces of legislative discrimination were often created without his direct involvement—but he had pointed the way.[85]

Once the laws had been passed, the NSDAP entered a ten-month legislative lull to prepare for the 1936 Olympics. Hitler originally loathed the idea of hosting the spectacle; it was anathema to think that that non-Aryans could be fit to challenge the master race. Goebbels encouraged the Olympics, however, as a way to make Germany appear tolerant to those worried about the nation's increasingly bigoted policies and expanding army.

In the months before the Olympics, Putzi Hanfstaengl worked diligently as the Führer's international spin doctor to cultivate the image of Hitler as a cultured artist-statesman. He arranged for the publication of profiles in the

United States beginning in the second half of 1935. Colorful features and portraits of the Führer began to show up on the coffee tables of American houses. *Life* magazine featured a photo spread of "candid" pictures of Hitler wrestling with his German Shepherd, working at his desk, reading a newspaper in his Berghof solarium, and wearing "a checked coat that might be the envy of the Prince of Wales."[86]

A *New York Times* article praised Hitler's love of eighteenth-century German artists and his excellent taste in color schemes, his present preference being for blue, white, and gold. The *New York Times Magazine* upped the ante with a glowing profile titled "Hitler His Own Architect," praising the dictator's love of a green color scheme at the Berghof, where he had hung a picture of his mother in his bedroom, tended baby cacti, cultivated cherry trees, and sketched. The magazine writer generously and inaccurately described Munich as "the Mecca of German art, where Hitler went in 1912 to study architecture."[87]

In the meantime, Hitler ordered the Nazi diehards to stay civil no matter the circumstances in the run-up to and during the Olympics, and they duly complied, even refraining from protesting when a Jewish European activist assassinated Swiss Nazi leader Wilhelm Gustloff in February.

——◆——

After the Olympics, Goebbels and Hitler returned to preparing for the summer 1937 opening of the Great German Art Exhibition. In mid-January 1937, German newspapers published a call to German artists at home and abroad to submit artworks. Hopefuls submitted a staggering 15,000 pieces.

Paul Troost, the House of German Art's original architect, had died in January 1934 at only fifty-five years old, a premature death that he superstitiously predicted after Hitler's silver hammer broke at the Foundation Stone Ceremony. His thirty-three-year-old wife, skilled fellow architect Gerdy Troost, had taken over the project with Hitler's full confidence and support and completed the building in April 1937. Architecturally speaking, this building, meant to embody Hitler's regressive art program, was one of the world's most progressive museum structures. It featured a layout that enabled the display of large-scale works within a structure that had a clear, unique

style but, unlike many museums, did not threaten to upstage the artworks. It was imposing but streamlined; its colonnade supporting the roof evoked classical Greece and Rome but used simple lines for a modern feel.

The 55,000 square feet of floor space and 19,000 square feet of wall space were generous but not cavernous.[88] Troost concealed wiring and pipes for modern functions including heating, ventilation, and lighting to create a clean atmosphere, also creating space for automatic fire alarms to avoid a disaster like the one that had destroyed the Glaspalast. She installed elevators to aid the elderly, injured war veterans, and those bringing children, all radically progressive measures at the time.[89] Two bronze inscriptions above the entrance, however, managed to convey a message both inspiring and menacing: "Art is a sublime mission, which necessitates fanaticism" and "No person lives longer than the documents of his culture."[90]

"The building is fabulously beautiful. One day it will be counted among the truly great buildings of our epoch," wrote Goebbels.[91] In May, Goebbels formed a selection jury that included Gerdy Troost and six artists, including forty-four-year-old Adolf Ziegler, known among Nazis as the "master of pubic hair" for his painstakingly clinical depictions of genitalia in supposedly romantic paintings of nudes.[92]

On reviewing the submitted artworks in early June, the jury mortifyingly realized that the expulsion of controversial artists and dealers from the Reich Chamber of Culture in the early 1930s, along with the lack of specifics from Hitler on what constituted "good" art, had produced a particularly mediocre submission pool. The would-be Great German Artists were largely a dully homogenous group of older men who showed few new techniques. If artists continued to work in this vein, the panel realized with alarm, German culture would surely atrophy, incapable of rising to the level that Hitler had prophesied.

"The sculptures are passable, but the paintings are in some cases outright catastrophic," complained Goebbels upon seeing the selection. "The Führer is wild with rage," he added. The review session challenged Goebbels's relatively liberal taste in art and preferences for Nolde and Barlach. More broadly, it exposed the reality that, with diverse artistic viewpoints now silenced, the definition of what constituted the genre of Great German Art

risked becoming lifeless.[93] Sulking on a train with Goebbels on 7 June, Hitler railed against the jury. "Would rather postpone the Munich exhibition a year than exhibit such crap," Goebbels noted in his diary as Hitler fumed.[94] Ultimately, Hitler tapped Heinrich Hoffmann, his personal photographer, to cull a new selection from the submitted works, a task the fifty-one-year-old embarked upon with focused efficiency.

Mulling over how to improve the opening of the House of German Art and its inaugural Great German Art Exhibition, Goebbels spontaneously proposed to Hitler that they organize a Degenerate Art Exhibition to open concurrently, holding it near the House of German Art. By doing so, Goebbels reasoned, the Nazis would send a clear message that professional artists now belonged to one of two opposing camps: good artists and Degenerate Artists.

Hitler agreed, giving Goebbels less than a month to curate an exhibition that would damn the futures of dozens of artists who had prospered before 1933. Though German artists, including Nolde and Pechstein, had hoped to obtain the status of Great German Artist, this now created the possibility that they would be not merely left out of that exclusive circle but defamed by the Führer and exposed to the entire nation as degenerate, their livelihoods ruined. Goebbels enlisted the aid of Adolf Ziegler, an original jury member for the Great German Art selection whom Hitler admired for his painstakingly detailed nudes. With only weeks to prepare, the pair frantically worked to assemble a list of artists whose artwork they could vilify as examples of the type of degeneracy that Hitler was eliminating from his Third Reich. Ziegler was tireless, canvassing thirty-two collections in twenty-eight towns and selecting 650 artworks.[95]

On 9 July, as Ziegler was zipping around the country to find Degenerate Art and Hoffmann was evaluating approved works in Munich for the exhibition of Great German Artists, Goebbels drove to the Berghof with his wife, three daughters, and son to visit the Führer for a working vacation. As they pulled up to the house, Hitler was already waiting to see them. He gregariously greeted daughters Hildegard and Holdine and the only boy, Helmut, but he positively doted on the oldest, the precocious four-year-old Helga, who was his favorite. Over the next few days, the group played cards,

watched movies in Hitler's home cinema, and jubilantly discussed the up-
coming exhibitions.[96] Heading to Munich, Goebbels and Hitler reviewed the
new selection of 884 works by 556 artists that Hoffmann had chosen. "The
selected pictures are now very beautiful, even better than the sculptures,"
Goebbels told his diary contentedly. "The Führer is very happy."[97] The man
who had been rejected by Vienna's Akademie der Künste was about to pre-
side over the Third Reich's determination of what was and was not great art.
He accepted only 6 percent of applicants, a lower admission rate than the
year he had applied to the academy.

———✦———

The Great German Art Exhibition opened on 18 July, and the festivities
kicked off with a gaudy parade stretching over seven kilometers and featur-
ing 456 horses. The parade's 6,403 participants paid tribute to 2,000 years of
German history by dressing up in elaborate costumes from various epochs.[98]
Standing in front of a crowd of admirers, under blue skies that compliant
journalists increasingly referred to as "Hitler weather," the Führer ruminated
on the 1933 groundbreaking ceremony for the House of German Art, ignor-
ing the silver hammer fiasco.

"At the festive laying of the foundation stone for this building four years
ago, we were all aware that not only the stone for a new house was to be laid
but that the ground had to be prepared for a new and truly German art,"
Hitler shouted.[99] Weimar officials had neglected Germany's cultural past and
jeopardized her future, he said. "Yet with the opening of this exhibition the
end of the mockery of German art and thus of the cultural destruction of our
people has begun." Then, using language that ominously echoed the words
and phrases he used to justify genocide, Hitler concluded, "From now on,
we will wage a pitiless, purifying war against the last elements of our cultural
decay."[100] Goebbels was ecstatic. "An ecstasy of forms. Wonderful. We are all
deeply moved. Most of all the Führer," he chronicled.[101]

Adolf Ziegler, who had been on Hitler's panel, had five works in the
Great German Art Exhibition. One of them, *The Four Elements*, was Ziegler's
most famous; it featured four nude women with the painstakingly painted,
almost clinically depicted pubic hair for which Ziegler was known.

The following day, on 19 July, the Degenerate Art Exhibition opened at the Hofgarten Arcades a few minutes from the House of German Art. Adolf Ziegler was chosen by Hitler and Goebbels to introduce it. He did so by effectively chastising German museums for having wasted the hard-earned savings of the German people on artworks.

A few days after the opening of both exhibitions, a seventeen-year-old named Peter Guenther came to Munich from Dresden, leaving with razor sharp memories of both exhibitions that he wrote down for posterity. Guenther's father was a culture critic whom the Nazis had banned in 1935 because his second wife, Guenther's stepmother, was Jewish. Growing up, Guenther had revered modern art, pasting reproductions of van Gogh's artworks on his wall. Entering the House of German Art, he was struck by how quiet it was, despite the crowds. Visitors whispered, as if in a church. "It was obviously due to the semi-ecclesiastical atmosphere created by the size of the rooms, their decor, the impressive lighting, and the careful placement of the exhibits," Guenther observed.[102]

At Hitler's insistence, the exhibition featured none of Hitler's own artworks and only seven portraits and five busts of the Führer.[103] As the Nazi Party considered itself the church's replacement, Christian art was absent, though the Nazis appropriated Christian symbolism and motifs. One such painting was by Hermann Otto Hoyer, an artist so obscure that he had never before been reviewed or profiled in the media. Hoyer painted the remarkably photorealistic *In the Beginning was the Word*, which depicts Hitler giving a speech to a small, rapt audience; the painting's title, taken from the first line of the gospel of John, underscored the Nazis' view of Hitler as a Christlike savior.

The first room in the Great German Art Exhibition featured three works arranged as a triad. In the middle was a portrait of Hitler by Heinrich Knirr, a seventy-four-year-old Austrian who depicted the Führer in a traditional statesman's pose, sporting a brown uniform with a swastika armband and wearing his Great War medals, his hand on his hip and his body unrealistically buff. On the left hung *The Last Hand Grenade* by forty-five-year-old Elk Eber, who hailed from the Bavarian border with Austria. The work showed a soldier with huge hands, about to toss his final weapon, gazing reverently out

of the frame toward Knirr's toned Führer. On the right hung Eber's *Roll Call on 23 February 1933*, in which a pair of strapping young Nazis are buttoning their brownshirt uniforms.

The next room housed *Comradeship*, a massive, homoerotic statue by Josef Thorak, a forty-eight-year-old Austrian who was Hitler's favorite sculptor. Two naked men with rippling muscles, holding hands placed over the left man's genitals, towered over the exhibition's visitors. Peter Guenther was unimpressed: "I thought that they were intentionally attempting to imitate famous Greek sculptures I knew from books, but they lacked the grandeur and quiet balance that I considered to be the hallmarks of that art."[104] Busts of Mussolini, Atatürk, and Nazi leaders flanked Thorak's statue.

Guenther wandered into the room featuring the exhibition's most revered paintings. Ziegler's *Four Elements* was spotlighted, showing four female nudes staring off listlessly. Nearby hung a work by Sepp Hilz, one of the youngest featured artists. Hilz's work showed a country peasant undressing in her room, a thick red-and-white striped sock still on her foot. The nudes struck Guenther as "bland" and clinical. The proportions, even to a layman, appeared preposterous. The models' shoulders were broader than their barely existent hips, their breasts were spaced wide apart, their chests seemed to have male dimensions, and their necks, though slender, supported heads that corresponded with the typical size of men's heads. "It was not that I had been brought up a prude: on the contrary, my mother was very much in favor of anything healthy and natural," noted Guenther. Natural these women were not.[105] Ultimately, Guenther sought out works that were appealing due to their "unpretentiousness," including a bronze of wild ducks by fifty-two-year-old Max Esser and a bronze of a young maiden playing the recorder by forty-eight-year-old Hermann Geibel.

In contrast with the stagnant, even backward content of the work, the young Guenther recognized that the exhibition's layout and the museum's architecture were trailblazing. A clearly marked red line guided visitors through forty rooms that ended at a modern gourmet restaurant with an electric kitchen and a bar—innovations in 1937. Floor runners created a clean look, and the works were well hung with enough space to view each piece in comfort. Rather than distracting wall placards, cards with information

about each piece could be viewed in the middle of each room at comfortable benches perfectly suited for a quick rest.

As he left the exhibition, Guenther noticed a red card tucked into his complementary exhibition catalogue advertising the Degenerate Art Exhibition. "Check it out! Judge for yourself!" it said, so he made the short walk to the Hofgarten Arcades, sneaking in because minors were technically banned from the exhibition. In contrast to the stellar layout of the Great German Art Exhibition, the rooms of the archeology institute in the Hofgarten were narrow, the ceilings low, and the works badly lighted, creating a claustrophobic atmosphere.[106] The dozen wall texts in a large, messy font carried slogans rather than information, including "Crazy at any price!" and "Even museum bigwigs called this 'art of the German people'!"[107] Adolf Ziegler had organized the show into nine themes: generally inferior color or form, blasphemy, anarchy, insults to the military, sexually deviancy, misrepresentation of nonwhites as fully human, positive depictions of the mentally and physically disabled, Jewish artists, and evil "isms": Dadaism, Cubism, and Expressionism. Though Germans would quickly come to refer to the exhibition as one of degenerate Jewish art, only 6 of the 112 condemned artists were actually Jewish. Most of the doomed artists actually were Aryan.

In creating the show, the Nazis prioritized the shaming of artists who were still alive. Max Liebermann, the most prominent Jewish German artist of the era and the creator of *Two Riders on the Beach*, had already died in 1935—a man who had become seriously depressed after his fellow artists removed him as honorary president of the Academy of Arts. With Liebermann's once popular works already banned and now largely forgotten, Goebbels had no inclination or incentive to reignite interest in him.

The artists whom Goebbels had admired before Hitler's rise to power suffered the most, as the Propaganda Minister was eager to prove his unquestioning loyalty to the Führer's vision. The exhibition's first room, which focused on religious art, removed any doubt about whether Goebbels had accepted Emil Nolde's anti-Semitic gamble. There, the teenage Guenther observed works by the sixty-nine-year-old artist who had until then been so revered in Germany. Spanning an entire wall was Nolde's *Life of Christ* triptych, next to which the Nazis had scrawled the wall text "Insolent Mockery

of the Divine Under Centrist Rule."[108] Overall, thirty-six artworks by Nolde were on display in the exhibition, more than by any other artist.

In the third room, which focused on the ambiguous theme "Revelation of the Jewish Racial Soul," sat the bronze statue *Christ and John* by Ernst Barlach, whom Goebbels had admired as a young man. Born after the Great War, the high schooler Guenther was particularly confused to see artworks that confronted the trauma of the Great War in a way that he considered reflective of what he saw in his daily life; placed next to each other were Ernst Ludwig Kirchner's *Self-Portrait as a Soldier* and Otto Dix's *The War Cripples*. Also on the wall hung *The Trench*, the painting that Konrad Adenauer, as mayor of Cologne, had blocked the city from purchasing.

Though he did not dare say it, Guenther was particularly impressed by Otto Dix, who had twenty works in the show, including *Horse Cadaver* and *Corpse in Barbed Wire*. Guenther understood how someone who had never seen such impoverished war cripples might be shocked, but residents of Berlin or Dresden, he noted, had often seen "men whose legs had been amputated or with other visible deformities sitting in the streets selling shoelaces and matches." He recalled, "My mother frequently gave me a coin to put into the caps they had placed in front of them."[109]

The fourth room was an assortment of paintings not arranged by any theme; they included Oskar Kokoschka's 1914 work *Bride of the Wind*, the portrait of the artist and his lover at the time, Alma Mahler, now maligned by the Nazis because her late husband, composer Gustav Mahler, had been Jewish. Guenther saw Kirchner's exploration of his postwar depression, *Sick Man at Night*, before he entered the fifth room, where the Nazis had arranged art under the themes "Nature as Seen by Sick Minds" and "Madness Becomes Method." There, Nolde's painting *Young Oxen* hung catty-corner to Kirchner's *Winter Landscape in Moonlight*, which was near his glamorization of prostitutes from 1913, *Five Women on the Street*.

It was clear, looking through this room, that even artists who had tried after the Great War to paint subjects they considered harmless were being skewered if their artworks deviated even slightly from what Hitler considered ideal depictions of Aryan culture and the perfect Aryan body. Beckmann, the artist who had created the massive painting of the *Titanic*'s sinking, had

worked after the Great War to create portraits of acrobatic performers and still life depictions of musical instruments, two themes he was convinced would be noncontroversial. The Nazis had not been able to find one of his greatest works, *The Lion Tamer*, a vibrant gouache work on paper of a circus trainer teaching a lion tricks, but in this fifth room hung other portraits of acrobats and even a still life of a saxophone; Hitler hated the instrument, believing that it represented the "niggerization" of German music.

Winding his way through the crowds, down the narrow staircase, Guenther came to a catacomb-like corridor packed with paintings and works on paper crammed together on the walls. Works from Max Pechstein's series *The Lord's Prayer* hung alongside Dix's portrait of a prostitute, *Leonie*. Also here was *Keep Your Mouth Shut and Do Your Duty*, George Grosz's etching from 1927 and the most famous of the twenty works of his in the exhibition. On the wall around Grosz's works were quotes from his publisher, Wieland Herzfelde, about the potential merits of communism.

Guenther did not notice the discrepancy, but one artist appeared in both exhibitions. Rudolf Belling, a fifty-year-old Berliner who had moved to Istanbul in early 1937 after much of his work was confiscated by the Nazis, had submitted a 1929 sculpture of the celebrated boxer Max Schmeling. The German boxer had been heavyweight champion of the world between 1930 and 1932 and had beaten Joe Louis in 1936. Hoffmann had accepted and prominently displayed the work in the Great German Art Exhibition—clearly a statement of the superiority of Aryans—even as Ziegler put Belling's cubist-inspired *Triad* and a sleek brass work of a gorgeous woman's head in the Degenerate Art Exhibition.[110]

When a "journalist" quietly pointed out the discrepancy to party officials, Nazis removed the "degenerate" Belling work; the exemplary one remained on show.[111] In their reporting, the press toed the party line. On 20 July, the front page of the *Berliner Morgenpost* classified the works in the Degenerate Art Exhibition as "shoddy products of a melancholy age" when Bolshevism and dilettantism celebrated their triumphs."[112]

Having their works in the Degenerate Art Exhibition represented the professional death knell for Nolde, Kokoschka, Dix, Pechstein, Kirchner, and dozens of other artists who had hoped to continue their livelihoods in Europe after the Nazis took power. In total, thousands of their artworks were confiscated by the Nazis for potential use in the Degenerate Art Exhibition. When that exhibition closed in Munich in 1937 before touring the country, over two million people had visited, a number that even New York's Metropolitan Museum of Art would not surpass until the *Mona Lisa* visited Manhattan in 1963.

The Great German Art Exhibition, by contrast, saw 554,759 visitors between July and its closing on 31 October.[113] The artworks it showcased were put up for sale; this, combined with the growing Nazi censorship of artists featured in the Degenerate Art Exhibition, was an explicit attempt by the government to rig the art market: it declared Aryan work valuable even as it condemned and confiscated supposedly Degenerate Art. "The prices of these works were tenfold excessive, and the big German companies and industrialists were ordered to buy the exhibited works, which they did not want to possess, for large sums," Emil Nolde fumed to a friend about the "trivial, average pictures and sculptures" on display at the House of German Art. "A similar art fraud under the cloak of the state had probably never happened before," he added.[114]

He was right.

By 22 July, three days after the show at the House of German Art opened, 250,000 reichsmarks' worth of art had sold. Ultimately, Germans bought around five hundred works for a total of 750,000 reichsmarks that year from the House of German Art.[115] The Führer himself popped up at the sales: he was the largest supporter, paying 268,449 reichsmarks for an unknown number of works.[116] Goebbels piled in, too: he bought 50,000 reichsmarks' worth of art for the Propaganda Ministry and 200,000 reichsmarks' worth for his private collection. "The Führer has taken many beautiful things away, but there is still a lot," Goebbels recorded, adding that there were "wonderful things among them." Primarily German firms hoping to ingratiate themselves with the regime purchased the remaining third of the artworks.[117] Ultimately, there was no genuine popular enthusiasm for the work displayed in the Great German Art Exhibition. The sales were mostly manipulated.

Nevertheless, Nolde did not give up the fight to ingratiate himself with the Nazis. He continued protesting to Goebbels that he was a true German artist whom the regime should cherish. "I take this particularly hard, and especially because I was—before the beginning of the National Socialist movement—almost the only German artist in open struggle against the foreign infiltration of German art and fought against the unclean art dealers," he wrote to Goebbels.[118] Nolde retreated to the remote hinterlands of Frisia in northern Germany, working on a six-hundred-page memoir he would publish two decades later, conveniently leaving out any mention of the period between 1933 and 1945.

Oskar Kokoschka, living in Prague, soon fled to England. Otto Dix retreated with his family to a house on Lake Constance at the Swiss border, hoping that the Nazis would forget about him. Max Pechstein escaped detection for a few years, until the Nazis drafted him into the Volkssturm, their national militia.

Inclusion in the Degenerate Art Exhibition hit Ernst Ludwig Kirchner the hardest of all. After years of battling clinical depression and insomnia, he told his partner, Erna, on the night of 14–15 June 1938 that he was about to shoot himself. After Hitler invaded Austria, he could not cope with a growing fear that the Nazis would invade Switzerland and capture him, a fear he developed after being so maligned in the Degenerate Art Exhibition. Erna immediately went to the telephone to call his doctors for help but, as she was doing so, he walked outside and pulled the trigger. "He chose a radiantly beautiful day," Erna recalled a few days later. "He had been suffering grievously until he was able to make this decision."[119]

In summer 1938, Max Beckmann, his career in tatters, traveled to London to warn the English art world about the censorship that had increased in the year since the opening of the House of German Art and the Degenerate Art Exhibition. In vain, Beckmann cautioned that the collectivism that had taken over the art world in Germany would extend into other parts of German society if other nations did not actively oppose it. "The greatest danger that threatens humanity is collectivism. Everywhere attempts are being made to lower the happiness and the way of living of mankind to the level of termites. I am against these attempts with all the strength of my being," he unsuccessfully entreated.[120]

The majority of the art world did not listen. Meanwhile, Hitler and Goebbels moved forward with their plans to process the thousands of artworks they had stolen or confiscated from museums and institutions around Germany even as they eyed the private collections of Jewish and other minorities. Their ambitions were not limited to Germany. Both men aimed to use military expansion into other western European countries to gain access to the greatest art collections on the continent so that they could rewrite—on a continental scale—the cultural history of European art in favor of their Germanic prejudices. In order to do this, they realized, they would need to assemble a team of savvy museum directors and art dealers to help them accomplish what would become the largest art heist in history.

CHAPTER V

BAD COMPANY CORRUPTS GOOD MORALS

"Occasionally, the soul can be turned into money."

—Publisher Heinrich Ellermann to Hildebrand Gurlitt

I N THE MIDST OF WORLD War I, Hildebrand Gurlitt, then a soldier in his early twenties, wrote on an undated page of paper that "in the moments of great danger," humans "freeze" their emotions, and a man is able to make himself "a clearly thinking, unfeeling machine."[1] It was a skill that Hildebrand set aside for twenty years until autumn 1938, when, faced with a regime that sought to destroy the modern art he had once nourished, it became politically and financially expedient for him to use his connections to help the Nazis dismantle that very system in which he had been so influential.

Born on 15 September 1895 to the respected art historian Cornelius Gurlitt and his wife, Marie, Hildebrand was the youngest of three children. The family was immersed in the German art world. Cornelius was professor at the respected Königlich Sächsische Technische Hochschule in Dresden, where the family lived in a stately villa on the urbane Kaisitzer Straße;

his paternal grandfather, Louis, then an octogenarian, had been a landscape painter beloved by the upper middle class.

As a child, Hildebrand went with his mother to see an exhibition of the Brücke artists, the group of which Emil Nolde had been a part and that George Grosz had admired as a student. Even at such a young age, Hildebrand appreciated how the Brücke artists challenged convention. Discussing the exhibition with his father after the show, he was thrilled to hear Cornelius predict that the Brücke artists would represent a freshness for the boy's generation that the Jewish German artist Max Liebermann and the Christian German artist Lovis Corinth had represented for Cornelius's generation.

Shortly before the Great War, the art school where Hildebrand's father was a professor accepted him as a student, offering him a chance to avoid serving in the military provided that Germany won the war quickly. Yet Hildebrand and his younger brother Wilibald eagerly volunteered for the front with the same enthusiasm that had swept up Adolf Hitler and George Grosz. Like Grosz and his artist friends, however, Gurlitt was quickly disillusioned by combat—a point that the military noted in its reports when moving the twenty-two-year-old Gurlitt in October 1917 to a desk job in Lithuania, where he propagandized to the natives regarding the superiority of German art and culture. The job, Hildebrand wrote at the time to Wilibald, made him yearn to work after the war as a museum director in "some town or other with modern, heavy industrial life," where he could influence the mind-sets of blue-collar workers indifferent to art or high culture and ignite in these philistines an enthusiasm for contemporary art.[2]

After the Great War's end on 11 November 1918, Gurlitt studied art history in Berlin and Frankfurt before returning to Dresden to work at the Architectural History Collection that his father had helped establish. His professional life was thriving, thanks to his father's connections, but the family experienced tragedy at home: Hildebrand's younger sister Cornelia killed herself, seemingly motivated by a breakup with her married lover, an esteemed art critic ten years her senior.[3]

On 1 April 1925, Hildebrand Gurlitt became director of the König Albert Museum in Zwickau, a small industrial town near the Czech border. At just twenty-nine years old, Gurlitt achieved the goal he had set for himself

at his army desk job in 1919. The position offered him an opportunity to showcase a unique curatorial style that he hoped would draw the attention of more prestigious museums. Early on as director at Zwickau, Gurlitt took a stand against the more powerful, more traditional, and better-funded museums in Berlin and Hamburg by bluntly positing that a museum director should not solely operate as "the faithful guardian and propagator of ancient treasures" but also instruct visitors, particularly local ones, about the merits of art made in their own time. He issued a direct challenge to the establishment by declaring that he wanted to be the first director in an industrial area to exhibit abstract art.[4]

Gurlitt shrewdly devised an innovative and lucrative system through which to promote contemporary art on a shoestring budget, enriching Zwickau's collection as he also expanded his own bank account. He would stage exhibitions as a curator but also encourage sales that he would personally broker. On a large, dark wooden desk covered with papers and small figurines, he successfully organized exhibitions promoting artists then embroiled in controversial political struggles, notably Max Pechstein and Käthe Kollwitz. The artists welcomed his support; Kollwitz, then in her early fifties, was reeling from the death of her son Peter on the battlefield, and Pechstein, in his late thirties, had recently created his works based on his 1914 trip to the Palau Islands. The Pechstein exhibition was particularly profitable, not only because a large number of Germans bought tickets to see it but also because Gurlitt successfully brokered sales of Pechstein's works while they were hanging in the museum; the scheme gave a 10 percent kickback to the museum and generated a commission for Gurlitt.[5] He became both curator and dealer, artfully blurring the line between the two professions, a move that, while legal, respected directors in Europe considered ethically dubious.

Following the success of the shows, Gurlitt began recruiting wealthy sponsors who endowed the Zwickau museum in exchange for his advice on what they should buy and sell for their private collections. The quid pro quo worked well. Salman Schocken, a Jewish German businessman, displayed his private collection in the Zwickau museum. Gurlitt had a similar arrangement with Leo Levin, another Jewish German collector.[6] The ability to showcase

art owned by wealthy collectors increased the museum's social status and revenue while also upping the value of Schocken's and Levin's collections. It also brought personal profits for Gurlitt. He soon expanded his art advisory business to Dresden, where Jewish German industrialist Kurt Kirchbach also used him as a consultant.[7]

Despite creating a stronger financial footing for the museum, Gurlitt angered the retirees in Zwickau, who protested that he was replacing the calming landscapes and portraits in their beloved museum with what they considered bizarre art by radical young artists—the men and women from whom Gurlitt was profiting personally. Controversially, Gurlitt balanced the museum's budget by selling old-fashioned works in its permanent collection that he considered subpar, including one by Wilhelm Kuhnert. Though hardly a heavyweight in the great canon of German art, Kuhnert crafted animal scenes that were both biologically accurate and emotionally charming, and the Zwickau traditionalists were greatly attached to his paintings.[8] After selling off Kuhnert's work, Gurlitt curated shows with lascivious themes, including one exhibition in 1928 on the history of sexually transmitted diseases. For a small city like Zwickau, it was a smashing success; predictably, however, the topic offended the more reserved townspeople.[9]

Confrontation was inevitable. Zwickau officials, Gurlitt's supporters, and Gurlitt himself exchanged hundreds of pages of tightly typed letters debating whether he should leave his post. Ultimately, on 1 April 1930, he left his directorship, pushed out by those in Zwickau who considered him a vulgar populist.

Gurlitt quickly bounced back. He secured a position as head of the Hamburg Art Association, a placement that thrilled him. He and his wife, Helene, hoped to start a family, and on 28 December 1932, she gave birth to their son. The couple named him Cornelius after Gurlitt's father, who was then in his early eighties. Working in Hamburg, Gurlitt continued to support female artists, holding a show for Gretchen Wohlwill, a Jewish German artist in her early fifties. He still blurred the line between curator and dealer as he had in Zwickau, selling art he displayed in the exhibition space and pocketing profits. Just months after Hitler's ascent to power in 1933, the association's authorities fired Gurlitt both for his love of avant-garde art and

for his refusal to fly the Nazi flag outside the building. Undaunted, he began focusing exclusively on dealing.

Now that Hitler was in power, the apolitical and agnostic Gurlitt began worrying about his future. Although he was nominally a Protestant, Gurlitt's grandmother had been Jewish, making him a *mischling*, or "mongrel," in the eyes of the Nazi elite. Yet, despite qualifying as a "mongrel second-degree," he continued dealing in modern art that Hitler would soon declare degenerate. In 1935, Gurlitt's family grew with the birth of his second child, a daughter, whom he and Helene named Renate Nicoline Benita. That same year, he put on a show of twenty-five works by the Jewish Swiss artist Karl Ballmer, helping the artist, then in his mid-forties, maintain a modicum of financial security and academic respect at a precarious time in his career.[10] The support for Ballmer was appreciated by one of his more famous fans, Irish writer and later Nobel laureate Samuel Beckett, who attended the exhibition.

By early 1937, after Hitler instructed Joseph Goebbels to round up modern art inside German museums for the Degenerate Art Exhibition in autumn of that year, Gurlitt became aware that staying above the fray would be impossible: he would need to either leave the country, join the resistance, retreat into obscurity, or collaborate with the Nazis. He would later maintain that, as a quarter Jew, he had chosen to lay low. In reality, he actively sought to undermine the very market he had once nurtured, not to survive but instead to make millions of reichsmarks.

When faced with grave danger, Gurlitt became what he had described twenty years before: a "clearly thinking, unfeeling machine."

———◆———

By early 1938, the Führer was ready to expedite his plans for European expansion. On 12 February, he met with Austrian Chancellor Kurt Schuschnigg at the Berghof. Alone in the Berghof office, Hitler talked at—not with—Schuschnigg for two hours.[11] Hitler's entourage at the Berghof could distinctly hear when Hitler shouted at Schuschnigg, "I am Austrian by birth, and I have been sent by providence to create the Greater German State! And you stand in my way! I will crush you!"[12] After three days, Schuschnigg acquiesced to Hitler's instruction to legalize the Nazi Party in Austria and

create a joint foreign policy that Hitler would control. By 11 March, Schuschnigg had resigned. Within hours, on 12 March, German troops crossed the border between Bavaria and Austria, where civilians welcomed them with open arms. Greater Germany had arrived. Soldiers referred to the military operation as the Flower War because Austrian women pelted them with so many garlands.[13] After the annexation, Germany effectively shared borders with Italy and Hungary, while Czechoslovakia was almost totally encircled.

Hitler soon visited Vienna. He toured the Kunsthistorisches Museum, which he had roamed as a failed art student twenty years before. He remembered the time he went into the foyer outside the office of Professor Alfred Roller, the art expert whom his neighbor in Linz had contacted on young Hitler's behalf after he failed the art entrance exam. Recalling his youth, Hitler, now in his late forties, joked about his decision not to enter Roller's office. "He would have accepted me immediately. But I don't know if it would have been better for me: everything would have been much easier!" scoffed Hitler.[14]

After the Anschluss, the Nazis rounded up members of the same Jewish communities in Vienna that had funded the warming stools and homeless shelters that Hitler had used as a young man twenty-five years before. Yet, privately, the Führer was willing to throw aside the racist dogma he publicly espoused to help one man: Eduard Bloch, the doctor who had tried in vain to save his mother, Klara, during her fight with cancer. Bloch suffered financially after the Nazis closed his medical practice when they annexed Austria. Convinced that his persecution was a horrible misunderstanding, he reached out to Hitler, who placed him and his wife under official Gestapo protection until they could emigrate to America in 1940.[15]

Samuel Morgenstern, the most consistent buyer of Hitler's paintings when the future Führer was a struggling artist in Vienna, was not as fortunate.[16] In 1938, his framing workshop was taken over by non-Jewish Viennese without compensation. The elderly man was forbidden from working at all, leaving him with no income to pay the "Reich flight tax" required for an exit visa. Remarkably, Morgenstern still had the receipts to prove he had financially supported Hitler in his youth—and that most buyers of Hitler's artwork had been Jewish Austrians. The retiree wrote to Hitler in Berlin,

saying that he knew Hitler was "a correct and honest man." He asked to be allowed to leave the country with his family. He offered to leave his assets behind. "Please have my application checked and please approve it. Faithfully yours," wrote Morgenstern. The postman delivered the letter to Hitler's secretary, who sent it to the chancellery's mail department. It was then forwarded to the Finance Ministry, where it was filed away and forgotten.[17] Samuel Morgenstern and his wife were moved to a ghetto, where he died. His widow was then deported to a concentration camp, where she soon perished.[18]

By this point, German and Austrian art dealers, though excited by the opportunities that resulted from Hitler's expansion of power, had become worried about the legal risks that might arise from acquiring artworks that the Nazis had confiscated. Recognizing their concerns, the Nazis passed the Law for the Confiscation of the Products of Degenerate Art on 31 May 1938, legalizing both retroactively and for the future the confiscation of Degenerate Art from both private and public collections. The law also waived the need for the Nazis to provide compensation to those from whom they confiscated artworks. The passing of the legislation was the trigger for the Nazis to seize 5,000 paintings and 12,000 other artworks from over one hundred galleries and museums across Germany. Though the Nazis burned many of the artworks, they planned to sell the others across the continent to increase their reserves of foreign currency. Eventually, they reasoned, they could destroy the works after conquering the countries to which they had been exported. The foreign reserves handed over to Germany in exchange for these degenerate works would help to fund the invasion of Europe.[19]

In the summer of 1938, one in four Jewish Germans, about 150,000 people, had fled the country. Three-quarters of them sought refuge in western Europe, though many hoped to emigrate to North America. They became the topic of a conference at the chic French resort of Évian on 6 July 1938, where thirty-two nations, including France, Great Britain, and the United States, spent nine-days socializing with dignitaries from smaller nations that were far removed from Hitler's regime, including New Zealand and Mexico. Enjoying the luxurious conditions of the Hotel Royal at the expense of their taxpayers, they discussed how to handle the deluge of Jewish German

refugees. At the end of their lengthy stay, they decided to do nothing. The Jewish refugees were displaced, with no obvious haven.[20]

Within his own borders, Hitler began encouraging Jewish Germans to engage in "self-extermination" shortly after the Évian conference; the NSDAP rescinded the medical licenses of around 80 percent of Jewish German doctors and prohibited the remainder from treating non-Jewish Germans.[21] Laws were also passed restricting the professional activities of Jewish lawyers, bankers, and entrepreneurs. For roughly half a century before Hitler's rise to power, it had been possible for professional middle-class Jews to curate impressive artworks, creating diverse collections comprising both traditional older works and daring new styles. Though most were still hesitant to move out of Germany, these professionals began seriously exploring how to liquidate their art assets in the event that such a time might come, as well as to provide for their families given their newly straitened circumstances.

Hildebrand Gurlitt was poised to take advantage of their plight.

By late summer, Joseph Goebbels made public the plan that he and Hitler had created for confiscating Degenerate Art, declaring that the regime had decided in private meetings that the works would be offered to Americans and non-Germans in Europe in exchange for foreign currency. "In doing so we hope at least to make some money from this crap," Goebbels wrote.[22] Gurlitt was aware of this when, in August, Goebbels arranged for Schloss Niederschönhausen to house 780 of the best paintings and sculptures and 3,500 works on paper confiscated thus far, along with putting 16,000 works in an empty depot in Berlin's Köpenicker Straße.[23] The Nazis also burned approximately 5,000 artworks in a bonfire outside Berlin's opera house. Hildebrand Gurlitt voluntarily approached Goebbels's Propaganda Department, hoping to work with it in liquidating the artworks after a friend informed him of the repositories and Hitler's plan to sell artworks abroad.[24]

Soon thereafter, Hitler's government authorized four art dealers to help with raising money from art sales: Ferdinand Möller, Bernhard Böhmer, Karl Buchholz, and Hildebrand Gurlitt.

World leaders were too ill prepared to help those persecuted by the Nazis to even consider the fates of the victims' assets or of art confiscated from Germany's public and private collections. They were also ill equipped to

accurately assess the treatment of those whom Hitler despised; in August 1938, an international committee for the Red Cross lead by Colonel Guillaume Favre visited the Dachau concentration camp and wrote a positive report.[25]

Appeasement progressed further when, on 29 and 30 September, representatives of Britain, Italy, France, and Germany signed the Munich Agreement allowing Germany to annex the Sudetenland, parts of Czechoslovakia that had large German populations, without input or participation from anyone representing Czechoslovakia itself. Hitler was pleased with Neville Chamberlain's acquiescence. The British Prime Minister, twenty years the Führer's senior, nodded deferentially when SS men gave him the *Hitlergrüß*. When Chamberlain entered the negotiation room, Hitler did not bother to stand up. He and Goebbels also purposefully had arranged for Chamberlain's seat to be cloaked in shadow. Upon leaving the negotiations, Chamberlain even raised his hat when SS officers again gave him the *Hitlergrüß*.[26] The image was the perfect visualization of appeasement politics.

This amused Hitler, who on 30 September invited Chamberlain to his Munich flat to pose for a photograph. It made for a striking propaganda image.[27] In the photograph, the Führer stands over the baffled-looking Briton, who is sitting on a sofa with a backdrop of German artworks, including a piece by Edward von Grützner, a quirky German painter who specialized in portraits of intoxicated monks. Hitler had never met Grützner, who died in 1925, but he had been sufficiently enamored of the eccentric artist to have praised him in *Mein Kampf*. The photograph was stunningly symbolic: the antiquated Chamberlain in repose at Hitler's house, while the young Führer stands confidently, showing off his surroundings. Hitler appears as the physical embodiment of a new nation.

David Lloyd George, who had been Prime Minister of Great Britain during the Great War, met with Hitler that autumn and praised him effusively in the British press. "Whatever one may think of his methods—and they are certainly not those of a parliamentary country—there can be no doubt that he has achieved a marvellous transformation in the spirit of the people," wrote George in one essay, declaring Hitler's regime "a miracle." As to Germany's rearmament, George predicted it would take Germany "at least

10 years" to build up an army equal to that of France. As for Russia, wrote George sarcastically, "Germany is no more ready to invade Russia than she is for a military expedition to the moon." Though the British statesman admitted in passing that "public condemnation of the Government" was censored "ruthlessly," he lauded Hitler's "magnetic, dynamic personality" and "dauntless heart" and noted, without irony, that he heard no criticism of him from German citizens.[28]

Like most European politicians, George had been duped.

Just one week after the photograph was taken, a seventeen-year-old Jewish Pole, Herschel Grynszpan, took a revolver to the German embassy in Paris after learning that his parents had been deported from Germany to Poland under Hitler's new policies. Grynszpan fatally shot the first German diplomat he could find, a young junior official named Ernst vom Rath. The killing provided an opportunity that Hitler seized. The timing of the assassination was opportune for the Nazis, occurring only one day before Hitler's annual speech commemorating the 1923 Beer Hall Putsch. Goebbels discreetly encouraged a series of violent reprisals against Jewish Germans. As anti-Semitic arson attacks raged throughout Germany, firemen in numerous towns rushed to the scenes of burning Jewish-owned buildings—in order to protect the adjacent Aryan-owned ones. German police arrested roughly 30,000 Jewish German men, deporting them to Dachau, Buchenwald, Sachsenhausen, and other camps. The government demanded that Jewish families hand over their firearms; the majority complied. Three hundred Jews committed suicide, while anti-Semites murdered between 1,000 and 2,000 more. Neither the Catholic nor Protestant churches issued statements of condemnation.[29]

With their typical sardonic humor, Berliners referred to the evening as Reichskristallnacht, or "Reich crystal night," because the smashed glass of Jewish windows sparkled on the sidewalk like shattered crystal chandeliers. Jews the world over named it "The Night of Broken Glass."

It was now obvious to Jewish German academics, entrepreneurs, and other affluent professionals that to remain in Germany would be fatal. However, they realized to their horror that for the majority of their persecuted group, it was now too late to escape abroad. Jewish Germans with substantial

art collections or real estate holdings understood that they were in immediate danger, as Nazi elites began targeting them. They were now in no logistical or legal position to defend their valuable possessions. The terror affected not only these adults but also their children, as the Nazis began breaking apart families, and their non-Jewish neighbors and friends began complying with the anti-Semitic persecution.

<center>—◆—</center>

One child caught up in the terror was thirteen-year-old Klaus Günther Tarnowski, who lived in Breslau, a prosperous city in eastern Germany. Tarnowski had recently celebrated his bar mitzvah at the local synagogue. While worshipping there and on Jewish holidays, he answered to his religious name, David Toren. His parents, Georg Martin and Marie Hildegard (née Friedmann), not only used Tarnowski as their surname—it was the eastern German version of the traditionally Jewish surname "Toren"—but had given traditionally German birth names to both Klaus and his seventeen-year-old brother, Hans Hermann.

Georg and Marie had made that decision not out of shame or fear but out of patriotism and pride in their fatherland. Georg was a Great War veteran who had earned the Iron Cross First Class for his valor; returning home after the war, he published numerous poems and plays that were performed in Breslau. In addition to being a homemaker, Marie, in her mid-forties, was an accomplished pianist and tennis player, and the couple had an active social life in Breslau. They enrolled Peter at a prestigious local school attended mostly by Christians and, as proud Germans, never conceived that their affable neighbors could become complicit with an anti-Semitic regime like that of the NSDAP. Even once the Nazis took power and anti-Semitism surged, the Tarnowskis viewed it as a temporary reversal: like many other Jewish Germans, sixty-year-old Georg began wearing his Iron Cross First Class around Breslau, convinced it would prove his patriotism to anti-Semites.

The nationalistic sincerity of Jewish German veterans was a particularly sensitive topic in Breslau. Georg had suffered nerve damage from sarin gas attacks during the war. Fritz Haber, also a Jewish German from Breslau, had helped develop the toxic chemical and was known nationwide as the

"father" of the poison. The fact that Haber was Jewish fueled rumors spread by Breslau-based anti-Semites that the Jews who had served in the Great War had actually been planted in their units by a secret international Jewish organization to help poison "real" Germans. Regardless, when the teenage Klaus asked his parents about the growing anti-Semitism, both Georg and Marie seemed genuinely unconcerned. "No one thought that Hitler would last very long," Klaus Tarnowski would recall with sadness over half a century later, after he had legally changed his name to David Toren.[30]

In autumn 1938, Klaus was focused primarily on his academics, on karate, at which he excelled, and on a schoolgirl named Anita, a fellow Jewish resident of Breslau. Klaus and Anita had admired each other since kindergarten; now, at the beginning of adolescence, the two frequently held hands at the end of the school day. On 9 November, a Wednesday, Klaus headed from school to his weekly 7 p.m. karate lesson with his instructor, a Korean immigrant. To the boy's surprise, his instructor said that there would be no lesson: the Nazis, believing that Koreans were also a superior race, had recruited him as an SA member. "You go home now and avoid the street corners, because bad things are going to happen to the Jews this night," he told Klaus, revealing that the SA was planning to smash the store windows of Jewish shops before setting them on fire. Rushing home, Klaus spotted a Jewish friend who had just been at the synagogue and warned him of the coming destruction. Heading to Klaus's house, the two saw a few SA members marking up the windows to be smashed. Spotting the boys, the men rushed at them. Klaus put his martial arts training to good use—kicking one of the men in the genitals before grabbing his friend's hand and running home. The family hid in an interior room, listening to the sirens of fire trucks wailing through the night.

The next morning, the Gestapo knocked on their door and announced that they would be arresting Klaus's father for a crime they had yet to determine. It was a surreal moment for Klaus; the men smiled at him and his mother and were, he later recalled, "impeccably polite."[31] After she recovered from the shock, Marie called her uncle, David Friedmann, a wealthy widower and retiree in his early eighties, who had made his money in the sugar and brick industries and lived nearby with his daughter, Charlotte. Friedmann was not only shocked to hear about Georg's arrest but also alarmed

because Georg was supposed to represent him that morning as he sold a portion of his 10,000 acres to a Nazi officer in an attempt to appease Hitler's elites. Now, Friedmann worried that the officer would turn against the entire family, including Marie and her sons.

After a few frenzied phone calls, the officer located Georg and brought him to the estate, where Marie and Klaus were waiting to see him. As the adults brokered the sale, Klaus wandered around the house eating chocolates that the Nazis had given him; though he had showed up to the estate scared, his father greeted him calmly and encouraged him to eat the sweets and enjoy this "surprise school holiday." Going through each room, Klaus said good-bye to the estate where his family had enjoyed most of their leisure time. Delicate marble statues and exotic African ivory carvings sat on the pristine tables; on the walls hung artwork by both German and French Impressionists—his uncle's favorite genres. Friedmann had a Lovis Corinth ink drawing of a politician, an oil painting of a river landscape by Camille Pissarro, and a portrait by Max Liebermann of a girl sewing.

The hardest work for Klaus to say good-bye to hung in a dark annex that protected it from light: Liebermann's 1901 painting *Two Riders on the Beach*. Klaus did not know much about the artist, but it was his favorite work because his uncle had taught him to ride horses. The boy liked to imagine that, one day, the two of them could take a trip to the seashore and ride there just like the men in the painting. As evening set in, he ventured out of the annex to say farewell to his father. After the sale had been completed, the Gestapo rushed Georg to their Mercedes; they had been warned that the next train to the Buchenwald concentration camp would leave promptly at 7 p.m. Georg told his son that it was simply a routine business trip and the boy was not to worry.

———◆———

On 12 November 1938, the Nazi government ordered Jewish Germans to pay one billion reichsmarks in compensation for the "services" the government provided by cleaning up the destruction of Reichskristallnacht, which it had quietly encouraged. On 3 December the government legalized the takeover of Jewish business by non-Jews. As with the law that legalized the

confiscation of Degenerate Art, which the NSDAP had enacted in May, the Nazis made this change in order to mollify complaints by non-Jewish Germans who were appalled at the attacks on Jewish businesses—not for their cruelty but because they had not been legally sanctioned. Now, the destruction of property and assets owned by Jewish Germans could be conducted in plain sight.

The Nazi government concurrently enacted legislation clarifying that marriages in which the husband was Jewish but the children were raised Christian were legally privileged, which included Hildebrand Gurlitt's own marriage. Moreover, Gurlitt was in a protected position given his job as an art dealer for Hitler, which by now was lucrative not only due to the deals he struck for the Führer but because of the purchases he made for himself.

In December 1938, Gurlitt bought twenty-three drawings by Adolph Menzel, a revered nineteenth-century German realist artist noted for his delicate, precise sketches and etchings, from the Wolffson family, Christian Germans who were being persecuted by the Nazis for their Jewish ethnicity and who desperately needed funds to plan and finance their emigration to the United States. Gurlitt was well qualified to assess the quality of the works, particularly *Interior of a Gothic Church*, with elegantly curving arches, and *Roofs*, a charmingly quirky view of the rooftops of the quaint Saxon town of Schandau. Gurlitt took advantage of the desperate straits of the Wolffson family, offering only 150 reichsmarks for *Gothic Church* and 300 reichsmarks for *Roofs*, roughly $60 and $120 at the time. Immediately after buying them, however, Gurlitt flipped *Roofs* for 1,400 reichsmarks—a 367 percent profit. He decided to keep *Gothic Church* for himself.[32]

As Germans rang in the New Year in 1939, signs of impending war were clear. Germany had surpassed the United States as the world's largest aluminum producer, an ominous indication of a surging need for military equipment. Clampdowns on Jews continued, a point about which Hitler was clear: "The Jews among us will be annihilated," the Führer bluntly told the Czech Foreign Minister on 21 January, a point he reiterated in a 30 January speech to the Reichstag.[33]

Hitler met on 15 March with Czechoslovakian President Emil Hácha to demand that he sign an agreement making his country a German

protectorate. When Hácha refused, Hitler resorted to shouting at him, "If you don't sign, German bombers will reduce Prague to ruins!" The threat caused Hácha to faint, and he had to be revived by Hitler's doctor, Theodor Morell; one of Hitler's assistants then pushed a fountain pen into Hácha's hand. Hácha complied. Around midnight, Hitler's huge Mercedes limousine sped into Prague. Unlike the Anschluss of Austria, which the majority of Austrians had supported, this encroachment into Czechoslovakia was deeply unwanted by the inhabitants. It was a landgrab well beyond any historic German boundaries. At Prague's Hradčany, Hitler climbed out of the car and, in its headlights, stood before the door of the castle that seemed to float above Prague's roofs. Inside, he ordered those present to bring all available food and drink to a table for his men. Hearing from his advisors that Neville Chamberlain was astonished by Hitler's move, the Führer was genuinely baffled. "I don't understand why London is so amazed; they must have known it was going to happen," he remarked to his men.[34]

A few weeks later, Hitler woke up at 8 a.m. to celebrate his fiftieth birthday on 20 April 1939. His staff had packed the chancellery with flowers and exotic plants, and as the Führer entered the Great Hall, a band struck up the Bavarian military tune "Badenweiler Marsch," one of his favorites. Following that, they played the national anthem, "Deutschland, Deutschland über Alles." They then presented Hitler with birthday presents, including toy models of tanks, field guns, and aircraft; delighted, he played with his new trinkets before attending a military parade in his honor.

Hitler spent a relaxing summer of 1939 at the Berghof. The Bavarian retreat was the Führer's pride and joy. Carefully chosen decorations evoked a sophisticated yet simple German home and gave no hint of grand imperial pretensions. The Great Hall featured a seventeenth-century Gobelins tapestry; there were Persian carpets on the floor and a group of red upholstered easy chairs around a large wooden table. Downstairs, Hitler had had a bowling alley installed.[35] He regularly entertained requests from journalists to visit and photograph the Berghof, not only from German reporters who were under the control of the Propaganda Ministry but also from American journalists whom Putzi Hanfstaengl, the Führer's German American public relations officer, wooed using his Harvard connections.

Hitler's style and love of art had been a topic of significant interest in the United States since a profile in *Vogue* in August 1936. In an article for the fashion world's magazine of record, style experts had referred to the Berghof as Hitler's "hiding spot at little Berchtesgaden," featuring photographs of his chunky swastika throw pillows and declaring Hitler not merely a politician but rather an "art dictator" who firmly believed in the integrity of Nordic art.[36] Hitler had put intense effort into making the Berghof appear like a modest but chic chalet; its terrace was covered with red marble sourced from Mount Untersberg, and his study featured oil portraits of his parents.[37]

Even after the atrocities of The Night of Broken Glass, American editors were eager to report on Hitler's fashion and art interests. In the summer of 1939, the *Chicago Daily Tribune* published a lengthy profile of Hitler, glibly titled "Europe's Man of Mystery!" It emphasized his "keen interest" in the well-being of children, citing how he gave his staff between $80 and $100 in addition to a new baby buggy when they had their first child. "They speak with glowing eyes of Hitler's understanding for their problems and his generosity," wrote the *Tribune*'s reporter. The article also casually noted Hitler's passion for art and his plans to expand the influence of German art throughout Europe. "In his joy in these projects his tension eases and he turns back to face his daily problems with renewed strength," gushed the *Tribune*. The journalist stressed that Hitler was curating a collection "of paintings, prints, and sculptures of young German artists" to evaluate, noting the Führer's passion for sketching water fountains and foliage and holding soirees to discuss art. "Gay parties have taken and take place," wrote the reporter, "with scores of Germany's most famous artists helping beautify them." According to the newspaper, the artists would "proudly tell you: 'The Führer is happiest when he can forget his care of state in the midst of his artists. We are closer to him than many of the politicians who take themselves so very seriously.'"[38]

That summer, unbeknownst to the *Tribune*, Hitler was solidifying his plans to collect artwork for a future Führermuseum in Linz. He had been dreaming of creating the museum since he was a small boy, drawing plans for it at the dinner table as his mother doled out dishes. Now Hitler invited Hans Posse, the respected sixty-year-old museum director of Dresden's Gemäldegalerie, to visit him at the Berghof.

Hitler had full confidence in Posse. Initially, Posse had tentatively supported modern artists and supported Hildebrand Gurlitt, sixteen years his senior, during his struggles with the Zwickau traditionalists in the 1920s. Posse had been the head of Germany's pavilion at the 1922 Venice Biennale, where he promoted Oskar Kokoschka as the face of German art. Yet Posse rescinded this position once Hitler came to power, at which point the director shuttered the Dresden Gemäldegalerie's modern and contemporary art department.

Though low-level officials had rejected Posse's 1934 application to join the NSDAP on the ground that he was a supporter of Degenerate Artists, Hitler passed this off as a bureaucratic mix-up. Impressed by his flattery regarding Hitler's taste in art and by Posse's sincere pledges of loyalty, Hitler offered him the directorship of the top-secret Führermuseum Project in late June 1939. The Führermuseum, Hitler explained to Posse, would house an elite selection of Aryan art, focusing on the nineteenth century and beyond. It was the natural next step after the opening of the House of German Art in July 1937.

The Führer openly admitted to Posse that the museum's permanent collection would consist of not only works owned by the German state but also those confiscated from the private collections of non-Aryans and from the public collections of nations that the Nazis would invade. Posse did not question whether this was ethical but clearly worried that carrying this mission out might necessitate violating the law. Assuaging his doubts, Hitler reassured him, saying, "I shall give you all necessary legal documentation and authority."[39] The project, Hitler's inner circle acknowledged, would cost a tremendous amount of time and money.

With Posse's becoming director of the Führermuseum Project, yet another formerly liberal art historian was now opportunistically working with the Nazis to dismantle the modern art world he had helped create. This move provided a new connection with Hitler's inner circle for Gurlitt, who had casually known Posse for years and who was still focused on selling Nazi-confiscated artworks; Posse was close enough to Gurlitt to have had attended the funeral of his father, Cornelius, in 1938.[40]

On 30 June 1939, four days after Posse accepted his position, the Nazis held a three-hour auction at the stately Grand Hôtel National on the banks of

Lake Lucerne in Switzerland. Their goal at the auction—held in German, English, and French—was to transform confiscated art into cash. Though dozens of dealers and curators worldwide boycotted the auction, art world elites from Belgium, Switzerland, France, and America were all in attendance; this included Henri Matisse's son Pierre, an art dealer based in Paris and New York, who accompanied Joseph Pulitzer Jr., son of the famous newspaper magnate.

The Nazis chose Swiss auctioneer Theodor Fischer to lead the auction, the only experienced Swiss dealer who had international ties but was not Jewish. Fischer, like Gurlitt and Posse, had once been a champion of avant-garde artists, including Edvard Munch and Oskar Kokoschka. Now the auctioneer was eager to exploit his connections for personal gain, receiving commissions of 15, 12.5, or 7 percent depending on the value of individual lots.[41] The Nazis told Fischer not to mention the Third Reich in connection with the auction in order to increase the chances of luring buyers, but the international art world was well aware of the artworks' origins.

Fischer produced an auction catalogue featuring the 125 offered paintings and sculptures; he had many of the 108 paintings reframed for the ten-day preview between 17 and 27 May. Fischer charged three Swiss francs for attendance and sold three hundred tickets. Gurlitt did not attend the auction but helped Georg Schmidt, director of the Kunstmuseum Basel, identify artists whose works Schmidt was interested in purchasing.[42]

The most important and expensive piece offered was a self-portrait of Vincent van Gogh, completed in 1888 and confiscated from Munich's Neue Staatsgalerie. The work sold to Jewish American industrialist Maurice Wertheim for $40,000, and Wertheim subsequently donated it to Harvard's Fogg Art Museum. It was a strong price but fell $8,000 below the presale estimate in an auction that saw only 70 percent of works sold, significantly below the 88 percent sell rate that denotes, albeit somewhat arbitrarily, a resounding success in the art world.[43] The quality of the artworks was staggeringly high; yet most international art dealers, museum directors, and collectors who attended out of curiosity ultimately felt it untoward and damaging to their international reputations to purchase works that the Nazis had acquired under morally dubious—even if technically legal—circumstances.

Two paintings by George Grosz, still living in exile on Long Island, sold for only 980 Swiss francs, or $220, in total, one to New York dealer Curt Valentin and the other to Antwerp's Koninklijk Museum voor Schone Kunsten.[44] Eight works by Kokoschka sold to dealers, museums, and collectors in France, Switzerland, Sweden, New York, and Ohio. Seven works by Emil Nolde were now for sale; two went unsold, while the others went for between 1,800 and 3,500 Swiss francs each. Two Max Pechstein paintings went unsold, while a Swiss doctor bought a third for only 820 francs, less than half its estimate.[45]

Still, the auction made the Nazis 500,000 Swiss francs, or about $113,000 at the time. Hours afterward, Fischer brokered a deal of one work that had failed to sell on the auction block, Pablo Picasso's 1902 *Absinthe Drinker*, bringing in an additional 42,000 Swiss francs ($9,500).

Shortly after the auction, as the summer was winding to a close, Hitler invited Carl Burckhardt, the commissioner for the League of Nations, the precursor to the United Nations established by Woodrow Wilson, to visit the Berghof. He still presented himself as an artist who had been forced into politics in order to restore Germany to its proper position of cultural supremacy. "Oh, how I wish I could stay here and work as an artist," Hitler said. "I am, after all, an artist."[46]

<p style="text-align:center">———✦———</p>

Hitler now was ready to expand his power throughout Europe in order to cement Germany's cultural dominance. The time was ripe, the Führer decided, to implement his eugenics program and prepare to invade Poland.

Shortly before the invasion, German doctors had used a small set of test subjects to whom the press and diplomats were paying scant attention: disabled, non-Jewish German children. The Nazis asked parents, doctors, and midwives to register minors with problems ranging from severe disabilities to the vague, nonmedical diagnosis of "idiocy." The government paid these medical professionals bonuses for each child they reported. Doctors dispatched the minors to three dozen government-run clinics, overriding the protests of their parents. Over the course of a few months, medical professionals killed

5,000 children through a combination of starvation and drugging; in doing so and filing detailed reports, they helped the Nazis to perfect the most efficient methods of assembling, killing, and disposing of victims.[47]

Hitler's euthanasia program, code-named "Action T-4" because its office was located at Tiergartenstraße 4 in Berlin, now began authorizing the murders of non-Jewish adults whom Nazi doctors classified as possessing "life unworthy of life." The government authorized SS officers to drive thousands of mental patients to a remote field, where they shot the adults, many confined in straightjackets. Following this, thirty-nine-year-old SS head Heinrich Himmler personally reviewed a session in which government employees placed several patients in a specially sealed room and poisoned them with carbon monoxide. It marked the first time a gas chamber was used for mass murder in recorded history.[48] As a reward, Herbert Lange, a thirty-year-old SS officer, arranged for his men to receive ten reichsmarks for every person they killed—an amount, he estimated, sufficient for them to buy their children one Christmas or birthday toy per human life.[49] Half the murdered patients came from hospitals run by Protestant or Catholic churches.[50] Soon, residents near sanatorium crematoria throughout Germany began noticing smoke wafting through the air on a daily basis. William Shirer, the American journalist living in Germany, even wrote of the killings in his diary.

Yet editors in the United States shelved stories by journalists who attempted to cover Hitler's atrocities within Germany and his plans for territorial expansion. Forty-eight hours before Hitler assembled his top military advisors at the Berghof on 22 August 1939 to finalize plans to invade Poland, the *New York Times Magazine* featured a piece on him at the Berghof, describing the chalet's atmosphere as one of "quiet cheerfulness" and reporting on the dictator's love of chocolate and fondness for brook trout.[51]

On 1 September 1939, Hitler's troops invaded Poland, a move that initially shocked ordinary Germans. William Shirer observed "astonishment, depression" on the faces of Germans he interviewed.[52] Yet a mere seven days later, even as German forces were sweeping across a near-defenseless Poland with an anti-Semitic fervor, Shirer recorded that "the average German is beginning to wonder if it is a world war after all." While Great Britain and France nominally declared war, they took no military action to either aid the

Poles or target Germany. "Is that war?" noted Shirer one weekend. "The long faces I saw a week ago today are not so long this Sunday."[53]

The opinion that the invasion was regrettable yet manageable was also present in the 11 September 1939 edition of America's *Life*. The magazine's editors admitted in a lengthy feature that "Europe had arrived at that point of dull deadlock that spells war," but their analysis blamed the harsh terms of the Treaty of Versailles, particularly those advocated by France and Great Britain. Those terms had forced Germans to elect a radical leader, representing an angry minority, a man "who told the Germans it is better to demand than beg," the editors argued, concluding that the United States should refrain from interfering in European affairs. "In the last war we tried to preserve democracy and peace and justice for the world by taking arms. But when the war was over we, like the rest, were tired and embittered," they wrote. "This time if we stay out, when the war ends we may have the strength and spirit to help the exhausted peoples of Europe build for their children a new and better world out of the ruin of the old."[54]

Hitler's presentation of himself as a cultural figure to America's mainstream press was so successful that he even succeeded in having *Life* publish an article on 30 October, two months after the invasion of Poland. *Life* analyzed the Führer's artistic preferences and praised him as preferable to Napoléon, a notorious art looter. Hitler, they suggested admiringly, was "molding all German art into the pattern he prefers." In an oddly wistful tone, *Life* speculated that perhaps the artists in Munich who ignored Hitler when he moved there before the start of the Great War were to blame for his bellicosity now. *Life*'s subsequent issue included a letter to the editor from a Mrs. V. Seefried, noting "Adolf certainly scores one up on the Roosevelt family when it comes to decorating a home."[55]

Pleased, Hitler continued with his plans to redesign Europe.

———◆———

Throughout most of 1939, Gurlitt conducted few professional deals, focusing on his wife and two young children, seven-year-old Cornelius and four-year-old Benita. Yet Gurlitt was aware that the Nazis were rounding up thousands of citizens they opposed, and by the end of the year he was poised to profit

from the material possessions the Nazis forced these victims to leave behind. He brokered a deal for *Fate of the Animals*, painted by Franz Marc, a German Expressionist, in 1913. The canvas was a kaleidoscope of dramatic red, blue, and green bursts of light, all surrounding a horse with an elongated neck, her head stretched high into the sky. Confiscated by the Nazis under unclear circumstances, the painting languished in a government depot before Gurlitt sold it to the Basel-based curator Georg Schmidt, who had contacted the dealer, hoping to acquire confiscated art for Switzerland. Gurlitt charged Schmidt 6,000 Swiss francs but told the German government he had charged only 5,000. He pocketed the extra 1,000 and also charged Schmidt a 900 Swiss franc "commission fee" that he did not disclose to the German government. Gurlitt's sale of *Fate of the Animals* represented a rare instance in which the dealer kept a full paper trail of his transactions. Generally, he diligently destroyed documents that personally incriminated him—showing how he had taken advantage of those from whom the Nazis confiscated artworks or how he had fleeced the Nazis themselves.[56]

On 9 April 1940, the German army began its invasions of Norway and Denmark. The Danish surrender came in a matter of hours. Although the occupation of Norway was protracted, the Reich soon turned its focus toward invading the Netherlands, Belgium, and France. Germany's invasion of these three countries on 10 May 1940 and the surrender of the Dutch on 15 May 1940 signaled to both Gurlitt and Hans Posse, head of the Führermuseum Project, that Dutch artwork would soon be available for purchase or plunder and that opportunities in France probably also would unfold. Yet the campaigns also brought increased military involvement from the British.

Although they lived in Hamburg at the time, Gurlitt and his family were unharmed. The dealer's attention was focused on a major deal with the Propaganda Ministry, sealed on 22 May 1940, through which he acquired Degenerate Art confiscated by the Nazis from respected German museums. Using cash he had amassed by brokering deals in Switzerland and had not disclosed to the Nazis, Gurlitt paid just 4,000 Swiss francs for 259 pieces, a bargain basement sum.

This newly acquired stash included several paintings and works on paper that Gurlitt decided to keep for himself, works created by nearly all of the

artists whom he had once admired and whose misfortunes he now exploited. In terms of volume, it was the largest purchase for his private collection that Hildebrand Gurlitt ever executed. The set included Max Beckmann's 1920 drypoint on paper *Old Woman with Cloche Hat*, a whimsical piece showing a posh, uppity woman sporting a fancy hat. After the Nazis took it from the Kunsthalle in Hamburg, they valued it at a mere 0.8 Swiss francs, about one cent in US currency—the value of the paper and nothing more.[57] Gurlitt also acquired Beckmann's 1934 watercolor *Zandvoort Beach Café*, a colorful portrait of a black man and white woman cavorting on a beach. Also in the cache was a lithograph by Emil Nolde depicting a starkly dressed Danish redhead, along with a Nolde watercolor that the Nazis confiscated from the Kunsthalle in Kiel, a haunting flood scene. In addition to two watercolors by George Grosz, the selection included one of Käthe Kollwitz's classic works lamenting the dead soldiers of the Great War. There was a nude scene by Ernst Ludwig Kirchner that the Nazis had confiscated from the König Albert Museum, the same museum in Zwickau that had fired Gurlitt for refusing to work with the Nazis before Hitler came to power.

In late May 1940, Belgium surrendered to Hitler, and on 14 June, German troops occupied Paris unopposed. "Berlin has taken the news of the capture of Paris as phlegmatically as it has taken everything else in this war," observed Shirer in his diary, noting that he had gone to swim at a lake in the capital city and only three of about five hundred Germans there had bothered to read the news when a paperboy came to report the fall of Paris.[58] The Vichy government came to power on 10 July 1940, dividing France into an occupied northern zone with a coastal strip on the Atlantic Ocean and a French-administered center and south. The Vichy regime tacitly agreed to Hitler's looting of French art, and Hitler charged Hans Posse with organizing and implementing the seizure of works in France for the Führermuseum.

Gurlitt, meanwhile, continued liquidating Degenerate Art and taking special orders from his growing client base. Though he did not know the specifics of the Führermuseum Project, which was still confidential, he had heard rumors that Posse was either buying or confiscating works in France that fit the style of the Great German Art Exhibition of 1937. In mid-November, he traveled to Holland and Belgium, cryptically writing a friend he was going "to

visit some old customers that still are always interested in certain pictures," a common euphemism for Degenerate Art available to sell abroad.[59]

In December 1940, Gurlitt worked directly with Posse in the first instance that he formally documented. Posse came to Gurlitt on behalf of a client who wanted to acquire a last-minute Christmas gift for Hermann Göring on a large budget of 25,000 reichsmarks. "The main thing is to find something that the Reichsmarshall will still find pleasure in, given the vastness of his collection," Gurlitt wrote Posse.[60] Gurlitt took time to help Posse pick out a medieval painted-glass work from Cologne, which Posse knew Göring would adore. The speed with which the two men collaborated—exchanging letters within hours of each other—clearly indicated that they were well acquainted. It was also the first recorded instance of Gurlitt's dealing in art of which the Nazis approved.

Brokering this Christmas deal emboldened Gurlitt to explore other ways in which he could profit from sales of works not labeled as Degenerate Art. Three months later, he sold Posse a work by his grandfather, Louis Gurlitt, an obscure artist who had died in 1897. Posse trusted Gurlitt's judgment so completely that he sold the Louis Gurlitt artwork to Albert Speer, Hitler's architectural advisor and the Reich Minister of Armaments and War Production.[61]

By March 1941, Gurlitt was ready to close the most significant of at least eight other deals with the Nazis for which documentation survived after the war, transactions in which he received Degenerate Art in exchange for artworks that suited Hitler's tastes. Rumors of the Führermuseum Project now were widespread among dealers, collectors, and curators—though the general public and the press remained ignorant of the operation. Gurlitt exchanged three nineteenth-century paintings and three sixteenth-century prints for an astounding forty-two artworks by Kokoschka, Nolde, Beckmann, Corinth, and Otto Dix. The deal was a testament not only to Gurlitt's business acumen but to the Nazis' desperation to acquire Old Masters and traditional artworks for the Führer, regardless of the quality of the pieces or the fame of the artists.[62]

After Operation Barbarossa commenced on Germany's eastern front on 22 June 1941, Posse increased his efforts to cull artworks for the

Führermuseum, eager to please Hitler. Though still not an official dealer for the Führermuseum Project, by autumn 1941 Gurlitt was traveling regularly to Paris, attempting to find artworks that matched Hitler's aesthetic for him to sell to German museums.[63]

The successful persecution of Jewish Europeans throughout the continent in 1941 provided a flood of artwork onto the market, pieces by both Old Masters and artists labeled degenerate that ranged from masterpieces to sketches and minor works. Over the year, Hitler had tightened laws in territories he occupied. It was now forbidden for Jewish Europeans in the Reich to socialize with Aryans; Jewish men were prohibited from shaving or even buying shaving soap; and all Jews in territories that Nazis occupied were forbidden from attending museums, buying flowers, wearing fur coats, or eating in restaurants—infractions that could all be punished with the death penalty. The NSDAP designed the regulations to dampen Jewish Europeans' morale, to isolate them from the rest of society, and to make them look physically "subhuman" to their neighbors.

Arresting Jews now was so common that it was impossible for ordinary Germans to be unaware of the sudden disappearance of thousands of their fellow citizens. As the 1941 Christmas season approached, several Catholic bishops in Germany jointly wrote a carefully worded letter to Hitler that protested Nazi killings of the physically weak and mentally ill throughout the Reich. While the bishops did not refer to Jewish Germans explicitly, the clergy clearly understood Hitler's persecution was also directed at them. Yet Cardinal Adolf Bertram suppressed the letter's distribution because he was hesitant to anger the man who, he felt, was waging a just war against the heretical ethnic group whose ancestors had murdered Jesus Christ.

The urgency with which Posse and Goebbels worked on the Führermuseum only increased after Japan bombed the US fleet at Pearl Harbor on 7 December 1941 and as the wider military involvement of nations outside Europe only reinforced Hitler's belief that his artistic struggles were of global importance. The same month, the Allies bombed Hamburg again, this time severely damaging Gurlitt's home. He had ample time to protect his art and records from damage, however, as the Royal Air Force threw down leaflets beforehand warning civilians of the impending bombings.

The Gurlitts subsequently made plans to move into Hildebrand's childhood home in Dresden at Kaisitzer Straße 26, where his mother had been living alone since his father's death in 1938. During this frenetic time, Hildebrand was able to close a lucrative deal with Cologne's Wallraf-Richartz Museum, selling it thirty-two pieces created by major French artists including Eugène Delacroix, Pierre-Auguste Renoir, Edgar Degas, Édouard Manet, Jean-Auguste Dominique Ingres, and Auguste Rodin; exactly how Gurlitt had acquired the works in France and to whom they had belonged was of little interest to the museum, and the dealer saved no documents that would betray how he took possession of them.[64]

<p style="text-align:center">—◆—</p>

In early 1942, plans for active and formal extermination of Jews worldwide intensified, culminating with the 20 January conference that the NSDAP hosted in a beautiful lakeside villa in the upscale western Berlin district of Wannsee. In Goebbels's words, it was necessary to "clear the decks," eventually even in neutral Switzerland. Goebbels and Hitler did not attend the conference. After the meeting, the group celebrated with a bottle of brandy.[65] The same day, Goebbels wrote admiringly in his diary about how Hitler's focus on creating a world of Aryan culture had only increased in the wake of increased extermination and US involvement in the war. "The intensity of the Führer's longing for music, theater and cultural relaxation is enormous," he wrote, noting that Hitler believed fighting the war on degenerate culture was equally as important as fighting to expand the Reich's territory.[66]

A few weeks after the Wannsee Conference, the first transports arrived at Auschwitz from Slovakia and France.[67] The Nazis began murdering them using Zyklon B gas. The victims took at least two minutes to die. After the systematic and publicly implemented T-4 program aimed first at disabled Aryan children and then at "subhuman" Aryan adults, the Nazis had experimented with Zyklon B on six hundred frail Soviet prisoners of war, before then successfully murdering nine hundred healthy Soviet POWs with the poison.[68] "A pretty barbaric procedure is being applied here, and it's not to be described in any more detail, and there aren't too many Jews remaining," Goebbels wrote in his journal a week later, concluding that 60

percent of European Jews needed to be actively "liquidated," while the remaining 40 percent would be conscripted as slave workers until they died of exhaustion.[69]

The family of Klaus Tarnowski, the teenager whose great uncle David Friedmann owned Max Liebermann's *Two Riders on the Beach*, was destroyed by the "Final Solution" implemented at Auschwitz. Georg and Marie had been able to arrange a place for Klaus on one of the last *Kindertransport* journeys to Sweden in August 1939. The *Kindertransport* program functioned roughly like the Underground Railroad during the US Civil War: non-Jewish Germans risked their lives to smuggle Jewish youths to countries not controlled by the Nazis. Klaus's brother Hans was eighteen in 1939 and did not qualify for the program, but he managed to escape to safety in England.

After David Friedmann died in early 1942 of old age in Breslau, the Nazi regime homed in on his property, including the Liebermann painting; they marveled at Friedmann's collection, which, an official appraiser noted, "must have been brought together over a period of approximately sixty years under expert direction," adding, "There are a whole series of pieces which, in peacetime, would certainly bring in foreign currency quickly."[70] Nazi officials swiftly confiscated his possessions and deported his daughter, Charlotte, to Ravensbrück, an all-female concentration camp in northern Germany. After the gassings at Auschwitz commenced, they transferred Charlotte there and immediately killed her. Living in Sweden, Klaus knew something was amiss when he stopped receiving postcards from his parents around this time. Later, he learned that they also had been deported to Auschwitz and immediately murdered.[71]

Within weeks, Gurlitt was contacted by Cornelius Müller-Hofstede, head of the regional museum in the Breslau; the director had for months received letters from Gurlitt imploring him to pass on any information on confiscated art for sale. In euphemistic language, Müller-Hofstede informed Gurlitt that some works were coming onto the market. He brokered a deal to sell Liebermann's *Two Riders on the Beach* for an unknown sum.

On 11 November 1942, mocking the anniversary of World War I's armistice, German troops took over the Vichy region of France. Gurlitt's power was about to grow as well: on the one-year anniversary of Pearl Harbor, 7 December, Hans Posse lost a battle with oral cancer that he had been fighting for weeks. His death was a shock to many who knew him well, Gurlitt included. Posse had continued working tirelessly for Hitler, and though he appeared exhausted, few suspected he was seriously ill. Over three years, Posse had already amassed roughly 2,500 works of art for the Führermuseum, but Hitler wanted even more.

Now Posse's death left a hole in Hitler's Führermuseum Project, one that Gurlitt hoped to fill.

Max Beckmann's vibrant and diverse 1934 watercolor *Zandvoort Beach Café* was acquired by Hildebrand Gurlitt during World War II under unclear circumstances. The Nazis confiscated hundreds of Beckmann's works.

Hildebrand Gurlitt acquired Otto Dix's 1923 lithograph of a sex worker, *Leonie*, in 1941 after the Nazis confiscated it from a small museum.

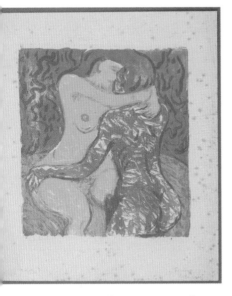

stwar, Hildebrand Gurlitt never returned Ernst dwig Kirchner's 1908 *Love Scene*, confiscated Nazis from a small art club in Jena.

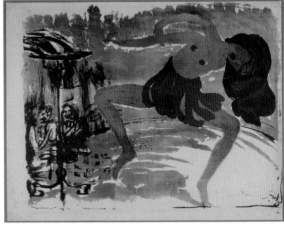

Hildebrand Gurlitt admired Emil Nolde's bold brushstrokes and earthy pigments. He acquired *The Dancer* (1913) under unclear circumstances. The Nazis labeled Nolde, a Hitler supporter, as degenerate.

Hildebrand Gurlitt preferred acquiring easily transportable works on paper that the Nazis confiscated, including Otto Dix's 1924 war scene *Horse Cadaver*. He destroyed documents revealing from whom they had been taken.

A young Hildebrand Gurlitt with his older sister, Cornelia, in an undated photograph. Cornelia, a budding artist, committed suicide in 1919.

Hildebrand Gurlitt posing during World War I with his father, Cornelius, and sister, Cornelia.

After Käthe Kollwitz's son died during World War I, she created his *Lamentation for the Dead*. Hildebrand Gurlitt acquired it after the Nazis confiscated it. The Nazis ruined Kollwitz's career.

Käthe Kollwitz, a master draftswoman, crafted this self-portrait in 1924. It is unclear how and when the Gurlitts acquired it.

Hildebrand Gurlitt routinely acquired artworks confiscated from vulnerable art clubs and collectors by Nazis—including Otto Dix's 1924 *Corpse in Barbed Wire*.

Hildebrand Gurlitt feigned friendships with artists whose confiscated artwork he secretly held, including Max Beckmann, who created 1920's *Old Woman with Cloche Hat*.

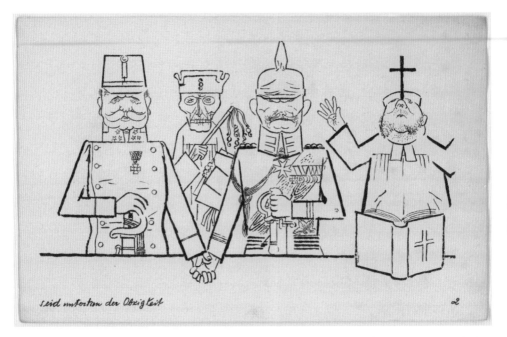

George Grosz pilloried religious and governmental corruption via widely published artworks, including his 1928 work *Bow to the Authorities*.

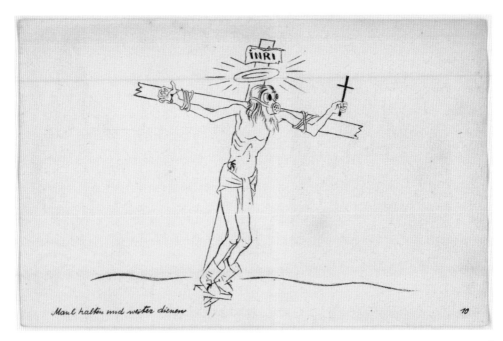

Even the Quakers in America supported George Grosz's antiwar artworks, including *Keep Your Mouth Shut and Do Your Duty* from 1927.

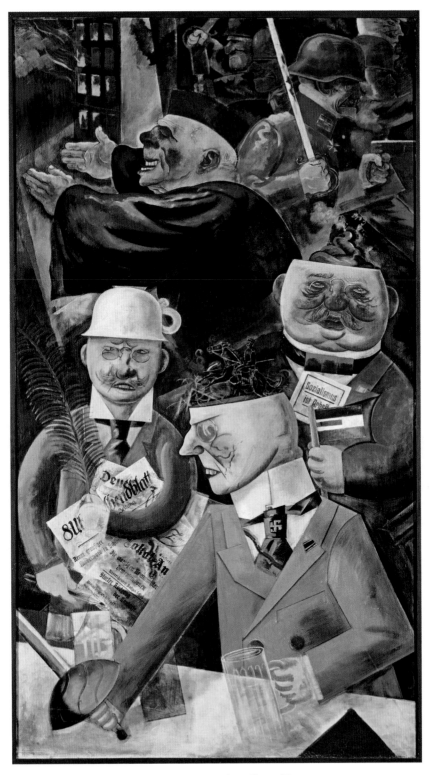

George Grosz's 1926 masterpiece painting *The Pillars of Society* warns against corrupt generals, judges, journalists, and politicians, including Nazis.

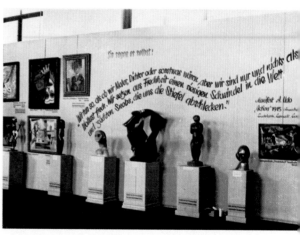

The Degenerate Art Exhibition opened on 19 July 1937 in Mun[...] to excoriate confiscated art and artists loathed by the Nazis. [...] show's targets included Max Beckmann, George Grosz, and E[...] Nolde.

Artist and political activist George Grosz (1893–1959) with his faithful Scottish Terrier in 1928.

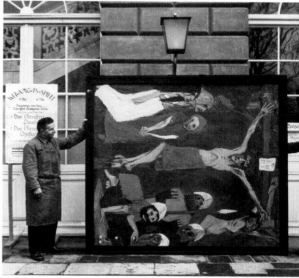

Nordic Artist and anti-Semitic sympathizer Emil Nolde (1867–1956), in a circa 1920 portrait.

Emil Nolde's attempts to ingratiate himself with Hitler backfir[...] They confiscated his artworks, including *The Life of Christ*.

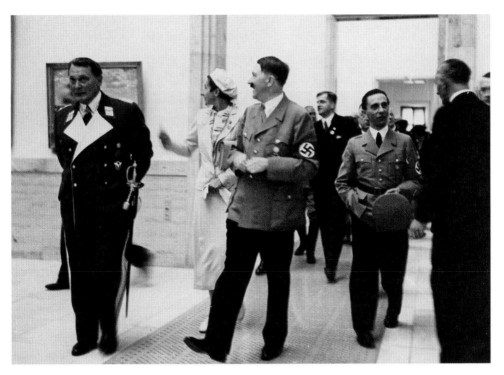

Hermann Göring, Adolf Hitler, Joseph Goebbels, and their entourage at the House of German Art on 18 July 1937. The building housed artworks that promoted Aryan racial purity, motherhood, and war.

Hildebrand Gurlitt's stately home in Dresden, where he conducted many art deals. The RAF bombed it, when empty, in February 1945.

Christopher Marinello, lawyer for the Rosenbergs, with Henri Matisse's *Woman with a Fan*, looted by the Nazis in France, found in the Gurlitt trove, and restituted to the Rosenbergs.

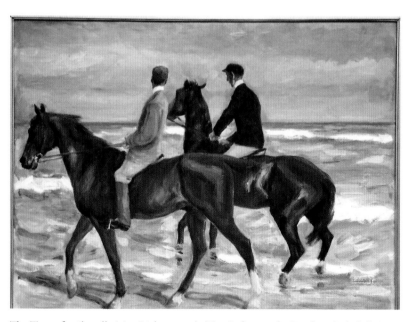

The Toren family sells Max Liebermann's *Two Riders on the Beach* at Sotheby's London for $2.95 million, restituted from Hildebrand Gurlitt's trove.

CHAPTER VI

CULTURAL COMPLICITY

"I know Dr. Gurlitt's character and can assume on the basis of experience so far that his drive and savoir-faire are the best guarantee he will carry out his task quickly and safely."

 —Hermann Voss, second director of the Führermuseum
 Project

A FTER HANS POSSE DIED OF cancer, Adolf Hitler could easily have allowed his enthusiasm for the Führermuseum to wane. The military leadership desperately hoped that the Führer would abandon the project and focus solely on winning the war. Occasionally during strategy meetings with his generals, Hitler would stop focusing and turn to Joseph Goebbels to discuss art. Goebbels noted in his journal on 23 January 1943 that "despite the gravity of the situation" in Russia and the fact that Hitler was "colossally over-exhausted," "the Führer still has as open a heart as ever for the arts and is eyeing the time when he can focus on the arts to an even stronger" extent.[1]

A week later, Field Marshal Friedrich Paulus surrendered in Stalingrad.

Around two million people, from both the Russian and German sides, died in the Battle of Stalingrad alone. The Russia campaign had been the high-water mark of Nazi expansion into the east; its end marked the last

major offensive Germany would undertake. In the face of the humiliating and devastating defeat, Hitler became ever more obsessed with his plans to build the Führermuseum in Linz. He scheduled a trip to his hometown, visiting the opera house for the first time since he was young. Standing in the cheap seats at the top gallery where he used to sit, the Führer daydreamed for a full five minutes about how his Führermuseum would attract millions to the city of his youth. His staff gathered around him and waited quietly. "For some time, he gazed dreamily into space, his eyes absent, his features slack," noted Hitler's architect, Albert Speer.[2] In the final days of the Russia campaign, Hitler had completed plans for dozens of buildings other than the Führermuseum that he would construct in Linz: a planetarium, hotel, community center, exhibition hall, concert hall, library, weapons museum, and sports stadium. They would, he explained to his entourage, transform his sleepy hometown into the finest cultural center in the world.

Finding a replacement for Hans Posse to direct the Führermuseum Project became Hitler's major priority. After Posse's death in December 1942, his widow contacted Hitler's staff. Upon learning that his cancer was fatal, she said, Posse had repeatedly told her that Hermann Voss, a fifty-eight-year-old art historian and dealer, would be a solid candidate to succeed him. Upon learning this, Hitler immediately arranged to meet Voss.

Although he had expressed anti-Nazi sentiments before Hitler's rise to power, Voss had started to ingratiate himself with Nazi art elites after Germans elected the NSDAP, even giving a lecture in 1939 to the SS that lauded the new Nazi cultural vision.[3] Voss had an extensive background researching early German painting and was a specialist in the Italian Old Masters, whom Hitler admired. By 1941, Voss's complicity with the regime was not merely ideological but also practical; he unashamedly appraised artwork for the Nazis that belonged to Jewish Germans who had fled the country or whom the government had deported to camps. He was thus a natural choice to fill Posse's position as director of the Führermuseum Project, now often referred to as the Sonderauftrag Linz, or Special Commission for Linz.

In Hitler's meeting with Voss, the Führer spoke for over an hour, taking scant pauses for breath as he explained his childhood dream to create a museum in Linz housing the best of Great German Art. Despite Posse's death

and state funeral, the details of the Führermuseum Project were still a state secret. Voss quickly realized that Hitler had already accepted him for the position and, while listening to his Führer, began thinking of potential candidates who could help assemble the museum's collection. Hildebrand Gurlitt immediately came to mind.

Voss and Gurlitt, eleven years the new director's junior, had not only known each other for decades but shared complementary research styles. While Voss loathed traveling, relished routine, and enjoyed pouring over documents in his office, Gurlitt enjoyed going from city to city and the constantly changing schedules that came with this peripatetic lifestyle. Voss knew that Gurlitt's fondness for Paris, the appeal of which Voss had never understood, would save him from needing to visit the City of Light himself.

Within hours of his meeting with Hitler, Voss contacted Gurlitt and presented him with the opportunity for which the forty-seven-year-old had been pining: the chance to work directly under the Führer's command and protection, with state-funded trips to Paris to boot.[4] Gurlitt had already been cultivating international contacts whom he considered useful for just such an opportunity. He had been preparing for a possible move into the inner circle of the Führermuseum Project for months, aware of the opportunities to acquire works not only for it, for which he could receive a finder's fee, but for himself on the side.

Since the beginning of 1943, Gurlitt had been working with Erhard Göpel, an art historian who, like himself, had been a proponent of avant-garde art before the war. Göpel now worked as a Nazi-protected art dealer in occupied areas, especially the Netherlands, and had known Gurlitt for decades. Now that the Nazis controlled most of Europe's art market, Göpel, like Voss and Gurlitt, was actively exploiting his own knowledge of traditional and contemporary art to aid Hitler; he valued Gurlitt's expertise, even arranging for him to have documentation certifying him as a protected supporter of the Nazis' cultural program in order to ease his travel abroad.[5] Göpel was deliberately cryptic when he wrote to Gurlitt about works he had obtained in areas where Jewish Germans were persecuted. In one letter from Paris, Göpel referred to a portrait by the late German realist Wilhelm Trübner as a painting he had acquired from "Berlin emigrants who brought it to

France," a known euphemism for Jewish Europeans who had fled Germany.[6] In the months before Voss was appointed the second Führermuseum director, Gurlitt had also forged ties with the Dutch art dealer Theo Hermsen, who had extensive experience acquiring confiscated art to sell at the prestigious Viennese auction house Dorotheum, which by now was the largest institution in Austria approved to sell art confiscated from Jewish Austrians.

Gurlitt was strategic about developing contacts within the German administration based in Paris. On one trip to France, even before he was part of the Führermuseum Project, Gurlitt had worked closely with Karl Epting, head of the Nazi-sponsored cultural outreach organization Deutsche Institut, to create an exhibition in Paris titled "Watercolors and Works on Paper of German Artists." The show aimed to educate the French about Aryan art, and Gurlitt loaned it works from his personal collection and arranged for it to tour France. Yet his more practical purpose for helping Epting mount the exhibition was twofold: it ingratiated Gurlitt further with the Nazis, and it increased not only the prestige of the artworks but their monetary value as well. The more his paintings were exhibited, the more valuable Gurlitt's collection became and the more he profited from the persecution of the owners who had been forced to sell the art or from whom it had been stolen.

Voss and Gurlitt immediately began working together to carry on Posse's work. While Voss worked from Dresden, juggling his new directorship with his old job as the head of the Dresden Picture Gallery, Gurlitt prepared to take to the roads of war-torn Europe.

<hr />

Hitler, now secure in his choice of Posse's successor, spent the spring of 1943 at the Berghof. To his generals the war was now a defensive struggle, but Hitler remained optimistic. At his mountain retreat, the Führer and his entourage mixed military and cultural meetings with ample leisure time.

Hitler commonly went to bed late and slept in. His valet, Heinz Linge, would begin the leisurely wake-up process by placing his boss's newspapers and dispatches on a chair outside his bedroom at around eleven o'clock. Hitler would retrieve the papers, read them for approximately an hour, and descend the stairs for "breakfast" around 1 p.m. Lunch took place at 2:30 p.m.,

with the Führer's preferred meal being a gruel of puréed linseed, granola, and vegetable juice. Occasionally, he treated himself to a baked potato with curds and unrefined linseed oil. Sitting with him at a table decorated with fresh flowers that Eva Braun would pick outside, his guests enjoyed traditional German fare: a standard meal was braised beef marinated in vinegar and herbs, mashed potatoes, and a simple salad.[7] In the past, Hitler had enjoyed a lunchtime beer or glass of wine, but having gained weight, he now abstained from alcohol.[8]

Eva Braun considered herself the Berghof's homemaker. "It was almost a family environment, with grown-ups sunning themselves, children running around madly and, between them, yapping dogs," noted Hitler's secretary, Traudl Junge.[9] That Braun and Hitler were romantically connected was an open secret among his close confidantes, a fact kept quiet from the public. Even around Hitler's entourage, the pair refrained from even the slightest display of physical affection. Braun was, however, the only person allowed even gently to tease Hitler. When she joked about his spartan choice of food, he countered that she should actually eat more to maintain the traditionally feminine, curvaceous figure befitting an Aryan woman. "When I first met you, you were so nice and plump, and now you're positively skinny. All the ladies say they want to be beautiful for their menfolk, and then they do everything they can to be opposite what a man likes," the Führer said at one meal.[10]

In the afternoons, Hitler would draw sketches of landscapes and plans for the Führermuseum.[11] Ensconced in his office, he would hear Negus and Stasi, Eva Braun's Scottish Terriers, racing through tall grass on the hillsides barking at deer and other wildlife so tame that they only moved aside when the Scotties came extremely close.[12] In the early evenings, the group often played in Hitler's bowling alley. He kept the facility's existence a closely guarded secret. "If the bowling associations get wind of it," he told his valet, Linge, "they will make me honorary president of every club."[13]

After dinners, the group gathered in the living room, a large, open area with a massive bookcase holding encyclopedias, rarely perused Western classics, and copies of *Mein Kampf*, which they picked up even more infrequently than the classics. The walls were covered in medieval tapestries; a portrait by

Anselm Feuerbach of his Italian lover, Anna Risi, nicknamed "Nanna," hung over the hearth. Hitler admired Feuerbach's realistic style. "Her hand is as radiant as if she were alive," he marveled, noting that he wanted the works that he displayed at the Berghof to be specially featured in the Linz museum after the war. On one sidewall hung a portrait of Hitler's beloved niece Geli, who had committed suicide by gunshot in her uncle's home in 1931.

The Führermuseum was often a topic of conversation during these nighttime discussions, which lasted until 4 or 5 a.m. "I shall make Linz a fine city and give it a gallery that people will flock to see," he told Traudl Junge and friends one evening. Hitler was reticent to hang too many artworks in the Berghof; he believed that because it was his private retreat and not a house of the people, covering it with too many artworks intended for the Führermuseum would be inappropriate. "I regard the pictures hanging here in my house as only on loan, something that brightens my life," he explained.[14]

As the entourage spent the evening hours discussing art and music, Blondi, Hitler's German Shepherd, would impress the group with a plethora of tricks. One of Hitler's favorites was to tell Blondi to "play schoolgirl" when she was sitting next to his chair. Blondi would turn toward him and put her paws on the arm of his chair, mimicking a female pupil sitting at a school desk.[15]

It was during one such evening of discussion about art and music that the only recorded instance of anyone directly confronting Hitler about his treatment of Jewish Europeans took place. Henriette Hoffmann, the daughter of Hitler's official photographer Heinrich Hoffmann, was visiting with her husband, Baldur von Schirach, who was the head of the Hitler Youth. In a momentary pause in the conversation, Henriette turned to Hitler and blurted out, "My Führer, I saw a train full of deported Jews in Amsterdam the other day. Those poor people—they look terrible. I'm sure they're being very badly treated. Do you know about it? Do you allow it?" After an awkward silence, Hitler stood up, said goodnight, and left the room. The room remained silent, and Henriette was banned from the Berghof.

The expansionist and genocidal plans about which Henriette Hoffmann was so concerned showed no signs of abating. As the spring of 1943 turned into summer, German manufacturing was in full force as the Nazis

attempted to recover from the devastating loss at Stalingrad. After the death in a plane crash of fifty-year-old Minister of Armaments Fritz Todt, Albert Speer transitioned from being Hitler's architect of buildings to an architect of war, reorganizing armament production and reducing the time to make a U-boat from forty-two weeks to sixteen. The Reich was producing around 1,000 aircraft monthly, twice the amount that it had eighteen months before, portending a prolonged war even as the Soviets were beating German tank production by a ratio of four to one.[16]

Plundering for the Führermuseum was also increasing in pace. Although more and more German men were conscripted into the armed forces, even those of middle age, Voss discreetly arranged for Gurlitt and roughly a dozen other workers to be given permanent exemptions from military service so that they could focus on acquiring art for Hitler.[17] As he plundered from Jewish Europeans whom he did not know, Voss looked out for those who had been his friends before the war, traveling in late spring to the Netherlands to meet with art historian Vitale Bloch and Max J. Friedländer, the seventy-five-year-old former director of the Gemäldegalerie in Berlin. The two men had managed to escape being rounded up by the Nazis, and Voss told Bloch and Friedländer to contact him if they ran into trouble with the authorities. The Nazis and their supporters were willing to make exceptions for Jews with whom they personally sympathized. Those without these slivers of good fortune were doomed.[18]

<p style="text-align:center">—◆—</p>

The Führermuseum team was busy preparing in mid-1943 for its biggest and trickiest deal yet: securing the confiscation of 333 artworks that the late Jewish French art collector Adolphe Schloss had bequeathed to his wife, Lucie. Sensing the looming Nazi threat, her family had hidden the treasures, mostly paintings, in 1939 at the Château de Chambon, the elegant country estate of a family friend located sixty miles south of Paris. It was French officers, not German ones, who had discovered and confiscated the so-called Schloss Collection, hoping to keep the paintings in the country for the enjoyment of French Aryans. Yet many of the works were created by Dutch masters whose styles Hitler admired, piquing the interest of the Führer's entourage. These

included a pietà by Petrus Christus, a fifteenth-century eastern Dutch artist known for his realistic paintings; a Venus by Jan Gossaert, famed in the late fifteenth and early sixteenth centuries for his skill at painting lush fabrics that seemed to pop off the canvas; and numerous other masterpieces by Dutch icons, including Peter Paul Rubens and Anthony van Dyck.[19]

The successful plundering of the collection of another wealthy Jewish Frenchman, art collector and dealer Paul Rosenberg, led the Nazis to believe that looting the Schloss collection would go relatively smoothly.

Paul Rosenberg, born in 1881, had been one of the most influential French art dealers before Hitler's rise to power. In 1910, Rosenberg had opened his gallery on rue la Boétie in the 8th arrondissement of Paris, home to the Champs-Élysées and the Arc de Triomphe. The building's spacious interior featured high ceilings and windows through which ample sunlight could stream, though soft brown curtains easily could be drawn to protect more fragile works. Rosenberg had been proud that one of the first artists he signed to a contract was a woman, Marie Laurencin, a thirty-year-old who worked in the cubist circle to which Pablo Picasso also belonged. Rosenberg also secured exclusive contracts with Picasso and Henri Matisse, championing them despite the skepticism of many other established dealers. On the ground floor of his gallery, Rosenberg proudly hung art by these avant-garde artists, whom he represented exclusively. Recognizing that many of his clients would reject these more daring works, however, Rosenberg featured nineteenth-century masterpieces in the upstairs space—Paul Cézanne, Edgar Degas, Pierre-Auguste Renoir, Auguste Rodin, Édouard Manet, and Claude Monet.[20]

The Degenerate Art Exhibition held in Munich in 1937 alarmed Rosenberg, who warned his colleagues not to purchase art from the subsequent auction of Nazi-confiscated Degenerate Art in the Swiss city of Lucerne. Still, not until 1939 did Rosenberg feel threatened enough to secure his own collection in earnest. Though disturbed by the growing anti-Semitic wave in Europe that Hitler had already codified in Germany, he was optimistic that France would not be invaded by the Nazis. Rosenberg worked with Alfred Barr, the first director of New York's Museum of Modern Art, to organize the first major retrospective of Picasso, sending works by the cubist master

to New York. In autumn 1939, he also transported several of his works to Tours, a mid-sized city in central France, where a friend held them in safe keeping.

Recognizing the growing Nazi threat, Rosenberg decided to leave Paris in February 1940, renting a home for his wife and sons in Floirac, a tiny suburb of Bordeaux. Three months later, in May 1940, Matisse visited to discuss business, and the two chatted under a centuries-old cedar tree outside the Rosenberg family's rented house. Matisse was annoyed at Hitler's rise, which he described as "thunderstorms brewing all around, to which I pay no attention whatsoever."[21] Yet now Matisse complained that these thunderstorms had become impossible to ignore, a burdensome inconvenience to his late career. Rosenberg had recently cancelled an exhibition of Picasso and Matisse in Paris, fearing for the safety of his family and that of the paintings; this irked Matisse even as Picasso saw it as a warning sign that artists should create politically provocative artwork to oppose fascism. After the visit with Matisse, Rosenberg's sense of unease only increased. Not only were his countrymen largely apathetic, but his friend and business partner, Matisse, was as well. "On the whole, people don't say much because they don't know what the future holds, although they fear it," was how Matisse summarized the mood of most Frenchmen.[22]

Taking action, Rosenberg rented a bank vault in Libourne, twenty-two miles east of Bordeaux, where he stored 162 of his most precious paintings in what he assumed would be a secure location. These artworks included masterpieces by Delacroix, Cézanne, Picasso, Monet, and Matisse. One of the most striking paintings in the trove was *Woman with a Fan*, an oil on canvas that Matisse had painted in 1921 of a creamy-skinned brunette with a flowered blouse waving a fan to ward off the summer heat.

After storing his works in the vault, Rosenberg finally realized he needed to escape France as soon as he could secure passports for his family. Within days after the fall of Paris on 14 June 1940, art experts who supported Hitler arrived at Rosenberg's gallery, disappointed to discover that the dealer was not there. The Nazis swiftly made plans to turn the gallery into their Institute for the Study of Jewish Questions, which would help organize the ghettoization of Jewish Frenchmen. On the most prominent of the walls that had

displayed Rosenberg's treasures they hung a large panel of a nude woman, representing France, sprawled on the ground with a French flag. A vulture, representing Jews worldwide, prepares to peck her to death. "Frenchmen, Help Me!" read the caption below it.[23]

The Nazis immediately began searching for the dealer himself, hoping to round up not only Rosenberg and his family but also their vast art collection. Yet the Rosenbergs escaped via Lisbon to New York City, arriving in Manhattan in autumn 1940. A year later, in September 1941, the Nazis found the vault in Libourne. After consulting the bank's French civilian employees, the Nazis catalogued and transported the paintings to the Jeu de Paume in Paris.

Organizing the dispersal of the Schloss collection in 1943, two years after raiding the Rosenberg collection, the Nazis expected the same level of deference from France's Aryan art world elites that they had received during the raid of Rosenberg's vault. Yet French curators, particularly those at the Louvre, were jockeying to take possession of the entire Schloss collection. The situation required delicate negotiations that would last until late 1943. Though the Nazis could in theory loot French museums at will, they were aware that the passions stoked by this behavior could well provoke the violent anger of the French at a time when, after the Battle of Stalingrad, it was important to keep the peace in conquered nations. While any protesters could assuredly be defeated, doing so would divert military resources that were badly needed elsewhere.

Knowing that curators from the Louvre were eager to take possession of the entire collection, Erhard Göpel, one of Gurlitt's business partners, wrote to Hitler's personal assistant, Martin Bormann, on 26 April urging the Nazis to broker a deal to acquire at least some of the works for the Führermuseum.[24]

As Hitler's art team worked on the details to resolve the Schloss Affair, Gurlitt also worked on acquiring art in Paris from Theo Hermsen, the dealer who acquired looted work for the Dorotheum. Gurlitt aimed to obtain art both for himself and for the Führermuseum. Though he destroyed his files specifying what purchases he made for himself, the amount was clearly prodigious. Hermsen confirmed this on 16 June, writing Gurlitt a gushing confidential letter after a recent meeting: "Given our discussion, allow me to

write you about how thankful I am that you have bought so many paintings and artworks from or through me."[25]

Though the Führermuseum Project remained a state secret—even Posse's official state funeral had included no mention of it—Hitler hoped that the Führermuseum would bring relief to an increasingly dejected *Volk* after the war. The people needed encouragement. Hitler's popularity was in decline after the crushing defeat at Stalingrad and the increased bombings on the home front; mothers and fathers had been willing to send their older sons away to war, but now the war was coming to them at home, terrifying their daughters and younger boys. The SS internally noted a stark decline in the use of "Heil Hitler" as a greeting.

Living in Dresden with Cornelius, now ten, and Renata, now seven, Gurlitt and his wife received a flood of letters from their friends in Hamburg, terrified by bombings and seemingly unaware of Gurlitt's work for the Führer. "The English have done monstrously precise work. I believe that a natural disaster would hardly have been able to accomplish what they have completed in about six hours. What will remain of poor Germany if this rage doesn't stop? The poor Fortress of Europe without a roof!" wrote one friend on 20 August. A Doctor Merck wrote of depression, noting, "When and how will this all be withstood and when will life get going again? I wager I'll hardly live to see it." "I find it bizarre that I'm even still alive," wrote another friend on the back of a postcard urging Germans to carry any burdens for Hitler that they could, because the Führer knew "only struggle, work and worry."[26]

Gurlitt was also in close contact with military officers, who exchanged letters with him during this month that all described low morale. Kurt Fessel, an SS *Hauptsturmführer* (captain) stationed in Prague, wrote to Gurlitt to lament that the bombings in Hamburg had caused his pregnant sister to miscarry. Carl M. H. Wilkens, a Hamburg resident and commander stationed in Lutsk, in modern-day Ukraine, expressed fury that he was so jaded by his surroundings in eastern Europe that he could not fully regret the destruction of Hamburg. "I'm very much affected, but the life in the Eastern areas has already blunted a lot of my bitterness, and I've barely been truly conscious that my Hamburg home is now destroyed," he wrote.

As around 80 percent of Hamburg had been bombed, Gurlitt's friends delivered details of the destruction. "Dear Dr. Gurlitt, I wanted to quickly let you know your house in the Alte Rabenstraße has totally burned down," wrote a notary named Dr. Ratjen on a postcard, mailed with a purple postage stamp of Hitler that bore a stamp cancellation celebrating the destruction of thirty-two million tons of Allied shipping material. One friend, architect Werner Kallmorgen, wrote bluntly, "Never come back to Hamburg, it looks harrowing."[27]

Reading this batch of letters, Gurlitt swiftly and stoically pulled off new deals for the Führermuseum, selling about twenty works to the Führermuseum that he recorded in a 25 August invoice. It included a Van Dyck for 250,000 reichsmarks and an Ingres portrait for 300,000 reichsmarks.[28]

A few weeks later, his team closed the deal with the French regarding the Schloss Affair. The Nazis allowed the Louvre to pick 49 paintings, while the Führermuseum picked 262 artworks, mostly paintings. The Nazis then transferred fifty million French francs to the French government's bureau to address "Jewish questions," the department that handled the liquidation of the property of Jewish French families. The remaining twenty-two paintings were sold to the French art dealer Jean Francois Lefranc to distribute as he wished. The family of Lucie Schloss, the Jewish widow who had inherited the collection, received nothing. Hitler's art team subsequently delivered their stolen works to Hitler's air raid shelter in Munich, until they could be displayed in Linz once the Führermuseum was constructed there after the war.[29]

By the end of 1943, Gurlitt's business buying art for himself was booming as he scavenged the areas that the Nazis had conquered. Six years before, in 1937, he had purchased around half of his artworks in Berlin, far more than in other cities. Now, emboldened by his Führermuseum credentials and the ease with which he could travel to occupied countries to exploit their markets, he made around 70 percent of his annual purchases in Paris, mostly from his Dutch dealer, Theo Hermsen; he made around 20 percent in The Hague, where Hermsen also had a presence, reflecting the widespread connections cultivated by this small clique of war profiteers.[30]

Around this time, Gurlitt acquired several stunning paintings by respected Old Masters for his personal collection, including a luminous work

from the 1630s by Jan Brueghel the Younger of Dutch villagers welcoming home sailors. Painted with oils on copper, the blue water and the peasants' colorful clothing glow. Other works from the Low Countries included a pristine Isaak van Nickelen oil on canvas circa 1696 of the bright white arches of St. Bavo's Church in Haarlem, Holland, and an early seventeenth-century oil on panel of the Marriage at Cana by the Flemish artist Frans Francken the Younger in which the lavish costumes of the wedding guests are painted with painstaking detail.

What is certain is that, even if he paid something for them, it was a fraction of the paintings' true value, and the money probably did not reach the genuine owners. It is inconceivable that on his salary Gurlitt could have acquired the more than 1,000 artworks he obtained during the war were it not for the dirty money he took in exchange for working as a high-ranking member of Hitler's Führermuseum Project.

Hitler had largely retreated from the public eye by the end of 1942. For the past twenty years he had thrived on holding large political rallies, seemingly speaking off the cuff and giving impassioned speeches to raucous and adoring supporters. Now, however, though smaller crowds still came out to see him as he conducted official functions and on special occasions, he was aware that the somber mood enveloping the nation would not abate in the foreseeable future. By year's end, he had given only two public addresses, compared to five in 1942, seven in 1941, and nine in 1940.[31] His generals grew ever more anxious after Sicily was surrendered to British and American troops and Allied bombing continued to devastate German cities.

Yet Hitler's passion for art proceeded unabated in 1943 and 1944, as Goebbels summarized in a 25 January 1944 journal entry after a meeting during which he and Hitler discussed "a thousand-and-one questions about cultural and artistic life which absolutely fascinate the Führer." Unlike millions of his fellow Germans, Goebbels was as admiring of his Führer as ever. "I am amazed at how accurately informed he is about hundreds of details," he reported.[32]

Much of Hitler's enthusiasm was due to the fact that, even as the military was bogged down by mounting challenges, the Führermuseum dealers

were picking up speed. At the end of January, Voss bought for the museum several works from Gurlitt that included *Scene of the Grande Canal* in Venice by Francesco Guardi, an eighteenth-century Viennese classicist painter, for 60,000 reichsmarks and a bacchanalia set in Venice circa 1510, by an unknown artist, for 30,000 reichsmarks.[33] Voss also purchased from Gurlitt *Winter Landscape with Windmills, Skating, and Ice Hockey Players*, a charming scene by the seventeenth-century Dutch realist painter Pieter Jacobscz Codde, for 20,000 reichsmarks and *Landscape with Turkeys* by Giuseppe Crespi, a seventeenth- and eighteenth-century artist known for his unconventional artistic lighting in paintings, for 75,000 reichsmarks. Gustav Rochlitz, a Parisian dealer, had sold Gurlitt the Crespi; Gurlitt chose not to ask for the provenance of Rochlitz's inventory. It is unclear where or how he acquired the other pieces as he did not preserve receipts in his personal files.

Gurlitt was able to benefit from deals he had made before joining the Führermuseum Project. Though he had to account for any transfers of funds to his work account from the Führermuseum budget, he could use his own money earned from dealing on the grey market to buy pictures and claim that he had acquired them in undocumented sales before he worked for Voss. If he then sold them on for the Führermuseum, he earned a larger profit than he would have from a commission alone. This way, he got paid twice. Gurlitt sold a drawing by Moritz von Schwind, a nineteenth-century Austrian romanticist, to Voss for 12,000 reichsmarks; he had acquired it with his own funds for only 1,000 reichsmarks.[34]

Gurlitt earned a reputation as a tireless worker, albeit a moody one. "Sometimes he is as angry as a film diva but then very nice again," Gustav Rochlitz complained to Voss in a letter. Rochlitz, who had previously sold art to Gurlitt for which he received funds out of Gurlitt's personal account, also worked with him to secure purchases using Führermuseum funds on behalf of Voss.[35] Despite his occasional testiness, Gurlitt had the full confidence of the Reich's Chamber of Art, which would routinely respond to—and grant—his requests for money to purchase art within hours, fully trusting in his efficiency and artistic judgment.[36] In March and April 1944, Gurlitt used the Führermuseum budget to purchase fifty-three paintings and around twenty drawings, miniatures, and pastels for 1.7 million reichsmarks, for

which Gurlitt was paid a finder's fee; the amount is unknown, but it was likely around 15 percent, his standard commission.[37]

In public Gurlitt appeared to be indifferent about Jews involved in the art world who had disappeared. When Paul Roemer, a Berlin art dealer, asked him about the provenance of a Delacroix work on paper, Gurlitt responded laconically, "I don't know anymore whom I bought that sheet from, probably a non-Aryan dealer who's gone underground, so I can't find him anymore," implying that the former owner was probably Jewish and most likely now dead.[38]

Hitler and his entourage relocated to the Berghof for the spring of 1944. It would be his last there. Hitler instructed that the acquisition of appropriate art should continue briskly. By this point, he had spent 92.6 million reichsmarks assembling the Führermuseum collection, but he dreamed of further acquisitions. A renowned magician entertained guests at Eva Braun's invitation, but no sleight of hand could disguise the course of the war that summer.[39] By the end of 6 June—D-day for Operation Overlord—155,000 men and 16,000 Allied vehicles had successfully advanced into Normandy. The Allied invasion threatened the plans to continue gathering art from France, Belgium, and the Netherlands, a point Voss emphasized by writing to Gurlitt and instructing him to send future art through diplomatic channels with the aid of the German embassy in Paris.[40] Despite the Allied military push toward Paris, Gurlitt closed a huge deal in the summer of 1944, purchasing French Beauvais tapestries for between 2.2 million and 3.13 million reichsmarks. His finder's fee was a staggering 156,500 reichsmarks.[41]

As the Allies began retaking France, Gurlitt pressed forward with an enthusiasm that astounded Voss. Perhaps he knew that the years of wartime opportunity for him were nearing their end. Gurlitt sent a cautiously optimistic letter to two friends who had been close to the family since his father Cornelius was alive. "What exactly will the next year bring for us and you all? One cannot make any plans at all, instead one has to wait and see what fate brings us, hopefully nothing so burdensome," he mused.[42]

Leading up to the summer of 1944, Hitler had been confident of his invincibility. In addition to a narrowly unsuccessful assassination attempt by Johann Georg Elser at the fifteenth anniversary of the Munich Beer

Hall Putsch on 8 November 1938, Hitler had already survived a botched attempted plane explosion on 13 March 1943 by Henning von Tresckow and a bungled 21 March 1943 attempt by Colonel Rudolf-Christoph von Gersdorff, who had transported a bag loaded with explosives to a show of confiscated Soviet military equipment in Berlin.[43]

On 20 July 1944, Hitler survived another attempt, this time from Count Claus von Stauffenberg, a thirty-six-year-old lieutenant colonel, who rigged a time-delayed detonator in a briefcase bomb that he left in a barracks at the Wolfsschanze, the military headquarters on the eastern front where Hitler was attending a meeting. Although the briefcase exploded, Hitler was relatively unharmed. Instead, he was left with a feeling of increased omnipotence and disdain for his detractors. "If this Stauffenberg had drawn a pistol and shot me down, then he would have been a man. But instead he is a miserable coward!" he told an aide.[44] Stauffenberg was soon discovered and summarily executed.

To his secretary, Traudl Junge, and a female colleague he declared, "Yet more proof that Fate has chosen me for my mission, or I wouldn't be alive now." Thrilled by his seeming immortality, Hitler sent his tattered uniform to Eva Braun as a memento.[45]

———◆———

Shortly before the United States liberated Paris on 25 August 1944, Gurlitt conducted his last major deal in the City of Light, acquiring 610,000 reichsmarks' worth of art; it is unclear exactly what the works were or whether they were for his collection, the Führermuseum, or a combination of both. This deal was, however, a clear testament to Gurlitt's desire to continue cooperating with Hitler's regime for his own monetary gain, long after many other accomplices tasked with traveling outside Germany to conduct missions had backed away, using the increasingly dangerous travel conditions as an excuse.[46]

It is extremely likely that, by this time, Gurlitt had acquired dozens of works by the most significant names in modern French art. They would remain in his permanent collection after the war. Among them were several sculptures, paintings, and works on paper by the most revered French

Impressionists. Gurlitt carefully brought back to Germany a fragile three-inch-tall wax-and-cork statue by Edgar Degas of a woman bathing, along with at least four other works by the artist, including one of his classic portraits of lithe ballet dancers rehearsing. He acquired Édouard Manet's dramatic 1883 painting *Sea in Stormy Weather*, showing two sailboats battling the rain on a choppy ocean, and his circa 1864 pastel landscape *View of Sainte-Adresse*, as well as three works by Camille Pissarro and an oil portrait of a nude young brunette by Pierre-Auguste Renoir, along with at least six other Renoir works. Gurlitt also obtained at least five works by the French realist Gustave Courbet, including a portrait of the nineteenth-century French socialist Jean Journet painted around 1850.

Works by pointillists were rare because the painting style, consisting of hundreds or even thousands of tiny dots on the canvas, required a tremendous amount of time to master and execute. Yet Gurlitt acquired at least five works by the pointillist master Paul Signac, including *Quai de Clichy*, a charming riverboat scene.

Gurlitt coveted paintings and sculptures; dealers and collectors generally regard them as more significant representatives of an artist's career, and they are thus more valuable on the market. Yet he also recognized that works on paper were easier to transport. Woodcuts, lithographs, and etchings were also particularly difficult to trace as artists usually produced them in limited editions. As well as a breathtaking marble sculpture of a crouching woman, a bronze work of a daughter of the Greek god Danaus, and a terra-cotta female figure, Gurlitt's Rodin collection included roughly thirty works on paper by the artist, fascinating preparatory drawings for numerous sculptures. Additionally, Gurlitt obtained at least six woodcuts by Paul Gauguin. One depicted the origin story of the European continent in Greek mythology, in which Zeus rapes a mortal named Europa, impregnating her with the future Cretian king Minos.

After the war, "The Rape of Europa" would become shorthand in the international art world for the confiscation and looting of artworks by the Germans.

—◆—

When Bulgaria declared war on Germany on 8 September, sensing that the once formidable Reichswehr was weakening, Hitler knew the Reich urgently needed more troops, and the Nazis shut down nearly all businesses to free up men for the front lines. For years, German companies had been taking full advantage of forced labor, beginning with the exploitation of Jewish Europeans. Bayer Pharmaceuticals purchased Jewish women from Auschwitz for seven hundred reichsmarks each to use as human guinea pigs for drug tests. At Ravensbrück, the largest all-female camp located just outside Berlin, doctors injected women with gas bacilli and staphylococcus and presented reports on their torture at prestigious medical conferences. Siemens used prisoners as slaves, and Degussa Goldhandel processed the gold fillings taken from the teeth of murdered Jews at Auschwitz, melting the metal into bars. Stolen gold, often from the teeth of Jewish Germans, represented 95 percent of Degussa's gold intake between 1940 and 1944.[47]

By late 1944, when Germany's industry was depleted of able-bodied men, private firms accepted help from the Nazi government to conscript non-Jewish Europeans as well. BMW exploited 16,600 displaced workers from areas the Nazis had invaded,[48] while Daimler-Benz conscripted around 6,000 displaced and even kidnapped workers to make aircraft engines and other military equipment.[49] Krupp used connections within the Nazi Party to move refugees to its factory near Essen, placing these largely Slavic and eastern European workers in particularly poor housing.[50]

Yet, despite the shortage of workers and resources, Hitler was adamant that the Führermuseum Project would not be paused. On 12 September, the Reich Chamber of Culture wrote to Gurlitt's wife, Helene, the official owner of the family business, to reassure her that "art publishers and dealers [were] exempt from the closing of all businesses," and she was officially "authorized to continue her business just as before."[51] The letter reassured her greatly; she was already struggling to maintain a sense of normalcy for Cornelius and Benita, now eleven and nine years old, who like other Dresden schoolchildren had to wear identity cards around their necks in case they were maimed beyond recognition by a bomb.

Helene's husband was still traveling frequently, leaving her to manage the household alone. His trips to Paris in 1944 had been so frequent that

the German government issued his war rations in a form of traveler's checks. His time in Paris wasn't limited to work, however. He was also conducting an affair with Olga Chauvet, a native Russian eighteen years his junior who lived in the rue de Four and was estranged from her husband, a Swiss diplomat and member of Geneva's wealthy Chauvet family. It's unclear whether Helene ever learned of her husband's infidelities, though they were noted by Parisian officials in reports for the Allies after the war.[52]

Continuing his work for the Führermuseum, around this time Gurlitt sold six paintings to Voss, including a still life by Franz Snyders for 70,000 Dutch guilders.[53] He also acquired a still life of fruit and a wine glass by Hendrik van Struck and a painting of a wreath of flowers at a spring by Hieronymus Galle, both for 20,000 Dutch guilders; it is unclear who sold him the works.[54]

Gurlitt did not shy away from socializing with the same artists whose artworks he acquired for his secret collection through dubious means. In autumn 1944, he traveled to Amsterdam and visited the sixty-year-old Max Beckmann, whom Hitler had labeled degenerate years before and whose confiscated work had appeared in the 1937 Degenerate Art Exhibition in Munich. Deprived of a livelihood, Beckmann was in dire financial straits, and Gurlitt bought the painting *Bar, Brown* from him for a decent price, also bringing back several more pieces for Munich dealer Günter Franke to sell.[55]

Though Gurlitt had long admired Beckmann, this move was not purely altruistic. He was well aware that he needed to show that he had helped persecuted artists during the war, given that the conflict would now certainly end in the Allies' favor.

Unbeknownst to Beckmann, Gurlitt was in possession of at least six of his artworks that the Nazis had confiscated from museums, including *Zandvoort Beach Café* and *Old Woman with Cloche Hat*, the pieces that were in the roughly 238-strong cache that he had bought from the Nazis in May 1938. Gurlitt took ample advantage of his access to the depots that held confiscated Degenerate Artworks. He acquired at least thirty-one pieces by Otto Dix, including *Leonie*, his portrait of a prostitute painted in 1923, and *Horse Cadaver* and *Corpse in Barbed Wire* from his 1924 war series. The dealer obtained at least fifty works by Emil Nolde, still living in seclusion

in northern Germany, including *Children of the Forest*, the fairytale scene painted in 1911, along with *Flood, Evening* and *The Dancer*. Though he did not particularly admire George Grosz's artworks, Gurlitt recognized their value and procured at least forty-seven, all of them works on paper. He had taken some of them out of one of the Berlin-based depots of Degenerate Art, including a lithograph from 1919, *Heads of Teutons*, which the Nazis had taken from the Nassauisches Museum in Wiesbaden, a city in the central-west German province of Hesse.

Much more to Gurlitt's liking were the works of Max Liebermann; he acquired at least seventy-nine, all or nearly all of which were most likely in his possession by late 1944. In addition to David Friedmann's painting of *Two Riders on the Beach*, major works that Gurlitt acquired included two self-portraits of Liebermann as well as a pastel rendition of *Two Riders*.

The hundreds of other artworks that Gurlitt amassed by the end of the war were created by dozens of artists spanning a vast array of genres and periods, from the 1590s to the early 1940s. Though the largest number of works came from German artists, followed by artists from France and the Low Countries, Gurlitt had also obtained works from farther-flung locales, including ceremonial masks from unidentified African countries and even a small selection of Japanese works. These striking pieces included an early nineteenth-century color woodcut by Shungyosai Ryukoku of a woman in a kimono sitting at a table and an 1814 color woodcut of a ghost consumed by burning flames.

———✦———

By October 1944, Hitler had grown increasingly anxious about the Allied invasion. The invincibility he had felt after Stauffenberg's failed assassination attempt had dissipated. Finally recognizing the Allies as a threat that could well bring his Thousand-Year Reich to an ingloriously early end, he began exhibiting tremors in his hands and was increasingly reliant on sedatives to help him sleep and stimulants to sustain his energy during the day. By November, his erratic health made lengthy public appearances impossible. He sent the forty-four-year-old head of the SS, Heinrich Himmler, to make the annual speech to the "Old Fighters" at the ceremony in Munich

commemorating the 1923 Beer Hall Putsch. Remaining in Berlin, the Führer ordered Goebbels to cut 75 percent of the Reich Chamber of Culture's budget—severely impacting theaters, orchestras, and newspapers.

Yet the Führermuseum Project was not to be touched. On 2 December, Hitler had a five-hour conversation with Goebbels about the future of art in the Reich. "The Führer is pursuing quite grand plans in regards to the re-establishment of cultural life," noted Goebbels. "Consequently, after the war, the Führer is determined to start afresh in the cultural sector on quite a grand scale."[56]

Even as the Russians were closing in on Berlin and swiftly dismantling the Nazi infrastructure, Hitler steadfastly believed that the Führermuseum would be built. On 27 January 1945, the Red Army took over Auschwitz, where 7,000 prisoners were still alive. The Soviets found the survivors wandering around six hundred corpses decomposing on the ground. While there, the Red Army catalogued 7.7 tons of human hair that the Germans had kept in storage, presumably to sell to wigmakers after the war.[57]

At long last, the Führermuseum Project finally wound down. In total, Hans Posse and Hermann Voss had spent at least seventy million reichsmarks, most probably up to ninety million reichsmarks, to purchase thousands of works for the museum. Voss, however, was not about to risk his life for Hitler's passion project.[58] In early 1945, he moved to Schloss Weesenstein, an eight-hundred-year-old castle located twelve miles from Dresden. There, he hoped to avoid detection by the Allies in the remote fortress. Voss soon sent word of his whereabouts to Gurlitt, still living in Dresden with Helene and their children, Cornelius and Benita.

By the end of the war, Gurlitt had completed approximately 3,800 deals for the Führermuseum. His nearest competitors had managed a fraction of his output: Ferdinand Möller completed approximately 850 deals, Karl Buchholz completed approximately 880 deals, and Bernhard Böhmer completed approximately 1,200 deals for the Führermuseum.[59] The exact amount of money Gurlitt earned from his commissions was unclear, but his profits working for the Führer were certainly high enough that he and his wife could retire and his children would never need to work in order to live out their entire lives in affluence.

In addition to the proceeds from these deals, Gurlitt amassed around 1,000 works for his private collection during the war. Having anticipated that the Allies would target Dresden, Gurlitt had already been working since early 1944 with a professional moving company to transport around 550 kilograms in approximately forty boxes out of the city to a secret location, in addition to having some works stored in an east German mill house.[60] Despite painstakingly planning how to hide his artworks, he showed no interest in saving the records that proved their provenance. Had the previous owners sold them willingly, these provenance records would have dramatically increased their value. The only conceivable reason for Gurlitt not to have protected this documentation was to obscure the dubious circumstances under which he had amassed his trove.

Protecting the artworks and his other assets now became Gurlitt's top priority. Reluctantly, he decided to stop adding to his collection. Dresden had become very dangerous.

CHAPTER VII

REVISIONIST HISTORY

"Enjoy the war, for the peace will be terrible."

—Common German joke in late wartime

I N MID-FEBRUARY 1945, HILDEBRAND GURLITT loaded up a truck with his wife, mother, son, and daughter, along with some of the most precious works of early twentieth-century art. Taking the driver's seat, Hitler's forty-nine-year-old dealer slowly but urgently made his way to Schloss Weesenstein, the manor outside Dresden where Hermann Voss, his boss for the Führermuseum Project, was hiding.

During the late hours of 13 February and into the morning of Valentine's Day, 773 Royal Air Force (RAF) bombers had dropped 650,000 firebombs over the roofs of Dresden, rendering the once picturesque city a blazing hellhole: 80,000 houses and buildings were destroyed, and 25,000 people died. The RAF maneuver kept the pressure on Germany to surrender.

Leaving the city with such a conspicuous amount of art was a risk for Gurlitt, particularly as he was traveling with his wife and two children. Enraged by what their comrades, families, and Hitler's victims had suffered, Russian soldiers were determined to exact revenge and did not spare women

and even girls as young as Gurlitt's nine-year-old daughter, Benita, from bru-
tal gang rapes. By the end of the war, the Red Army had suffered eleven
million losses, and the brutalization of a few thousand German women and
children seemed proportionate payback.

Despite these perils, Gurlitt risked the journey to Schloss Weesenstein.
There, he and Voss swiftly decided to take their chances and travel to Schloss
Aschbach, a manor owned by the Baron von Pölnitz, an acquaintance who
lived 250 miles away in southwest Germany. Gurlitt left behind his octoge-
narian mother Marie, who was too weak to travel; she returned to Dresden
to live alone in her bombed-out basement.

Packing up their wagon again, Gurlitt and his family gathered wood
chips to use as fuel because there was a gasoline shortage. His sputtering
truck traveled over bomb-cratered roads to the new manor, as Cornelius and
Benita sat in the back with the artwork. Upon arriving, the group was wel-
comed into the estate by Baron von Pölnitz, and Helene spent most days
homeschooling the children while her husband, unable to work or travel,
unsuccessfully tried to stave off boredom. Helene had no idea what to teach
the children about their Führer. As far as she knew, Hitler was still fighting
for the Fatherland, but it was obvious that the Allies would soon declare
victory.

———◆———

Adolf Hitler saw the sky for the last time on 20 April 1945.

The Führer celebrated his fifty-sixth birthday by briefly leaving the bun-
ker in which he had been living since mid-January to pin decorations on
child soldiers who had begun fighting Russian tanks.[1] As these recruits from
the Hitler Youth paraded for him, the Führer beamed. His twenty-five-year-
old secretary, Traudl Junge, tried to conceal her horror. "Was he planning to
rely on that kind of defense?" she thought to herself.[2] Going into the bun-
ker and celebrating his birthday with a rare glass of champagne, Hitler an-
nounced that he would never leave Berlin.[3]

Hearing his decision, Eva Braun was briefly sullen. Soon, though, a fire
entered the thirty-three-year-old's eyes, a spark that Junge immediately iden-
tified. "She wanted to celebrate once again, even when there was nothing left

to celebrate; she wanted to dance, to drink, to forget," Junge observed. Braun dashed through the halls of the bunker, the walls of which displayed valuable artwork from Hitler's planned collection for Linz that he had ordered his entourage to hang in his underground office to remind its residents of the future Führermuseum.[4] Braun assembled a small group of younger staff, including Junge, and herded them up into the first floor of the chancellery. There, they danced as champagne flowed, pausing only to reset the gramophone after an explosion outside. "This was a party given by ghosts," noted Junge.[5]

Hitler's entourage knew that an Allied victory was a foregone conclusion. Russian soldiers were quickly closing in from the north, the city was in smithereens from bombing, and the army consisted largely of old men and children.

Hitler's conversations with other bunker residents increasingly revolved around his German Shepherd, Blondi, Braun's Scotties, and art, including the model of the Führermuseum that his entourage had taken great pains to transport into the bunker. "No matter at what time, whether during the day or at night, whenever he had the opportunity during those weeks, he was sitting in front of this model [as if he were standing] at a promised land into which we would gain entrance," observed an aide.[6]

The day after Hitler's birthday, his thirty-two-year-old valet, Heinz Linge, woke him at an uncharacteristically early 9:30 a.m. to tell him the Russians were shelling Berlin. "The Russians are already so near?" exclaimed Hitler.[7] The next day, Hitler uttered damning words during the situation conference: "The war is lost."[8] Braun quickly adopted the tone a caregiver would use with a small child, telling him, "But you know I shall stay with you." Hitler's eyes shone, and he kissed her right on the mouth, the first and only time his close circle saw him do so.[9]

Going outside with two of the other women to smoke cigarettes and walk Blondi, Eva Braun noticed a beautiful bronze statue of a lithe naiad in a hidden spot behind shrubs that surrounded the Foreign Office. Birds were tweeting, flying around daffodils that encircled the statue. The women sat sullenly on a rock as Blondi played in the grass, then dashed back underground when the sirens howled once more.

Back inside the bunker, Eva told Adolf about the statue of the naiad. "It would look really good by the pool in my garden," she told him. "Do please buy it for me if everything turns out all right and we get out of Berlin!" she pleaded.[10] Calmly but adamantly, Hitler admonished Braun for wanting a publicly owned statue for her private collection, explaining that the statue was owned by the people and part of the revolutionary museum system that he had created over the past twelve years.

Within hours, the bunker was filled with not only the high-pitched sounds of sirens from outside but also the delighted shrieks of children as Joseph and Magda Goebbels moved their six children into it: twelve-year-old Helga, eleven-year-old Hildegard, nine-year-old Helmut, eight-year-old Holdine, six-year-old Hedwig, and four-year-old Heidrun.[11] Their cheerful obliviousness made the situation more disconcerting for Hitler's staff. Traudl Junge, trying to distract the children, took them to the area where the staff stored birthday presents for Hitler, which included children's toys from young Reich residents.[12] When Hitler began plodding through the bunker halls aimlessly, Blondi never leaving his side, the Goebbels children clamored for attention from "Uncle Adolf," thrilled about this unexpected school holiday.[13]

On 25 April, a telegram from Hermann Göring arrived in which he declared himself Führer, effective 26 April. Göring cited the fact that Hitler was in the bunker and thus unable to assess the war's status above ground. Alarmed by this insubordination, Hitler's assistants began destroying his personal documents in Berlin, including art records documenting purchases for the Führermuseum.[14]

The bunker residents began casually discussing the best methods for their suicides. "The best way is to shoot yourself in the mouth. Your skull is shattered and you don't notice anything," said Hitler. This horrified Eva Braun. "I want to be a beautiful corpse," she insisted.[15]

Minutes later, Hitler asked Junge to take dictation of his last will and testament. She expected it to be a confession, a reflection, a justification. Instead, Hitler criticized the German people for not being sufficiently passionate about establishing the Third Reich before issuing a tirade on the importance of his role as an artist and curator. "I collected the paintings in the collections I have bought over the years, never for private purposes, but

always exclusively for enlarging a gallery in my hometown of Linz on the Danube. It would be my most fervent wish for this legacy to be realized," he insisted.[16]

Hitler had told Eva Braun that he would marry her after he won the war so that they could retire to the Berghof, where he would resume painting and write his memoir as the Führermuseum was being constructed in Linz.[17] Now, Hitler made good on his promise. The Goebbels family and the staff attended the marriage ceremony, during which the officiant amended the vows so that they would not include lines such as those about staying married "until death do us part," given that their deaths were so imminent.[18] Afterward, the group celebrated over champagne, sandwiches, and tea; Braun's eyes glowed as the others began addressing her as "Frau Hitler."[19]

Preparations then began for Hitler and Braun's suicides, starting with the killing of Blondi to test the cyanide capsules. The Führer's medical doctor ushered Blondi into the washroom, after which the smell of burnt almonds quickly wafted into the hallway. It was the odor of working cyanide.[20]

Shortly thereafter, around 11 p.m., staff informed Hitler that members of the Italian resistance movement had assassinated sixty-one-year-old Benito Mussolini and his thirty-three-year-old mistress, Clara Petacci, and that their bodies had been hung upside down in a public square to be mocked and photographed. "Had Hitler needed a final shove in order to make his own suicide a reality, that was probably it," observed Rochus Misch, Hitler's bodyguard.[21]

On the morning of 30 April, preparations for the Führer's death escalated as the bunker was rocked by the sounds of explosions above ground. Hitler formally said good-bye to his staff and had a final luncheon with Traudl Junge, before taking his valet, Linge, and chauffeur, Erich Kempka, aside, instructing them to burn his and Braun's bodies so they wouldn't meet Mussolini and Petacci's fate.

"I am going to shoot myself now. You know what you have to do," Hitler said, giving his final salute.[22] Braun was wearing the Führer's favorite dress of hers, a black frock with roses at the neckline. Her hair was perfectly coiffed.[23] Eating buttered bread, Helmut, the Goebbels's nine-year-old son, heard a shot ring out. "That was a bullseye!" he exclaimed.[24]

The valet Linge approached Hitler and Braun's bedroom when he smelled the pistol discharge. Going inside, he saw Hitler with a head wound the size of a penny in the right temple. By his right foot was a 7.65-mm Walther pistol; by his left foot was a 6.35-mm pistol, presumably a backup.[25] Braun's revolver lay on a table, near a picture of Hitler's mother, Klara, as a young woman.[26] Braun was sitting on the sofa, her legs drawn up under her and her face contorted from the cyanide.[27] The brass case of her used cyanide capsule was lodged on the floor near the sofa. "It looks like empty lipstick," thought Junge, peering into the room.[28]

Outside, the bunker's residents lay Hitler and Braun side by side. Shells exploded in the vicinity as Kempka opened petrol bottles, pausing to straighten Hitler's arm against his side before pouring petrol on the newly-weds. Braun's dress fluttering in the air caught his eye. He lit a petrol-soaked rag and flung it from a few feet away onto the bodies. "Slowly the fire began to nibble at the corpses," he observed.

The group gave the *Hitlergrüß* one last time, their right arms extending high into the air.[29] "The most powerful man in the Reich a few days ago, and now a little heap of ashes blowing in the wind," Junge ruminated to herself, watching the bodies burn. Several hours later, the Soviets delivered news of Hitler's death to Joseph Stalin in Russia. Stalin was annoyed that he could not take his foe captive.[30]

At around 5 p.m. Magda Goebbels quietly but efficiently began changing her children into white nightdresses. She praised their "Uncle Adolf" using the present tense, as if he were still alive.

The bodyguard Misch, a new father himself, observed the scene in the cramped quarters but absolved himself of any responsibility for the deaths he knew the children would soon face. "I knew this was the final parting of a mother from her children, but I did not want to see it. Frau Goebbels was preparing her children for death," he noted, trying not to let four-year-old Heidrun's confused looks make him think of his own young daughter.[31] He developed a deliberately indifferent mentality: "I asked no questions when it was best to ask none, but I also raised no questions when I could have," he noted later.[32] At 7 p.m., Misch observed Magda Goebbels playing a card game at a table. Her eyes were red but dry. Joseph Goebbels approached

her, solemn and silent.[33] Misch then began pacing the bunker hallway and chain-smoking before leaving the bunker, only to be captured quickly by the Soviets, who kept him in a labor camp before eventually releasing him.[34]

Traudl Junge, Hitler's secretary, also felt a visceral urge to leave the bunker. Taking one final look inside Hitler's bedroom, she saw Blondi's leash dangling from the coat rack. "It looks like a gallows," she thought to herself. Going back into the hall, she saw that Hitler's valuable portrait of Friedrich the Great was gone; someone inside had taken it as he or she fled.[35] As Goebbels prepared to shoot his wife and then himself, Junge fled home to Munich, anticipating condemnation from her family and friends about her involvement with Hitler. The condemnation never came.

A week later, on 7 May 1945, at 2:41 a.m., Alfred Jodl signed Germany's surrender, officially ending the war on 8 May 1945. While the Allies and those whom they liberated referred to this day as Victory in Europe Day— VE Day for short—the Germans referred to it as *Stunde Null*, or "Zero Hour." The term had a dual meaning: not only had they lost everything, they now had the opportunity to create a new Germany, seemingly from scratch.

In reality, however, war profiteers were not starting from zero. Whether they had dealt in ammunition, automobiles, art, or other industries, a few lucky men exited the war with substantial assets that would sustain them and their families for decades to come. Their primary concern during the Zero Hour period was portraying themselves as victims of Hitler in order to hide their profits from whichever Allied organization was tasked with investigating their wartime activities.

For Hildebrand Gurlitt, that organization was the Monuments Men.

———◆———

The Monuments Men, a group of roughly four hundred men and women who formed the Monuments, Fine Arts, and Archives Program, were art experts from Allied nations. Primarily funded by the US government, these historians had long been concerned about Hitler's attempts to eradicate any art that he considered degenerate. American civilians had lobbied the federal government in 1943 to research how to protect art and other culturally significant artifacts in the event of an Allied victory. The initiative garnered the

support of the Rockefeller Foundation, although it granted only $16,500 to pay the salaries of staff in New York and Washington.[36]

The parsimonious attitude of the Rockefeller Foundation was somewhat understandable. No government in the history of warfare had ever spent funds, let alone solicited donations from civilians, in order to preserve the culture of the territory it was about to defeat. The notion that art experts would be accompanying them on missions annoyed Allied militarily officials, who worried about preserving lives over inanimate objects, however culturally significant. One member of the Monuments Men summarized the situation. "I doubt there is need for any large specialist staff for this work, since it is at best a luxury and the military will not look kindly on a lot of art experts running around trying to tell them what not to hit."[37]

Hiding out at Schloss Aschbach, the manor owned by Baron von Pölnitz, Gurlitt heard rumors about the Monuments Men and worried that they would find him. He and Helene also griped about their living conditions, even though they were fully aware of their good fortune in comparison to other Germans during the Zero Hour period.

The fact that the Gurlitts had a roof over their heads was a postwar luxury: 40 percent of the nation's homes were now destroyed.[38] Upper Franconia, the Bavarian region surrounding Baron von Pölnitz's estate, was in chaos, but the pandemonium in other regions made for a far grimmer picture.

Rape was now rampant throughout Germany. Allied courts convicted 284 American and British soldiers of the crime.[39] French troops from North Africa raped around 260 young girls and adult women around Stuttgart on Hitler's birthday, one hundred miles from Schloss Aschbach.[40] Yet the overwhelming majority of sexual violators hailed from the Red Army. They routinely forced men to watch the rape of their wives, daughters, or sisters, killing both the men and the women if the men attempted to intervene.

— For survivors of concentration camps, the horror that they had experienced continued as they struggled to regain their sense of humanity and identity among fellow Europeans who had contributed to their persecution and were not inclined in the postwar period to help them reintegrate into society.

American and British personnel, though earnest in wanting to assist Hitler's victims, were ill equipped to deal with the emotional, mental, and

physical trauma that these survivors had endured. At Dachau, *Time* maga-
zine reporter Sidney Olson observed how lice-bitten, typhus-infected male
prisoners confused soldiers with their glee at announcing they had banded
together to kill two German soldiers themselves. At Bergen-Belsen, a Jewish
chaplain with the British army described how the soldiers were unprepared
for the sight of the prisoners, who seemed like real-life zombies. "Their skele-
ton arms and legs made jerky, grotesque movements as they forced themselves
forward," the chaplain wrote.[41] The idea of helping the Germans rebuild
their country—with the use of US taxpayer funds—was unfathomable.

Against the backdrop of these postwar horrors, Baron von Pölnitz, a
longtime friend of Gurlitt, was thrilled to host the dealer's family but was
none too happy about what he dubbed the "Jewish manor invasion": the use
of a section of his estate by the Allies to house a small community of Jew-
ish Europeans hoping to emigrate to Palestine. The army confiscated some
of the buildings to hold classes for Holocaust survivors to help them learn
English, Hebrew, agricultural basics, and logistical information relevant for
their move.[42]

Gurlitt wrote a series of letters complaining about how the conditions
were subpar compared to those he had enjoyed before. "Believe me, we ar-
en't living in Paradise here; we have sufficient potatoes, bread and flour, but
everything else is limited and no special allotments like fish, etc!" he penned
to one friend.[43] Writing to his cousin, Gurlitt complained, "There's nourish-
ment and quiet here, but that is it; bucolically speaking, it is disgracefully
primitive and one is alone in a way that one cannot possibly describe."[44]

Cornelius Gurlitt was now twelve and his sister, Benita, nine. Cornelius,
due to his father's status, had avoided the conscription as a child soldier that
had befallen many boys his age. Both children, though emotionally shaken
by the war, were physically unscathed and well fed throughout even the worst
days. This was not good enough for their parents. Despite access at the es-
tate to a tutor—most schools were in shambles—Gurlitt wrote to his cousin
complaining, "The children are getting tans [playing outside] but aren't get-
ting any brighter" from studying.[45] Hildebrand and Helene Gurlitt's largest
parental worry was that other adults joked that Benita's name was Benito,
referring to the recently assassinated Mussolini.[46] Helene Gurlitt even had

the gall to write to Lisa Arnhold, the Jewish widow of the banker and art collector Heinrich Arnhold, who, after Heinrich's death, had hopscotched around Europe with her children to avoid the Nazis before escaping to the United States. Helene claimed that the Gurlitts had endured great hardships and asked Arnhold to send clothes and shoes for Cornelius and Benita, along with sewing thread.[47]

Hildebrand Gurlitt, meanwhile, worried constantly that the Monuments Men would not only find and confiscate the small fraction of his collection that he had brought to Schloss Aschbach but also discover his bigger trove. All he could do for the moment was wait and hope.

———❖———

It did not take long for Europeans who had been deeply complicit in or actively helpful to Hitler's cause to begin spinning false narratives about their actions during the war—deceptions with devastating consequences for victims of the Third Reich.

Support for Hitler during the war had been so widespread among ordinary Germans that even those in Hitler's elite circle were shocked to receive no condemnation from fellow citizens, even as stories of those with the courage to resist Hitler began circulating.

Returning to her home in Munich, Traudl Junge learned of Sophie Scholl, a fellow Munich resident her age who had risked her life to warn Germans of the murderous policies of Hitler, the same policies for which Junge had taken dictation on her typewriter. The Nazi regime beheaded the twenty-one-year-old Scholl for her activism. Junge felt both guilty and defensive that she had not displayed the courage that Scholl had shown. In light of this, Junge expected to be pilloried by Munich's residents, who knew that she had been Hitler's secretary. Yet, to her shock, her fellow Bavarians pretended that she had never had any connection to the Nazis, let alone direct access to Hitler during his last days.[48]

Junge correctly attributed this to the fact that most Germans realized that holding their fellow citizens responsible for the rise of Hitler and his successful genocide would require them to examine their own actions—or inactions—during the war. "We were all looking to the future and

trying—with remarkable success, incidentally—to repress and play down our past experiences," noted Junge.[49]

Gurlitt never articulated his views on complicity with the Nazis as clearly as Junge did, but he was acutely aware of the seriousness with which the Allies intended to investigate all aspects of Hitler's program. However, he also knew that the Monuments Men were a small group of pioneers in a gargantuan Allied machine attempting to assess millions of people in a short period. Though he remained anxious, Gurlitt knew that too many Germans had aided the Nazis or been complicit in their actions for the Allies to identify all of them; even if the Allies were able to do so, punishing them all would effectively mean punishing most of the country.

In July 1945, Great Britain, Russia, and the United States met at the Cecilienhof in Potsdam and agreed on the "five Ds" of "demilitarization, denazification, democratization, decentralization and decartelization." As a result of this meeting and what he observed around him during the Zero Hour period, Gurlitt decided to bet his future and his art trove on the probability that he could tell calculated lies to the Monuments Men, which they would have insufficient resources to fact-check or rebut.

The Monuments Men first investigated Gurlitt's direct superior, Hermann Voss. He and Gurlitt had remained close during the first months of the postwar period, both aware that the Allied treatment of Voss would serve as precedent for their eventual investigation into Gurlitt. Voss gave the Monuments Men a line that Gurlitt would repeat: because of his prewar support of modern art and his association with Jewish art dealers before Hitler's rise, he was a victim, not a perpetrator, of the regime.

It was nonsense, and the Monuments Men detected Voss's attempt at deception. "Voss represents himself as a person of strong anti-Nazi sympathies who accepted the Linz position only with the idea of saving the pictures and handing them over, intact and inventoried, to the Allies, who he felt certain would win the war," they noted in Voss's interrogation file.[50] Voss claimed to have an astounding level of ignorance regarding the nature of the very Führermuseum Project for which he was the director, telling the Allies that he had barely known his predecessor, Hans Posse, and had no idea that the Führermuseum's art collection could possibly include

art confiscated from Jews, occupied territories, or other museums. Voss stated that he had been "shocked" to learn, upon becoming head of the Führermuseum Project, that even a few works in the collection had been purchased from Hitler's victims under duress or confiscated outright. He rationalized, however, that this was not his problem because it had occurred before his time. The interrogators immediately noted Voss's unctuous and deceptive tactics, quipping, "His constant reliance on failure of memory to explain discrepancies in his testimony did not improve the atmosphere of the interrogations."[51] The Monuments Men summarized Voss's mentality: "He states that the confiscated pictures were sure to go somewhere, and what difference did it make?"[52] Furthermore, they saw Voss as emblematic of the overall mentality of Germans about the material possessions of Jewish Germans and other victims of Hitler. "Voss takes the profoundly German attitude that art history is pure science, and that one can pursue it without exterior moral responsibility," they noted.[53]

Voss justified his actions thus: "Things had gone too far for me to stop them."[54]

Allied suspicion escalated when they discovered a 16 December 1943 letter written by Voss in which he joked—implying the possibility of Germany losing the war—that art dealers would be able to "escape" responsibility for their actions. The Allies were flabbergasted when Voss solemnly submitted to them, without sarcasm, a poem he composed for them about his love of art and peace as proof of his anti-Nazi sentiments.[55] Incredulous, the Monuments Men noted that Voss seemed baffled that the Allies didn't consider him a "savior" and a war hero.[56]

The Monuments Men wrote a damning report to conclude Voss's file. "He constantly avoided the question of moral responsibility involved in accepting [a Führermuseum] position" and "claims immunity from the consequences"[57] of his involvement in "the most elaborate purchasing expedition in the history of art"[58] by justifying that the Führermuseum Project had been conceived by those more powerful than himself. The Allies rejected the idea that Voss was merely a "fellow traveler," concluding that "he had the chance to stop proceedings and that he did not, even though he was sufficiently informed to know what he was getting into."[59] Voss had "kept his hands clean

by leaving the dirty work to others and not asking too many questions," they wrote, strongly suggesting that this mentality likely applied to his entire Führermuseum Project team.[60] "In short," the Monuments Men concluded, Voss "pictures himself as both the important man who was responsible for saving the pictures of Dresden and Linz, and as a pure scientist who was not concerned with what went on behind the scenes."[61]

The Monuments Men recommended to their Allied superiors that Voss be detained as a "potential war criminal."[62] This report came a few weeks before General Lucius Clay created the Denazification Policy Board that functioned in the provinces of Hesse, Baden-Württemburg, and Bavaria, putting Voss's case under Clay's jurisdiction. Yet Clay's subordinates dropped the case, and Voss went on to enjoy a long and prosperous postwar career in the art world before dying in 1969. Clay concluded that disciplining supporters of Hitler who had committed violent crimes should take priority over investigating and disciplining nonviolent criminals such as Voss. It was this decision that served as precedent for the handling of Hildebrand Gurlitt.

———◆———

When authorities investigate a group of potential criminals, one of two things usually happens. Typically, the suspects turn on each other during interrogation, having not discussed a strategy beforehand. In rare cases, however, the group schemes beforehand to decide what version of the truth they want to tell. In this sense, the art world elite of Nazi Germany was an impeccably organized cartel. Once the Nazis surrendered and the Monuments Men found Voss, the director "outed" Gurlitt as one of Hitler's top-three most important art dealers, seemingly in a gesture of goodwill toward the Allies. The two men had arranged this beforehand.

After the investigation of Voss began, Gurlitt quickly compiled his own character references from around the globe, knowing he would also soon be investigated. Many were written by men and women who felt compelled to vouch for Gurlitt due to their own complicity with the regime and fears that, were they not to support him, he might recommend that the Allies investigate them, too. Brazenly, Gurlitt also requested character references from Jewish Europeans and other victims of the Nazi regime who had fled Europe

early enough to avoid persecution, yet now, in a cruel twist, were unaware of Hildebrand's complicity with the very regime that had expelled them.

Gurlitt's references thus fell into two categories: those given by others who had also been complicit in Hitler's art crimes and those given by people who had fled the Third Reich and were unaware of what Gurlitt had done during the war.

In the first group, Robert Oertel, a researcher at the Art History Institute in Freiburg, testified that he had known Gurlitt since long before the war and that Voss had bought artwork from Gurlitt "just like [Voss did] from countless other German art dealers." Oertel added that Gurlitt had nothing to do with any artwork confiscated from Jewish Europeans and that "Dr. Gurlitt has never had a special status or carried out anything but pure business duties" for Hitler's Führermuseum Project. Oertel failed to mention that he himself had jockeyed for a position to work with Gurlitt and Voss to become a lower-ranking art dealer for Hitler.[63] Kurt Martin, director of the Kunsthalle Karlsruhe, wrote that Gurlitt was anti-Nazi and that he was "convinced that [Gurlitt's] activities as a trader abroad have always been respectable." Martin did not disclose that he had arranged for the Kunsthalle to take art that had been confiscated from Jewish Europeans.[64]

Gurlitt also submitted a January 1946 testament from Walter Clemens, a lawyer in Hamburg, who testified "without reservation that [Gurlitt] always has been an unlimited adversary of Nazism" and that "the house of Gurlitt was a center of culture" and "an island of refuge for free art and expression" where diverse opinions were "honored with care."[65] The Allies had recently reinstated Clemens's legal license, so he had a vested interest in mollifying Gurlitt, who could have denounced him as a Nazi sympathizer, prompting renewed investigation into Clemens's own work during the Third Reich.

The Jewish Europeans and other victims of Hitler's regime to whom Gurlitt reached out were most likely ignorant of his wartime dealings and undoubtedly desperate to preserve what few connections they still had in the German art world in the event that they repatriated. Guido Schönberger, a German academic in New York, wrote from his Upper East Side home a carefully worded letter declaring, "When Hitler came into power, [Gurlitt] did __not__, as so many others did, made [sic] his position easier through

compromises."[66] Albin von Prybram Gladona, a Jewish Austrian who had lived in Munich before the war, had spent time in a concentration camp and fled in 1938 to France to work for the resistance. He vouched that Hildebrand was an "ardent and sincere anti-Nazi."[67]

Gurlitt also instructed his secretary from 1942 to 1944, Maja Gotthelf, to vouch for him. Describing herself as a "half-caste Jewess," Gotthelf voluntarily acknowledged that she owed Gurlitt a debt for hiring her, given her vulnerable status in Nazi Germany; she falsely testified that she had never signed his letters with "Heil Hitler."[68]

Even Max Beckmann, the exiled artist whom Gurlitt had visited in Amsterdam during the war, was unaware that Gurlitt had numerous Beckmann works in his stash. The artist wrote him a letter of support, assuring him, "I'm glad that you have escaped Hell and are still alive."[69]

Most of these letters of recommendation were ready by mid-November 1945, when the Monuments Men confiscated the artworks that Gurlitt had brought with him to Schloss Aschbach. Gurlitt carefully and deliberately had assembled the collection, ensuring that it comprised economically valuable works along with obscure and relatively inexpensive idols and sculptures from New Guinea, Nepal, and unidentified African countries. Among the approximately 7 percent of Gurlitt's collection that the Monuments Men confiscated and catalogued were one of the statues by Auguste Rodin, the pietà by Käthe Kollwitz, two works by George Grosz, *The Lion Tamer* by Max Beckmann, and Max Liebermann's *Two Riders on the Beach*.

Through this clever strategy, Gurlitt concealed from the Allies around 93 percent of his collection. Rumors, however, were percolating in the small village surrounding Schloss Aschbach. A few weeks later, the Monuments Men received a tip from an unexpected source informing them that Gurlitt was deceiving them. On 29 April 1946, forester Karl Gruell wrote to Bavaria's Governor and Finance Minister, as well as the Monuments Men, noting that he had heeded the declaration by the Allies nine days prior that ordinary Germans with knowledge of those who, during the war, had "robbed or removed property" from victims of the Nazis should report that information. "It's known to me—as it has to be to the responsible [government] office in our local community—that in March 1945, Dr. Gurlitt from Dresden came

with two trucks laden with around 100 [crates]," he said. Gruell implied that it had become common knowledge that Gurlitt's boxes contained valuable French artworks, copper engravings, and rare books so that even he, as a lowly forester, knew about it.[70] The widespread rumor, Gruell warned, was that Gurlitt's collection of hidden artworks was worth about twelve million reichsmarks.[71] Gruell had no way of knowing, but the roughly one hundred works that Gurlitt turned over to the Monuments Men were probably worth slightly less than twelve million reichsmarks. The total worth of Gurlitt's roughly 1,000 works far exceeded his valuation.

The Monuments Men asked Gurlitt to respond to what Gruell had said, while keeping the forester's identity hidden from him. Gurlitt wrote on 18 June that he had been a low-level dealer for German museums and "institutions" and that all his business records and correspondences had been destroyed in the Dresden bombings. Consequently, he claimed, it would be "immensely difficult" for him to prove rightful ownership of his artworks. Even overlooking the reality that Gurlitt had purposefully neglected to preserve his records, most art dealers have a rough idea of where and when they acquired their artworks, particularly those with the highest market value. Essentially, Gurlitt was implying that he suffered from severe amnesia, at least as far as his art trove was concerned.[72]

On 26 September, the Monuments Men recorded in their file that they asked Gurlitt to swear that he did not have any artworks acquired in or from foreign countries, which, of course, even Gurlitt could not.[73] Without noting the source, Gurlitt's interrogators wrote that they had "received information" that Gurlitt had eleven paintings and drawings by Max Liebermann that he had purchased in Paris during the war but that he had not included these alleged Liebermann works in the list that he submitted to the Monuments Men. In reality, unbeknownst to the Monuments Men, Gurlitt had around seventy works by Liebermann. Gurlitt was never asked to clarify how many Liebermann artworks were in his possession, a sign of the overwhelming task that the understaffed team of Allies was trying to accomplish—frantically sifting through hundreds of thousands of pages regarding potential looting by dozens of Europeans.

Observing how overworked the Monuments Men were, Gurlitt reached out to French art historian Rose Valland, one of the few women who had worked in Nazi-occupied Paris to protect art from rapacious Germans like Gurlitt. Now that Valland was a captain for the Monuments Men and a high-powered member of the squad investigating him, Gurlitt wrote her a fawning letter on 1 October, pontificating about who could have enabled Hitler's looting of artworks without once mentioning his own participation in the Führermuseum Project.[74] A lack of coordination between the French government and the Monuments Men, including French nationals like Valland, was instrumental in Gurlitt's successful deception. Writing to the Monuments Men, the French government expressed concern that Gurlitt had returned sixty-nine wrongfully acquired paintings to Paris but that he had bought over two hundred paintings there that dealers in Paris might have acquired under dubious circumstances—a point in direct contradiction to what he had told the Americans. The French officials believed that Gurlitt had not only acquired paintings for the Führermuseum in Paris but also amassed a collection there for his personal use. "Were they lost?" they wondered about the paintings, adding, "We do not think so," implying that Gurlitt was being honest with the Allies about only a fraction of his collection.[75] French officials further submitted a document to the Monuments Men, stating, "It is probable that there were still other paintings bought from [France] by Gurlitt and which are not on the list."

Yet, because resources for the Monuments Men were scarce, the tip languished in the file of the Monuments Men, forgotten until the twenty-first century.

Nineteen months after the end of the war, the Allies began winding down their punitive responses toward Germany, aiming to rebuild the nation and strengthen western Europe in preparation for possible aggression from the Soviet Union. The total who had died in the war—due to the famines, genocides, diseases, and fighting it engendered—numbered between fifty million and eighty million people. Yet relatively few Germans were punished. On

1 October 1946, the International Military Tribunal at Nuremberg handed down death sentences to just twelve Nazi defendants.

Gurlitt was aware that the conclusion of the Nuremberg Trials gave many citizens from Allied countries the feeling that justice had been served and that it was time to move past this troubled period in Western history. This mentality began working to his advantage in 1947. Despite witnesses still insisting to the Monuments Men that he had transported about one hundred crates to Schloss Aschbach, Gurlitt kept repeating that he had only brought twenty-five and had handed over his complete collection. "I have never hidden artworks or anything else," he testified falsely.

Through his insistence that he had "very few paintings," Gurlitt in fact hid his secret in plain sight. He had realized during the war that acquiring hundreds of works on paper was the best means to avoid punishment for dubious deals. They were easy to transport and hide, they were often dismissed as less important than paintings, and it was harder for investigators to trace their original ownership.[76] On 9 March 1947, Monuments Man Edgar Breitenbach recommended formal dismissal of the tip from the forester Gruell. The Allies followed Breitenbach's recommendation.[77]

By mid-1948, the Monuments Men were experiencing fatigue and dwindling resources, further emboldening Gurlitt to push them to exonerate him. He sent them a statement in June falsely reiterating that all of his artwork had been acquired between 1942 and 1944, that any trace of the origins of the works had been destroyed in the Dresden bombings, and that he could not remember anything about their provenance.[78] He added a short autobiography, writing that he had fought the "hardest of fights with members of the NSDAP" and emphasizing his position as director of the left-leaning Zwickau museum before Hitler's rise.[79]

The strategy succeeded. Over the summer of 1948, the Monuments Men formally dismissed the complaints filed against Gurlitt by observers around the Pölnitz estate. "Mr. Gurlitt has been thoroughly and repeatedly questioned by representatives of this office on his art purchases in formerly occupied countries, as well as on the allegations made by Karl Gruell," they concluded in July. In August, they added that "this office believes that it has extracted from Gurlitt all desired information."[80]

The Monuments Men were in no position to request further resources to investigate Gurlitt and the dozens of other men who, they suspected, might have amassed collections of looted or confiscated art during the war. By this time, the United States, the main funder of the Monuments Men, was too preoccupied with the creation of the North Atlantic Treaty Organization (NATO) in spring 1949 and with supervising Germany's first postwar elections.

Growing more impatient, Gurlitt contacted the authorities on 6 November 1950, writing, "If I may, can I ask what steps I need to take in order to regain possession of the artworks, and if it would somehow be possible for you to send me a list of the confiscated artwork?"[81] The Monuments Men sent him an inventory of what they had itemized and approved for release. Before Christmas 1950, the Monuments Men returned to Gurlitt the 115 paintings, 19 drawings, and 72 other objects that he claimed represented his entire collection.

This included Beckmann's *The Lion Tamer* and Liebermann's *Two Riders on the Beach*. At some point before or around this time, Gurlitt had also acquired Henri Matisse's *Woman with a Fan*, the 1921 portrait of a brunette that the Nazis had looted from the Libourne vault of Paul Rosenberg during the war. It was these three works that would trigger the unraveling of Hildebrand Gurlitt's secret half a century later.

———✦———

Gurlitt's deception of the Monuments Men was hardly a sign of their incompetence as art experts. Rather, it was indicative of the overwhelming pressure this small team of dedicated historians faced in attempting to catalogue a gargantuan number of artworks. Though the group comprised around 400 men and women and was funded mostly by the United States, its members came from fourteen nations, often did not speak the same languages, and oversaw millions of items.

The dirty truth of postwar Germany—one that the Allies begrudgingly recognized and that the Germans and Austrians used to their advantage—was that so many Germans had either actively helped or been complicit with the Nazis that to bring them all to justice would require economically

annihilating the very parts of western Europe that were crucial to advancing NATO in the face of the growing Soviet threat. Even punishing official Nazi Party members and ardent Hitler supporters would necessitate prosecuting 10 percent of the population.[82] In this sense, Hitler gained a posthumous victory: his campaign of hate had been so successful that his movement was immune to full denazification, with consequences that would impact Germany and Hitler's victims for decades to come.

In a prescient line, Monuments Man Richard F. Howard predicted that, despite his team's efforts, Hitler's obsession with art would have a lasting impact on the international art world and on Germany's standing in the global community. "The legal status of 'Degenerate Art' is today as confused as the times and circumstances which saw its development," he warned.[83]

OUR SINCERE CONDOLENCES

"One gets a strange feeling, breaking up a home in which one has lived for a long time. It is as if one were destroying something as intimate as the shell of a snail or a mussel."

—George Grosz, describing exile

AFTER NEWS REACHED THE UNITED STATES that Adolf Hitler had "fallen," most Americans rejoiced in the defeat of the Third Reich, planning parades and parties to celebrate the eventual return of their boys fighting abroad. The mood was euphoric in New York City, but the atmosphere set off an extreme bout of depression for George Grosz, who was now fifty-one years old and living with his wife, Eva, in Huntington, Long Island. VE Day catalyzed the next phase in a vicious cycle that the exiled artist had been battling since moving with his family to America twelve years before. Grosz's depression followed a clear pattern: happiness at being free from Nazi threats, followed by guilt about the persecution of his friends, fellow opponents of Hitler, who had not been able to escape the Third Reich. This subsequently devolved into anxiety about being in exile, along with anger at how

the Nazis had irreparably harmed his career. Finally, Grosz would feel intense guilt about experiencing all these emotions in the safety of America, a country that had welcomed him and for which he felt a genuine admiration. He would subsequently try to cope with the stress by drinking heavily and retreating into his office; he never mistreated his wife or children, but he grew withdrawn and sullen. Upon regaining sobriety, Grosz would begin the loop again. By 1945, this destructive pattern was repeating itself more frequently and with an escalating intensity that would eventually kill him.

Only three days after Hitler's suicide on 30 April 1945, Grosz sent a letter to Wieland Herzfelde, his friend and former publisher, who was trapped in Germany. In it, Grosz stressed that he understood why Americans wanted to celebrate victory but said the triumphant mood felt like a national requirement, leaving little room for his own mourning and anxiety. Even as troops were uncovering the horrors of the war, many fellow New Yorkers did not want to focus on them or on the trauma that Hitler's victims had endured. "They've found the first of the Concentration Camps. And we'd rather not talk about the now tormented millions in Poland" and other camp zones, he wrote, admitting he was in a nihilistic phase. "It's maybe just a sign of the blindness of fate, given that [I have] lived through all this," wrote Grosz.[1]

The war that had only started for America after the bombing of Pearl Harbor on 7 December 1941 had lasted thirty-one years for George Grosz. Since Germany had entered the Great War in 1914, now referred to as World War I, Grosz's life had been embroiled in a never-ending swirl of psychological peril and emotional pain. Throughout the war, he felt not only guilty that his artworks and political activism had been insufficient to stop Hitler's rise but angry with the majority of Germans for ignoring, underestimating, or abetting the Nazi regime.

Grosz and Eva experienced the same trauma of exile as most other displaced Europeans, a phenomenon that would not be discussed widely in American and European societies for decades. Such a mass exodus of intellectuals and the middle classes had never before occurred in the history of a Western nation like Germany. Members of the press, psychologists, and the general public in the United States and England—the key host countries

of those exiled—were ill equipped to identify or understand this particular branch of post-traumatic stress disorder.

Its impact on not only Grosz but also the entire art world would be permanent and profound. The war had pushed the center of the art and fashion worlds to New York City; they would never again be anchored in Paris or Berlin. American art and fashion, created by native-born Americans who had never seen war on their own soil save for the attack on Hawaii, would dominate these spheres. The Europe that Grosz had tried his whole life to protect was now dead. In its place was ruins, and it would be many years before it became the continent that Grosz had always wanted it to be: a peaceful network of economically prosperous nations with vested interests in avoiding future wars.

Once George Grosz's sons, Peter and Martin (called "Marty" by his family), arrived in autumn 1933, the family moved into a house in Bayside, Long Island, and Grosz impressed upon his young boys the importance of integration. Though his poor English embarrassed him greatly, he began speaking it as much as possible until he was finally fluent. "He was nuts about America," Marty Grosz would later recall. "He put a lot of emphasis on being in America and being American." Eva worked on learning English, as well. At home, however, she still spoke German with their sons. She also learned American styles of cooking, while ensuring that Peter and Martin retained a healthy appetite for German fare. "We were very 'kraut-oriented' at home," remembered Marty. "My mom had radar; wherever we were she could snoop out a German butcher."[2]

Searching for themes in the United States to depict in a new body of artworks, Grosz felt that it would be inappropriate to turn the acerbic style he used to pillory German society on the country that had rescued him from a future of "only horror, terror and humiliation," he wrote in his notebook.[3] The majority of Grosz's greatest paintings warning against fascism were trapped in Berlin. These were the very artworks that had made him famous in America, where magazine and newspaper readers had seen reproduced images of them in numerous publications.

Resuming his crusade in 1934, without the benefit of exhibiting his older works in the United States, Grosz held nothing back in trying to warn America about Hitler. Through correspondence with his friends in Germany, Grosz had heard that the Jewish German writer Erich Mühsam had been dragged out of bed in the small hours of the morning by Nazis, then bludgeoned to death in July 1934 in a latrine at the Oranienburg concentration camp. Grosz created a three-part series on Mühsam titled *A Writer Is He!* In one work a Nazi hooligan kicks the fifty-six-year-old, still in his nightshirt, while another looks on laughing; in another, grinning guards beat him with a rifle, and a German Shepherd snaps at his trembling legs. In the background are two middle-class civilians, standing outside the camp near a house. It was a clear repudiation of the idea that ordinary Germans were unaware of the camps: located at the end of a residential street in an outer Berlin borough, Oranienburg was hardly remote. In the third work, *After the Questioning*, Grosz depicts the aftermath of Mühsam's murder, after camp guards had crudely staged the scene to look like a suicide. The work shows blood spattered on the walls as two Nazi guards, their boots covered in the writer's blood, exit the torture chamber.[4]

Grosz was furious that these graphic artworks made Americans so queasy that publishers did not want to distribute them. He wrote to Herzfelde that while he understood they were "atrocious scenes," depictions of Nazi atrocities "require a certain truthfulness." Still, he expressed to Herzfelde a conflicting, visceral desire to protect his native country now that he was on foreign soil, though he would soon shed this inhibition.[5]

Another 1934 work by Grosz, *Peace*, was completely devoid of the violence and sexuality that made Americans uncomfortable. In *Peace*, Grosz predicted that Germany would successfully pressure other powerful nations to appease Hitler's rapacious desires, triggering a second Great War. In the work, three cars speed along a road, egged on by a back car bearing a swastika on its hood. The first three cars bear the flags of Imperial Japan, Italy, and the Second Spanish Republic. On the side of the road, an angel of peace, drenched in the stormy weather, her wings dripping, holds a reed upon which is scrawled the supplication "PEACE." She tries in vain to flag the nations down. Grosz created the work a full two years before the Spanish

Civil War, three years before the Second Sino-Japanese War, and five years before World War II. It seemed too preposterous to be prophetic, and no institution would publish or display it.[6]

Writing Herzfelde again, Grosz complained, "Dearest Wiz, I believe that only a very small part of [Americans] who are already intellectually inclined are interested in my 'art,'" he wrote, noting that the struggle was even harder as Americans increasingly were turning to film for entertainment and reflection.[7] Still, he wrote Herzfelde, he hoped to assimilate regardless.

Grosz risked one trip back to Europe to alleviate his homesickness, as well as to dampen his guilt at leaving behind his frail mother. She had not wanted to emigrate because she did not foresee war but still had urged her son to escape the death threats that he and his family were receiving from the Nazis. Between May and September 1935 Grosz visited France, the Netherlands, and Denmark, arranging to see his mother outside Germany. Inspired by the trip, Grosz created a series of works depicting castaways and shipwrecks as metaphors for the dislocation of European intellectuals, hoping to draw attention to the matter in the United States. Yet the works failed to sell; the topic was too depressing for Americans, many of whom saw Grosz's immigration to America more as a strategic move to benefit his career than as a result of direct persecution, a danger that they still largely dismissed.[8]

Despite feeling adrift, Grosz looked on 1936 with optimism. The year promised to see the publication in the United States of *Interregnum*, a portfolio of sixty-four drawings made between 1918 and 1936 on the themes of fascism, antifascism, and communism, most of which neither the German public nor the American public had ever seen. He hoped that it would be just as successful in America as his portfolios had been in Germany—not only financially but also to serve as a catalyst for intellectual reflection and political change.

In *The Voice of Reason*, the artist mocked the idea that Nazism could be stopped with words instead of military force. In the drawing, an intellectual on a broomstick horse, wearing a dunce cap, is dwarfed by German troops passing by him, wearing swastika boot spurs. Nazism, Grosz advises, is too terrible to be stopped by rhetoric alone. In *Jigsaw Puzzle* Grosz warns America against considering communist Russia a possible long-term ally. The work

shows the body of a man divided in half, modeled on the Roman god Janus. The right half is a scowling fascist, with a soldier's cap, a gun slung on his back, and a knife in hand. The other half, a communist, is smiling but holds a hammer concealed in a bunch of peace reeds. Grosz's message is clear: both communism and fascism are enemies of America and, ultimately, two sides of the same danger—violent authoritarianism. Grosz warned decades before the Cold War that after fascism was defeated, communism would pose the next threat.

Publishing such incendiary works in 1936 was risky for Grosz; holding only a German passport, he was risking extradition now that the Nazi government made criticism of the Reich a prosecutable offense for German citizens. Though the chance of this was relatively small, it was an extra burden Grosz put on himself.

Hoping for support from American cultural heavyweights, Grosz wrote to Ernest Hemingway in July 1936, asking him to write an introduction for *Interregnum*. He praised Hemingway's writing and politely explained that he had undergone difficulties establishing himself after fleeing fascism, an ideology that the thirty-seven-year-old author fervently opposed. "I think a writer like you (naturally, if you're interested) can write a much better essay than an erudite 'Art Historian,' or some professional bloke," Grosz wrote.[9] Hemingway never replied, and Grosz decided to publish without the support of prestigious intellectuals—the kind of support that he had received in Berlin.

The book launch failed, in large part due to overpricing by the publisher, who charged $50. The amount was far out of reach for most Americans, given that the working class, which had made up the majority of Grosz fans in Germany, earned around $14 weekly. Compounding the failure was the fact that even educated Americans were largely ignorant of European politics, making the unlabeled and unexplained pieces of highly specific social satire fall flat. Out of a planned edition of 280, only about 40 were sold. There was very little press coverage, as Grosz was still learning English, and even the *New Republic* declared it an unrealistically negative view of European politics.

Interregnum was Grosz's last great portfolio of artworks. Instead of invigorating his faith in the American art world, it exposed to Grosz the large

chasm between his desire to integrate and the language and cultural barriers he faced.

Grosz's challenges grew after a December 1936 exhibition at New York's Museum of Modern Art (MoMA), titled *Fantastic Art, Dada and Surrealism*. The section on Surrealism, the genre more popular in the United States, was more thoroughly researched and laid out; visually, it was more entertaining. The section on Dada, by contrast, lacked an explanation of its origins as a movement that often purposefully made nonsensical art in an effort to demonstrate how post–World War I Europe was embroiled in illogical, chaotic policies and growing racial intolerance. Instead, the movement to which Grosz had belonged seemed pointless to Americans. Lazily, MoMA did not fully translate commentaries in German by Grosz and Herzfelde that explained Dada's goals. Moreover, it arranged the works among famous pieces by revered Old Masters such as Hieronymus Bosch, resulting in a hodgepodge exhibition of three wildly disparate artistic movements. The tragic consequence was that Dada, a movement that staunchly supported equal rights for Jews worldwide, was poorly understood and subsequently pilloried by Paul Rosenfeld, a prominent Jewish American critic: "Dada indeed was anti-art. It was the startling continuation, by a number of hurt and embittered, or possibly merely lazy and envious artists, of the world's perennial effort to belittle art and dismiss it."[10] It was a devastating end to 1936 for Grosz. The next few years would bring some significant successes professionally but no respite from his anxiety.

The first half of 1937 felt unbearably painful. Learning in exile about the Degenerate Art Exhibition, Grosz became depressed about his failure to stop the Nazi Party's rise. He tried to reach out for advice from his trusted art dealer, the Jewish German Alfred Flechtheim, only to learn that after fleeing to London, the fifty-eight-year-old had become frail due to the stress and died after slipping on a piece of ice. "I'm muddled," Grosz wrote to a friend stuck in Berlin.

Grosz drew some comfort from helping the few other German dissidents who made it to America. In July 1937, he rushed to Ellis Island to meet Hermann Borchardt, a Jewish German writer and friend who, astoundingly, had escaped Dachau. He "sat there, bewildered and frightened, without a

jacket, in a raincoat over a shirt, a conspicuous figure under the scorching sun," observed Grosz.[11] He invited Borchardt to live in his home, drawing a beautiful portrait of him in chalk. The work was hopeful—the kind of happy ending Americans preferred—and masterfully showed Borchardt as frail but strong, slightly haunted yet dignified, in a loose white shirt, looking forward to being part of the American dream. Still, no one wanted to purchase the work, as prospective buyers were captivated instead by more dramatic artists like Pablo Picasso and Salvador Dali.

———◆———

Not all Americans ignored Grosz's efforts. He drew hope from receiving a coveted Guggenheim Fellowship in 1937, which allowed him to devote himself fully to his art for the next two years. He continued trying to find an artistic style appealing to Americans without eschewing his roots. The pressure to do this became more intense in summer 1938 when the Nazis stripped Grosz and his wife of their citizenship, rendering them stateless. The US State Department worked quickly to grant him a hearing for US citizenship. Though viscerally devastated, Grosz would not let himself properly process his grief once he heard of the horrors inflicted on Jewish Germans on Reichskristallnacht on 9 November, an atrocity that made him feel ashamed to have been born a German Protestant.[12] Yet he was unmoored and increasingly turned toward alcohol and nicotine to cope. In a rare self-portrait, titled *Myself and the Bathroom Mirror*, Grosz is looking into a mirror inside a bathroom cabinet in his new home in Douglaston, Long Island, where he has stashed an assortment of wine and liquor bottles. It was a brutal confession that his alcohol dependency, artistic creativity, and stress release had become inextricably intertwined. The work was lauded by the Art Institute of Chicago, which put it on display in the museum.

Recognizing Grosz's troubles, Eva organized a vacation for the family to Cape Cod. The time away from New York City in the summer of 1939 cheered Grosz greatly, reminding him of the trips to the Baltic Sea that he had taken as a child. "My drawings mirror my mood. I was happy again," Grosz noted two decades later of his Cape Cod summer.[13] During the vacation, he drew sketches of Peter, now thirteen, and Marty, now nine, as they

frolicked in the waves. His enthusiasm for exploring the beach with his boys made them feel loved, as they delighted in the "inherent curiosity" that their father "just couldn't turn off," Marty observed.[14] He also created a series of delicate drawings of the dunes at Truro on the cape, a subtly sexual work that he paired in an exhibition in New York with a drawing of Eva sleeping nude on the beach, the mound of her vulva echoing the shape and style of the dunes. It was meant to be a touching tribute to his beloved wife and the mother of his children, a drawing that would have been considered mild even by Hitler's standards. Yet the sexuality, particularly that of a mother, made the general American public uncomfortable. One of his Cape Cod works was awarded the esteemed Watson F. Blair Prize by the Art Institute of Chicago, which included a much appreciated $600 award, but the others failed to sell well.

Infuriatingly for Grosz, the exhibition of his Cape Cod works coincided with a display at MoMA of Pablo Picasso's antiwar painting *Guernica*, only two years old, which MoMA's director Alfred Barr declared the sole significant antifascist work of art. It was a slap in the face to everything George Grosz had worked on and sacrificed for over the past twenty years—and a sign of Barr's unfulfilled promise to help Grosz integrate into the upper strata of the New York art world. The Cape Cod artworks had been Grosz's attempt to create the type of pleasant art that Americans supposedly wanted. Now, recognizing the looming threat of war in Europe, MoMA and the American public were declaring that no one was producing antifascist art except for Picasso, who in reality had spent the past several years creating apolitical art.

Dismayed but undaunted, Grosz continued creating artwork correctly predicting international military policy in ways that even the Department of War did not foresee. He was almost certain his works would not sell but felt an inescapable moral compulsion to warn the world. In one work from 1940 that languished unpublished, Grosz depicted Hitler in an armchair with a self-inflicted gunshot wound, a pistol at his side. Behind the Führer hangs a poster indicating that Germany has staged a failed campaign against Russia, a chillingly prescient image given that Hitler and Stalin had just signed the Molotov-Ribbentrop Pact in August 1939, promising neutrality; Hitler would not break it until a year after Grosz completed this work on paper.[15]

Straitened finances required Grosz to return to teaching in 1941, a job he enjoyed because he loved interacting with students but that made him feel like a failure for not earning enough from the sale of his art. He finally managed to publish one drawing that delicately depicted the strength of a concentration camp prisoner in Germany in his regulation pajamas, behind a barbed wire fence, gaunt and bald but determined to live. Grosz had mined the details of the piece from Borchardt, his friend who had escaped Dachau. It was far more accurate than contemporaneous journalism in America, which was largely ignoring Hitler's atrocities.

Months before the Japanese attacked Pearl Harbor, Grosz had predicted that an attack by the Axis powers, quite possibly an aerial attack, would force President Franklin D. Roosevelt to enter the war, making Americans feel foolish for not recognizing the threat earlier. In *A Handful of Don Quixotes*, an ink-and-pen work on paper, an American man on a tiny horse waves a banner urging "KEEP AMERICA OUT" of the war, even as swarms of Axis airplanes come to bomb the mountain on which he is standing. Author Ben Hecht published the drawing in one of his books, but US involvement in the European war still seemed like a fantasy to many Americans. Grosz resisted the urge to publicly declare "I told you so" after the attack in Hawaii on 7 December 1941 killed over 2,300 people.[16]

Characteristic of his fearless nature, Grosz was open with journalists about his depression, his anxiety in exile, and his persistent hopes in the face of what he perceived as his current failure. Despite appearing in over fifteen exhibitions in 1942 and 1943, Grosz was unable to sell much artwork. In February 1943, he gave an interview to Helen Boswell, a leading journalist for *Art Digest*, in which he was blunt about his torment. "I am torn in two," he told Boswell. "It is like living in a haunted house, you can't escape it and you can't forget."[17]

At the end of the year, the *New Yorker* published three lengthy articles focusing on Grosz. The series, by Richard O. Boyer, opened with the declaration that "George Grosz is one of the world's great artists," chronicling his success at integrating into America. Grosz had, Boyer noted, a "handsome, buxom" wife, a two-story house with a lovely garden and a new lawnmower, and a feisty Scottish Terrier named Punch.[18] The article also noted that

Grosz had successfully reared two intelligent and polite sons who attended the esteemed Dwight School and Phillips Andover Academy. Unbeknownst to Boyer, Grosz now had enlisted his son Marty in not only mastering English but also understanding what the artist considered the pinnacle of subtle American satire: *New Yorker* cartoons.[19]

Yet Boyer indicated some of Grosz's inner turmoil: describing him as "a taut, and troubled German of middle age, with suspicious blue eyes in a brick-red face," Boyer noted that Grosz felt anxious and under pressure as an immigrant artist.[20] He felt a burden that an "artist must find and identify that extra something for which there are no words."[21] Boyer referred to "demons in the suburbs," noting that Grosz had become obsessed with dissecting the nature of evil. The journalist described the artist as a man who had thrown himself into learning how to successfully integrate without taking time to mourn the shock of exile.

At night, Boyer observed, Grosz bounced between trying to relax by reading inspiring books, such as Dale Carnegie's *How to Win Friends and Influence People*, and absorbing horror books and nonfiction works on serial killers; his literary pursuits were part of the artist's never-ending search to identify the "it" that results in evil like that of Adolf Hitler.[22] He decorated his studio with reproductions of art by Norman Rockwell, only one year his junior, as symbols of a reassuring normalcy. Rockwell's works contrasted strikingly with his own creations, which were filled with trauma, death, and destruction.[23]

"When Grosz does talk about himself, he has the gingerly, tentative manner of a man fingering a bruise," wrote Boyer.[24] The series observed the signs of post-traumatic stress disorder, but it was a full nine years before the first *Diagnostic and Statistical Manual of Mental Disorders* (DSM-I) would attempt to identify this type of stress that victims of trauma often exhibit.

There simply was no set of terms available to Grosz to begin to describe his pain. The artist angrily vented to Boyer that Hitler's rise to power and thus the slaughter of millions could have been prevented. It was a point that the *New Yorker* article addressed in a dismissive quip without acknowledging its veracity: "Grosz feels that if the rest of the world had been as psychically observant as he was, everybody would have known as early as 1919 that

Fascism was coming," wrote Boyer, as if Grosz were speaking from the bene-
fit of hindsight rather than having warned about this for years.[25]

Boyer introduced his third and final installment, titled "The Yan-
kee from Berlin," by announcing that he would focus on Grosz's current
work. Throughout the entire article, however, the journalist continued to
focus on Grosz's life before Hitler's rise to power. In fact, in all three arti-
cles, Boyer did not describe any artwork that Grosz had created after coming
to America in 1933. Though his profile was an astute, if flawed, observa-
tion of what brought the artist to America, it did little to educate readers
about Grosz's contemporary work and the decade he had spent in Amer-
ica attempting to sound the alarm about the threat that Hitler posed to the
United States.[26]

By 1944, after the *New Yorker* articles were published, Grosz expressed a
feeling of irrelevancy, writing a friend, "[The] more I go on with my work, it
changes and all of a sudden there is fire and ruins and grim debris all over,"
noting that "sometimes I feel so utterly out of step of our times."[27]

As the war drew to an end in spring 1945, Grosz felt more anxiety, not
less, particularly after his son Peter joined the US Armed Forces to fight the
Nazis. The proud parent could not forget what his fellow artist Käthe Koll-
witz had undergone when her son, also named Peter, had signed up for the
Great War and quickly been killed. Peter Grosz survived the war, going on
to graduate from Harvard University. Yet the stress of his army enrollment,
while it lasted, was another burden on Grosz. The fifty-one-year-old, worried
about what the future held for his career and his family, tried to mask his
pain with yet more drink.

———◆———

After Victory in Europe Day on 8 May 1945, as his fellow Americans felt a
relief that they could now release the war's stress and celebrate victory, Grosz
grew more obsessed with the war than ever, expressing a feeling that he was
"trapped."

Writing a friend still in Germany, he expressed frustration that his new
painting, *Cain*, arguably one of the best-ever commentaries on Hitler, was
being ignored by a nation too eager to move on from World War II. Grosz

drew parallels between his war-themed works and those of Francisco Goya, whose output also was underappreciated during the times when the atrocities Goya depicted were actually occurring. Grosz had named the work *Cain* as a deliberate rejection of the popular idea that Hitler should be equated with Satan. Referring to Hitler as "Satan" or "a monster," Grosz believed, fetishized the Führer and obscured the reality that he had been a real human whose atrocities had been enabled by fellow humans. Instead, Grosz compared Hitler to Cain, the son of Adam and Eve who, in the Book of Genesis, murders his brother, Abel. Cain had been jealous of Abel's success and piety, which Grosz saw as an apt metaphor for Hitler's hatred of Jews. In his own painting, Grosz explained in his letter, Jewish German men, women, and young children—the "victims of fascism" who have "long since been transformed into lousy skeletons"—lie in a pile at Hitler's feet. In the background are bombed, burning cities. Hitler, by now realizing the Allies will defeat him, is "sitting in the infernal landscape he designed himself. He has sown hatred, and hatred he hath harvested," wrote Grosz of the artwork. "It is a documentary of our time for future generations—maybe it's a nightmare but still: it's as it really was," he concluded in the letter.[28]

The artist felt mentally exhausted. Even a $700 prize by the Carnegie Institute in Pittsburgh was not sufficient to cheer Grosz for long; it coincided with his learning in October 1945 that his aunt and mother had been dead for six months, having perished in one of the last Allied bombings of Berlin in spring 1945. Grosz felt unable to mourn their loss openly, though he felt it deeply as he had been close to both women. Americans gave little thought to the thousands of German civilians, mostly women and children, who had died at the end of the war as casualties of a necessary but bloody barrage of bombings designed to expedite the Reich's capitulation. Grosz's psyche was torn in two when he thought of his family's loss: as an anti-Nazi and patriotic American immigrant with a newly minted US passport, he understood the necessity of the bombings. Yet they severed him from his family. As pained as his wife was at seeing her husband's depression, her family had escaped the war intact. Indeed, thousands of Americans also were mourning the losses and injuries of American troops in Europe. Unlike Grosz, however, they could console themselves that their young men had laid down their lives

to ensure that good triumphed over evil, a far more heroic death than being a desultory casualty of war.

Overall, there was a tremendous amount of optimism in the United States after Hitler's defeat. The war had invigorated the economy, and the relative isolation of America ensured that, despite rationing, new innovations could be developed during wartime that now could be put into production. Grosz succinctly described the postwar atmosphere in America as an obsession with the new phenomenon of "supermarkets" and the luxury of iceboxes, tethered to an increasing anxiety regarding the nation's position as a growing world power with nuclear capabilities.[29] At the same time, corpses lined the streets of Berlin, providing fodder for a burgeoning rat population in a city that had once been a world power but had become a sea of rubble. The dichotomy between where Grosz now lived and the land from which he came was vast.

The last major retrospective for George Grosz, comprising around seventy artworks, took place at the American Artists Galleries in October 1945. His hours of poring over *New Yorker* cartoons with his son Marty had finally borne fruit. Having finally mastered the ability to pun in English—one of the hardest tasks in learning a foreign language—he titled it *A Piece of My World in a World Without Peace*. The show also represented progress for the artist on another level: his curator for the show was a woman, Pegeen Sullivan. While Grosz had always been ahead of his time in supporting female expressions of sexuality, including those of his wife, and in promoting the artistic efforts of his female peers such as Käthe Kollwitz and Hannah Höch, prior to his integration into the United States he had been unaccustomed to considering women his full intellectual equals in leading the charge to shape the art world itself.

Grosz's professional relationship with Sullivan signified the artist's ability to evolve regarding his views of women in the workplace. The two enjoyed a warm friendship, and Sullivan regularly came over for dinner with Grosz, Eva, and Marty. The teenage Marty would chuckle as his father subjected Sullivan to one of his favorite pranks: the ever-economizing Grosz would buy expensive wine in lovely-looking bottles to share with Eva over intimate nights in. Then, before Sullivan or other friends came to the house in

Huntington for a party, he would pour cheap wine he ordered in bulk into the empty bottles that once stored the expensive vintages. Marty held the bottles and a funnel steady as Grosz poured in the cheaper liquid. "George, darling, what is your secret? This wine is delicious!" Marty would hear Sullivan exclaim as she puffed away on a cigar while he and his father suppressed chuckles.[30]

In her catalogue foreword for the retrospective *A Piece of My World in a World Without Peace*, Sullivan praised Grosz's persistence in trying to warn the public about fascist and racist injustices. "In their deeply felt, penetrating and ironic commentaries on life during the past three decades, these pictures form a unique artistic and sociological document," she wrote, noting that they demonstrated how Grosz had risked his life and livelihood because of attempts at "crying out his warning against the growth of Nazism," the very movement that had stolen hundreds of his artworks that were still missing in Germany.[31] Speaking with the press and visitors, Grosz emphasized the fact that his artworks had a purpose, clear goals that could be deciphered by looking at them, in contrast to the growing abstract art movement. "My pictures can be 'explained,'" he said, likening them to biblical parables.[32]

The title work, for which the retrospective was named, had been Grosz's attempt in 1938 to use art as therapy after he had fled to America and started experiencing nightmares during which, as he described, "the horror came back again, and all the terrible things emerged from the bloody closet room to which I had relegated them. Then those memories streamed through my pictures: men wading through swamps and bloody fog, bones rattling, flesh wasting away, chasms that were flat and long and eternal and never ended; and the men trotting along like ghosts in the crackling, blazing, smoldering glare of the burned cottages and the poised earth, without hope or goal."[33]

The retrospective included other key works that Grosz had created in his failed attempt to warn America about the threat the Nazis posed. Among them was *The Pit*, which Grosz considered the most significant of his American-made paintings because it was, in essence, several paintings rendered on a single five-foot-by-three-foot canvas that succinctly summarized key points of Grosz's career. In executing *The Pit*, Grosz used the same ferocious red, yellow, and brown tones that Hieronymus Bosch used in his late fifteenth-century

apocalyptic paintings. Moving clockwise, *The Pit* depicts a maimed German soldier from the Great War, followed by a corpulent prostitute copulating with a faceless man, indicative of the vices of post–World War I Germany. They are followed by a gallows from which three corpses dangle, painted in black, white, and red—the official colors of the Weimar Republic. Following several scenes of death, bombing, and murder is the image of a safe, out of which tumble a series of books; by this point in 1946, it had been widely reported that, upon opening Hitler's safe in Munich, GIs had been disappointed to see that it held only copies of *Mein Kampf.* Also on the canvas are a begging older woman and a maimed female torso, probably reflecting Grosz's continued mourning for his mother and aunt. In the center of the painting, surrounded by flames, is an overweight figure chugging liquor while sitting over a quagmire painted in dull browns and maroon.

It is hard not to see *The Pit* as indicative of Grosz's own despair and the crippling pull that it had on him; it was quickly acquired by the Wichita Art Museum for its permanent collection. Overall, the exhibition was a tacit acknowledgment by the American art world that Grosz's warnings about Hitler had been correct.

Still, Americans were not ready to agree with Grosz on what he named America's newest and largest threat: communism. The artist was not alone in fearing the far-left movement. Eric Blair, writing under the pen name George Orwell, had published *Animal Farm* the year before and would later publish *Nineteen Eighty-Four* in 1948. Like the writer Orwell, the artist Grosz faced pushback from elite critics skeptical that Russia—an ally in the defeat of Hitler—was now an adversary. "We should get used to 'war' the same way we are used to railroads, airplanes, telephones, radios and refrigerators," Grosz noted.[34]

Herzfelde, who wrote the introduction for *A Piece of My World in a World Without Peace*, underplayed Grosz's objections to communism because he was a communist himself. As with many of his other shows, the journalists covering the exhibition were ill informed about the intricacies of German politics, which were critical to the meaning of Grosz's work. Writing in the *New York Times*, prominent art critic Edward Jewell excoriated Grosz's painting techniques rather than focusing on the validity of the themes present.[35]

By 1943, Grosz was earning between $2,000 and $5,000 for a large oil painting and between $200 and $500 for a watercolor.[36] Combining these earnings with his salary as a teacher, he was able to maintain a middle-class lifestyle. Still, his annual income fluctuated, fueling his anxiety.[37] "I asked myself realistically: 'How much do you earn a week?'—and that was sufficient cause to consider myself a failure," Grosz wrote in his autobiography, *A Little Yes and a Big No*, published by Dial Press to coincide with the retrospective.[38] The book was well received by the *New Yorker*'s Edmund Wilson, who highlighted its sections on the Weimar Republic. "I have not read anything else which had made me feel to what degree life in Germany became intolerable during the years after the Treaty of Versailles," lauded Wilson.[39] Still, Grosz did not desire to return to his native land, even after the Hochschule für Bildende Kunste in Berlin offered him a position teaching master classes. "I determined to cast aside my earlier 'German' personality like an old, worn-out suit," Grosz noted in his autobiography. He now felt a persisting "bitterness" toward Germany and craved a calmness. "America seemed very normal to me after all those mad and hectic years in Germany. And I wanted to become just as normal."[40]

Despite his depression and cynical disposition, Grosz still felt it vital to foster young talent in the American art world. In addition to mentoring his students, he agreed in 1948 to allow an awkward, lanky twenty-year-old man to photograph him for *Look* magazine; the publication had named Grosz one of the ten most important American artists alive, following a poll of museum directors and art critics. The artist got on well with the aspiring photographer, who, like Grosz's younger self, had received mediocre grades in school but yearned to create art that sardonically commented on societal ills. The photograph that *Look* published showed George Grosz firmly planted on a chair in the middle of a Manhattan sidewalk—steps away from a "No Parking" sign. The impish portrait represented a big break for the young Stanley Kubrick, who went on to make *Dr. Strangelove* and *Full Metal Jacket*, films that warned of war's consequences and, like Grosz's images, were simultaneously serious and filled with dark humor. Regarding Grosz as an inspiration, Kubrick would treasure a copy of the career-making photograph, pasted in his personal scrapbook, for the rest of his life.[41]

Grosz was annoyed by how most of the young men and women he taught at the Art Students League were different than Kubrick. Unlike the aspiring filmmaker, Grosz's students were obsessed with the new enfant terrible of the New York art scene, the thirty-seven-year-old Jackson Pollock, nineteen years Grosz's junior. The growing popularity of abstract art occurred as a direct result of growing nihilism among artists like Pollock and Mark Rothko, who was forty-six at the time. Like Grosz, Pollock and Rothko drank heavily, but unlike Grosz they possessed violent tempers and severely misogynistic streaks absent in the German American's psyche. They advocated for Abstract Expressionism, an artistic movement divorced from social commentary that scorned the depiction of humans, figures, and symbols. It seemed to Grosz to be a form of anarchy, a point that Rothko, Pollock, and other Abstract Expressionists did not reject.

By 1950, the Cold War was slowly but surely visible, spurred on by the announcement of the Truman Doctrine three years before, in which the thirty-third President pushed for opposition to Soviet geopolitical expansions. Grosz wanted his students to fight against the Soviet threat rather than veering into abstract nihilism. Yet he was unable to convince them of this. Upset but still possessing his sense of humor, Grosz painted a portrait of himself surrounded by canvases that have been eaten out by vermin. He scowls at the viewer, with an exaggeratedly elongated face, holding a paint brush in his mouth. The canvas depicted in the self-portrait is broken, and a mouse peeks through.

———◆———

Six years after the war, in spring 1951, George and Eva Grosz traveled back to Germany for the first time in eighteen years. While Eva was thrilled to go, she knew the trip was upsetting for her husband; the couple only had the funds to afford it due to a small inheritance from Grosz's sister Clara, who recently had died. Clara had given Grosz a set of oil paints when he was ten years old, seeing in him a talent that few others recognized then.[42] From May to November 1951, using the funds that Clara had bequeathed them, Eva and George traveled throughout Germany and through the Netherlands, France, Italy, and Switzerland.

Postwar Berlin seemed bizarre to Grosz, though he enjoyed connecting with friends and loved ones. In late June, when the sun stayed high until 10 p.m., he went for a walk with his former publisher Wieland Herzfelde, heartened to see him again after years apart. Yet he felt an omnipresent pain at returning to Germany. A week later, he drank so much with Max Pechstein, the artist who Emil Nolde had falsely claimed to Joseph Goebbels was Jewish, that Grosz somehow broke two teeth. In Berlin, Grosz was angry that so many of his artworks had disappeared. He had no idea that many of them were trapped in the homes of those who had been complicit in supporting Hitler's regime, including Hildebrand Gurlitt, who by now had been cleared by the Monuments Men and had no intention of returning works by Grosz or anyone else.

The devastation that the war had wrought on Grosz's finances was clearer than ever during his visit to Berlin: a post-1933 drawing by Grosz fetched around $150, but his pre-1933 works had a market value of around $1,500.[43] Though dealers and collectors in Germany could not afford even the lowest of these prices, US buyers were jostling to purchase the early works. Yet Grosz had no idea where the majority of them were. As the trip concluded and winter set in, Grosz noted that he and Eva had felt like "survivors" back in Germany, and he was relieved to return to America.[44] Speaking with his son Marty, he expressed his pain at returning to Germany. "He outfoxed the Nazis. He got out. But it was never the same as it could be," Marty Grosz summarized of the conversations he had with his father about the return trip.[45]

Grosz had been disturbed by the reality that Berlin now was a split city, a casualty of a war in which Russia and the United States had divided control of the country. The communists would not build the Berlin Wall for another ten years, but the disparities between East Berlin and West Berlin were already apparent. West Berlin, though patently more prosperous, would clearly never be the art world power that it once had been. Grosz realized that the reordering of the art market away from France, Great Britain, and Germany and toward Manhattan was permanent; moving back to Germany would further damage his career. Art world elites now saw Germany as a backwater.

Now fifty-nine years old, Grosz expressed to Marty his angst that he would never be a great artist again. He worried justifiably that his career,

derailed by the Nazis, would be defined by the artworks he had created during the Weimar Republic. "He thought many artists were one trick ponies—they do one thing and then never anything else ever again—and he hated one trick ponies," noted Marty.[46]

Returning to the United States, Grosz received the commercial success that he had craved for years when Dallas-based department store magnate Leon Harris commissioned him to create a series of four paintings and several drawings portraying Texas. It was a welcome diversion. Grosz loved the Texan style of humor, which resembled his own—upfront, somewhat offensive, but ultimately jolly. He spent hours wandering around Dallas, asking indulgent residents to pose for the types of five-minute sketches he had learned to make in Paris decades before. Texans found him fun and fascinating, and one even gave him a Stetson cowboy hat, which thrilled him.

Harris arranged for the artworks that Grosz created to be exhibited at the Dallas Museum of Art under the title *Impressions of Dallas*. They showed Grosz's observational techniques at their best. During the twelve years he had spent living in the United States, Grosz had grown to appreciate African American culture to an extent that represented a significant progression from the attitude that he had shown upon first arriving in America. Though he was now an American himself, Grosz's German roots allowed him to visit and depict Dallas's African American community in a way that a native-born citizen could not at the time. In *A Glimpse into the Negro Section of Dallas*, a watercolor in bold tones of brown, gold, black, and red, the artist portrayed a crowd of black Texans as distinct, dignified individuals. In the foreground, a young black woman with a chic bob and trendy red lipstick walks toward the left; a dapper older man wearing a fedora and sporting a chic yellow and blue coat—much the type favored by Grosz himself—walks toward the right. In the background is a lively bar.

The generous $15,000 that Grosz earned from Harris allowed him in 1953 to pay off the mortgage on his house in Long Island. Remarking on this success, Grosz wrote in his journal that buying the house for Eva and himself was a successful embodiment of the American dream.

Still, this success came with yet another bureaucratic frustration—this time from America. At the same time as he came into ownership of his

house, Grosz became the subject of a two-year investigation by the Federal Bureau of Investigation (FBI), whose officials required him to fill out reams of forms confirming that he was not a communist threat. This enraged Grosz because he had been an early outspoken critic of communism, an ideology against which he had warned for twenty years.[47] The effects of the Red Scare also extended to the American art world's treatment of Grosz. The Whitney Museum in Manhattan curated a retrospective of Grosz that traveled to Kansas City, Pasadena, and San Francisco. Yet the curators refused to highlight the criticism of communism that had been present in Grosz's art for years, fearing that doing so would bring attention to the fact that Grosz had briefly been a pacifistic communist in the early 1920s and cause the FBI to investigate the museums.

After reading in a newspaper that the Metropolitan Museum of Art had paid $15,000 for a single Salvador Dali painting—a gargantuan sum at the time—Grosz contacted a lawyer to see if he could seek compensation from the German governments for not only his artworks that the Nazis had confiscated from museums but also the works they had stolen directly from his studio after he fled in 1933. He was unsuccessful. Both East and West Germany, he realized, felt it was in their best interests to discourage programs that compensated the victims of Hitler's regime.

By the beginning of 1956, Grosz was plummeting, despite his best efforts, into the very type of nihilism espoused by Jackson Pollock and Mark Rothko against which Grosz had warned his students. For the past several years, Grosz's disdain for Pollock had grown, particularly as Pollock was seeing more commercial success. Privately, Grosz referred to Pollock as "the dribbler" and, more wittily, "Jack the Dripper," even as Grosz envied his seemingly perfect life.[48] In that he was mistaken: within a few months, Pollock would run his car off the road in a drunken stupor, killing himself and a passenger.

If Pollock's destructiveness was internalized, Grosz's was globalized. The world appalled him; his family, however, he cherished. Grosz had a wife whom he adored and who adored him in return. He was deeply proud of and close to his sons, Peter and Marty, and took solace in celebrating Christmas together with them, Eva, Peter's wife Lillian, and Karin, the baby girl whom Lillian had recently delivered. He desperately wanted to be happy, and for

those few days, he was. Yet, as he wrote in his journal, after the carols were sung, the presents unwrapped, and the children returned to their homes, it seemed so difficult. He scribbled a garbled poem on a crumpled paper about his thoughts regarding his future:

> *it is all over—*
> *everything's lost—*
> *nothing—*
> *NOTHING—*
> *is working out*
> *over*
> *it is*
> *Nothing*[49]

———◆———

Grosz was now spending between $35 and $50 every eight weeks for large orders of alcohol at a local liquor store—roughly three times the amount an average family of three paid for groceries at that time. Eva encouraged him to go to local Alcoholics Anonymous meetings, and he did, but he found the program ineffective. His sons tried to help, and he was open with them about needing their support.

The final straw for Grosz came after he served on a jury for a local art show in Huntington. He did so as a favor to his community but became infuriated after hearing the other jurors ridicule art on display that was not abstract while complaining that Grosz's art was outdated. Afterward, Grosz told Marty that he felt like an inadequate and weak father, husband, and grandfather. "I'm honestly just a dumb dog—I could just throw up," he told his son.[50]

George Grosz was teaching the next generations of art world luminaries. Among the students at the Art Students League were Robert Rauschenberg, Cy Twombly, and James Rosenquist. Yet he felt that the belonged to the past.

So it was that in autumn 1958, George and Eva Grosz decided to move back to West Berlin, a tentative step toward repatriation after twenty-five

years in exile. Eva's family was still in the city, and while she had appreciated all that America had provided her, her husband, and her children, she had never shaken off an intense feeling of homesickness. George's strength to work temporarily returned. He climbed atop piles of rubble still left over from the war, sitting for hours and furiously drawing the city's ruins.

Grosz's politically infused sense of humor also returned. Now, he aimed it at the postwar government that wanted to forget the origins of the catastrophe. He wrote an op-ed in Berlin's *Telegraf* newspaper, weighing in on the debate over what to do with the bombed-out Kaiser-Wilhelm Memorial Church in West Berlin. Some West Berliners wanted to fully restore it, while others wanted to tear it down. Grosz had a different, stinging suggestion: "One should, I think, leave the single remaining [church] tower just as it is, as a sign of remembering and reality, instead of fully restoring it." He then went on, in a scathingly sarcastic tone, to propose turning it into a tourist attraction. Perhaps, he suggested, the remnants of the war could be bedecked in gold and silver coins: "Everyone will speak of the 'ideal city,' and the few million in costs will quickly be recouped," he quipped.[51] He may not have intended his suggestion to be taken seriously, but apart from the flourish with gold coins, the West German government adopted exactly the policies that Grosz predicted they would implement. Visitors to the church, its last remaining tower carefully stabilized and officially designated a memorial to the horrors of the war, would eventually carefully wind their way through market stalls hawking gaudy jewelry, souvenirs, and trinkets for an oversized profit, a portion of which they paid to the government.

———◆———

Back in Long Island, as 1958 came to a close, Eva wrote to Herzfelde about Grosz's depression, arguing that the permanent move back to Berlin was the best solution. Eva acknowledged that Grosz's depression significantly stemmed from his feeling that the German governments under which he had lived had robbed him of his possessions and career. She wrote to the German government pleading for restitution of some kind. "It was horrible for us to know that Germans had destroyed most of my husband's [artistic] output," she wrote, adding, "I can only claim—rightfully so—that the Nazis have ruined

our lives." She pointed out that emigration had "fully changed" George Grosz from the vibrant man she had married in the 1920s into someone depressed and broken. "When we received the news that a large portion of his life's work had been burned up by the Nazis, [he had] a total breakdown. From that day forward, his psyche changed," she wrote, concluding, "I am of the opinion, that the Nazis did not only destroy a large portion of his life's work, but completely destroyed his health."[52] The West German government eventually awarded George and Eva Grosz 117,437 marks and sent its sincerest condolences. It was a fraction of the monetary loss that Grosz had suffered.[53]

By the end of 1958, Eva felt that the family had sacrificed enough for George and that a return to Germany would benefit her marriage.[54] The couple had several talks and decided to move back to Berlin, selling their cottage in Long Island for around $20,000 to finance the move.

In May 1959, the American Academy of Arts and Letters in New York awarded George Grosz the Gold Medal for Graphic Arts, a tremendous achievement for any American artist, especially a foreign-born one. Grosz took the podium to speak to the audience, which included the playwright Arthur Miller, who was accompanied by his glamorous wife, the actress Marilyn Monroe.

The acceptance speech that Grosz gave was a rousing, articulate swan song, a scathingly honest, witty, and self-deprecating entreaty to encourage improvement in the nation that he had grown to love. He had, Grosz reminded his audience, come to New York twenty-six years earlier as a German. He was now leaving as an American.

Pacing along the stage, Grosz simultaneously made his audience feel entertained and uncomfortable. "The life of an artist is a story of constant growth, constant curiosity, and of observations and explorations," he began. Grosz argued that contributing to culture necessitated creating artworks that stood the test of time. "The thing is, for the general public, a drawing without a history is uninteresting," he noted, before transitioning into a criticism of abstract art. In a remarkable show of constraint, Grosz kept his remarks earnest but polite. "The decisive rejection of reality is a dangerous thing," he warned of the movement's nihilistic tendencies. "I've experienced the hidden joys and the horror and the angst of [life]," Grosz noted. Pausing to

contemplate his career, however, Grosz pointed to a moment in time that had made him feel truly content and fully loved: the summer he had spent with Eva and his sons at Cape Cod. "I was filled with joy and inner peace," he noted.[55] The crowd had no way of knowing that his allusion to that summer was his way of paying tribute to Eva's love and loyalty over the past forty years. It was their special secret.

———————*———————

A week later, Eva and George Grosz left for West Berlin. They arrived carrying the same suitcases with which they had fled to America, now a bit more battered and faded.[56] Eva expected—and George hoped—to join a community in Berlin that was at least somewhat similar than the one they had left.

It was nowhere to be found.

Otto Dix, who had made his name creating works depicting the graphic horrors of World War I, had been conscripted into the Volkssturm in 1945 while in his early fifties. He had been captured by the French and returned to Berlin emotionally shattered, one of Grosz's few friends still living in Germany. Many of Grosz's friends were now resigned to living in the countries to which they had been exiled. Erwin Blumenfeld—the friend who many years ago had woken up seminaked in Grosz's bathtub—had moved to New York and become a successful fashion photographer. Given the decline of Berlin's status in the art world, he had no intention of returning. Oskar Kokoschka had fled to Prague after Hitler took power and then to London. He was also mired in depression, regretting that he had not done more to be part of an anti-Hitler resistance movement and feeling personally responsible for the atrocities that his society had committed.[57] Kokoschka had received British citizenship and did not want to move back to Germany.

While dealing with the shock of reentry, George and Eva also were forced to confront how many of their friends and compatriots were now dead, mostly as a result of Hitler's policies. Ernst Ludwig Kirchner had fled to Switzerland, fallen into a depression, and shot himself in June 1938. The diplomat Harry Kessler, Grosz's patron, had stayed out of Germany after Hitler took power, spending time in Mallorca, scared to return to the Reich given his homosexuality and anti-Nazi sentiments. He had died in a clinic in

Lyon in November 1937. Käthe Kollwitz had her home destroyed in a bomb-
ing in 1943; she held on until two days after Hitler's death in April 1945 be-
fore she died herself, having never really recovered from the loss of her son in
the Great War. The Jewish German author Kurt Tucholsky, who had widely
and publicly praised Grosz during the Weimar Republic, had fled to Sweden
and become depressed, overdosing five days before Christmas 1935 in the
southwestern village of Hindås. Max Beckmann had left Germany after the
opening of the House of German Art in Munich, realizing that his life and
livelihood were at stake. The Art Institute of Chicago had tried to offer him
a position teaching a summer course; yet, by that point, the US government
was severely restricting visas, and he was unable to obtain one. He fled in-
stead to Amsterdam, where Hildebrand Gurlitt had visited him during the
war. Beckmann finally had been able to move to the United States where,
unable to take the stress of exile, he died of a heart attack on a New York
sidewalk two days after Christmas 1950. He had been on his way to see one
of his own paintings finally hanging in the Metropolitan Museum of Art.
He went to his grave unaware that so many of his confiscated and dubiously
acquired works were part of Gurlitt's ill-gotten trove.

———◆———

Back in Berlin, Grosz also tried to locate the hundreds of works of his that
had been confiscated from museums and stolen from his studio. He knew
that many of them had probably been destroyed by bombings or neglect but
that some were probably still intact. Like Beckmann, Grosz had no idea that
Hildebrand Gurlitt had acquired dozens of his artworks and hundreds of
works by other artists.

Unlike the artists of whom he took advantage, Gurlitt had escaped the
postwar period unscathed. In the late 1940s, he had become director of the
Kunstverein, or "art association," in North Rhine-Westphalia, an organization
that agreed with him that the activities of its members during the Third Re-
ich should simply be ignored.

Only one family had learned that works of theirs were in the Gurlitt
collection: the descendants of Jewish German lawyer and art collector Al-
bert Martin Wolffson. In December 1938, Gurlitt had bought twenty-three

drawings by Adolph Menzel, a revered nineteenth-century German etcher. The sale had occurred under duress; the family had desperately needed money to escape deportation to concentration camps and pay their way to New York. Gurlitt had knowingly taken advantage of this, paying only a fraction of the collection's actual worth. Immediately after acquiring the Menzel pieces, he sold one, *Roofs*, to Cologne's Wallraf-Richartz Museum for 1,400 reichsmarks—he had paid the Wolffson family only 300 reichsmarks for it. After the war the Wolffsons reached out to Gurlitt directly, asking for help in locating *Roofs* and their other artworks. Gurlitt responded to them only through his lawyer to say he had no knowledge of the collection's existence.[58]

By the time George Grosz returned to Germany in early 1959, it would have been too late for him to interrogate Gurlitt, even if he had learned that the dealer was hoarding a substantial number of his artworks. After a meeting with a publisher in Berlin, Gurlitt, who had always refused to have his poor vision corrected by an optometrist, crashed his car on the Autobahn after careening into the opposite lane and hitting a truck. He died on 9 November 1956. The sixty-one-year-old dealer left behind his wife Helene, twenty-three-year-old son Cornelius, and twenty-one-year-old daughter Benita.

Eerily, his death came thirty-eight years to the day after the 9 November 1918 revolution that ended the reign of Kaiser Wilhelm following the Great War, thirty-three years to the day after Adolf Hitler's failed 9 November 1923 Beer Hall Putsch, and eighteen years to the day after the 9 November 1938 Reichskristallnacht—The Night of Broken Glass—that set off the officially sanctioned persecution of Jewish Europeans that enabled Hildebrand Gurlitt to amass his gargantuan art trove.

Struggling to solve the mystery of what had happened to his artworks, Grosz tried to support Eva's desire to relocate but felt alienated from his native country. It seemed to be a completely different place. Walking along the streets, he was painfully aware that he was one of the few men left; so many of them, ranging from the youthful to the elderly, had been conscripted by Hitler in the final days of the war. Grosz felt angry that most Germans claimed that they had been completely unaware that Hitler had

physically harmed Jewish Europeans and others whom the Führer considered subhuman. The artist referred to them, often to their faces, as "piously meowing" liars.[59] It was not the most advisable way to make friends, but Grosz was correct: Germans were wistfully entering into a period of collective amnesia.

Three decades after his "Merchant of Holland" prank during World War I, Grosz created a scene in June 1959 in a German restaurant as a way to force Germans to confront the reality that the vast majority of them had either cooperated with or been complicit in implementing Hitler's policies that caused the deaths of millions and ruined the lives of millions more. Making sure that all around him could hear him, Grosz began loudly lauding Adolf Hitler as Germany's savior, its protector. He specifically used the phrases and catchwords that the Nazis had used during their time in power.[60]

The room went silent. Yet no one spoke out.

Grosz was miserable, but he once again proved that his political and psychological instincts were acute. He could see the demons with which Germany had to grapple.

He was, however, unable to continue struggling with them himself. On 5 July 1959, Eva, George, and a few close friends went out for dinner and drinks. After the meal, they drank schnapps as Grosz puffed away on a Havana cigar. When Eva announced she was headed to bed, the group hailed a taxi. Eva got out at their temporary home on Savignyplatz, in the Charlottenburg district of the divided city. She gently suggested to George that he come home with her. He declined.

The rest of the group continued to Dieners Restaurant, a cultural mainstay of Charlottenburg. Grosz was a regular there and had a pleasant exchange with the proprietor. Yet the artist seemed melancholy. More alcohol flowed. Eventually, he and the others headed back to Savignyplatz. Grosz hugged his friends and opened the door to his apartment building. Turning around, he lifted his hat, and said, "Ladies and Gentlemen!" before winking as the door closed.[61]

What happened immediately thereafter is unclear. Grosz, clearly intoxicated, seems to have tripped on the stairs. Yet there was no obvious sign of an injury on impact that would have killed him. A newspaper delivery boy

discovered him near the mailboxes early in the morning of 6 July, having asphyxiated on his own vomit. It appeared to be less of a case of a man too injured to stand and ask his wife for help than that of an artist too exhausted to do so.

Someone, perhaps the delivery boy, alerted Eva, and a few men carried Grosz upstairs. George Ehrenfeld Grosz, aged sixty-six, was already dead. The city coroner registered his death as heart failure.

In shock, Eva called Marty and Peter in the United States. Living in Chicago and working as a successful jazz musician, twenty-nine-year-old Marty immediately arranged to come back and comfort his mother. He felt shock but not surprise. He was aware of the extent of his father's drinking and the demons with which he was grappling, but his father had never possessed a death wish or been suicidal.

Five days later at noon, George Grosz was interred in a Berlin cemetery. His death was an irrevocable shock for Eva. Physically speaking, she had been far weaker than her husband for the past several years, so she had always expected to die first. Just one year after George's death, almost to the day, Eva passed away. Her family buried her next to her husband. Half a century later, Marty would still attribute her death to heartbreak at losing the love of her life.

Decades before Grosz's death, Charles Baudelaire, the French art critic and translator of works by Edgar Allen Poe, had written of Poe, "A part of what today is the source of our enjoyment is what killed him."[62] To a certain extent, the same could be said for Grosz, who, like Poe, was highly passionate, depressed, and dependent on alcohol. Yet Grosz had spent his life fighting for a more tolerant, less racist world, perpetually pushing Germany to confront the faults not only of her past but of her present. He had done so despite the knowledge that it cost him his career and took a crushing toll on his psyche.

In his final interview, with the *New Yorker* in 1943, Grosz had admitted that he coped with the stress of his work via methods that were detrimental to his own physical and mental health. However, he told the publication, he would not have changed anything he did to resist Hitler, fascism, racism, and violence in the years before he had fled to America as a consequence of

speaking out about those very topics. "On Judgment Day," he told the magazine, "I will take back nothing!"

Without intending to, the magazine anticipated his demise by ending that article—ostensibly about his future—with an epitaph that the *New Yorker* thought would be suitable for Grosz when he died. It was a passage that the poet William Butler Yeats had written about author Jonathan Swift's death:

> *Savage indignation there*
> *Cannot lacerate his breast*
> *Imitate him if you dare*
> *World besotted traveller, he*
> *served human liberty*

CHAPTER IX

HITLER'S LAST HOSTAGES

"No person lives longer than the documents of his culture."

—Adolf Hitler

Cornelius Gurlitt arose in his Munich apartment at sunrise on 28 February 2012 and puttered to the kitchen for a glass of water. It was a day like nearly any other in the past thirty years since he had moved to Munich. Against the wall leaned a rickety dining table, a single chair tucked in, with a placemat set, as always, for one. The kitchen had a few bulging trash bags ready for disposal—a chore that the seventy-nine-year-old dreaded. He was wary of his neighbors. His favorite sound was silence. Even his own inhaling and exhaling seemed intrusively loud. Cornelius did not own a television, rarely listened to the radio, and had never used the internet or a mobile phone. He did not visit restaurants. Instead, he bought canned goods—he rarely bought fresh fruits and vegetables—and painstakingly rationed them. Only occasionally he would treat himself to coffee and cake at a café ten minutes away from his house, a cozy establishment with a Queen Elizabeth II bobblehead doll in the window.[1]

Cornelius, Hildebrand Gurlitt's son, largely spent his years sitting quietly in a threadbare brown chair. It was not a spiritual exercise; although he had considered becoming a monk as a young child, his belief in any form of social cohesion, religious or secular, had crumbled long ago. He was not sure why or how. He only felt that life was safest when he sat still and alone.

Above all, Cornelius worried about spies. They could be any of the people on the street, in the hallway, or in the grocery store. He did not use the word "love," but he felt a deep connection to his sister, Benita, the only surviving member of his direct family. They had cared for each other since they had fled in February 1945, during the bombings, with their parents.

Half a century later, sitting in the silence, Gurlitt was acutely aware of even small noises, so it was with great alarm that he heard footsteps, then rapping on his door, then the buzzer. He did not answer.[2]

Suddenly, within seconds of the buzzer sounding, the door was being broken down. Cornelius stood, pale and trembling, in a vintage nightgown, his deep blue eyes contrasting with his papery skin. Men he did not know handed him a search warrant as they barged into the room, ordering him to stay seated and quiet. Here they were at last, he thought: the spies.[3] In actuality, they were government tax and customs officials. They had, however, been spying on Gurlitt for over a year, using multiple CCTV cameras to film not only him but his neighbors in the apartment complex.

As Gurlitt sat uneasily in his dingy brown chair, the officers looked to the right of him and saw a marble statue by Auguste Rodin on a table next to a bookcase. Exploring the apartment further, they were shocked to find over 1,000 works of art. Some were stacked on wooden shelves, while others were in a bespoke cabinet created to house works on paper. Henri Matisse's *Woman with a Fan*, the painting that the Nazis had looted from Paul Rosenberg seventy years before, was rolled up in the pantry and stuffed among canned tomatoes. On the living room wall was Max Liebermann's *Two Riders on the Beach*, which had been looted from David Friedmann, the great uncle of David Toren.

Mid-level customs officials had initiated the investigation into Cornelius a full year before, suspecting him of dealing in Nazi-looted art. Yet they were now under orders from their boss, Bavarian tax prosecutor Reinhard

Nemetz, to assess the works solely for taxation purposes. Nemetz considered the identities of their rightful owners to be irrelevant.

On this 28 February 2012 morning, only one thing was certain. The officials had arrived in a small wagon. Seeing the amount of art in the small apartment, they realized they would need a fleet of trucks to take away the loot.

After the police and customs officers left three days later, taking with them the Gurlitt family's art trove, Cornelius grabbed his diary and jotted down a succinct line: "Door broken open. Customs Investigators."[4] Then his silence returned as he contemplated his past.

The last traumatizing event for Cornelius Gurlitt, before the raid on his apartment, had been his father's death on 9 November 1956. On hearing the news', Cornelius had written in his agenda calendar just five simple words: "6:30 a.m., my father died."[5] Almost immediately thereafter, Cornelius quit university in Cologne. At twenty-three, he had inherited 80,000 deutschmarks in assets, roughly $157,000 in 2019. He jotted down that he was determined "never" to earn his own money or "assiduously pursue a sensible profession." He was forthright about his reasoning: "I'm completely selfish and don't want to improve myself."[6] Cornelius considered his father's artworks a formidable asset, a view reflected in the nearly one hundred condolence letters that the family received in the wake of Hildebrand Gurlitt's death, most of which made no mention of the period from 1933 to 1945.[7]

After Hildebrand's death, his European business partners were eager to help liquidate his collection and courted Cornelius and his mother. Rudolf Schleier, a Nazi operative in Paris during the war, wrote that he had worked with Gurlitt "during a challenging time during the war in Paris and came to appreciate him" for his ability to discuss and solve their "mutual problems."[8] Another letter arrived from Aenne Abels, a dealer in Cologne. After a cursory mention of Gurlitt's death, Abels expressed his wish that the Gurlitts would employ him to discretely sell off parts of the trove, particularly works by Max Liebermann and specifically *Two Riders on the Beach*.[9]

These letters made Cornelius acutely aware that it was now incumbent on him to manage his father's estate in a way that preserved the family's public reputation while also allowing them to sell works discreetly on the grey market. Initially, Cornelius focused on misleading the financial authorities about the estate. Helene Gurlitt had inherited 700,000 deutschmarks in liquid assets from her husband, which she declared and on which she paid taxes. She also declared his collection, but valued it at only 12,000 deutschmarks, a sliver of its real value.[10] This mollified the authorities.

For two years after his father's death, Cornelius lived with his mother and loafed around Düsseldorf. His ambitions for a social life or career withered, especially once he was romantically rebuffed by a woman at a local museum after he told her of his affection for her; she did not reciprocate, and Cornelius would never reach out romantically to anyone again.

In spring 1959, Cornelius and his sister, Benita, both in their twenties, traveled to Paris for a mission that seemed surreally cinematic. They visited the dealer Raphaël Gérard, who had worked with their father, to retrieve 2,500 gold coins worth roughly 190,000 deutschmarks. To do this, they stuffed the coins into knapsacks and lugged them to banks, where they exchanged them for cash.[11] The pickup from Gérard occurred around the time that the family received two letters from Germany's Federal Office for External Restitution, the institution tasked with continuing the work of the Monuments Men. The bureau inquired about artworks they suspected Hildebrand Gurlitt had acquired in France for the Führermuseum. Cornelius trashed the letters, telling his mother, "No important mail came. Just yet another letter from the Federal Office for External Restitution," adding, "It's all too idiotic."[12]

Cornelius was convinced that his father had technically acted legally in acquiring the artworks. The war was over, he rationalized, and Hildebrand Gurlitt was a hero for saving the art from destruction. Moreover, the Gurlitt family had possessed these works long enough that previous owners should simply move on.

Helene Gurlitt shared her son's conviction. She decided in 1960 to move 380 miles away from Düsseldorf to Munich, where she could start anew. She

purchased two apartments there and agreed to finance a third home elsewhere for Cornelius. He found a 6,400-square-foot plot in Salzburg, nestled below the Austrian Alps, ninety miles away. He designed a two-floor, one-thousand-square-foot house with a white picket fence.[13]

For a few hours on a chilly January evening after Cornelius first arrived at his new cottage, it might have seemed to Cornelius that he had escaped his past. The kitchen featured a state-of-the-art refrigerator and new electric oven. Upstairs was an office and a small bedroom with a tiny bed that left no room for a partner. The walls throughout were bare, white and pure.

Yet, the very next day, a moving truck arrived with 250 of the most precious, historically significant masterpieces from his father's trove—and from European history.

Into the house came five works by Pablo Picasso and five by Edvard Munch. Movers carried in works on paper by Wassily Kandinsky, Ernst Ludwig Kirchner, and Max Beckmann. Cornelius Gurlitt carted in numerous paintings to decorate the walls—three works by Gustave Courbet, including a striking portrait of a shepherd with a scarlet scarf, framed in ornate gold; an Édouard Manet seascape with a dramatic gray sky and foamy green waves; a Camille Pissarro view across the Seine; two works by Eugène Delacroix, including a dramatic knight on a mighty grey steed; and an iconic Edgar Degas pastel of Parisian ballerinas arranging their hair. Six works by Pierre-Auguste Renoir, including a charming portrait of a peasant with a pipe, were placed throughout the house.

In some respects, Cornelius's new living room looked quite normal; a Danish-style lounge chair sat in front of a coffee table, placed on a Persian rug; light-colored bookcases on dove grey walls held books on history and culture. Yet, among these banal furnishings, Cornelius hung and placed permanent reminders of Hitler's Führermuseum Project and his father's involvement in it.

Two Riders on the Beach was still hanging in one of his mother's Munich apartments. However, Cornelius brought nine other of Max Liebermann's works to Salzburg, including two unique self-portraits. He squirreled away around twenty-five works by Emil Nolde in drawers throughout the house,

along with twenty works by George Grosz and thirty Rodin drawings. Behind Cornelius's lounge chair rested a fragile Rodin sculpture of a woman holding a sphere perched on an undersized pedestal.

Once he was comfortably ensconced in Austria, Cornelius's descent into isolation continued unchecked. "The thing is, people are easiest to deal with when they are dead. One can only endure very few of the living ones; most are latent murderers, torturers, robbers, scoundrels and those who beat others to death," he wrote to his mother.[14] Sometimes this worldview made Cornelius quietly despondent; other times it manifested in extreme anger, though there are no indications that he ever turned violent. When his mother suggested visiting him with a friend—in the house she owned—Cornelius flew into a rage. "I have no interest in that!!" he wrote her. "Now I'll have to figure out how to get food, make supper, chat about stupid rubbish," he wrote, signing the letter before adding a postscript underlined twice: "I want my peace and quiet."[15]

Cornelius did spend Christmas 1961 with Benita and her boyfriend, Nikolaus "Klaus" Fräßle, whom she had met studying art history at the University of Freiburg. Marriage was on Benita's mind, and she hoped that the two men would get along. She was acutely sensitive to Cornelius's social anxiety, and to her relief, Cornelius and Klaus hit it off quite well. The morning that the couple departed, however, Cornelius firmly told his sister that only she and their mother were welcome in Salzburg from then on. Klaus was not. Cornelius saw no reason to expand his social network.

Shocked, Benita refused to end her relationship but agreed never to bring Klaus around her brother again. She and her mother agreed to visit quarterly; Helene also paid for a maid to clean his home.[16] She hoped that taking care of Cornelius's basic needs would encourage him to venture out more into Salzburg society. She was confused that Benita had adjusted to postwar life but Cornelius had not. "You have gotten yourself worked up into a truly alarming paranoia," Helene wrote her son. "What in the world has happened to make you so jittery?"

He did not reply.[17]

From his windows Cornelius observed his neighbors, but only in so far as they brushed up against his property. A common diary entry read,

"//Neighbor-Children playing soccer / my fence as 'goal' / Ball more than once over the goal, came into the garden, hitting flowers etc / banged against the garden door //."[18] Ultimately, Cornelius's life was one of limited but regular routines. He took walks only after dark so as not to attract attention. Otherwise, he only left the house every two weeks to buy food and take his suits to the laundromat.

<center>———✦———</center>

In 1967 Cornelius returned to Munich, visiting his mother and sister for Pentecost. The square on which Helene's two apartments were located had recently been christened Artur Kutscher Platz, in honor of a Nazi playwright who had died in 1960. Soon after Cornelius returned, doctors diagnosed his mother with cancer. By New Year's Eve, it was clearly terminal. Cornelius stayed by his mother's side, dutifully recording his hours with "Mommy" in his diary. He and Benita were present in late January 1968 when she died.

The brother and sister responded to their mother's death in vastly different ways.

Cornelius, now thirty-five, retreated into his solitary world. Benita, however, began feeling a spiritual unease that could not be placated. She now regarded their father's collection and the wealth it had provided them with as sinister. "I've sensed a curse around [the artworks] like in Wagner's 'Ring,'" she told Cornelius, referring to the magic ring in Richard Wagner's Ring Cycle, a piece of jewelry that gives its owner the power to rule the world at the cost of contentment and peace. "What have we [inherited] other than angst, anger, worry and strife from this?"[19]

Yet, while Benita distanced herself from the collection, she felt unable to extricate herself from its allure. From Helene, Cornelius inherited the deed on his Salzburg home, Benita inherited the two Munich flats, and each sibling inherited about 340,000 reichsmarks in cash—the modern equivalent of nearly half a million dollars each. Benita felt queasy about staying in the flats: stacks of her father's artworks were still propped against the walls after all these years. She refused to relinquish them, however, and instead handed over the keys to Cornelius for safekeeping. Moreover, Benita took

twenty-two artworks to the home in Kornwestheim, outside Stuttgart, that she shared with Klaus, now her husband.[20]

Cornelius knew that to sustain their leisurely lifestyles, he had to sell a mid-priced artwork every few years, enough to provide for his needs without raising suspicion. By 1971, he had concluded that working with German and Swiss dealers would be most discreet. Cornelius reached out to the two auction houses that would become the mainstays of his transactions for the next four decades: Ketterer Kunst in Stuttgart and Galerie Kornfeld in Bern, Switzerland.

After Cornelius had written Wolfgang Ketterer a letter, the auctioneer's wife visited him in one of the Munich flats, where she placed 90,000 deutschmarks in cash on the table and took away *Bar, Brown* by Max Beckmann, a 1944 oil on canvas that the exiled artist had painted in Amsterdam and that Hildebrand Gurlitt had purchased from him. Ketterer promised "strict discretion" on this and any future deals; it was, Cornelius learned with relief, unnecessary for him to provide information about how his family had acquired their artworks.[21] *Bar, Brown* would later make its way into the permanent collection of the Los Angeles County Museum of Art.

Cornelius's arrangements with Eberhard Kornfeld were also discreet; the middle-aged dealer personally came from Switzerland to Munich for several watercolors and prints by Beckmann, Kirchner, and Nolde, which he successfully sold in July 1971. Cornelius chose to travel to Bern on 9 November—the anniversary of his father's death—to retrieve his 71,000 deutschmarks in cash.[22]

The exact volume of traffic between Cornelius and Ketterer Kunst, the Düsseldorf-based auction house, is unclear. The number of works he sold through Galerie Kornfeld in Bern, however, was almost certainly far higher. Cornelius found the policies of the murky Swiss art world, as well as the option of storing his earnings in a secret Swiss bank account, comforting.[23] Kornfeld was the closest Cornelius came to having a friend over his lifetime; the two exchanged banal pleasantries in their letters, though they always addressed each other with the formal *Sie* rather than the informal *Du*. Between 1971 and 1991, Cornelius sold at least thirty paintings, woodcuts, watercolors, and pastels at Galerie Kornfeld. Hildebrand Gurlitt's preference

for works on paper now proved shrewd: in wartime they had been easier to transport than paintings or sculptures and also attracted less attention in auctions because no single work fetched a conspicuously high price. Postwar, these same attributes benefited Cornelius as he sold off artworks of dubious provenance.

The thirty sales together raised 1.321 million Swiss francs, from which Kornfeld took a 10 percent commission. Gurlitt kept the remaining 1.18 million francs, then worth roughly $787,000. The works included three woodcuts by Emil Nolde, four pieces by Ernst Ludwig Kirchner, one work by Otto Dix, and one watercolor by Max Beckmann. The highest price, 600,000 Swiss francs, was paid for *Woman at Her Toilette*, a pastel by Edgar Degas.[24]

The deals went off smoothly, but Cornelius must have feared exposure because, over the years, his fear of spies grew. He warned Benita never to send him postcards, instructing her to seal letters in tinfoil before placing them in envelopes. He kept his shutters closed and covered in black fabric. "I just want to know what seedy pack is continuously spying on me," he told her.[25]

Eventually, Cornelius pushed Benita to a breaking point with his anxiety, for which she saw no basis, and his demands for circumventing the nonexistent espionage. "You issue written statements [to me] and I am supposed to act like a robot and [carry them out], however absurd," she eventually wrote to Gurlitt. "It's like I'm paralyzed, because I don't know how someone can help you anymore," she added. Cornelius soon cut Benita out of his life completely, refusing even to open the door to her when, in the 1990s, she made one final attempt to pierce his seclusion by visiting him in Salzburg. Seeing her outside his house, Gurlitt walked away from the window. The next day, when she returned, Cornelius had left a note pinned to his front door: "I do not want any visitors."[26]

———✦———

Cornelius's self-imposed seclusion ended on 22 September 2010 when he traveled from Munich to Zurich. In the morning, he took the high-speed Eurocity 196 to Switzerland and headed straight to his bank, formerly the Schweizerischer Bankverein but now a part of UBS. He withdrew €9,000, but

in his deposit box Cornelius had €18,000 in cash and around 290 gold coins worth about €250,000. It is unclear if he had other bank accounts. A few hours later, he boarded the Eurocity 197 for the return journey to Munich.

Passengers and police alike nicknamed the Eurocity 196/197 train the "Black Market Express," as assets were easily moved in and out of Switzerland. Yet the German Finance Ministry had started cracking down on its passengers to fund the country's expanding welfare needs.

As the train zipped past the affluent resorts on Lake Constance on the German-Swiss border, at around 9 p.m. German customs officials came through the car where Cornelius was sitting. Cornelius was utterly exhausted. A few weeks earlier, a local doctor had diagnosed him with a "weak heart," urging him to find a specialist. Confused, Cornelius had reconnected with Benita after decades of estrangement. She helped her brother meet with a cardiologist, who diagnosed him with "calcified coronary arteries and a heart valve defect" and recommended a treatment plan.[27] Yet Cornelius did not trust doctors and refused care, though he felt increasingly frail.

It was at this point that German customs officials reviewed Cornelius's passport, noticed that he had only stayed in Zurich for a few hours, and found his envelope with €9,000 inside. When customs agents asked Cornelius how he had earned the money, he said that it was proceeds from a sale that his father had made at the Galerie Kornfeld before the end of the war.

The officers had no choice but to let Cornelius go, assuming correctly that he was a quirky old man ill accustomed to speaking with the authorities. Yet a few days later, back at his desk, one junior officer writing up the routine report of the search paused. No one during the search, the junior officer realized, had asked Cornelius Gurlitt the question that Germans born after the war had been instructed from childhood never to ask their elders: "What did your family do during the war?"

The officer did something that Cornelius had never heard of, a rapid response that two years later would be replicated thousands of times in dozens of countries and numerous languages across the globe: he typed "Gurlitt," "art," and "Nazi period" into a search engine and pressed "enter."

After reading the little that existed in 2010 about Hildebrand Gurlitt on the internet, the junior customs officer correctly surmised that Cornelius

was selling off artworks that his father had acquired during World War II and that hundreds of artworks were likely in his possession. Strictly speaking, the junior officer's remit did not extend to items obtained before the Federal Republic of Germany was founded in 1945. If Nazi-looted art were in Cornelius Gurlitt's possession, however, this seemed to him to warrant an official inquiry on ethical grounds.

The junior customs officer wrote a report warning that a moral alarm needed to be sounded within the bureaucracy: Cornelius Gurlitt might be in possession of Degenerate Art, looted art, or both.[28] He dutifully sent his report to a senior officer in Munich, who agreed that Cornelius's fortune "may have been generated from crime in conjunction with the sale of art in Nazi Germany" and that Cornelius might have related assets stored in Switzerland.[29] An experienced bureaucrat, this senior official was unfamiliar with the murky world of grey market art, as the majority of his cases concerned weapons, counterfeit fashion items, and drugs. He would soon learn that, astoundingly, Cornelius had a greater legal right to possess a work of art stolen from Jewish Europeans gassed at Auschwitz than he did to own a pistol, a counterfeit briefcase, or a packet of marijuana.

This senior officer was curious about what Cornelius looked like, and in the first week of November 2010, he sat on Artur Kutscher Platz waiting for the mysterious old man to leave his apartment. His opportunity came one afternoon as Cornelius, now seventy-seven, tottered back from buying groceries, dragging a trolley full of food behind him, a grim expression on his face.

Unbeknownst to the senior German officer, Cornelius was incensed because he had returned to Munich from Salzburg, where the police had broken the lock to his house and looked inside after a neighbor reported him missing. Finding nothing untoward, the Austrian police had replaced the lock and seemed none too curious about the house's dazzling array of art. Yet the break-in had unnerved Cornelius; to him it was a bad omen—or evidence of spying.

The senior Munich customs officer had given himself a crash course on the Washington Principles, the set of eleven tenets pledging research into and restitution of Nazi-looted art that forty-four countries, including Germany, Switzerland, and Austria, had endorsed on 3 December 1998 at a conference

in Washington, DC. The Washington Principles stated that "art that had been confiscated by the Nazis," once discovered, "should be identified," that "relevant records and archives should be open and accessible to researchers," and that "every effort should be made to publicize art that is found to have been confiscated by the Nazis and not subsequently restituted in order to locate its pre-War owners or their heirs."[30]

Only a few months after the 1998 conference, Germany's Culture Ministry had flagged Hildebrand Gurlitt as someone who had worked in a prominent position for Hitler, recommending that the German government research what had happened to the dealer and his collection. Yet nothing happened. Now, in 2010, the customs office reached out to its counterpart in Switzerland for help. Hearing nothing, it sent another plea, reiterating that the case concerned money laundering and the liquidation of Nazi-looted art-works seemingly in violation of the Washington Principles. The office never received a response from Zurich.[31]

The silence caused the senior officer to turn for help in March 2011 to Augsburg-based prosecutor Reinhard Nemetz. It turned out that Nemetz personified the general German mentality that the letter of the law and the spirit of ethical behavior—even in cases where the Holocaust is concerned—are unrelated. Known throughout Bavarian legal and political circles as an emotionless "bulldog for the law," Nemetz disdained interactions with the media. To Nemetz, his professional role in the Gurlitt case had nothing to do with the horrific damage that the Third Reich had left in its wake. The stories of Jewish families who had spent seventy years searching for art that the Nazis had snatched from them after murdering their loved ones did not appear to move him. He knew that even if Cornelius did possess Nazi-looted art, the statute of limitations for the victims to reclaim it had expired in the 1970s.

To Nemetz, the Gurlitt case was purely a matter of tax evasion, and he was determined to extract a financial cut from the Gurlitt art trove to add to Germany's coffers. His investigation soon stalled, however. There was no concrete evidence that Cornelius had committed any crimes, the Swiss would not divulge information about his finances, and the Austrians noted that Cornelius had paid taxes there as a Salzburg resident, shrugging off further responsibility.

Nemetz needed proof that Cornelius Gurlitt was selling off art from his father's archive. If he had this, Nemetz knew, he could successfully bring Cornelius to justice for tax evasion, which had no statute of limitations in Germany, provided that the alleged evader was still alive.

<p style="text-align:center">———✦———</p>

As Cornelius's heart condition continued to worsen, doctors in June 2011 recommended surgery. Though he staunchly refused, he realized that he needed a larger reserve of cash for potential medical expenses. For years, Cornelius had owned a plot of land thirty miles outside Munich, planning to eventually build a second cottage there. He decided to stay in Munich permanently to avoid the strain of travel to Salzburg and sold the plot for €100,000. Additionally, he decided to sell another piece of art.

In September 2011, Cornelius contacted the Lempertz auction house in Cologne. Initially, he wanted to sell off Max Liebermann's *Two Riders on the Beach*. He had difficulty taking the painting off the wall, however, and instead opted to sell *The Lion Tamer*, the vibrant 1930 work on paper by Max Beckmann that his father had acquired in 1934, a year after the Nazis had started targeting Beckmann as "degenerate."

A few days after Cornelius called Lempertz, a specialist visited him in Munich. She found him "friendly and charming," yet was unnerved by how the apartment in which she received her seemed frozen in the late 1960s.[32] Indeed, when she encouraged Cornelius to speak about his parents, he used the present tense as though they were still alive. Even his manner of speaking seemed unusual, though she could not quite put her finger on why. She would decipher it later: Cornelius had spent so little time in conversation over the past six decades that his cadence still contained the rhetorical tics of a bygone era.

Cornelius claimed *The Lion Tamer* was his "crown jewel," a gift from his beloved mother.[33] Inspecting it, the specialist noticed that the work was dusty and had two small tears on its left margin. Still, it was an obvious catch. In contrast to many of Beckmann's cerebral works created in dark, muddled colors, *The Lion Tamer* featured a thrilling subject matter executed with bright colors that popped off the paper. Against a black-and-white

striped background, a male lion with a flowing mane perches on a squat stool with his paws under his chin, as a shirtless circus trainer with a spear stares at him head-on, striking a dramatic pose with his fists on his hips. His legs, clad in sunflower yellow pantaloons, are spread in a fighting stance.

The specialist swiftly restored the work's minor damage and prominently featured it in the catalogue for Lempertz's December 2011 sale, just in time for the holidays. Perusing the catalogue, Jewish German lawyer Markus Stötzel spotted *The Lion Tamer* and immediately wrote to the auction house, explaining that it belonged to Stötzel's longtime friend and client, the American Mike Hulton, who was now heir to Alfred Flechtheim's estate. Stötzel sent the auction house a copy of a postcard that Flechtheim had written to George Grosz about *The Lion Tamer* in 1933, hoping that the news would delay the auction.

Karl-Sax Feddersen, Lempertz's legal specialist, subtly informed Stötzel of what the lawyer already knew: it was not legally relevant that Flechtheim had lost dozens of pieces in fleeing for his life—or even whether Hildebrand Gurlitt knew this when he acquired the work. It did not legally matter if Stötzel could produce more evidence that the work belonged to the Flechtheim family. The statute of limitations on reclaiming the Beckmann had expired.

Lempertz feared bad press coverage, however. The auction house offered to give 30 percent of the sale price to the Flechtheim family, from which Stötzel would take a fee. With the sale in under two weeks, the auction house knew that it had the upper hand; if the family did not accept, the work would be sold and probably disappear once more. German law would protect not only the identity of the new owner but his or her right to possess the piece.

The family accepted the offer, and the auction house placed the estimate between €280,000 and €300,000. Demand was high. On 2 December, the piece sold for an astounding €871,200 and nearly broke the record for a Beckmann work on paper. The Flechtheim heirs received €216,000, while Cornelius Gurlitt earned €450,000; the Lempertz auction house took the remainder. The outcome irritated Cornelius. He told the auctioneers that the Flechtheim family members were "threats" to his father, who, Cornelius maintained, was the true victim of Hitler.[34]

Only days after the Lempertz specialist picked up *The Lion Tamer*, a judge issued the search warrant authorizing the breach of Cornelius's apartment to search for evidence indicating tax evasion.

In shock after the raid, Cornelius took comfort in his daily routine. He sat in his chair and listened to the silence. Now, though, he stared at the bare crates that the government officials had emptied. He was never charged with a crime. He did not hire a lawyer. He told those who later met with him that he did not understand that he had the right to do so. On 3 May 2012, Benita died of breast cancer, and Cornelius's isolation seemed complete—until eighteen months later when his secrets were splashed on the front pages of newspapers worldwide.

——◆——

On 3 November 2013, Germany's *Focus* magazine—a quirky blend of *Time* magazine–style articles and celebrity gossip—broke the silence surrounding the Gurlitt family by publishing the news that for nearly two years Nemetz had been holding a 1,200-strong "Munich Art Hoard" belonging to a ghostly-looking octogenarian recluse whose father had worked for Hitler.

The article, written by journalists who were intrepid but not art experts, wildly overestimated the value of the Gurlitt trove at $1 billion. Nevertheless, the names of the artists in the collection that had already leaked included Matisse, Renoir, Beckmann, Kokoschka, and Nolde. The collection clearly contained works that historians had presumed destroyed or that were utterly unstudied; if it was made public, resulting revelations could impact these artists' legacies on both financial and historical levels.

The *Focus* exposé was risky under German press laws. The magazine had not only exposed a government investigation—however narrowly focused—but also revealed the identity of the man whom the government was investigating. German courts frequently employ gag orders to silence the domestic press, but once the story broke, it was impossible to suppress international outlets. Soon Cornelius Gurlitt's front lawn was inundated with curious art enthusiasts, journalists, and Nazi hunters.

In the week after the *Focus* article was published, numerous other articles followed covering Hildebrand Gurlitt's beginnings as an innovative museum

director in Zwickau, his work for Hitler, and the lies he told the Monuments Men. The reporting made clear that despite being a signatory to the Washington Principles at the Washington Conference in 1998, Germany had amended almost nothing within its legal system regarding art restitution. For looted items held in government collections, the burden was on the alleged heirs to prove that artworks had been looted or "sold" under duress. Moreover, any claims were still ruled on by a commission that included colleagues of the very museums that the heirs were accusing of possessing their families' artworks. Routinely, this commission violated tenet four of the Washington Principles that "consideration should be given to unavoidable gaps or ambiguities in the provenance [of the art] in light of the passage of time and the circumstances of the Holocaust era."[35]

At this early stage in the breaking scandal, the US State Department's Holocaust specialists, including Stuart Eizenstat, the man who drafted the Washington Principles, considered it wisest to urge Germany behind the scenes to publish information regarding the Gurlitt trove, reasoning that this would allow Eizenstat and his team to admonish Germany publicly as a last resort. Still, even after international news outlets and Holocaust advocacy groups requested that both Nemetz and Chancellor Angela Merkel comment publicly about the Gurlitt case, both leaders repeatedly refused to do so. These German public servants even refused to acknowledge, in more opaque terms, the need for Germany to increase its efforts to restitute Nazi-looted and Nazi-confiscated art. Furthermore they forbade their underlings from speaking even indirectly on their behalves.

Within a few days of the news breaking that the German government had confiscated over 1,000 artworks from Cornelius Gurlitt's apartment two years before and kept the find a secret, Nemetz gave his one and only press conference. With him was Meike Hoffmann, an art historian at Berlin's Freie Universität whom he had asked to research the Gurlitt hoard. Although the Washington Principles stated that if Germany discovered potentially looted art, sufficient "resources and personnel should be made available to facilitate [its] identification," Hoffmann had been working alone, was based five and a half hours from where the artwork was located, and was balancing a full course load at the university. Unsurprisingly, she had made little progress.

Nemetz was deeply perturbed that the Gurlitt case had leaked—and even more irked that so many people throughout the world, including Holocaust victim advocacy groups, saw his investigation as somehow tied to history as opposed to a routine tax evasion case. "We don't see our task as art historical," the prosecutor declared, rejecting tenet seven of the Washington Principles that Holocaust victims from whom art had been stolen "should be encouraged to come forward and make known their claims to art that was confiscated by the Nazis."[36]

Hoping that as few people would attend as possible, Nemetz held the press conference not in Munich, Bavaria's accessible capital, but in Augsburg, his small hometown best known for its elaborate puppet theater. He refused to answer basic questions or provide a transcript of the event. Nemetz's assistant put it bluntly when the probability was raised that, at this pace, Holocaust survivors might die before seeing their art returned: "We're in no hurry."[37]

<p style="text-align:center">—◆—</p>

By far the most poignant and emotionally charged reactions to the Gurlitt collection came from the Jewish families who had clear proof that their Nazi-looted artworks, which they had presumed lost, were actually in the Gurlitt trove. David Toren, the descendent of David Friedmann and heir to Max Liebermann's *Two Riders on the Beach*, and the Rosenberg family, from whom Henri Matisse's *Woman with a Fan* had been looted in France by the Nazis, were righteously furious.

A few days after the news of the Gurlitt trove went public, David Toren was sitting in his Manhattan apartment high above the New York skyline when his phone buzzed. A friend was calling to ask if the Liebermann painting circulating in the press was indeed the same one that Toren had been trying to find for decades.

Memories of Toren's childhood in Nazi Germany now came flooding back. Particularly emotional for him was the moment when he was thirteen and, then known as Klaus Tarnowski, had gazed at *Two Riders* as his father, Georg, helped broker the "sale" of his great uncle David Friedmann's land to the Nazis before they escorted Georg to a concentration camp.

In August 1939, the young boy had escaped via the *Kindertransport* to Sweden, where he received postcards from his mother before both his parents were deported to Auschwitz and gassed. His brother, Peter Tarnowski, four years older, had been too old to qualify for the *Kindertransport* and had made his way to London, changing his name to Peter Tarnesby. After the war, Klaus had moved from Sweden to Israel, changing his name to David Toren. He worked for a patent attorney in Tel Aviv and met his wife, Sarah, a Jewish New Yorker in her late twenties. The couple moved to New York City in the mid-1950s, and Sarah gave birth to their son, Peter, in 1959.

As an international patent lawyer, Toren had reluctantly worked with German companies over the years. "I will never forget that they killed my parents. I work with them, but I don't like Germans," he resolved. Because of America's Marshall Plan, Toren realized, Germany was likely to become a major world power once more. He hoped that the nation would use its economic prosperity as a force for good and atone for its sins.

Over the decades, however, Toren observed how the German government, wealthy once again, often shirked its responsibility to help Jewish families reclaim their looted artworks. Even after the nation signed on to the Washington Principles in 1998, German bureaucrats continued to demand reams of documents that most Jewish Europeans who fled the Nazi regime had been unable to take with them and which the Nazis had subsequently destroyed.

Part of Toren's pain stemmed from the fact that he actually had escaped with numerous letters, photographs, and postcards, including his mother's final missive before the Nazis herded her and her husband into the gas chambers. Toren had kept them in his safe at work, calculating that they would be most secure there.

Yet, one Tuesday morning, as autumn was settling into New York, Toren headed to his Manhattan office and saw smoke billowing from his work building. It was 11 September 2001. Toren's family heirlooms on the fifty-fourth floor of the North Tower of the World Trade Center were about to be obliterated.

Toren felt a pang of anger upon learning of the Gurlitt trove, not only for the painful memories it resurrected but also because the German

government had kept the discovery quiet for almost two years, citing "data protection." "Whose data are they trying to protect—a bad guy's or my family's?" he fumed.[38]

The resurfacing of *Two Riders* had also startled David Toren's son, Peter, a patent lawyer in his mid-fifties living in Washington, DC. Beginning in childhood, Peter had learned from his parents about his grandparents' bravery and self-sacrifice. "There wasn't a time that I remember not being aware of it." Now, here was a tangible object, thousands of miles away, to remind the Torens that for David, the war was not yet over. One of the fifty paintings the family had thought to be lost still existed, waiting to come home.

Seeing *Two Riders* on the front pages of newspapers jolted Peter Toren, who had never expected even one of the family's lost artworks to ever be found. "It was very much out of the blue," he said.[39] Within days, David and his brother, Peter Tarnesby, filed documents with the German government showing they were the sole heirs to the Friedmann estate when the Nazis had looted it. They provided a copy of a document the Nazis had written about the collection, in which one officer noted, "It should be stressed that, especially among the paintings, there is a whole series of pieces" that would "certainly bring in foreign currency quickly." Cross-referencing this with Hildebrand Gurlitt's file, which was now accessible in the US National Archives, they clearly showed that Gurlitt had deceived the Monuments Men about the provenance of *Two Riders*.

Coincidentally, filming of *The Monuments Men* starring George Clooney, Cate Blanchett, John Goodman, and Matt Damon had recently wrapped up in Germany. Around €8 million of the film budget stemmed from German government contributions and subsidies. As marketing for the film began to escalate, an awkward question hung in the air: Would the German government put as much effort and money into rectifying the flawed work of the Monuments Men in real life as they did into lionizing the Allied heroes on the silver screen?

The German government replied to the Torens, telling them to wait and citing its two-year-old tax investigation.

"I thought the painting would be returned very quickly," said Peter. "I was naïve."[40]

Marianne Rosenberg was the granddaughter of collector and art dealer Paul Rosenberg and daughter of Paul's son Alexandre. After Paul had escaped to the United States following the Nazi invasion of France in the summer of 1940, he had worked with the help of Alfred Barr, the Museum of Modern Art's founding director, to regain a foothold in the modern art world in Manhattan. He wrote to Henri Matisse to say he had arrived safely in New York. The artist, upon receiving the letter, was primarily concerned with how his former dealer's Jewish heritage would affect his own career. Much to Matisse's annoyance, his daughter Marguerite, like Rosenberg's son Alexandre, became part of the European-based resistance. Although Alexandre could have escaped to America with his father, he firmly believed that, as an able-bodied man, he should combat the Nazi threat by joining the Free French Forces.[41]

In August 1944, toward the end of the war, Alexandre had unexpectedly rescued crates of his father's artworks in a train the Nazis had loaded up as they prepared to retreat from Paris. The rescue was turned into the 1964 feature film *The Train*, in which Burt Lancaster portrayed Alexandre. Feeling the need to be closer to his family now that the war was over, Alexandre moved to the United States in 1946 and married his wife, Elaine, on 29 February 1948, joking that the leap year anniversary would save him from buying her a present each year. Around this time, he had returned to France and was "disgusted" by the fact that everyone he met claimed to have been part of the resistance. Returning to America, Alexandre recognized that the art market had permanently moved to New York, and he resolved to make Manhattan his home as he followed in his father's footsteps as an art dealer. He insisted that Marianne receive a French education in the United States as a child, and while his daughter held both French and American passports, Alexandre never became a US citizen. After his father died in 1959, Alexandre continued the family's efforts to relocate their stolen art, the majority of which was still missing.[42] It was a quest he would pursue for the rest of his life, until he died in London in 1987.

At the time of her father's death, Marianne had earned a law degree from the Université de Paris II and her LLM from the University of Pennsylvania Law School. She pursued a successful career as an international finance

lawyer, rearing two children of her own. Like her father before her, she continued the search for the family's artworks, impressing the importance of this on her children as well.

Shortly after the tax prosecutor Reinhard Nemetz's tense press conference, Marianne received a call from Christopher Marinello, the family's lawyer specializing in art restitution. Marinello had been sipping coffee in his hotel room in Manhattan when he saw a shoddy, low-resolution photograph of Matisse's *Woman with a Fan* in the newspapers. Despite its graininess, the image was unmistakable: the portrait of a pale brunette with big eyes and perfect posture was part of the Gurlitt trove.

"They've got the painting—your painting," Marinello, a spirited Italian American extrovert, told Marianne. She had long wondered what had happened to the Matisse, one of the 160 artworks that her grandfather had stowed in his bank vault in southern France.

Marianne began to gather fragments about what had happened to *Fan* over the past seventy years. Hitler's art experts had stolen the portrait from the bank in September 1941, then transferred it to the Jeu de Paume in Paris and, later, to a storage area in Baden-Baden, a wealthy spa town on the French border. Then the trail had gone cold, until now.

Unbeknownst to the Rosenbergs, Cornelius Gurlitt had wanted to sell *Fan* after his father's car crash in 1956, correctly assessing it as one of the most valuable pieces in the collection. Yet a French dealer and friend of his family had warned him not to; *Fan* was too "hot" for sale even on the grey market because Rosenberg had been such a prestigious dealer. Begrudgingly, Cornelius had deferred to the dealer's judgment, eventually rolling up *Fan* and shoving it in the crate of tomato cans in his Munich apartment's kitchen.

It became immediately clear in November 2013 that *Fan* would serve as a test case for the German government's handling of the entire Gurlitt trove. The portrait belonged to the 1 percent of looted artworks for which clear documentation of ownership still survived, and its owners belonged to a family that understood the legal paperwork necessary to file a claim for looted art and had the funds to finance the legal battle. Rosenberg had been a professional dealer, accustomed to keeping a thorough inventory. Upon realizing that he and his family needed to flee to America, he had the foresight

to send his documents abroad. From a market perspective, the Matisse was one of the most valuable works in the Gurlitt collection, probably worth a low seven-figure sum in dollars, though the growing interest in the painting, given its bizarre postwar journey, could well push that value higher.

As much as the art world's dealers, collectors, and researchers shied away from saying it officially, they were all thinking the same thing, repeating it at champagne-filled parties in London and New York: if Germany did not expeditiously restitute *Fan*, it would be all but impossible for families with less money and less proof to see their artworks again. It did not take much time to confirm that, even for the Rosenbergs, reclaiming their stolen work would be an uphill battle.

Meike Hoffmann, the lone researcher of the Gurlitt trove, had known for twenty months that the Nazis had looted *Fan* from Rosenberg. Discovering this had not exactly been difficult. *Fan* was registered in the official German government database for looted art that she had been reading since embarking on the project to evaluate the collection.

Still, almost two weeks after the Gurlitt trove became public knowledge, the German federal government was silent, deeming it a "Bavarian issue." Bavarian officials, meanwhile, remained sluggish and evasive. They upheld Nemetz's rationale: the case was not historically significant and hardly differed from the thousands of other tax investigations Germany conducted.

The US State Department's Holocaust Issues office began to lose patience. Frustrated that the German government seemed unable to grasp the heartlessness of its actions, Stuart Eizenstat, Secretary of State John Kerry's special advisor on Holocaust issues, publicly urged Germany to publish a full list of the works in Gurlitt's apartment. Bavarian officials had begrudgingly acknowledged that they had flagged at least 590 artworks as probably looted but had published a list of only 25.

Meanwhile, Cornelius Gurlitt conducted an interview with *Der Spiegel*, the most respected weekly magazine in Germany. It was to be his sole interview. The drama in which he was now embroiled was Hitler's fault, Cornelius argued. He considered his father a hero.[43] Cornelius denied that Hildebrand Gurlitt had dealt in looted art, either for himself or for Hitler.

"That would have nauseated him," said Cornelius.[44]

Yet, in almost the same breath, Cornelius said that were it to come to light that works in the collection had been looted from Jewish Europeans, he still would not return them. "I'm not giving back anything voluntarily. No, no," he declared with obstinate conviction.[45]

As brazenly tasteless as that remark was, another point made by Cornelius resonated viscerally with everyday Germans, making him seem sympathetic, perhaps even a victim: "What kind of government are they to reveal my property?" he asked rhetorically.[46] Had he committed a crime, Cornelius noted, the government surely should have charged him within the past twenty months instead of holding his property indefinitely.

<center>——◆——</center>

Hanukkah in 2013 began on 27 November, the day before Thanksgiving. The Gurlitt discovery had been public for only twenty-four days, but to Peter Toren and Marianne Rosenberg, it felt like far longer. David Toren began experiencing a literal bad taste in his mouth from stress. He wrote multiple letters to Ingeborg Berggreen-Merkel (no relation to Chancellor Angela Merkel), head of the recently founded German taskforce charged with researching the Gurlitt trove. He was insulted that the government, after two years of holding it, still had not declared *Two Riders* a looted painting.

Despite declaring that the taskforce's aim was to increase transparency, Berggreen-Merkel had granted only one formal interview, to *Der Spiegel*. Published in German, the interview was inaccessible to those without a high mastery of German legal language. *Der Spiegel* never questioned her regarding the absurd fact that, even if her taskforce declared *Two Riders* and *Fan* looted, there was no way to compel Cornelius to return them to the Torens and the Rosenbergs. From its conception, the taskforce seemed purely symbolic. "If you continue with this snail's pace of examining paintings under suspicion it will take about 82 years and then we'll all be dead. But I suppose that's the intention," David Toren, now almost ninety, fumed in an angry letter to Berggreen-Merkel.

Tenet eleven of the Washington Principles had declared that nations should "develop national processes to implement" resolution of disputes

regarding Nazi-looted and Nazi-confiscated art.[47] Yet the prevailing German attitude was that the Holocaust should be remembered annually in speeches and ceremonies, but its victims should let go of hope that they would recover stolen property. Peter Toren summed up the mentality rhetorically: "Why do these damn Jews keep bringing up art they owned 75 years ago?"[48]

Two days before Christmas, the German judicial system finally did intervene—to the benefit of Cornelius. After his medical doctors expressed concerns about his declining physical health, a Munich court appointed a local lawyer, Christoph Edel, to represent him. Edel, a prickly man with a military-style buzzcut and no-nonsense attitude, assembled a motley crew of advisors: Hannes Hartung, whose resting face was a smirk, served as his assistant lawyer, and mild-mannered Stefan Holzinger, for whom the Gurlitt case represented his biggest break yet, became his public relations advisor. Holzinger immediately set up a website for Cornelius Gurlitt to humanize the "phantom," as many Germans still referred to him. The portrait he put on the website was a stock photo of a random silver-haired, blue-eyed man in a dapper suit.[49]

Cornelius spent the 2013 Christmas season alone in his apartment, as he had since his mother's death. He grew frail and needed hospitalization for his myriad heart problems. A member of his legal team who visited him in the hospital was struck by how angry Cornelius was, despite his physical frailty and normally placid demeanor. He "felt like a victim of Bavaria," his advisor stated. It was clear that Cornelius wanted to spite Germany for persecuting him.[50]

Inspiration for his revenge came from an unexpected source: Ingeborg Berggreen-Merkel. By Christmas 2013, the tax prosecutor Nemetz knew that the investigation had produced no proof of tax fraud. The case against Cornelius was deteriorating. Realizing that the government would soon need to release the artworks, Berggreen-Merkel reached out to Cornelius and arranged a meeting. She considered this a long shot, but Cornelius agreed to it. Gently, she suggested that he craft a last will and testament, donating his artworks to an institution as a way to help rehabilitate the public perception of the Gurlitt family name. She suggested that he bequeath his collection to a German museum. Leaving the meeting, which she considered a polite

and "serene" conversation, Berggreen-Merkel felt she had made headway and possibly secured a gargantuan donation for the museum system in which she had worked for thirty years.[51]

Cornelius, however, had a more cunning idea: he took Berggreen-Merkel's suggestion and used it to snub both her and his home country. Unbeknownst to anyone except his legal team, he immediately called a notary to his hospital and signed a secret will on 9 January 2014 that bequeathed his entire collection to the Kunstmuseum Bern in the capital of Switzerland. The will remained secret to all, other than Cornelius, his legal team of three, and his notary, for the next five months. By the time anyone would know to ask Cornelius why he had chosen to bequeath his trove to Switzerland's Kunstmuseum Bern, he was already dead.

———◆———

The Christmas season in Germany is long: white-collar workers and politicians shutter their offices and use up whatever is left of their legal minimum of thirty vacation days. That had typically been the routine of Winfried Bausback, the forty-eight-year-old Justice Minister of Bavaria. The year 2013, however, was different. The devoutly Catholic father of three found it difficult to stop thinking about the Gurlitt case, what it said about the unresolved moral issues regarding Germany's accountability for World War II, and the legacy it would hold for his children.

As a proud Bavarian, he had always been in a unique cultural position: unlike natives of most of Germany's other provinces, Bavarians were a fiercely independent bunch, fond of hunting and church and proud of their culture. Yet Bausback knew that Bavarians—and Germans—could only be proud of their heritage if they worked to right the injustices of Nazi Germany. He had only learned about the Gurlitt case from the press, which infuriated him, given that his prosecutor, Reinhard Nemetz, had been under orders to report all cases to him, especially those as culturally explosive as the Gurlitt trove.

It was Bausback who had created the taskforce that Berggreen-Merkel headed. It was he, not Chancellor Merkel or her deputies, who had met with Israeli and US diplomats to hear their concerns about the Gurlitt predicament.[52] The Justice Minister was not an art expert. To him, however, this case

was about the reputation of the state that he loved and represented as a public servant. On a pragmatic note, Bausback suspected that if there was one "Cornelius Gurlitt" out there, there very possibly were many others. The statute of limitations for returning Nazi-looted art that had expired in the 1970s would prove morally disastrous in bringing these "future Gurlitts" to justice. Suspecting that Cornelius had only months to live and that he wanted to see his art collection before he died, Bausback instructed Berggreen-Merkel, who had visited Cornelius around Christmas to discuss the elderly man's last will and testament, to negotiate with him and his legal team about what to do with works in the Gurlitt trove that were clearly Nazi-looted art.

The political pressure was high for Bausback—not because his bureaucratic colleagues expected him to secure justice for Holocaust victims but because the notion of bringing morality into a tax investigation went against the German tradition of following protocol. Bausback pressed on regardless. He pressured Germany's Culture Minister, Monika Grütters, who was based in Berlin only steps away from Chancellor Angela Merkel's office, to make a public statement on behalf of the federal government. On 11 February 2014, two years after the government raided Gurlitt's apartment in Munich, Grütters stated that the Gurlitt scandal had exposed severe problems within Germany's art restitution system, noting that the government had underestimated "the emotional components" of the scandal and needed to begin "earning back trust."[53]

She announced that Germany would create an independent center to investigate museum collections for Nazi-looted art, acknowledging, albeit in restrained terms, that German museums had been "a bit shy" in combing their collections for looted or confiscated artworks. The center, Grütters said, would have an annual budget of around €10 million.

Just hours after the announcement by Culture Minister Grütters, it leaked to the media that the legal team for Cornelius Gurlitt had recently visited his Salzburg home, loaded the 250 artworks he held there into a van, and ferreted them away to a secret location. Cornelius had not visited the home for years, and by the time his legal team opened the door, the air in the cottage was musty and damp. In a corner was a pile of trash from the time Cornelius had last been there. It was a small miracle that vermin had not taken over the house or that it had not been robbed of the works, which

included eighteen by Grosz, thirty by Nolde, and numerous from mostly French masters, including Monet, Renoir, Degas, and Rodin.

The leaked news of the treasures in the nearly abandoned house, occurring the same day as Culture Minister Grütters's announcement of the culture center, overshadowed her declaration and once again made the German government appear incompetent. Cornelius's legal team gleefully announced that they were keeping the works outside Germany and thus outside of Prosecutor Nemetz's jurisdiction. The German government had made no move in more than three years to learn what works were in his Salzburg home. Now, the world might never see a list of them. The brouhaha gave credence to the name art world insiders were increasingly using to refer to the Gurlitt scandal: *Scheißsturm*, or "shit show."

Bausback, the Bavarian Justice Minister, was not yet ready to give up hope. Reading Minister Grütters's announcement, he noted her promise to throw her support behind lifting the statute of limitations on art stolen between 1933 and 1945 from Jewish Europeans and other persecuted groups. In order for this to become law, however, the measure needed to be introduced to the Bundesrat, Germany's upper house of parliament, either by Chancellor Merkel or a Bundesrat member. Merkel would not budge on her policy of noninterference in the Gurlitt scandal, so, on Valentine's Day 2014, Bausback took to the Bundesrat floor even as Gurlitt's lawyers made a formal complaint to the government that Cornelius should either be charged with an actual crime or receive his artworks back.

Bausback was not a frequent orator, but he delivered a speech that was concise and articulate. After a short paragraph recapping Hildebrand Gurlitt's work for Hitler and the 28 February 2012 raid on Cornelius Gurlitt's house, Bausback led with a critical question: "To whom do these pictures belong today, and under what conditions can they be returned to the victims of Nazi art theft or their heirs?"

Bausback referred to the phrase that many Jews and Holocaust art researchers used regarding stolen artworks that had yet to be returned to their original owners or the owners' heirs. They were "Hitler's Last Hostages."[54]

"The international interest in how Germany goes about dealing with these issues is huge," he continued.[55] With tens of millions abroad watching Germany in this critical time, he stressed, it was crucial to implement

improvements swiftly. "The Bundesrat should build on this today," he implored. The laws allowing Jews to claim reparations from the German government had also expired, he pointed out.

Justice Minister Bausback had poured his heart—and much of his political capital—into pushing for at least a sliver of change. He firmly believed it was the litmus test for his generation to show the rest of the world that Germany was now a beacon of compassion, justice, and atonement. His efforts failed. His oration was the only speech given by any German politician on the parliamentary floor regarding the Gurlitt case. After he concluded, no one in the Bundesrat rose to support or even question his proposal. It was dead in the water.

Angelica Schwall-Düren, a member of the Social Democratic Party—the only party to oppose Hitler and survive the war—instead took the floor to initiate a lengthy, painstakingly detailed and bureaucratic discussion of the regulatory procedures for evaluating codified real estate management guidelines.

<center>————◆————</center>

Six weeks passed. Bausback pressed on with trying to improve the private talks between his ministers and Cornelius's lawyers. If he could not change the law, he reasoned, he could at least make a difference in this single instance. Clashes soon became frequent between one of the primary lawyers, Hannes Hartung, and a newer lawyer, Tido Park. While Park felt that Gurlitt should return Liebermann's *Two Riders* to the Torens and Matisse's *Fan* to the Rosenbergs, Hartung wanted Gurlitt to sell the paintings and give a portion of the proceeds to the two families.[56]

Marianne Rosenberg adamantly opposed setting a precedent in which her family paid for artworks that had been stolen from them. "Since when do you purchase works that belong to you?" she reasoned. "The term for purchasing something that you own is called 'ransom' and we don't indulge that," she stated.[57]

Hartung's attitude was cast into sharp relief when, in late March 2014, the Henie Onstad Art Center in Høvikodden, Norway, restituted Henri Matisse's *Woman in Blue in Front of a Fireplace* to the Rosenbergs. Sonja

Henie, an Olympic champion figure skater and her husband, Niels Onstad, a shipping magnate, had acquired the work in France in the 1950s, unaware that it was a looted piece. Because it was a "good-faith purchase," the art center had the right to keep the work under Norwegian law. At first, the art center was hesitant to relinquish the crown jewel of its collection. However, Norwegian Prime Minister Erna Solberg used the power of public pressure to urge that restituting the work was the morally correct decision. Solberg's move succeeded, and the museum returned *Woman in Blue* to the family. The fact that Norway's *Woman in Blue* was painted by Matisse, the same artist who created the work the Rosenberg's were still attempting to retrieve from Germany, made the parallel particularly damning of German government inaction.

The family called on Chancellor Merkel to aid the family in the way that Prime Minister Solberg had done. Yet still Chancellor Merkel and Culture Minister Grütters declined to intervene.[58]

By this point, Cornelius Gurlitt's heart was failing, and he checked into an intensive care unit before moving back to his apartment, now outfitted with a hospital bed, full-time caretakers, and a security guard. Aware that Cornelius's death was imminent, Justice Minister Bausback knew that time was running out to secure a deal and see his artworks again before he passed away. He submitted a six-page contract to Cornelius, which the octogenarian read over the weekend of 5 April 2014. It stipulated that whoever inherited Cornelius's art would be required to consent to a year of research by Berggreen-Merkel's taskforce, for which the German and Bavarian taxpayers would pay.

Unlike Bausback, Cornelius knew that, once he died, his roughly 1,200 artworks would belong to Switzerland's Kunstmuseum Bern as a result of the will he had signed in January. So why, he wondered, should he care about what might happen to works among those 1,200 or so artworks that had been looted from Jewish Europeans? Certainly, Switzerland would not care.[59]

Cornelius still had never used a smart phone or a computer and remained utterly baffled by the concept of the internet. Nevertheless, it was clear to him from reading print newspapers that his family name had been tarnished worldwide. His view of his father as a war hero and victim of Hitler

was unwavering, and he was determined to burnish Hildebrand's legacy as much as possible.

On 7 April, in the early afternoon, Cornelius signed the document. Within forty-eight hours, Prosecutor Nemetz's office had released the collection, citing "fresh elements" and noting that Cornelius's legal team should come pick the artworks up from a taxpayer-funded warehouse.[60] Then, the government dropped its tax investigation.

A few weeks later, on 6 May 2014, Cornelius's security guard stood outside his door and heard the elderly man stumble in his living room. He entered the apartment and helped him to bed. Hours later, with his guard and at least one caretaker present, Cornelius Gurlitt died in his sleep of heart failure. He was eighty-one. Klaus Fräßle, his sister Benita's widower, arranged for him to be buried in Düsseldorf next to Hildebrand and Helene Gurlitt, whose wartime secrets he had spent his life trying to keep.

———◆———

Just hours after Cornelius's death, Matthias Frehner, director of the Kunstmuseum Bern in Switzerland, had been sitting in a routine meeting, when his assistant interrupted to tell him that a middle-aged German man claiming to be the lawyer for Cornelius Gurlitt had called to inform Frehner that the Kunstmuseum Bern, a small institution in the sleepy Swiss capital, was the sole heir to the Gurlitt art trove. Frehner shrugged it off. The caller's claim was so far-fetched, he reasoned, that it was patently a prank.

The next morning, Frehner, a pensive Swiss academic in his late fifties, sat at his desk next to a massive window overlooking the grassy banks of the Aare River below. The weather was getting warmer, he noted, and local teenagers soon would be frequenting the spot on the bank, flirting and drinking beer. Though Bern was the nation's capital, the Swiss federation operated on a decentralized political system in which the different cantons, or provinces, were largely independent of each other. The museum housed mainly works by Swiss artists who, untested by war or political turmoil, largely painted banal, bucolic scenes of cows and pastures. As Frehner sipped his espresso, the phone rang. It was Christoph Edel, Cornelius Gurlitt's lawyer, telling the director that he had indeed called the day before and that Cornelius had

bequeathed roughly 1,200 artworks to the Kunstmuseum Bern. German tax-payers would pay for the task force's research into the provenance of each work and return any looted pieces to the rightful heirs, if they could be located. The remainder, a collection worth at least tens of millions of euros by Europe's great masters, would belong exclusively to the museum.

Frehner was flabbergasted. It was unclear what would happen to the works were the museum to reject the bequest. If it accepted them, however, the small and quiet institution would rocket to international fame and be permanently redefined as the home of this problematic trove. Berggreen-Merkel, head of the task force, urged Frehner to accept Cornelius's gift. If he did not, she warned, the works likely would be dispersed among Cornelius's distant relatives throughout Europe. The Swiss museum provided a stable location to house them, pushing them out of sight and mind for Germans uncomfortable with how botched the German government's handling of the investigation into the Gurlitt family had been. Frehner asked his board of directors to prepare for a formal vote.

In early June, Germany's Gurlitt taskforce officially declared *Two Riders* and *Fan* to be looted artworks that rightfully belonged to the Torens and Rosenbergs, respectively. Both families expected that now, finally, the works would be available to them immediately.

They were wrong.

Until the Kunstmuseum Bern accepted or rejected the will, the German government declared, the artworks were in limbo, held hostage in the government's storage facility.

It took six more months after Cornelius's death for the Kunstmuseum Bern's board of directors to accept the collection. "If you had told us before he died, 'Would you like to deal with the collection of some recluse whose father worked for the Nazis and have that tied to you forever?' then we would have said 'No way.' But ultimately when something like this falls into your lap of course you're going to vote to take it," summarized one board member.[61]

Several weeks later, the German government finally authorized the release of Liebermann's *Two Riders on the Beach* to the Torens and *Woman with a Fan* to the Rosenbergs.

The Rosenbergs, wealthier than the Torens, kept their Matisse. The Torens, however, decided to sell *Two Riders* at auction. David Toren's brother, Peter Tarnesby, had died in 2014 as the family was still battling to recover the artwork. Had David Toren and Peter Tarnesby been the only heirs, an arrangement could possibly have been made for one of the brothers to keep the work. Now, however, Peter's multiple relatives were coheirs to *Two Riders*, and with the market value especially high because of the interest surrounding the stories of the Gurlitt trove, the inheritance tax would be prohibitively high. The painting had to be sold.

The family approached Sotheby's and Christie's, but the former auction house gave them a better contingency rate—around 12.5 percent on the first million earned and 5 percent on profits over that. The family chose Sotheby's, and the auction house set the sale for its London-based headquarters during the annual June auctions there.[62]

Under normal circumstances, there might have been time for Sotheby's to ship *Two Riders* to New York, but the days between the restitution, authentication, and the auction were too tight. Even if the storied auction house had sent the work to Manhattan, however, it was already too late for David Toren to see the work again.

He had lost his eyesight in the time it took to locate the painting.

On 24 June 2015, shortly before 7 p.m., Peter Toren and his twenty-two-year-old son Ben took their reserved seats in the headquarters of Sotheby's in London. Despite the depressing twists and turns of the drama surrounding the Gurlitt art trove, it was important to Peter that he represent the family there on behalf of his father, too weak by now to travel to London. Equally critical for Peter was impressing upon Ben their European and American family history.[63]

In a steady stream, the audience filed in, taking their seats facing the rostrum where auctioneer Henry Wyndham, a tall Englishman with an ample tuft of unruly gray hair, would oversee the sales. In over two decades at the house, Wyndham had handled masterpieces worth far more money than the Liebermann. In February 2010 he had worked the room to sell a statue by Italian sculptor Aberto Giacometti for $104 million, the auction record at the

time. In December 2012 he had manned the rostrum as billionaire financier Leon Black bought Raphael's *Head of an Apostle* for $47.9 million, making it the most expensive work on paper. Wyndham and the Torens knew that the Liebermann would never reach those prices, but despite the almost religious reverence the art world had for Giacometti and Raphael, the stories behind the *Two Riders* made the work resonate strongly with potential buyers.

Looking around, Peter Toren observed how the atmosphere at Sotheby's was an odd mix of understatement and opulence. Against one wall, the press gathered. Younger reporters balanced spreadsheets with notes about the art-works with corporate-owned iPhones, from which their editors required they send rapid-fire tweets during the sales. The Sotheby's specialists—even the stouter and older ones—were all naturally good-looking, with coiffed hair, perfectly tailored suits, and paradoxically alert yet relaxed expressions. Everyone in the room seemed to know each other; yet no one appeared overly sociable. "The whole thing was just kind of bizarre with all these extremely well-dressed women in low cut dresses and fancy things," observed Peter Toren.[64]

Sotheby's had estimated the value of *Two Riders* at between $550,390 and $864,900. Wyndham opened the bidding at $377,400, and within thirty-nine seconds the price had climbed dramatically. Bidding stalled for twelve seconds, an interminable pause in the frenetic world of high-end auctions. Wyndham patiently waited for it to climb again. Within a minute and thirty-three seconds after the bidding began, three prospective buyers pushed the price up to $1.4 million. Lengthy pauses continued; it was clear that buyers were weighing the story behind *Two Riders* with the investment potential of the painting itself. Bidding stalled once again at $1.7 million before climbing again to reach $2.95 million and selling to buyer L0014, a bidder on the phone.

The sale of Max Liebermann's *Two Riders on the Beach* was a resound-ing success. The story of the Torens' fight to have their work restituted had pushed the final price of the work to five times its conservative estimate, far more than the Torens or even Sotheby's had predicted. "It was a bit of an overwhelming experience on a variety of levels," noted Peter Toren.[65]

After *Two Riders* sold, Peter and Ben watched the next twenty-two works sell, including an Henri Matisse portrait for $2.8 million and an Edgar Degas of two criminals in court for $762,700. Nearly all of the most successful artists of the night were those whom Adolf Hitler had labeled degenerate seventy-eight years before, artists whose works were now being fought over by the Germans, Austrians, and French whom Hitler had hoped his Reich would incorporate for 1,000 years. The long-dead Führer could hardly have dreamed that the works would also be sought after by newly wealthy Russian, Chinese, and Arab collectors as well.

Once Wyndham hammered down a price on the last work of the night, Ben and Peter Toren slowly made their way out onto the sidewalk in front of Sotheby's on New Bond Street. Peter knew that his family likely would never learn who bought *Two Riders on the Beach*. He or she wished to remain anonymous. For Peter, though, the "weirdest part" was the fact that he felt content to see the painting go to this new home. He understood that some people would criticize the family for selling the work, but there was no way they could have afforded to keep it. Though the decision to sell it had not been entirely their own, the sale had provided the family a certain sense of emotional closure regarding their fraught past.

On the way to a celebratory sushi dinner, Peter felt emotionally overwhelmed. How should he make sense of everything that had happened to his family—from his grandparents' murders at Auschwitz to the trauma his father, David, had suffered as a result? How, Peter wondered, should he process the ways in which his father's trauma had affected himself as a son of a Holocaust survivor?

Ultimately, however, Peter focused on the fact that the family's efforts to locate *Two Riders* had deepened their bond and was a further step in the long process of coping with the pain that Hitler inflicted on millions of people.

In that sense, despite everything, Peter could not help but feel a certain pity for Cornelius Gurlitt. Certainly, it was mixed with anger; Cornelius could have done so much more with his life, and he had not. Peter Toren realized that he felt something Cornelius never truly had: a sense of love, being loved, and true purpose in the world—a purpose not merely to preserve his family's past but to continue its future.

There would be time to contemplate all of these issues on the plane back to Washington, DC. For now, however, Peter and Ben felt a warm contentment sharing not only sushi but a bittersweet satisfaction that, even though *Two Riders on the Beach* was no longer in their hands, it had been rescued from the limbo in which Adolf Hitler, Hildebrand Gurlitt, and the German government had trapped it for seven decades.

One of Hitler's Last Hostages was finally free.

BUSINESS AS USUAL

"The root of all evil is laziness, stupidity, or greed. There is nothing truer than that. It governs everything."

—Marty Grosz, son of George Grosz

IN OCTOBER 2018, FIVE YEARS after I first started reporting on the Gurlitt case for the *Wall Street Journal* and six days after celebrating my thirty-first birthday, I took a taxi from Prenzlauer Berg, the trendy district in eastern Berlin where I had lived for several years, down to Mitte, Berlin's central district. There, I entered an exhibition of works from the Gurlitt trove on display in the Martin-Gropius-Bau, a Renaissance-style exhibition hall built in 1881 and still standing after the World War II bombings that had destroyed most other buildings in the vicinity.

Throughout the building, the German government had hung 200 of the roughly 1,200 artworks that I had spent thousands of hours researching. Most of them were by artists whom Hitler had labeled degenerate and whose upended lives and legacies I had come to understand intimately. Emil Nolde's *Flood, Evening* hung above Gustave Courbet's large portrait of Jean Journet, not far from Käthe Kollwitz's *Lamentation for the Dead* and her charcoal work *Mother with Dead Child*. Several of George Grosz's street scenes were

present, the vibrant reds of the prostitutes' dresses and garish glows of yellow streetlights more eye-catching in person than a reproduction can ever capture.

Also on display in the Martin-Gropius-Bau were several pieces by Max Beckmann, including *Old Woman with Cloche Hat*, *Zandvoort Beach Café*, and several others on paper that Hildebrand Gurlitt had obtained from collections confiscated by Adolf Hitler and Joseph Goebbels from small museums throughout Germany—leaving gaping holes in their collections that these provincial museums could now never financially afford to fill with other artworks of similar quality.

Max Liebermann's *Two Riders on the Beach* and Henri Matisse's *Woman with a Fan* were not present: the Rosenbergs had not wanted to lend *Fan*, and the Torens had no idea who had bought *Two Riders* when they auctioned it at Sotheby's in spring 2015. However, *Roofs*, the looted work by Adolf Menzel that Hildebrand Gurlitt had taken from the Wolffson collection and which the family had finally received back in 2017, was on display at the Wolffson family's request.

Making my way through the rooms of artworks, I had in my head the lengthy speech that Culture Minister Monika Grütters, who had held her ministerial position as the Gurlitt scandal was unfolding, had given at the exhibition's opening a few weeks earlier.

The remarks by Grütters did indicate some progress in the German government's attitude toward the restitution of Nazi-looted art. After five years of bureaucratic obfuscating, Grütters finally had agreed to the basic facts that Hildebrand Gurlitt was not "merely 'an art dealer during the Nazi period'" but also had been an "opportunist" as one of Hitler's four main art dealers for the Führermuseum Project. She also noted that her government had made desperately needed changes to the advisory commission that it had founded—only in 2003—to mediate between victims of Hitler and German museums that allegedly possessed Nazi-looted art; from 2016, the committee members no longer held lifetime appointments. Her ministry also had expanded the board to include a minority of members who were not affiliated with the museums whose fates they were deciding. Overall, however, Grütters's opening remarks revealed how little the German government officials

whom she represented actually had changed since their initial mishandling of the Gurlitt case.

The position of Culture Minister does not exist in the United States. In Germany, this officeholder is in charge of guiding the nation's museums and other cultural institutions, the vast majority of which are overwhelmingly funded by taxpayers without the aid of donations, sponsorships, or private fellowships. The Minister is responsible for setting the nation's cultural policy. This includes *Wiedergutmachung*, a euphemistic term that roughly translates to "The Making Better Policy" and refers to how Germany atones for World War II on governmental and legislative levels.

At no point before, after, or during the speech did Minister Grütters publicly acknowledge that the German government had erred. She refused to recognize that Germany had been wrong to hide the Gurlitt trove after its discovery. She continued to maintain that this was a local issue for Bavarian officials to address—despite the fact that these officials still refused to comment on the matter, deflecting that responsibility back to her, as the government's most powerful voice on cultural affairs in Germany. While touting the importance of the rule of law, Grütters refused to acknowledge that Germany had held Cornelius Gurlitt's trove for over two years without informing him of his legal rights or charging him with a crime.

In the autumn 2018 speech, Grütters finally did lament the loss of documents and witnesses that could have helped identify looted works in the Gurlitt trove. She declared that "behind every looted artwork stands the individual fate of a human being; we owe it to the victims of the Nazi regime of terror and the descendants of these victims to recognize this." Yet she did not address why the German government, by hiding the existence of the trove for over two years, had obstructed the very investigations into the artworks that she now claimed to advocate.

As I glanced up at a self-portrait of Max Beckmann hung near Nolde's *Flood, Evening*, it struck me as bizarrely tone-deaf that Grütters had ended her speech with a quote from the artist's 1938 essay "About My Painting," in which Beckmann had warned against the dangers of collectivist thought and eschewing personal responsibility. Collectivism, Beckmann had warned and Grütters reiterated eighty years later, was "the largest danger that threatens

all of humankind." Moreover, the Culture Minister cited Beckmann's essay in asserting that much of life consists of "having your happiness or opportunities to live get beaten down by a state" that treats its constituents like "termites," inconsequential pests, when they challenge government regulations. "I resisted this with all the power in my soul," she said, quoting from the end of Beckmann's essay, before adding her own conclusion: "This strength, Ladies and Gentlemen, I also wish for our democracy. May the 'Status Report: Gurlitt' exhibition also contribute to this!"

Beckmann wrote his essay a year after the 1937 opening of the House of German Art and the concurrent Degenerate Art Exhibition, in which the German government had displayed twenty-one of Beckmann's confiscated paintings, including *The Lovers*, a lithograph I now saw on display in another German government exhibition, the provenance of which the state had yet to clarify. Beckmann had made his comment about the so-called termite state as a criticism of the very type of bureaucratic lethargy that had made it impossible for him to have his artworks restituted before his death in 1950.

Rereading Max Beckmann's essay after the speech in which Culture Minister Grütters had cited it, I noted that he had delivered it in London, a year before Germany invaded Poland. Beckmann had attempted to warn other countries of the bureaucratic collectivism rampant in his native country. At the beginning of his 1938 speech, Beckmann explained how apolitical people tended to fall prey to the ability of governments to legalize moral injustices. The artist admitted he was no political expert but declared, "Nevertheless, I am aware that there are two worlds here: the world of the soul and the reality of politics."

It struck me how similar Beckmann's warning was to a comment made to me in 2013 by Michael Franz, the administrative head of the German government's Looted Art Commission. "There are two different rules: legal laws and moral guidelines, and they are very separate and distinct," he told me.[1] Franz had been one of the rare public officials willing to speak on the record, not only during the time that the Gurlitt scandal was unfolding publicly between 2013 and 2014 but also in the years since then.

In February 2014, after several rebuffed attempts, I met Minister Grütters herself in her office in Angela Merkel's chancellery overlooking the

German parliament. Finally, for the first time on the record with any publication, Grütters conceded that since the end of the war in 1945, German institutions responsible for the restitution of artworks had been "a bit shy in their public relations activity," adding, "It's a matter of earning back trust."

Now, over five years later, I wonder, what does it say about "earning back trust" that, were the Gurlitt scandal to unfold as of this writing, the Torens, Rosenbergs, and Flechtheims still would have no more significant legal protections than they had possessed in previous decades?

—✦—

Numerous German officials at local, state, and federal levels have acknowledged this reality to me in confidential conversations over the years. In postwar Germany, morality and legality are two distinct forums. When it comes to the restitution of looted artworks, bureaucratic collectivism discourages individual public servants from sticking their necks out to advocate for survivors of the Holocaust and their descendants, who, as a result of government atrocities committed decades ago, are no longer part of the citizenry that these public servants represent.

The only exception I have seen is Winfried Bausback, justice minister of Bavaria, the state representing Munich, where Cornelius Gurlitt lived. Bausback was the one politician to directly petition the Bundesrat, Germany's highest body of legislators, to amend the statute of limitations on stolen artworks that protected private individuals such as Cornelius Gurlitt. In his Valentine's Day 2014 speech to the Bundesrat, Bausback had referenced his hero from American literature, William Faulkner, citing the author's famed quote from his 1951 novel *Requiem for a Nun*: "The past is never dead. It's not even past." Yet, despite Bausback's singular pleas, no politicians—including Culture Minister Monika Grütters—backed his attempt to enact legislation that would prevent "a future Gurlitt" from doing exactly what Cornelius had done: admit to holding Nazi-looted artworks while flaunting how the law protected him over the victims from whom these works had been stolen.

A few months before I viewed the Berlin exhibition in October 2018, I had visited the West German city of Bonn and the Swiss capital of Bern—the

location of the Kunstmuseum Bern to which Cornelius Gurlitt had be-
queathed the trove—to view works from the Gurlitt trove for the first time.
I initially expressed optimism that the placards on the walls next to the art-
works displayed detailed descriptions of their provenance—the journey each
work had taken from the artist's studio to the present day.

Yet I noticed a disturbing pattern, beginning with a vibrant still life oil
painting, circa 1885, of a canned jar of cherries set between a pristine white
cloth and two liqueur glasses created by the Parisian realist artist François
Bonvin. The placards for that work and several others in the exhibition, in-
cluding a pastel of a Berlin garden by Max Liebermann, featured a cryptic
notation. For the last notation on each placard—the line indicating to whom
the works now belonged—ambiguously read, "By Descent to a Private Col-
lection, South Germany."

Alarm bells rang in my head. I called Rein Wolfs, director of the Kunst-
halle in Bonn, where the works were on display. After minutes of prodding,
Wolfs confirmed to me that the euphemistic line on the placards did, as I
suspected, indicate that these pieces were in the possession of Klaus Fräßle,
the widower of Benita Gurlitt, the sole sibling of Cornelius Gurlitt.

Why did the taxpayer-funded exhibition not simply note that directly
on the placards, I asked?

Wolfs demurred, saying that, while it was true that the exhibition and
Kunsthalle were taxpayer funded, "we to that [point], as a federal institution,
would not want to speak out so much about that," preferring instead to focus
on the life of Hildebrand Gurlitt. He openly acknowledged that "the situa-
tion with Cornelius calls into question" moral issues and "judicial questions"
that he did not care to confront.

"The thing is, we wanted to make an exhibition about the art itself and
not the aftermath, so to speak," he said.[2] In other words, fighting to secure
or even improve justice for Hitler's victims and their descendants was not his
problem either.

———————————✦———————————

The conversation with Wolfs made it clear to me that he, Grütters, and the
entire German legislative body were constantly pointing fingers at each other

rather than taking responsibility for fixing a broken restitution system. The legislative body claimed this was a matter for the Culture Ministry to solve, the Culture Ministry said that it was a matter for the legislative body to solve, and government-funded museums said it was not their responsibility to speak publicly about political matters, even those so clearly rooted in the cultural affairs that they oversaw.

Toward the end of writing this book, I developed an almost obsessive interest in trying to find the line where complicity with evil becomes evil itself. Adolf Hitler and Joseph Goebbels most certainly were evil, but what about Hildebrand Gurlitt? What about Cornelius Gurlitt? What about the public servants in Germany who still refuse to fix their broken system? What about their constituents, who do not insist that they do so?

I spent hours discussing this topic with Marianne Rosenberg, David Toren, his son Peter Toren, and George Grosz's son Marty, all of whom had nuanced and insightful takes on the matter. Hildebrand Gurlitt, we all agreed, was most certainly a war profiteer. Unlike the others, David Toren had some sympathy for Hildebrand for his behavior during the war, while his son was more forceful in wanting to hold Hildebrand to account. "He danced with the devil. He supported an evil regime," was Peter Toren's verdict. Marty Grosz put it more bluntly: Hildebrand "knew what kind of evil son of a bitch [Hitler] was and supported him because it was good for business."

Even if one does believe that Hildebrand Gurlitt was genuinely trying to save artworks from Hitler's regime and forced into working for Hitler because he was a quarter Jewish, an idea that Marianne Rosenberg dubs "bullshit," it is obvious that after the war, when the artworks were no longer in danger, he lied repeatedly about the content of his collection—to the Monuments Men, to the new German government, and to Jewish European families hoping to locate their lost treasures.

As I have learned more details of Cornelius Gurlitt's private life, also speaking with those who knew him personally, I have come to believe that it is highly likely that Cornelius was deeply traumatized psychologically by his wartime experience as a child. Does that excuse his complicity with his father in holding onto and hiding Nazi-looted works and initially declaring that he would refuse to return even those that the Nazis had looted from

Holocaust victims? I personally believe that it does not, but I have sympathy for those who feel otherwise because none of us can truly know the extent of his trauma, and now we never will.

When I asked Marianne Rosenberg her views on the nature of evil, she answered with one of her characteristically concise and confident quips: "I don't know how one splits evil into 'more or less evil.' I don't think it matters at the end of the day." What matters, continued Rosenberg, is, "Did they learn anything and are they applying any lessons that they might or might not have learned? Are they applying those lessons to therefore educate the public about what happened?"

<p style="text-align:center">⸺⬦⸺</p>

After leaving the exhibition at the Martin-Gropius-Bau, I traveled back to Prenzlauer Berg to process the exhibition at Weinberg, my favorite café-cum-bar in the neighborhood. I had first arrived in Germany in 2009 to finish my undergraduate studies. Working as a journalist at the Associated Press, then at the *Wall Street Journal*, and later for the *New York Times*, I had pushed back consistently against the stereotype I often faced outside Germany of the nation as still being full of boorish Nazis or vile anti-Semites. It is not, and often I had felt, even as a proud Virginian and American, more patriotic about Germany than Germans themselves.

Yet I had to face the reality that the answer to Rosenberg's query of whether Germany really had learned from the Gurlitt scandal and taken sufficient steps to prevent "future Gurlitts" was a resounding "no."

Until that occurs—until Hitler's Last Hostages are acknowledged, freed, and returned—the moral stain from the 1930s and 1940s remains in Germany.

<div style="text-align:right">

Mary M. Lane

September 2019

</div>

TIMELINE

Entries in **bold** type are significant world historical events.

Entries in *italic* type are significant art historical events.

Entries in regular type are significant personal events.

1867 — **Emperor Franz Joseph gives Jewish Viennese citizens equal rights**

20 April 1889 — Adolf Hitler is born

26 July 1893 — George Grosz is born

15 September 1895 — Hildebrand Gurlitt is born

29 October 1897 — Joseph Goebbels is born

1901 — *Max Liebermann (b. 1847) paints* Two Riders on the Beach

3 January 1903 — Alois Hitler, Adolf Hitler's father, dies of pulmonary bleeding

21 December 1907 — Adolf Hitler's mother, Klara Hitler, dies of cancer

Autumn 1909 — *George Grosz matriculates into the Dresden Academy of Fine Arts*

28 June 1914 — **Archduke Franz Ferdinand and his wife, Sophie, are assassinated in Sarajevo**

1 August 1914 — **Germany declares war on Serbia**

November 1914 — George Grosz and Adolf Hitler enlist in the German Army

9 November 1918 — **Kaiser Wilhelm II abdicates**

11 November 1918 — **The Great War ends**

28 June 1919 — **Germany signs the Treaty of Versailles on the anniversary of Archduke Franz Ferdinand's assassination**

1921 — *Henri Matisse (b. 1869) paints* Woman with a Fan

8 / 9 November 1923 — **Adolf Hitler's failed Munich Putsch occurs**

1 April 1925 — *Hildebrand Gurlitt becomes director of the König Albert Museum in Zwickau*

12 July 1925 — Joseph Goebbels first meets Adolf Hitler

December 1928 — *A Berlin court fines Grosz for slandering Jesus Christ, arguing they represent him on earth*

28 December 1932 — Cornelius Gurlitt is born

12 January 1933 — George and Eva Grosz flee to New York, and their two sons follow soon thereafter

30 January 1933 — **Adolf Hitler becomes Chancellor**

27 February 1933 — **Marinus van der Lubbe sets fire to the Reichstag**

15 October 1933 — *Adolf Hitler lays the cornerstone of the House of German Art*

18 July 1937 — *The Great German Art Exhibition opens in Munich*

19 July 1937 — *The Degenerate Art Exhibition opens in Munich*

12 March 1938 — **Germany annexes Austria**

9 / 10 November 1938 — The Night of Broken Glass, or *Reichskristallnacht*, occurs

Late June 1939 — *Adolf Hitler initiates the Führermuseum Project*

30 June 1939 — *A major auction of Nazi-confiscated art is held by Galerie Fischer in Switzerland*

August 1939 — David Toren (born Klaus Tarnowski in 1925) takes one of the last *Kindertransport* trips to Sweden

Autumn 1939 — Adolf Hitler implements Action T-4, his "pilot program" for the Final Solution, focusing on non-Jewish mental patients and disabled children

1 September 1939 — **Germany invades Poland**

14 June 1940 — **Germany occupies Paris unopposed**

Summer 1941 — Jewish-Frenchman Paul Rosenberg (b. 1881) escapes to New York from France

September 1941 — *Nazis raid Paul Rosenberg's French bank vault, stealing Henri Matisse's* Woman with a Fan *and over 100 other artworks*

7 December 1941 — **Japan bombs Pearl Harbor**

20 January 1942 — **At the Wannsee Conference, Nazi officials plan Germany's extermination of Jewish Europeans**

Early 1943 — *Hitler appoints Hermann Voss the Führermusem director; Voss quickly hires Hildebrand Gurlitt*

25 August 1944 — **US troops liberate Paris**

13 / 14 February 1945 — **The RAF bombs Dresden**

30 April 1945 — **Adolf Hitler commits suicide**

8 May 1945 — **Victory in Europe Day (VE Day)**

Late 1950 — *The Monuments Men close their years-long investigation into Hildebrand Gurlitt*

9 November 1956 — Hildebrand Gurlitt dies

Spring 1959 — George and Eva Grosz move back to Berlin

5 / 6 July 1959 — George Grosz dies

August 1961 — Construction of the Berlin Wall begins

9 November 1989 — The Berlin Wall falls

3 December 1998 — Germany signs the Washington Principles

11 September 2001 — *Family documents helping to prove that David Toren is an heir to Max Liebermann's* Two Riders on the Beach *are destroyed in the Twin Towers*

22 September 2010 — Cornelius Gurlitt is detained by customs officials on a train from Zurich to Munich

28 February 2012 — German police and tax authorities raid Cornelius Gurlitt's apartment in Munich

November 2013 — The story of the Gurlitt trove breaks to the public

6 May 2014 — Cornelius Gurlitt dies of heart failure

May 2015 — *Henri Matisse's* Woman with a Fan *is restituted to Paul Rosenberg's heirs*

24 June 2015 — *David Toren sells* Two Riders on the Beach *at Sotheby's for $2.95 million, five times the low estimate*

ACKNOWLEDGMENTS

"Do thy best and leave the rest."

> —Favorite saying of my maternal grandmother, Elizabeth
> Wetmore MacPherson Coblentz

On 21 May 2014, I received an email from Lauren Sharp, introducing herself as a literary agent at Kuhn Projects (now Aevitas Creative Management). Lauren had read my Page One articles on Hildebrand and Cornelius Gurlitt for the *Wall Street Journal*. For the past five years, Lauren has championed my writing and career, steadfastly supporting me.

My publishers and editors at PublicAffairs, Clive Priddle and Athena Bryan, have deftly shaped my writing while maintaining the integrity of my drafts. They also share my sense of humor, making the completion of a book about such a serious subject a tad less trying. Brooke Parsons, Miguel Cervantes, and Charles Conyers ensured that readers learned of the book and understood its message.

Pete Garceau transformed my suggestions for an aesthetically compelling book cover that would also be respectful of Adolf Hitler's victims and transformed them into what readers see today. Project Editor Melissa Veronesi and copyeditor Jen Kelland guided this manuscript to its ultimate phase: being a "real book."

Immensely worse than my literary tribulations was living through World War II and experiencing the pain Hitler inflicted. Marty Grosz, David Toren,

Peter Toren, and Marianne Rosenberg were generous with their time and memories. Marianne's lawyer, Christopher Marinello, also has been an invaluable, witty resource.

I wrote this book without the aid of any researchers; I am indebted to the following librarians and libraries for accessing primary sources on my behalf: Elizabeth Teaff at Washington & Lee University's Leyburn Library, Dan at the University of Bristol Library, Kevin Wilks and Bethany Bates at the Center for Research Libraries, Heidi Madden at Duke University's Perkins Library, Jessica Murphy at the Harvard Medical School Library, Will Gregg at Harvard's Houghton Library, Mary Ann Linahan and Leah Adler at Yeshiva University, Lauren Paustian and Ginger Barna at the Leo Baeck Institute, Robert Kusmer at the University of Notre Dame's Hesburgh Library, David Oester at the Kunstmuseum Bern in Switzerland, and the Wisconsin Historical Society.

Confidential American, Austrian, Israeli, German, and Swiss sources provided me with crucial information; I thank them for trusting me.

In Berlin, Jan, Benedict, Sean, and Shane have read drafts, encouraged me, and added their expertise on German history.

Phyllis gifted me my first diary and kindled in seven-year-old Mary the love for writing.

In London, Anne and Terence generously hosted me when I researched there.

In my personal life, my parents have advised academically on numerous drafts. Barbara J. and Al have added their fresh insight, particularly for the Prologue and Epilogue. Barbara J. has spent several years helping me successfully stay (mostly) sane. My friends since childhood, Rachel, Ashley, and Elizabeth, have cheered me on in my journalistic and literary aspirations. Ashley's parents have provided extensive support.

My husband, David, and our German Shepherds and Scottish Terrier— Stella, Blake, and Jex MacFarlane—have provided immeasurable love and encouragement, as have David's parents. David has read multiple drafts of this book and prudently suggested that books on Nazis be banned from the bedroom nightstand.

NOTES

CHAPTER I: PORTRAIT OF THE
DICTATOR AS A YOUNG MAN

1. Tagebuch Eschbach III 1946, Eintrag 31 August 1946, quoted in Maurice Philip Remy, *Der Fall Gurlitt: Die wahre Geschichte über Deutschlands größten Kunstskandal* (Berlin: Europa Verlag, 2017), 330.

2. Brigitte Hamann, *Hitler's Vienna: A Dictator's Apprenticeship* (New York: Tauris Parke Paperbacks, 2010), 43, 44.

3. Franz Jetzinger, *Hitler's Youth* (London: Hutchinson, 1958), 37–41.

4. Franz Jetzinger, *Hitlers Jugend* (Vienna: Europa Verlag, 1956), 81.

5. Hamann, *Hitler's Vienna*, 7.

6. Christa Schroeder, *Er war mein Chef* (Munich: Arndt Verlag, 1985), 64.

7. Alfred Zerlick, "Adolf Hitler in den Schulprotokollen der Realschule," *Jahresbericht des Bundesrealgymnasium Linz* (1974–1975): 36, quoted in Hamann, *Hitler's Vienna*, 11.

8. Hamann, *Hitler's Vienna*, 10.

9. Adolf Hitler, *Mein Kampf* (New York: Reynal & Hitchcock, 1939), 8. Author's note: Adolf Hitler first published *Mein Kampf* in 1923. The edition quoted throughout *Hitler's Last Hostages* was translated by a team associated with the New School for Social Research in New York and is the English-language edition that most closely reflects the language and tone of Hitler's original text. For fluent German speakers, the assiduously annotated *Mein Kampf: Eine kritische Edition* (Munich: Institut für Zeitgeschichte, 2016) serves as the definitive source.

10. Dr. Huemer, interview with Franz Jetzinger, date unknown, in Jetzinger, *Hitler's Youth*, 68.

11. Leonding Death Register for Alois Hitler, NS 26/65/84, Bundesarchiv Koblenz, Koblenz, Germany, quoted in Hamann, *Hitler's Vienna*, 18.

12. Emanuel Lugert, interview with Franz Jetzinger, unknown date, in Jetzinger, *Hitler's Youth*, 74, 75.

13. Hamann, *Hitler's Vienna*, 88.

14. Michael John, "Die jüdische Bevölkerung in Linaz," *HJ der Stadt Linz 1991* (Linz, 1992), quoted in Hamann, *Hitler's Vienna*,16; Ferdinand Krackowitzer, handwritten diary, Stadtsarchiv Linz, quoted in Hamann, *Hitler's Vienna*, 16.

15. No author, untitled article, *Krakowitzer* (newspaper), 16 October 1907, quoted in Hamann, *Hitler's Vienna*, 22.

16. Joachim C. Fest, *Hitler: A Biography* (London: Penguin Books, 2002), 19.

17. Fest, *Hitler*, 20.

18. Hitler, *Mein Kampf*, 27.

19. Hitler, *Mein Kampf*, 25.

20. See Hamann, *Hitler's Vienna*, 31.

21. Werner Maser, *Hitler: Legend, Myth and Reality* (New York: Harper & Row, 1971), 39, 40.

22. Hitler, *Mein Kampf*, 27.

23. Hamann, *Hitler's Vienna*, 33.

24. Hitler, *Mein Kampf*, 27.

25. Copy of Dr. Bloch's Cashbook, undated, NS 26/65, Bundesarchiv Koblenz, Koblenz, Germany, quoted in Hamann, *Hitler's Vienna*, 34.

26. Eduard Bloch, "My Patient Hitler," *Collier's Magazine*, 15 March 1941, 36.

27. Bloch, "My Patient Hitler," 39.

28. Manuscript, "Notizen für die Kartei: 8 December 1938," NS 26/17a, Bundesarchiv, Koblenz, Germany, quoted in Hamann, *Hitler's Vienna*, 36.

29. No author, "A. Hitler in Urfahr," in *Mitteilungen des deutschvölkischen Turnvereins Urfahr*, ser. 67, vol. 12, NS 26/174, Koblenz Bundesarchiv, Koblenz, Germany, quoted in Hamann, *Hitler's Vienna*, 38. Author's note: It was not unusual in the early twentieth century for both English- and German-language newspapers to publish articles without titles or authors listed.

30. Letter, Magdalena Hanisch to Alfred Roller, 4 February 1908 (F 19/19), Institut für Zeitgeschichte, Munich, quoted in Hamann, *Hitler's Vienna*, 38.

31. Letter, Alfred Roller to Magdalena Hanisch, 6 February 1908 (F 19/19), Institut für Zeitgeschichte, Munich, quoted in Hamann, *Hitler's Vienna*, 38.

32. Alfred E. Frauenfeld, *Der Weg zur Bühne* (Berlin, 1940), 273ff, quoted in Hamann, *Hitler's Vienna*, 60.

33. Adolf Hitler, *Monologe im Führerhauptquartier, 1941–1944*, ed. Werner Jochmann (Hamburg: A. Knaus, 1980), 357.

34. Max Nordau, *Entartung* (Berlin: Duncker, 1893), 2:498.

35. Fest, *Hitler*, 55.

36. Fest, *Hitler*, 27.

37. No author, no article title, *Alldeutsches Tagblatt*, 18 April 1908, quoted in Hamann, *Hitler's Vienna*, 78.

38. No author, no article title, *Deutsches Volksblatt*, 9 January 1908, quoted in Hamann, *Hitler's Vienna*, 344, 345.

39. Hitler, *Mein Kampf*, 32.

40. Werner Maser, *Adolf Hitler: Legende, Mythos, Wirklichkeit* (Munich: Bechtle, 1974), 310.

41. Hamann, *Hitler's Vienna*, 152.

42. Emil Kläger, *Durch die Wiener Quartiere des Elends und Verbrechens Ein Wanderbuch aus dem Jenseits* (Wien: Karl Mitschke, 1908), 96–100, quoted in Hamann, *Hitler's Vienna*, 147.

43. Hamann, *Hitler's Vienna*, 138.

44. Reinhold Hanisch, "I Was Hitler's Buddy," *New Republic*, 5 April 1939, 239.

45. Hanisch, "I Was Hitler's Buddy," 239.

46. Hamann, *Hitler's Vienna*, 158–162.

47. Fest, *Hitler*, 52.

48. Hanisch, "I Was Hitler's Buddy," 242.

49. Hanisch, "I Was Hitler's Buddy," 272.

50. No author, no article title, *Volkischer Beobachter*, 6 December 1905, quoted in Hamann, *Hitler's Vienna*, 343.

51. Hanisch, "I Was Hitler's Buddy," 239.

52. Hanisch, "I Was Hitler's Buddy," 241.

53. Hanisch, "I Was Hitler's Buddy," 240.

54. Hamann, *Hitler's Vienna*, 164.

55. Hamann, *Hitler's Vienna*, 174.

56. Hamann, *Hitler's Vienna*, 401.

CHAPTER II: ENIGMA OF WAR

1. Wieland Herzfelde, "The Curious Merchant from Holland," *Harper's Magazine*, November 1943, 570–571.

2. Herzfelde, "The Curious Merchant from Holland," 569.

3. Ludwig Meidner, "Vision des apokalyptischen Sommers," in *The Apocalyptic Landscapes of Ludwig Meidner*, ed. Charol S. Eliel and Eberhard Roters (Los Angeles, CA: Los Angeles County Museum of Art, 1989), 65.

4. George Grosz, *A Little Yes and a Big No* (New York: Dial Press, 1946), 17.

5. Grosz, *A Little Yes*, 50.

6. Grosz, *A Little Yes*, 22.

7. Grosz, *A Little Yes*, 56.

8. Grosz, *A Little Yes*, 67.

9. Grosz, *A Little Yes*, 72–74.

10. Grosz, *A Little Yes*, 106.

11. Grosz, *A Little Yes*, 110.

12. Grosz, *A Little Yes*, 82.

13. Grosz, *A Little Yes*, 122.

14. Grosz, *A Little Yes*, 118.

15. Grosz, *A Little Yes*, 84.

16. Grosz, *A Little Yes*, 84.

17. Grosz, *A Little Yes*, 83.

18. Grosz, *A Little Yes*, 29.

19. Grosz, *A Little Yes*, 138.

20. Grosz, *A Little Yes*, 139.

21. George Grosz to Robert Bell, July 1913, in *George Grosz Briefe 1913–1959*, ed. Herbert Knust (Reinbek bei Hamburg: Rowohlt Verlag, 1979), 27, 28.

22. Grosz, *A Little Yes*, 74, 75.

23. Grosz, *A Little Yes*, 142.

24. Max Beckmann, quoted in Sabine Rewald, ed., *Glitter and Doom: German Portraits from the 1920s* (New Haven, CT: Yale University Press, 2006), 29.

25. Grosz, *A Little Yes*, 146, 147.

26. Grosz, *A Little Yes*, 145.

27. George Grosz, "Notizen für Prozeß," George Grosz Archive, Houghton Library, Harvard University, Cambridge, Massachusetts, quoted in M. Kay Flavell, *George Grosz: A Biography* (New Haven, CT: Yale University Press, 1988), 27.

28. George Grosz to Robert Bell, 1916/17, in Knust, *George Grosz Briefe 1913–1959*, 42, 44.

29. George Grosz to Robert Bell, 1916/17, 44.

30. Grosz, *A Little Yes*, 123.

31. Flavell, *George Grosz*, 28.

32. Grosz, *A Little Yes*, 158.

33. George Grosz, "Lebenslauf," quoted in Beth Irwin Lewis, *George Grosz: Art and Politics in the Weimar Republic* (Princeton, NJ: Princeton University Press, 1991), 52.

34. Richard Huelsenbeck, "En Avant Dada: A History of Dadaism," in *The Dada Painters and Poets: An Anthology*, ed. Robert Motherwell (New York: Wittenborn, Schultz, Inc., 1951), 44.

35. Grosz, *A Little Yes*, 182.

36. Marion F. Deshmukh, *Max Liebermann: Modern Art and Modern Germany* (London: Routledge, 2016), 199.

37. Deshmukh, *Max Liebermann*, 297.

38. Harry Kessler, *Berlin in Lights: The Diaries of Count Harry Kessler (1918–1937)*, ed. Charles Kessler (London: Weidenfeld & Nicholson, 1971), 29.

39. Kessler, *Berlin in Lights*, 45.

40. Kessler, *Berlin in Lights*, 40.

41. Fest, *Hitler*, 94–95.

42. Kessler, *Berlin in Lights*, 53.

43. Max Pechstein, "What We Want," in *Voices of German Expressionism*, ed. Victor H. Miesel (Upper Saddle River, NJ: Prentice Hall, 1970), 179.

44. No author, no article title, *Völkische Beobachter*, 6 April 1920, quoted in Joachim C. Fest, *Hitler: A Biography* (London: Penguin Books, 1974), 99.

45. Kessler, *Berlin in Lights*, 117.

CHAPTER III: ECLIPSE OF THE SUN

1. Erwin Blumenfeld, *Eye to I* (London: Themes & Hudson, 1999), 210.

2. George Grosz, *A Little Yes and a Big No* (New York: Dial Press, 1946), 12.

3. Igaz Wrobel [Kurt Tucholsky], "Fratzen von Grosz," *Die Weltbühne*, 18 August 1921, quoted in Beth Irwin Lewis, *George Grosz: Art and Politics in the Weimar Republic* (Princeton, NJ: Princeton University Press, 1991), 136.

4. Kessler, *Berlin in Lights*, 64.

5. George Grosz, "Dadaist Manifesto, 1918," reproduced in M. Kay Flavell, *George Grosz: A Biography* (New Haven, CT: Yale University Press, 1988), 308.

6. Lewis, *George Grosz*, 94.

7. George Grosz and Wieland Herzfelde, *Die Kunst ist in Gefahr* (Berlin: Malik Verlag, 1925), 42.

8. Letter reproduced in Maximilian Scheer, ed., *Blut und Ehre* (Paris, 1937), quoted in Robert G. L. Waite, *Vanguard of Nazism* (Cambridge, MA: Harvard University Press, 1952), 182.

9. Kurt Tucholsky, *Werke—Briefe—Materialen*, ed. Mathias Bertram (Berlin: Rohwolt, 1987), 2:383.

10. Tucholsky, *Werke—Briefe—Materialen*, 3:27.

11. Harry Kessler, *Berlin in Lights: The Diaries of Count Harry Kessler (1918–1937)*, ed. Charles Kessler (London: Weidenfeld & Nicholson, 1971), 70.

12. Uwe M. Schneede, *George Grosz: The Artist in His Society* (Woodbury, NY: Barron's Educational Series, 1985), 118.

13. George Grosz to Robert Bell, 17 September 1931, in *George Grosz Briefe 1913–1959*, ed. Herbert Knust (Reinbek bei Hamburg: Rowohlt Verlag, 1979), 128.

14. Grosz, *A Little Yes*, 171.

15. Grosz, *A Little Yes*, 201.

16. Grosz, *A Little Yes*, 222.

17. Kirchner Museum Davos, 1992, news release, Biography Ernst Ludwig Kirchner, accessed 29 November 2018, www.kirchnermuseum.ch/fileadmin/Inhalte_Redaktoren/Bilder _Inhalt/E.L.Kirchner/Biography_E.L.Kirchner_english.pdf.

18. Joseph Roth, "With the Homeless," *Neuer Berliner Zeitung: 12 Uhr Blatt*, 23 September 1920, in Joseph Roth, *What I Saw*, ed. Michael Bienert (New York: W. W. Norton & Company, 2003), 65.

19. Joseph Roth, "The Unnamed Dead," *Neue Berliner Zeitung*, 17 January 1923, in Roth, *What I Saw*, 80.

20. Stefan George, *Das Neue Reich* (Düsseldorf: Küpper, 1964), quoted in Joachim C. Fest, *Hitler: A Biography* (London: Penguin Books, 1974), 102.

21. Fest, *Hitler*, 101.

22. Ernst Deuerlein, *Hitlers Eintritt in die Politik und die Reichswehr* (Bonn: Bundeszentrale fur Politische Bildung, 1959), 201, quoted in Fest, *Hitler*, 115.

23. Adolf Hitler, "Speech at the Conference in Genoa" (12 April 1922), in *The Speeches of Adolf Hitler, April 1922–August 1939*, ed. Norman H. Baynes (London: Oxford University Press, 1942), 1:8.

24. Hitler, "Speech at the Conference in Genoa," 17.

25. Deuerlein, *Hitlers Eintritt in die Politik und die Reichswehr*, 211, 215, quoted in Fest, *Hitler*, 130.

26. Karl Alexander von Müller and Otto Alexander von Müller, *Im Wandel einer Welt: Erinnerungen 1919–1932* (Munich: Süddeutscher Verlag, 1966), 129.

27. Fest, *Hitler*, 81.

28. Kurt Luedecke, *I Knew Hitler* (London: Jarrolds, 1938), 22, quoted in Fest, *Hitler*, 154.

29. Fest, *Hitler*, 184.

30. Helene Niemeyer Hanfstaengl, "Notes," FDR Library and Helene Niemeyer, taped interview by John Toland, Library of Congress, quoted in Andrew Nagorski, *Hitlerland: American Eyewitnesses to the Nazi Rise to Power* (New York: Simon & Schuster, 2010), 44, 45.

31. See Fest, *Hitler*, 190–193.

32. Hannah Arendt, quoted in Peter Gay, *Weimar Culture: The Outsider as Insider* (New York: Harper & Row, 1968), 70.

33. George Grosz to Otto Schmalhausen, 3 March 1918, in Knust, *George Grosz Briefe 1913–1959*, 58.

34. Hannah Höch, "Catalogue Foreword to First Solo Exhibition at the Kunstzaal De Bron, The Hague," in *Hannah Höch*, ed. Dawn Ades, Emily Butler, and Daniel F. Herrmann (London: Whitechapel Gallery, 2014), 140.

35. Otto Dix, "Notes on Conversations" (no date; post-1919), in *Otto Dix im Selbstbildnis*, ed. Diether Schmidt (Berlin: Henschel Verlag, 1978), 252.

36. No author, *Süddeutsche Zeitung*, 1924, quoted in Anne Marno, "The Etching Series Der Krieg," in *Otto Dix: The Evil Eye*, ed. Susanne Meyer-Bueser (Dusseldorf: Kunstsammlung Nordrhein-Westfalen, 2017), 184.

37. George Grosz to Otto and Lotte Schmalhausen, 27 July 1926, in Knust, *George Grosz Briefe 1913–1959*, 97.

38. Marion F. Deshmukh, *Max Liebermann: Modern Art and Modern Germany* (London: Routledge, 2016), 317.

39. Fritz Homeyer, *Ein Leben für das Buch: Erinnerungen* (Aschaffenburg, 1961), 173, and Matthias Eberle, *Max Liebermann: Werkverzeichnis der Gemälde und Ölstudien* (Munich: Hirmer, 1995–1996), vol. 2, 1919/7, 978, quoted in Deshmukh, *Max Liebermann*, 317.

40. Heinrich Strauss, "On Jews and German Art (The Problem of Max Liebermann)," *Leo Baeck Institute Yearbook* 2, no. 1 (January 1957): 266.

41. Schneede, *George Grosz*, 172.

42. Schneede, *George Grosz*, 174.

43. Houston Stuart Chamberlain, *Illustrierte Beobachter* (1926:2), 6, quoted in Fest, *Hitler*, 181.

44. Joseph Goebbels to Adolf Hitler, Undated Letter, 1923, quoted in Fest, *Hitler*, 200.

45. Fest, *Hitler*, 242.

46. Joseph Goebbels, *Das Tagebuch von Joseph Goebbels, 1925/26*, ed. Helmut Heiber (Stuttgart: Deutsche Verlags-Anstalt, 1960), 92.

47. Fest, *Hitler*, 255.

48. Konrad Heiden, *Der Führer* (Boston: Houghton Mifflin Company, 1944), 419.

49. Fest, *Hitler*, 278.

50. Adolf Hitler, *Hitler's Speeches: 1922–1939*, ed. Norman H. Bynes (London: Oxford University Press, 1942), 1:568, 572.

51. Fest, *Hitler*, 295.

52. Kessler, *Berlin in Lights*, 400.

53. George Grosz to Eduard Plietzsch, 23 August 1931, in Knust, *George Grosz Briefe 1913–1959*, 126.

54. H. R. Knickerbocker, *The German Crisis* (New York: Farrar & Rinehart, 1932), 227.

55. George Grosz to Robert Bell in Knust, *George Grosz Briefe 1913–1959*, 128.

56. Flavell, *George Grosz*, 83.

57. Undated typescript, Art Student League Files, quoted in Flavell, *George Grosz*, 85.

58. George Grosz to Eva Grosz, 18 August 1932, in Knust, *George Grosz Briefe 1913–1959*, 152.

59. George Grosz to Eva Grosz, 4 August 1932, in Knust, *George Grosz Briefe 1913–1959*, 149.

60. George Grosz to Wieland Herzfelde, 23 August 1932, in Knust, *George Grosz Briefe 1913–1959*, 159.

61. George Grosz to Eva Grosz in Knust, *George Grosz Briefe 1913–1959*, 154, 155.

62. Adolf Hitler, untitled speech (January 1932), *Hitler: Reden und Proklamationen von 1932 bis 1945*, ed. Max Domeus (Bavaria: Neustadt an der Aisch Verlag, 1962), 68, quoted in Fest, *Hitler*, 310.

63. George Grosz to Wieland Herzfelde, 23 August 1932, in Knust, *George Grosz Briefe 1913–1959*, 160.

64. George Grosz, untitled interview, Bayerischen Rundfunk, Bavaria, Germany, 2 November 1954, in Ralph Jentsch, *Alfred Flechtheim George Grosz. Zwei deutsche Schicksale* (Bonn: Weidle, 2008), 71.

65. George Grosz to Eva Grosz, 6 June 1932, in Knust, *George Grosz Briefe 1913–1959*, 134.

66. George Grosz, "Self Portrait of the Artist," *Americana Magazine*, November 1932, 22.

67. Jentsch, *Alfred Flechtheim George Grosz*, 116.

68. Grosz, *A Little Yes*, 292.

69. Fest, *Hitler*, 237.

70. Joseph Goebbels, "Diary Entry: 3 Feb 1932," in *Die Tagebücher von Joseph Goebbels*, ed. Elke Fröhlich (Munich: K. G. Saur, 2004), vol. 1, pt. 2/II, 210.

71. Fest, *Hitler*, 369.

CHAPTER IV: ADOLF'S SILVER HAMMER

1. No author, "Statement by the Reich Press Office of the NSDAP," *Volkische Beobachter*, 7 August 1933, quoted in Peter Longerich, *Goebbels: A Biography* (New York: Random House, 2015), 235.

2. Joseph Goebbels, "Diary Entry: 6 February 1924," in *Die Tagebücher von Joseph Goebbels*, ed. Elke Fröhlich (Munich: K. G. Saur, 2004), vol. 1, pt. 1, 89.

3. Richard J. Evans, *The Third Reich in Power: How the Nazis Won Over the Hearts and Minds of a Nation* (London: Penguin Books, 2006), 280.

4. Ines Schlenker, *Hitler's Salon: The Große Deutsche Kunstausstellung at the Haus der Deutschen Kunst in Munich, 1937–1944* (Oxford, UK: Peter Lang, 2007), 38.

5. Schlenker, *Hitler's Salon*, 50.

6. Wolfgang Willrich, *Säuberung des Kunsttempels* (Munich: Lehman, 1938), 84–85, quoted in Olaf Peters, "Genesis, Conception and Consequences," in *Degenerate Art: The Attack on Modern Art in Nazi Germany, 1937*, ed. Olaf Peters (New York: Prestel, 2014), 106.

7. Anton Sailer, *Münchener Aufzeichnungen: Tatsachen und Gerüchte* (Munich: Süddeutscher Verlag, 1976), quoted in Schlenker, *Hitler's Salon*, 50.

8. Longerich, *Goebbels*, 241.

9. Longerich, *Goebbels*, 279.

10. Joseph Goebbels, "Diary Entry: 28 April 1931," in Fröhlich, *Die Tagebücher von Joseph Goebbels*, vol. 1, pt. 2/I, 394.

11. Longerich, *Goebbels*, 5, 6.

12. Longerich, *Goebbels*, 11, 18.

13. Joseph Goebbels, Doctoral Diploma: 21 April 1922, NL 1118/128, Nachlass Joseph Goebbels, Bundesarchiv, Koblenz, Germany, quoted in Longerich, *Goebbels*, 22.

14. Joseph Goebbels, "Erinnerungsblätter," in Fröhlich, *Die Tagebücher von Joseph Goebbels*, 1, 29, quoted in Longerich, *Goebbels*, 4.

15. Joseph Goebbels, "Diary Entry: 17 October 1923," in Fröhlich, *Die Tagebücher von Joseph Goebbels*, 29.

16. Joseph Goebbels, "Erinnerungsblätter," in Fröhlich, *Die Tagebücher von Joseph Goebbels*, 25, quoted in Longerich, *Goebbels*, 24.

17. Joseph Goebbels, "Diary Entry: 25 July 1923," in Fröhlich, *Die Tagebücher von Joseph Goebbels*, quoted in Longerich, *Goebbels*, 43.

18. Joseph Goebbels, "Diary Entry: 13 March 1924," in Fröhlich, *Die Tagebücher von Joseph Goebbels*, vol. 1, pt. 1/I, 107.

19. Frederic Spotts, *Hitler and the Power of Aesthetics* (New York: Overlook Press, 2004), 17.

20. Joseph Goebbels, "Diary Entry: 24 March 1924," in Fröhlich, *Die Tagebücher von Joseph Goebbels*, vol. 1, pt. 1/I, 112; Joseph Goebbels, "Diary Entry: 26 March 1924," in Fröhlich, *Die Tagebücher von Joseph Goebbels*, vol. 1, pt. 1/I, 114; Joseph Goebbels, "Diary Entry: 29 March 1924," in Fröhlich, *Die Tagebücher von Joseph Goebbels*, vol. 1, pt. 1/I, 115.

21. Joseph Goebbels, "Diary Entry: 8 June 1925," in Fröhlich, *Die Tagebücher von Joseph Goebbels*, vol. 1, pt. 1/I, 312.

22. Joseph Goebbels, "Diary Entry: 12 July 1925," in Fröhlich, *Die Tagebücher von Joseph Goebbels*, quoted in Longerich, *Goebbels*, 59.

23. Joseph Goebbels, "Diary Entry: 10 May 1931," in Fröhlich, *Die Tagebücher von Joseph Goebbels*, vol. 1, pt. 2/I, 403.

24. Adolf Hitler, *Mein Kampf* (New York: Reynal & Hitchcock, 1939), 826–830.

25. Hitler, *Mein Kampf*, 423.

26. Hitler, *Mein Kampf*, 419, 420.

27. Hitler, *Mein Kampf*, 67.

28. Hitler, *Mein Kampf*, 75.

29. Joseph Goebbels, "15 March 1927: Propaganda in Wort und Bild," *Nationalsocialistische Briefe*, quoted in Longerich, *Goebbels*, 79.

30. Longerich, *Goebbels*, 71, 78.

31. Longerich, *Goebbels*, 151, 158.

32. Joseph Goebbels, "Introduction," in *The New Germany Desires Work and Peace: Speeches by Reich Chancellor Adolf Hitler, the Leader of the New Germany* (Berlin: Liebheit & Thiesen, 1933), n.p.

33. Ian Kershaw's *Hitler: A Biography* (London: W. W. Norton & Company, 2010) is a condensed biography of 969 pages from the original two-volume edition by Kershaw that totals 1,450 pages with over 10,000 footnotes. Kershaw cut out references to his original 450 pages of footnotes in the condensed biography. After consulting directly with Kershaw, I concluded that his research methods were assiduous enough that citing the condensed biography followed research ethics. Readers interested in the original footnotes should consult Kershaw's original two-volume biography. Adolf Hitler, quoted in Kershaw, *Hitler*, 263, 264.

34. Kershaw, *Hitler*, 276.

35. Kershaw, *Hitler*, 276, 279.

36. Hitler, *Mein Kampf*, 76.

37. Kershaw, *Hitler*, 282.

38. Kershaw, *Hitler*, 293.

39. Stephanie Barron, "1937: Modern Art and Politics in Prewar Germany," in *Degenerate Art: The Fate of the Avant-Garde in Nazi Germany*, ed. Stefanie Barron (Los Angeles, CA: Los Angeles County Museum of Art, 1991), 9.

40. Hitler, *Mein Kampf*, 640.

41. Sabine Brantl, ed., *Haus der Kunst 1937–1997: Eine historische Dokumentation* (Munich: Haus der Kunst, 1998), 30, quoted in Schlenker, *Hitler's Salon*, 48.

42. Jonathan Petropoulos, *Artists Under Hitler: Collaboration and Survival in Nazi Germany* (New Haven, CT: Yale University Press, 2014), 156.

43. Emil Nolde, *Jahre der Kämpfe*, rev. 5th. ed. (Cologne: DuMont, 1985), 90, quoted in *Emil Nolde*, ed. Peter Vergo and Felicity Lunn (London: Whitechapel, 1995), 10.

44. Hans Fehr, *Emil Nolde: Buch der Freundschaft* (Cologne: M. DuMont Schauberg, 1957), 86.

45. Petropoulos, *Artists Under Hitler*, 143.

46. Gertrud Stickforth to Emil and Ada Nolde, 19 June 1933, Archives: Stiftung Seebüll Ada und Emil Nolde (ANS), quoted in Bernhard Fulda and Aya Soika, "Emil Nolde and the National Socialist Dictatorship," in Peters, *Degenerate Art*, 190.

47. Fehr, *Emil Nolde*, 66.

48. Joseph Goebbels, "Diary Entry: 2 July 1933," in Fröhlich, *Die Tagebücher von Joseph Goebbels*, vol. 1. pt. 2/III, 219.

49. Exhibition catalogue, *Kollektiv-Ausstellung Max Pechstein Berlin*, ed. Fritz Gurlitt (Berlin: No publisher, 1913), referenced in Bernhard Fulda and Aya Soika, *Max Pechstein: The Rise and Fall of Expressionism* (Boston: De Gruyter, 2012), 127.

50. Fulda and Soika, *Max Pechstein*, 128.

51. Fulda and Soika, *Max Pechstein*, 200.

52. Letter, Max Pechstein to Hildebrand Gurlitt, 25 June 1925, Archiv der Kunstsammlungen, Städtische Museum Zwickau, Dusseldorf City Archives, Dusseldorf, Germany, quoted in Fulda and Soika, *Max Pechstein*, 258. Also see Fulda and Soika, *Max Pechstein*, 243.

53. Letter, Max Pechstein to George Grosz, 28 March 1933, George Grosz Archives, Houghton Library, Harvard University, Cambridge, quoted in Fulda and Soika, *Max Pechstein*, 297.

54. Fulda and Soika, *Max Pechstein*, 297.

55. Fulda and Soika, *Max Pechstein*, 302.

56. Fulda and Soika, *Max Pechstein*, 305.

57. Albert Speer, *Inside the Third Reich: Memoirs by Albert Speer* (New York: MacMillan Company), 27.

58. James A. Van Dyke, "Something New on Nolde, National Socialism, and the SS," *Kunstchronik* 65, no. 5 (May 2012): 265–270.

59. Nolde, *Jahre der Kämpfe*, 28.

60. Gustav Schiefler, *Meine Graphiksammlung* (Hamburg: Christians Verlag, 1974), 46.

61. Nolde, *Jahre der Kämpfe*, 33.

62. Nolde, *Jahre der Kämpfe*, 101.

63. Nolde, *Jahre der Kämpfe*, 101, 120, 124.

64. Nolde, *Jahre der Kämpfe*, 123.

65. Nolde, *Jahre der Kämpfe*, 133, quoted in Vergo and Lunn, *Emil Nolde*, 33.

66. Ernst Ludwig Kirchner to Gustav Schiefler, 20 December 1934, in Ernst Ludwig Kirchner, *Briefwechsel 1910–1935/1938*, ed. Wolfgang Henze (Stuttgart: Belser, 1990), 706.

67. Joseph Goebbels, "Diary Entry: 13 December 1923," in Fröhlich, *Die Tagebücher von Joseph Goebbels*, vol. 1, pt. 1, 60.

68. Petropoulos, *Artists Under Hitler*, 37.

69. Kershaw, *Hitler*, 303.

70. Kershaw, *Hitler*, 305, 306.

71. Spotts, *Hitler and the Power of Aesthetics*, 111.

72. Kershaw, *Hitler*, 312.

73. Kershaw, *Hitler*, 312.

74. Kershaw, *Hitler*, 315.

75. Kershaw, *Hitler*, 318.

76. William L. Shirer, *Berlin Diary: The Journal of a Foreign Correspondent, 1934–1941* (New York: Alfred A. Knopf, 1941), 17.

77. Kershaw, *Hitler*, 333.

78. Kershaw, *Hitler*, 335.

79. Kershaw, *Hitler*, 339, 340.

80. Joseph Goebbels, "Diary Entry: 13 July 1935," in Fröhlich, *Die Tagebücher von Joseph Goebbels*, vol. 1, pt. 3/I, 261.

81. Adolf Hitler, "Art and Politics: Address Delivered at the Seventh National Socialist Congress, Nuremberg, September 11, 1935," in *Liberty, Art, Nationhood*, ed. Adolf Hitler (Berlin: M. Müller & Sohn, 1935), 33, 34.

82. Hitler, "Art and Politics," 46, 47.

83. Hitler, "Art and Politics," 46, 47.

84. Kershaw, *Hitler*, 326.

85. I wish to credit historian Ian Kershaw for coining this term.

86. "Speaking of Pictures: Jugend um Hitler," *Life*, 6 December 1937, 6–9.

87. "Hitler His Own Architect: He Practices His Art on a Simple Chalet," *New York Times Magazine*, 13 October 1935.

88. Schlenker, *Hitler's Salon*, 54.

89. Schlenker, *Hitler's Salon*, 61.

90. Schlenker, *Hitler's Salon*, 61.

91. Joseph Goebbels, "Diary Entry: 6 June 1937," in Fröhlich, *Die Tagebücher von Joseph Goebbels*, vol. 1, pt. 4, 170.

92. Schlenker, *Hitler's Salon*, 119.

93. Joseph Goebbels, "Diary Entry: 6 June 1937," in Fröhlich, *Die Tagebücher von Joseph Goebbels*, vol. 1, pt. 4, 170.

94. Joseph Goebbels, "Diary Entry: 7 June 1937," in Fröhlich, *Die Tagebücher von Joseph Goebbels*, vol. 1, pt. 4, 171.

95. Katrin Engelhardt, "Die Ausstellung 'Entartete Kunst' in Berlin 1938: Rekonstruktion und Analyse," in *Angriff auf die Avantgarde: Kunst und Kunstpolitik im Nationalsozialismus* (Berlin: Akademie Verlag, 2007), 94, quoted in Longerich, *Goebbels*, 348.

96. Longerich, *Goebbels*, 348, 349.

97. Joseph Goebbels, "Diary Entry: 12/13 July 1937," in Fröhlich, *Die Tagebücher von Joseph Goebbels*, vol. 1, pt. 4, 216.

98. Schlenker, *Hitler's Salon*, 67.

99. Adolf Hitler, "Rede zur Eröffnung der 'Großen Deutschen Kunstausstellung' 1937," in *Die "Kunststadt" München 1937: Nationalsozialismus und "Entartete Kunst"* (Munich: Prestel Verlag, 1998), 242.

100. Hitler, "Rede zur Eröffnung der 'Großen Deutschen Kunstausstellung' 1937," 252.

101. Joseph Goebbels, "Diary Entry: 19 July 1937," in Fröhlich, *Die Tagebücher von Joseph Goebbels*, 224.

102. Peter Guenther, "Three Days in Munich: July 1937," in Barron, *Degenerate Art*, 34.

103. Zentralinstitut für Kunstgeschichte and Deutsches Historisches Museum and Haus der Kunst, "Trefferliste: Große Deutsche Kunstausstellung," GDK-Research, 2011, accessed 26 December 2018, www.gdk-research.de.

104. Guenther, "Three Days in Munich," 34.

105. Guenther, "Three Days in Munich," 35.

106. Guenther, "Three Days in Munich," 36, 38.

107. Readers interested in viewing a detailed layout of the entire exhibition should refer to the blueprint in Marion-Andreas von Lüttichau, "Entartete Kunst, Munich 1937: A Reconstruction," in Barron, *Degenerate Art*, 45–80.

108. Lüttichau, "Entartete Kunst, Munich 1937."

109. Guenther, "Three Days in Munich," 40.

110. Ines Schlenker, "Defining National Socialist Art," in Peters, *Degenerate Art*, 100; Lüttichau, "Entartete Kunst, Munich 1937," 55.

111. Schlenker, "Defining National Socialist Art," 100.

112. No author, *Berliner Morgenpost*, 20 July 1937; no author, *Berliner Illustrierte Nachtausgabe*, 25 February 1938, quoted in Evans, *The Third Reich in Power*, 173.

113. Schlenker, *Hitler's Salon*, 80.

114. Emil Nolde, *Reisen, Ächtung, Befreiung, 1919–1946* (Cologne: DuMont, 1967), 121.

115. Schlenker, *Hitler's Salon*, 82, 83.

116. Schlenker, *Hitler's Salon*, 199.

117. Joseph Goebbels, "Diary Entry: 17 April 1937," in Fröhlich, *Die Tagebücher von Joseph Goebbels*, vol. 1, pt. 4, 98; Joseph Goebbels, "Diary Entry: 18 July 1937," in Fröhlich, *Die Tagebücher von Joseph Goebbels*, vol. 1, pt. 4, 223.

118. Emil Nolde to Joseph Goebbels (2 July 1938), R 55/21014, doc. 64, Bundesarchiv Berlin-Lichterfelde, quoted in Petropoulos, *Artists Under Hitler*, 155.

119. Kirchner Museum Davos, 1992, news release, Biography Ernst Ludwig Kirchner, accessed 29 November 2018, www.kirchnermuseum.ch/fileadmin/Inhalte_Redaktoren /Bilder_Inhalt/E.L.Kirchner/Biography_E.L.Kirchner_english.pdf.

120. Max Beckmann, "On My Painting (First Read in London, 21 July 1938)," in *Max Beckmann: Self-Portrait in Words*, ed. Barbara Copeland Buenger (Chicago: University of Chicago Press, 1997), 305.

CHAPTER V: BAD COMPANY CORRUPTS GOOD MORALS

1. Undated diary entry, Hildebrand Gurlitt, Schriftlicher Nachlass Cornelius Gurlitt, N 1826_55 (Salzburg Archives), quoted in Meike Hoffmann, "The Long Shadows of the Past—a Critical Appraisal of Hildebrand Gurlitt's Life," in *Gurlitt: Status Report*, ed. Kunstmuseum Bern, Bundeskunsthalle (Munich: Hirmer, 2017), 16.

2. Hildebrand Gurlitt to Wilibald Gurlitt, 16 October 1917, Gurlitt Estate, TU Dresden, 126/045, quoted in Hoffmann, "The Long Shadows of the Past," 18.

3. Jürgen Paul, *Cornelius Gurlitt: Ein Leben für Architektur, Kunstgeschichte, Denkmalpflege und Städtebau* (Dresden: Hellerau Verlag, 2003), 51.

4. See Vanessa-Maria Voigt, *Kunsthändler und Sammler der Moderne im Nationalsozialismus: Die Sammlung Sprengel 1934 bis 1945* (Berlin: Dietrich Reimer Verlag, 2007), 134.

5. Michael Löffler, *Hildebrand Gurlitt: Erster Zwickauer Museumsdirektor* (Zwickau: Städtisches Museum, 1994), 22, quoted in Voigt, *Kunsthändler und Sammler der Moderne im Nationalsozialismus*, 134.

6. Voigt, *Kunsthändler und Sammler der Moderne im Nationalsozialismus*, 135.

7. Meike Hoffmann and Nicola Kuhn, *Hitler's Kunsthändler: Hildebrand Gurlitt, 1895–1956* (Munich: C. H. Beck, 2016), 130–133.

8. Voigt, *Kunsthändler und Sammler der Moderne im Nationalsozialismus*, 135.

9. *Gurlitt: Status Report*, 324.

10. Beat Wismer, *Karl Ballmer, Der Maler* (Aarau: Argauer Kunsthaus, 1990), 61.

11. See Richard J. Evans, *The Third Reich in Power: How the Nazis Won Over the Hearts and Minds of a Nation* (New York: Penguin Books, 2006), 649.

12. Henrik Eberle and Matthias Uhl, eds., *The Hitler Book: The Secret Dossier Prepared for Stalin from the Interrogations of Hitler's Personal Aides* (New York: PublicAffairs, 2005), 26.

13. Rochus Misch, *Hitler's Last Witness: The Memoirs of Hitler's Bodyguard* (London: Frontline Books, 2015), 24.

14. Adolf Hitler, "Monologe: 15/16 Januar 1942," in *Monologe in Führerhauptquartier, 1941–1944*, ed. Werner Jochmann (Hamburg: A. Knaus, 1980), 200.

15. Eduard Bloch, "My Patient Hitler," *Collier's Magazine*, 15 March 1941, 11; see also Brigitte Hamann, *Hitler's Vienna: A Dictator's Apprenticeship* (New York: Tauris Parke Paperbacks, 2010), 36, 37.

16. Testimony (no first name) Pichler to NSDAP Central Archive, NS 26/20, Bundesarchiv Koblenz, Koblenz, Germany, quoted in Hamann, *Hitler's Vienna*, 356.

17. Letter, Samuel Morgenstern to Adolf Hitler, Gew. 2,755/Box 216, Administration of Property Archives, Vienna, Austria, quoted in Hamann, *Hitler's Vienna*, 357.

18. Hamann, *Hitler's Vienna*, 358, 359.

19. See Evans, *The Third Reich in Power*, 176.

20. Evans, *The Third Reich in Power*, 555, 560.

21. Evans, *The Third Reich in Power*, 575.

22. Joseph Goebbels, "Diary Entry: 29 July 1938," *Die Tagebücher von Joseph Goebbels*, ed. Elke Fröhlich (Munich: K. G. Saur, 2000), vol. I, pt. 5, 399.

23. Stephanie Barron, "The Galerie Fischer Auction," in *Degenerate Art: The Fate of the Avant-Garde in Nazi Germany*, ed. Stefanie Barron (Los Angeles, CA: Los Angeles County Museum of Art, 1991), 135.

24. Meike Hoffmann, "Saboteur und Profiteur: Hildebrand Gurlitt als Händler 'entarteter' Kunst," in *Markt und Macht: Der Kunsthandel im "Dritten Reich,"* ed. Uwe Fleckner, Thomas W. Gaehtgens, and Christian Huemer (Berlin: Walter De Gruyter, 2017), 2:141–165.

25. Misch, *Hitler's Last Witness*, 61.

26. Eberle and Uhl, *The Hitler Book*, 34, 35.

27. See Despina Stratigakos, *Hitler at Home* (New Haven, CT: Yale University Press, 2015), 56.

28. David Lloyd George, "I talked to HITLER," *Daily Express*, 17 September 1936.

29. Evans, *The Third Reich in Power*, 582–595.

30. David Toren in discussion with the author, November 2015 and June 2018.

31. David Toren in discussion with the author, November 2015 and June 2018.

32. Britta Olényi von Husen, "'They Are the Finest Ones, for Which I Had Set the Highest Prices': Adolph von Menzel in the Collection of Albert Martin Wolffson," in *Gurlitt: Status Report* (Munich: Hirmer, 2017), 130, 132.

33. Evans, *The Third Reich in Power*, 575, 604.

34. Eberle and Uhl, *The Hitler Book*, 42.

35. Misch, *Hitler's Last Witness*, 65.

36. No author, "Hitler, Mussolini and Eden—in Retreat," *Vogue*, 15 August 1936.

37. Stratigakos, *Hitler at Home*, 90, 254.

38. John Dickson, "Europe's Man of Mystery!" *Chicago Daily Tribune*, 6 August 1939.

39. Frederic Spotts, *Hitler and the Power of Aesthetics* (New York: Overlook Press, 2004), 187.

40. Birgit Schwarz, "Hildebrand Gurlitt and the 'Special Commission Linz,'" in *Gurlitt: Status Report*, 50.

41. Stephanie Barron, "The Galerie Fischer Auction," in Barron, *Degenerate Art*, 138.

42. Barron, "The Galerie Fischer Auction," 138.

43. Barron, "The Galerie Fischer Auction," 141.

44. Barron, "The Galerie Fischer Auction," 155.

45. Barron, "The Galerie Fischer Auction," 165–167.

46. Carl J. Burckhardt, *Meine Danziger Mission 1937–1939* (Munich: G. D. W. Callwey, 1960), 344.

47. Götz Aly, "Der Mord an behinderten Hamburger Kindern zwischen 1939 und 1945," in *Heilen und Vernichten im Mustergau Hamburg: Bevölkerungs- und Gesundheitspolitik im Dritten Reich*, ed. Angelika Ebbinghaus, Heidrun Kaupen-Haas, and Karl Heinz Roth (Hamburg: Konkret Literatur, 1984), 151; Hans-Walter Schmul, *Rassenhygiene, Nationalso-zialismus, Euthanasie: Von der Verhütung zur Vernichtung "lebensunwerten Lebens," 1890–1945* (Göttingen: Vandenhoeck und Ruprecht Verlag, 1987), 188–189, quoted in Evans, *The Third Reich at War*, 81.

48. Volker Riess, *Die Anfänge der Vernichtung "lebensunwerten Lebens" in den Reichsgauen Danzig-Westpreussen und Wartheland 1939/40* (Frankfurt am Main: Universität Stuttgart, 1995), 355–358.

49. Evans, *The Third Reich at War*, 76.

50. Evans, *The Third Reich at War*, 94.

51. Hedwig Mauer Simpson, "Herr Hitler at Home in the Clouds," *New York Times Magazine*, 20 August 1939.

52. William L. Shirer, *Berlin Diary: The Journal of a Foreign Correspondent, 1934–1941* (New York: Alfred A. Knopf, 1941), 201.

53. Shirer, *Berlin Diary*, 207.

54. No author, "Europe's Children," *Life*, 11 September 1939.

55. No author, "Paintings by Adolf Hitler," *Life*, 30 October 1939.

56. George Kreis, *"Entartete" Kunst für Basel: Die Herausforderung von 1939* (Basel: Wiese Verlag, 1990), 53.

57. Meike Hoffmann, "Case Studies: Max Beckmann, Old Woman with Cloche Hat, 1920," in *Gurlitt: Status Report*, 111.

58. Shirer, *Berlin Diary*, 404.

59. Letter, Hildebrand Gurlitt to Rolf Hetsch, no file number listed, Federal Archives: Berlin (Reichsministerium für Volksaufklärung und Propaganda), quoted in Hoffmann and Kuhn, *Hitler's Kunsthändler*, 204.

60. Letter, Hildebrand Gurlitt to Hans Posse, 10 December 1940, B323-134, Bundesarchiv Koblenz, Koblenz, Germany, and letter, Hans Posse to Hildebrand Gurlitt, 12 December 1940, B 323-134, Bundesarchiv Koblenz, Koblenz, Germany, quoted in Catherine Hickley,

The Munich Art Hoard: Hitler's Dealer and His Secret Legacy (London: Thames & Hudson: 2015), 76.

61. Letter, Hildebrand Gurlitt to Hans Posse, 15 January 1941, B 323/134, no. 376 and 19 March 1941, no. 374, and Hans Posse to Hildebrand Gurlitt, 21 March 1941, no. 373, Bundesarchiv Koblenz, Koblenz, Germany, quoted in Schwarz, "Hildebrand Gurlitt and the 'Special Commission Linz,'" 50.

62. Hildebrand Gurlitt, business contract, 12 March 1941, no file listed, Federal Archives: Berlin (Reichsministerium für Volksaufklärung und Propaganda), quoted in Hoffmann and Kuhn, *Hitler's Kunsthändler*, 193, 194.

63. Hoffmann and Kuhn, *Hitler's Kunsthändler*, 208, 209.

64. Katja Terlau, "Hildebrand Gurlitt and the Art Trade During the Nazi Period," in *Vitalizing Memory: International Perspectives on Provenance Research* (Washington, DC: American Association of Museums, 2005), 165–170.

65. Evans, *The Third Reich at War*, 264–266.

66. Joseph Goebbels, "Diary Entry: 20 January 1942," *Die Tagebücher von Joseph Goebbels*, 152, 154.

67. Evans, *The Third Reich at War*, 301.

68. Peter Longerich, *Der ungeschriebene Befehl: Hitler und der Weg zur "Endlösung"* (Munich: Piper Verlag, 2001), 124.

69. Joseph Goebbels, "Diary Entry: 27 March 1942," *Die Tagebücher von Joseph Goebbels*, 561.

70. Inventory List, District President in Breslau, 28 June 1941, Peter Toren Family Archive, Washington, DC.

71. David Toren in discussion with the author, November 2015.

CHAPTER VI: CULTURAL COMPLICITY

1. Joseph Goebbels, "Diary Entry: 23 January 1943," *Die Tagebücher von Joseph Goebbels*, ed. Elke Fröhlich (Munich: K. G. Saur, 1993), vol. 2, pt. 7, 162, 181.

2. Albert Speer, *Spandau: The Secret Diaries* (New York: Pocket Books, 1977), 190.

3. Kathrin Iselt, *Sonderbeauftragter des Führers: Der Kunsthistoriker und Museumsmann Hermann Voss (1884–1969)* (Cologne: Böhlau Verlag, 2010), 114.

4. Document regarding Hildebrand Gurlitt's payments from the Führermuseum Project, no file listed, 10 March 1944, Federal Archives Berlin (Reichsstelle Papier- und Verpackungswesen), quoted in Meike Hoffmann and Nicola Kuhn, *Hitler's Kunsthändler: Hildebrand Gurlitt, 1895–1956* (Munich: C. H. Beck, 2016), 214.

5. Hoffmann and Kuhn, *Hitler's Kunsthändler*, 215.

6. Letters, Erhard Göpel to Hildebrand Gurlitt, 15 January 1943 and 22 Jaunuary 1943, no file listed, Dusseldorf City Archives (Mahn- und Gedenkstätte), quoted in Hoffmann and Kuhn, *Hitler's Kunsthändler*, 214.

7. Traudl Junge, *Hitler's Last Secretary: A Firsthand Account of Life with Hitler* (New York: Arcade Publishing, 2011), 65.

8. Heinz Linge, *With Hitler to the End: The Memoirs of Adolf Hitler's Valet* (New York: Skyhorse Publishing, 2009), 55–57.

9. Rochus Misch, *Hitler's Last Witness: The Memoirs of Hitler's Bodyguard* (London: Frontline Books, 2015), 68.

10. Junge, *Hitler's Last Secretary*, 66.

11. Linge, *With Hitler to the End*, 25.

12. Junge, *Hitler's Last Secretary*, 68.

13. Linge, *With Hitler to the End*, 24.

14. Junge, *Hitler's Last Secretary*, 79, 100.

15. Junge, *Hitler's Last Secretary*, 92.

16. See Richard Evans, *The Third Reich at War* (London: Penguin Books, 2008), 328.

17. Letter, Linz Special Commission to Reich Ministry for Science and Education, 8 May 1943, B 323-123, Bundesarchiv Koblenz, Koblenz, Germany, quoted in Catherine Hickley, *The Munich Art Hoard: Hitler's Dealer and His Secret Legacy* (London: Thames & Hudson: 2015), 87.

18. Vitale Bloch, "Erinnerungen (Persönliches und Kunsthistorisches)," in *Hommage à Hermann Voss*, no editor listed (Strasbourg: Impr. strasbourgeoise, 1966), 45–52.

19. No author, "Collection Schloss: Archives et patrimoine," Diplomatie France, article undated, accessed 22 December 2018, diplomatie.gouv.fr/sites/archives_diplo/schloss/sommaire_ang.html.

20. Anne Sinclair, *My Grandfather's Gallery: A Legendary Art Dealer's Escape from Vichy France* (London: Profile Books, 2012), 24.

21. Letter, Henri Matisse to an unidentified acquaintance, 2 April 1939, no file listed, Getty Center for the History of Art, Santa Monica, California, quoted in Hilary Spurling, *Matisse the Master: A Life of Henri Matisse: The Conquest of Colour, 1909–1954* (London: Hamish Hamilton, 2005), 385.

22. Letter, Henri Matisse to Pierre Matisse, 16 March 1938, no file listed, Pierre Matisse papers, Pierpont Morgan Library, New York, quoted in Spurling, *Matisse the Master*, 379.

23. Sinclair, *My Grandfather's Gallery*, 34.

24. Iselt, *Sonderbeauftragter des Führers*, 256.

25. Theo Hermsen to Hildebrand Gurlitt, 16 June 1943, in file provided to the author by a confidential German source.

26. (Signature unintelligible) to Hildebrand Gurlitt, 1943; file provided to the author by a confidential German source.

27. File provided to the author by a confidential German source.

28. Letter, Hildebrand Gurlitt to Linz Special Commission, 25 August 1943, B323-134, Bundesarchiv Koblenz, Koblenz, Germany, and letter, Hans Gerlach to Robert Oertel, 8 December 1943, B323-133, Bundesarchiv Koblenz, Koblenz, Germany, quoted in Hickley, *The Munich Art Hoard*, 78.

29. Iselt, *Sonderbeauftragter des Führers*, 257.

30. Johannes Gramlich and Meike Hopp, "Hildebrand Gurlitt as an Art Dealer During the Nazi Period," in *Gurlitt: Status Report*, ed. Kunstmuseum Bern, Bundeskunsthalle (Munich: Hirmer, 2017), 36.

31. Evans, *The Third Reich at War*, 508.

32. Joseph Goebbels, "Diary Entry: 25 January 1944," in Fröhlich, *Die Tagebücher von Joseph Goebbels*, vol. 2, pt. 11, 170.

33. Document, "Übernahmebescheinigung, ausgestellt von Hermann Voss," 31 January 1944, R 8 XIV/12, Bd. 2, Bundesarchiv Koblenz, Koblenz, Germany, quoted in Iselt, *Sonderbeauftragter des Führers*, 295.

34. Receipt, Hildebrand Gurlitt to Linz Special Commission, 4 April 1944, B 323-134, Bundesarchiv Koblenz, Koblenz, Germany, quoted in Hickley, *The Munich Art Hoard*, 90.

35. Letter, Gustav Rochlitz to Hermann Voss, Febuary 1944, B323-147, Bundesarchiv Koblenz, Koblenz, Germany, quoted in Hickley, *The Munich Art Hoard*, 81.

36. See Iselt, *Sonderbeauftragter des Führers*, 291.

37. Iselt, *Sonderbeauftragter des Führers*, 296.

38. Hildebrand Gurlitt to Paul Roemer, 11 March 1944, Berlin: Private Archive, quoted in Hoffmann and Kuhn, *Hitler's Kunsthändler*.

39. Henrik Eberle and Matthias Uhl, eds., *The Hitler Book: The Secret Dossier Prepared for Stalin from the Interrogations of Hitler's Personal Aides* (New York: PublicAffairs, 2005), 138.

40. Report, 6 July 1944, file shown to author by a confidential source, 2015.

41. Hermann Voss to Reichsstelle Papier, 1 July 1944, B323-134, Bundesarchiv Koblenz, Koblenz, Germany, and receipt, Kunstkabinett Dr. H. Gurlitt to Linz Special Commission, 26 June 1944, B323-134, Bundesarchiv Koblenz, Koblenz, Germany, quoted in Hickley, *The Munich Art Hoard*, 80.

42. Letter, Hildebrand Gurlitt to Erich and Arno Krause, 6 July 1944, quoted in Hoffmann and Kuhn, *Hitler's Kunsthändler*, 224.

43. Evans, *The Third Reich at War*, 635.

44. Linge, *With Hitler to the End*, 159.

45. Junge, *Hitler's Last Secretary*, 130, 135.

46. Hoffmann and Kuhn, *Hitler's Kunsthändler*, 219.

47. Jonathan Steinberg, *The Deutsche Bank and Its Gold Transactions During the Second World War* (Munich: Beck, 1999), quoted in Evans, *The Third Reich at War*, 345.

48. Horst Mönnich, *The BMW Story: A Company in Its Time* (London: Sidgwick & Jackson, 1991), 283–284, quoted in Adam Tooze, *The Wages of Destruction* (New York: Viking, 2006), 519.

49. See Bernard Bellon, *Mercedes in Peace and War* (New York: Columbia University Press, 1990), 249–251.

50. Ulrich Herbert, *Hitler's Foreign Workers* (Cambridge: Cambridge University Press, 1997), 209–211.

51. Letter, Reich Chamber of Culture to Helene Gurlitt, 12 September 1944, Private Archive, Berlin, quoted in Hoffmann and Kuhn, *Hitler's Kunsthändler*, 225.

52. Michel Martin, Rapport Docteur Hildebrand Gurlitt, 1946, Archives du ministère des affaires étrangères, Paris, quoted in Hoffmann and Kuhn, *Hitler's Kunsthändler*, 208.

53. Iselt, *Sonderbeauftragter des Führers*, 271.

54. Iselt, *Sonderbeauftragter des Führers*, 282.

55. Max Beckmann, Notebooks 1904–1948, Diaries 30.06.1944–31.12.1944, Archives of American Art, Smithsonian Institution, Washington, DC, quoted in Hoffmann and Kuhn, *Hitler's Kunsthändler*, 215.

56. Joseph Goebbels, "Diary Entry: 2 December 1944," in Fröhlich, *Die Tagebücher von Joseph Goebbels*, vol. 2, pt. 14, 327.

57. Sybille Steinbacher, *"Musterstadt" Auschwitz: Germanisierungspolitik und Judenmord in Ostoberschlesien* (Munich: K. G. Saur, 2000), 123–128.

58. Evans, *The Third Reich at War*, 588. Author's Note: It is difficult to quote a precise sum of the money spent on the Führermuseum Project. Evans provides this reasoned, perhaps even cautiously low, estimate.

59. Meike Hoffmann, "The Long Shadows of the Past—a Critical Appraisal of Hildebrand Gurlitt's Life," in *Gurlitt: Status Report*, 22.

60. Bill to Hildebrand Gurlitt, Mahn- und Gedenkstätte Düsseldorf, Dresdner Transport- und Lagerhaus-Aktiengesellschaft, Stadtarchiv Düsseldorf, Düsseldorf, Germany, quoted in Hoffmann and Kuhn, *Hitler's Kunsthändler*, 228.

CHAPTER VII: REVISIONIST HISTORY

1. Rochus Misch, *Hitler's Last Witness: The Memoirs of Hitler's Bodyguard* (London: Frontline Books, 2015), 145.

2. Traudl Junge, *Hitler's Last Secretary: A Firsthand Account of Life with Hitler* (New York: Arcade Publishing, 2011), 159.

3. Junge, *Hitler's Last Secretary*, 159.

4. Junge, *Hitler's Last Secretary*, 157.

5. Junge, *Hitler's Last Secretary*, 160.

6. Henrik Eberle and Matthias Uhl, eds., *The Hitler Book: The Secret Dossier Prepared for Stalin from the Interrogations of Hitler's Personal Aides* (New York: PublicAffairs, 2005), 205.

7. Eberle and Uhl, *The Hitler Book*, 225.

8. Misch, *Hitler's Last Witness*, 151.

9. Junge, *Hitler's Last Secretary*, 162.

10. Junge, *Hitler's Last Secretary*, 164–165.

11. Author's Note: The Children of Joseph and Magda Goebbels, whom their parents murdered, were Helga, born 1 September 1932; Hildegard, born 13 April 1934; Helmut, born 2 October 1935; Holdine, born 19 February 1937; Hedwig, born 5 May 1938; Heidrun, born 29 October 1940.

12. Junge, *Hitler's Last Secretary*, 168.

13. Misch, *Hitler's Last Witness*, 155; Junge, *Hitler's Last Secretary*, 171.

14. Erich Kempka, *I Was Hitler's Chauffeur: The Memoirs of Erich Kempka* (London: Frontline Books, 2010), 61.

15. Junge, *Hitler's Last Secretary*, 177.

16. Adolf Hitler, "Mein privates Testament: 29 April 1945, 4.00 uhr," in *Adolf Hitlers Tamente*, ed. Gert Sudholt (Leoni am Starnberger See: Druffel, 1977), n.p.

17. Heinz Linge, *With Hitler to the End: The Memoirs of Adolf Hitler's Valet* (New York: Skyhorse Publishing, 2009), 41.

18. Kempka, *I Was Hitler's Chauffeur*, 70.

19. Linge, *With Hitler to the End*, 194, 195; Kempka, *I Was Hitler's Chauffeur*, 70.

20. Misch, *Hitler's Last Witness*, 167.

21. Misch, *Hitler's Last Witness*, 168.

22. Kempka, *I Was Hitler's Chauffeur*, 75; Linge, *With Hitler to the End*, 199.

23. Junge, *Hitler's Last Secretary*, 187.

24. Junge, *Hitler's Last Secretary*, 187.

25. Eberle and Uhl, *The Hitler Book*, 271.

26. Kempka, *I Was Hitler's Chauffeur*, 89.

27. Linge, *With Hitler to the End*, 199.

28. Junge, *Hitler's Last Secretary*, 188.

29. Kempka, *I Was Hitler's Chauffeur*, 80.

30. Eberle and Uhl, *The Hitler Book*, xvi, xvii.

31. Misch, *Hitler's Last Witness*, 176, 177.

32. Misch, *Hitler's Last Witness*, 7.

33. Misch, *Hitler's Last Witness*, 177.

34. Junge, *Hitler's Last Secretary*, 192.

35. Junge, *Hitler's Last Secretary*, 192.

36. Lynn H. Nicholas, *The Rape of Europa* (New York: Vintage Books, 1995), 220.

37. Nicolas, *The Rape of Europa*, 224.

38. Ian Kershaw, *To Hell and Back: Europe, 1914–1949* (London: Penguin Books, 2015), 470.

39. J. Robert Lilly, *Taken by Force: Rape and American GIs in Europe During World War II* (Basingstoke, UK: Palgrave Macmillan, 2007), 117, 118.

40. Volker Koop, *Besetzt: Französische Besatzungspolitik in Deutschland* (Berlin: BeBra Verlag, 2007), 40.

41. William I. Hitchcock, *Liberation: The Bitter Road to Freedom, Europe 1944–1945* (London: 2009), 302, quoted in Frederick Taylor, *Exorcising Hitler: The Occupation and Denazification of Germany* (London: Bloomsbury, 2011), 167.

42. Hoffmann and Kuhn, *Hitler's Kunsthändler*, 231.

43. Letter, Hildebrand Gurlitt to Horst Meixner, no date, private archive, quoted in Hoffmann and Kuhn, *Hitler's Kunsthändler*, 232.

44. Letter, Hildebrand Gurlitt to Wolfgang Gurlitt, 12 June 1945, private archive, Berlin/Munich, quoted in Hoffmann and Kuhn, *Hitler's Kunsthändler*, 239.

45. Letter, Hildebrand Gurlitt to Wolfgang Gurlitt, 12 June 1945, private archive, Berlin/Munich, quoted in Hoffmann and Kuhn, *Hitler's Kunsthändler*, 241.

46. Letter, Karl Ballmer to Hildebrand and Helene Gurlitt, 14 August 1948, private archive, quoted in Hoffmann and Kuhn, *Hitler's Kunsthändler*, 242.

47. Letter, Helene Gurlitt to Lisa Arnhold, 1947, private archive, quoted in Hoffmann and Kuhn, *Hitler's Kunsthändler*, 232.

48. Junge, *Hitler's Last Secretary*, 23.

49. Junge, *Hitler's Last Secretary*, 1–2.

50. Detailed Interrogation Report No. 12: Hermann Voss, 15 September 1945, Monuments, Fine Arts, and Archives (MFAA), National Archives and Records Administration (NARA)/(Fold3), accessed 4 January 2019, www.fold3.com/image/231997074.

51. Detailed Interrogation Report No. 12: Hermann Voss, 15 September 1045, MFAA, NARA, (Fold3), accessed 4 January 2019, www.fold3.com/image/231997269.

52. Detailed Interrogation Report No. 12: Hermann Voss, 15 September 1045, MFAA, NARA, (Fold3), accessed 4 January 2019, www.fold3.com/image/231997136.

53. Detailed Interrogation Report No. 12: Hermann Voss, 15 September 1045, MFAA, NARA, (Fold3), accessed 4 January 2019, www.fold3.com/image/231997289.

54. Detailed Interrogation Report No. 12: Hermann Voss, 15 September 1045, MFAA, NARA, (Fold3), accessed 4 January 2019, www.fold3.com/image/231997301.

55. Detailed Interrogation Report No. 12: Hermann Voss, 15 September 1045, MFAA, NARA, (Fold3), accessed 4 January 2019, www.fold3.com/image/231997321.

56. Detailed Interrogation Report No. 12: Hermann Voss, 15 September 1045, MFAA, NARA, (Fold3), accessed 4 January 2019, www.fold3.com/image/231997257.

57. Detailed Interrogation Report No. 12: Hermann Voss, 15 September 1045, MFAA, NARA, (Fold3), accessed 4 January 2019, www.fold3.com/image/231997289.

58. Detailed Interrogation Report No. 12: Hermann Voss, 15 September 1045, MFAA, NARA, (Fold3), accessed 4 January 2019, www.fold3.com/image/231997269.

59. Detailed Interrogation Report No. 12: Hermann Voss, 15 September 1045, MFAA, NARA, (Fold3), accessed 4 January 2019, www.fold3.com/image/231997301.

60. Detailed Interrogation Report No. 12: Hermann Voss, 15 September 1045, MFAA, NARA, (Fold3), accessed 4 January 2019, www.fold3.com/image/231997239.

61. Detailed Interrogation Report No. 12: Hermann Voss, 15 September 1045, MFAA, NARA, (Fold3), accessed 4 January 2019, www.fold3.com/image/231997289.

62. Detailed Interrogation Report No. 12: Hermann Voss, 15 September 1045, MFAA, NARA, (Fold3), accessed 4 January 2019, www.fold3.com/image/231997308.

63. Letter, Robert Oertel to Hildebrand Gurlitt, 1945, Hildebrand Gurlitt Papers, Bundesarchiv Berlin, Berlin, Germany.

64. Letter, Kurt Martin to Hildebrand Gurlitt, 1945, Hildebrand Gurlitt Papers, Bundesarchiv Berlin, Berlin, Germany.

65. Collection: Gurlitt (Gurlitt Coll.), MFAA, NARA (Fold3), accessed 4 January 2019, www.fold3.com/image/231981232.

66. Letter, Guido Schönberger to Hildebrand Gurlitt, Hildebrand Gurlitt Papers, Bundesarchiv Berlin, Berlin, Germany.

67. Letter, Albin von Prybram Gladona to Hildebrand Gurlitt, c.1946, Hildebrand Gurlitt Papers, Bundesarchiv Berlin, Berlin, Germany.

68. Collection: Gurlitt (Gurlitt Coll.), MFAA, NARA (Fold3), accessed 4 January 2019, www.fold3.com/image/231981242.

69. Letter, Max Beckmann to Hildebrand Gurlitt, c. 1946, Hildebrand Gurlitt Papers, Bundesarchiv Berlin, Berlin, Germany.

70. Collection: Gurlitt (Gurlitt Coll.), MFAA, NARA (Fold3), accessed 5 January 2019, www.fold3.com/image/270055181.

71. Collection: Gurlitt (Gurlitt Coll.), MFAA, NARA (Fold3), accessed 5 January 2019, www.fold3.com/image/270055082 and www.fold3.com/image/270055099.

72. Collection: Gurlitt (Gurlitt Coll.), MFAA, NARA (Fold3), accessed 5 January 2019, www.fold3.com/image/270055121.

73. Collection: Gurlitt (Gurlitt Coll.), MFAA, NARA (Fold3), accessed 5 January 2019, www.fold3.com/image/270055392.

74. Collection: Gurlitt (Gurlitt Coll.), MFAA, NARA (Fold3), accessed 5 January 2019, www.fold3.com/image/270055636.

75. Collection: Gurlitt (Gurlitt Coll.), MFAA, NARA (Fold3), accessed 3 January 2019, www.fold3.com/image/270055601.

76. Collection: Gurlitt (Gurlitt Coll.), MFAA, NARA (Fold3), accessed 3 January 2019, www.fold3.com/image/270055441.

77. Collection: Gurlitt (Gurlitt Coll.), MFAA, NARA (Fold3), accessed 4 January 2019, www.fold3.com/image/270055259.

78. Collection: Gurlitt (Gurlitt Coll.), MFAA, NARA (Fold3), accessed 4 January 2019, www.fold3.com/image/231981199.

79. Collection: Gurlitt (Gurlitt Coll.), MFAA, NARA (Fold3), accessed 4 January 2019, www.fold3.com/image/231981211.

80. Collection: Gurlitt (Gurlitt Coll.), MFAA, NARA (Fold3), accessed 4 January 2019, www.fold3.com/image/270055191 and www.fold3.com/image/232020673.

81. Collection: Gurlitt (Gurlitt Coll.), MFAA, NARA (Fold3), accessed 4 January 2019, www.fold3.com/image/231980918.

82. Kershaw, *To Hell and Back*, 483.

83. "So-Called 'Degenerate Art,'" APO 742 to Information Control Division, Office of Military Government for Wuerttemberg-Baden, APO 154, 4 February 1947, NARA, Restitution Branch, Economics Division, Office of Military Government for Germany, Washington, DC, quoted in Hoffmann and Kuhn, *Hitler's Kunsthändler*, 259.

CHAPTER VIII: OUR SINCERE CONDOLENCES

1. George Grosz to Wieland Herzfelde, 23 April 1945, in *George Grosz Briefe 1913–1959*, ed. Herbert Knust (Reinbek bei Hamburg: Rowohlt Verlag, 1979), 340.

2. Marty Grosz (son of artist George Grosz) in discussion with the author, June 2018.

3. George Grosz, *A Little Yes and a Big No* (New York: Dial Press, 1946), 294.

4. Juerg M. Judin, *George Grosz: The Years in America (1933–1958)* (Berlin: Hatje Cantz Verlag, 2009), 74–79.

5. George Grosz to Wieland Herzfelde, 8 March 1935, in Knust, *George Grosz Briefe 1913–1959*, 213.

6. Judin, *George Grosz*, 132.

7. George Grosz to Wieland Herzfelde, 8 March 1935, in Knust, *George Grosz Briefe 1913–1959*, 212.

8. Judin, *George Grosz*, 52.

9. George Grosz to Ernest Hemingway, 24 July 1936, in Knust, *George Grosz Briefe 1913–1959*, 248.

10. Paul Rosenfeld, "Exhibition 'Fantastic Art, Dada and Surrealism,' at the Museum of Modern Art," *New Republic*, 6 January 1937.

11. See Ezra Mendelsohn and Richard I. Cohen, eds., *Studies in Contemporary Jewry*, vol. 6: *Art and Its Uses: The Visual Image and Modern Jewish Society* (Oxford: Oxford University Press, 1990), 121.

12. M. Kay Flavell, *George Grosz: A Biography* (New Haven, CT: Yale University Press, 1988), 181.

13. George Grosz, "Notizen für eine Ansprache: 1958" (unpublished notes, 1958) in *George Grosz: Leben und Werk*, ed. Uwe M. Schneede (Stuttgart: Verlag Gerd Hatje, 1975), 130.

14. Marty Grosz (son of artist George Grosz) in discussion with the author, June 2018.

15. Judin, *George Grosz*, 72.

16. Judin, *George Grosz*, 150.

17. Helen Boswell, "Grosz Paints What He Can't Forget," *Art Digest* (15 February 1943): 7, quoted by Barbara McCloskey in Judin, *George Grosz*, 13.

18. Richard O. Boyer, "1—Demons in the Suburbs," *New Yorker*, 27 November 1943.

19. Marty Grosz (son of artist George Grosz) in discussion with the author, June 2018.

20. Boyer, "1—Demons in the Suburbs."

21. Boyer, "1—Demons in the Suburbs."

22. Boyer, "1—Demons in the Suburbs."

23. Boyer, "1—Demons in the Suburbs."

24. Boyer, "1—Demons in the Suburbs."

25. Boyer, "1—Demons in the Suburbs."

26. Richard O. Boyer, "3—The Yankee from Berlin," *New Yorker*, 11 December 1943.

27. George Grosz to Ben Hecht, 21 May 1944, in Knust, *George Grosz Briefe 1913–1959*, 334, 335.

28. George Grosz to Estelle Mandel, 15 March 1945, in Knust, *George Grosz Briefe 1913–1959*, 345, 346.

29. George Grosz to Herbert Fiedler, February 1946, in Knust, *George Grosz Briefe 1913–1959*, 364–368.

30. Marty Grosz (son of artist George Grosz) in discussion with the author, June 2018.

31. Pegeen Sullivan, *Catalogue: A Piece of My World in a World Without Peace* (New York: AAA Galleries, October 1946), n.p., quoted in Flavell, *George Grosz*, 249.

32. George Grosz, *Press Statement: A Piece of My World in a World Without Peace* (New York: AAA Galleries, October 1946), n.p., reproduced in Flavell, *George Grosz*, 320.

33. George Grosz, "A Piece of My World II / The Last Battalion," in Judin, *George Grosz*, 192.

34. George Grosz to Ulrich Becher, 20 May 1947, in Knust, *George Grosz Briefe 1913–1959*, 394.

35. Flavell, *George Grosz*, 250.

36. Boyer, "3—The Yankee from Berlin."

37. Boyer, "3—The Yankee from Berlin."

38. Grosz, *A Little Yes*, 304.

39. Edmund Wilson, "Book Review: George Grosz," *New Yorker*, 4 January 1947, 6–70.

40. Grosz, *A Little Yes*, 301.

41. For a facsimile of Stanley Kubrick's scrapbook page, see Judin, *George Grosz*, 260.

42. Richard O. Boyer, "2—The Saddest Man in All the World," *New Yorker*, 4 December 1943.

43. Boyer, "3—The Yankee from Berlin."

44. Marty Grosz (son of artist George Grosz) in discussion with the author, June 2018; see also Flavell, *George Grosz*, 271.

45. Marty Grosz (son of artist George Grosz) in discussion with the author, June 2018.

46. Marty Grosz (son of artist George Grosz) in discussion with the author, June 2018.

47. Alexander Kluy, *George Grosz: König Ohne Land* (Munich: Deutsche Verlags-Anstalt, 2017), 349.

48. George Grosz, Diary 1955, MS Ger. 206/1094, Houghton Library, Harvard University, Cambridge, Massachusetts, quoted in Kluy, *George Grosz*, 350.

49. George Grosz, Diary 1955, MS Ger. 206/1094, Houghton Library, Harvard University, Cambridge, Massachusetts, quoted in Kluy, *George Grosz*, 350.

50. George Grosz, Diary Entry: 27 September 1956, Diary 1956, MS Ger. 206/1102, Houghton Library, Harvard University, Cambridge, Massachusetts, quoted in Kluy, *George Grosz*, 351.

51. George Grosz, "Manhattan-Ballade in Berlin," *Telegraf* (Berlin), Number 203, Issue 13, 7 September 1958, 25, quoted in Kluy, *George Grosz*, 360.

52. Letter, Eva Grosz to German Government, 19 August 1958, George Grosz Archive, Houghton Library, Harvard University, Cambridge, Massachusetts, quoted in Ralph Jentsch, *Alfred Flechtheim George Grosz. Zwei deutsche Schicksale* (Bonn: Weidle, 2008), 91.

53. No author, Receipt, MS Ger. 206/1115, Folder 5 in Houghton Library, Harvard University, Cambridge, Massachusetts, quoted in Kluy, *George Grosz*, 362.

54. Marty Grosz (son of artist George Grosz) in discussion with the author, June 2018.

55. George Grosz, "You Mistake Me for an After-Dinner Speaker," 20 May 1959, in George Grosz, *Berlin–New York*, ed. Peter-Klaus Schuster (Berlin: Staatliche Museen zu Berlin, 1995), 310, 311.

56. Marty Grosz (son of artist George Grosz) in discussion with the author, June 2018.

57. Flavell, *George Grosz*, 185.

58. Britta Olényi von Husen, "'They Are the Finest Ones, for Which I Had Set the Highest Prices': Adolph von Menzel in the Collection of Albert Martin Wolffson," in *Gurlitt: Status Report*, ed. Kunstmuseum Bern, Bundeskunsthalle, 130.

59. George Grosz to Elisabeth Lindner, 17 March 1949, in Knust, *George Grosz Briefe 1913–1959*, 426–429.

60. Judin, *George Grosz*, 58.

61. Kluy, *George Grosz*, 378, 379.

62. Charles Baudelaire, "Edgar Allan Poe, His Life and Works," in *Selected Writings on Art and Artists* (New York: Penguin Books), 184; Flavell, *George Grosz*, 266.

CHAPTER IX: HITLER'S LAST HOSTAGES

1. Confidential German source close to Cornelius Gurlitt in discussion with the author, spring 2014.

2. Confidential German source close to Cornelius Gurlitt in discussion with the author, spring 2014.

3. Confidential German source close to Cornelius Gurlitt in discussion with the author, spring 2014.

4. Confidential German source close to Cornelius Gurlitt in discussion with the author, spring 2014.

5. Agenda calendar, Cornelius Gurlitt, 9 November 1956, Gurlitt Family Private Archive, quoted in Maurice Philip Remy, *Der Fall Gurlitt: Die wahre Geschichte über Deutschlands größten Kunstskandal* (Berlin: Europa Verlag, 2017), 405.

6. Cornelius Gurlitt, Letter to N. N., October 1960, Salzburg Archives, Salzburg, quoted in Remy, *Der Fall Gurlitt*, 406.

7. See letters to Hildebrand and Helene Gurlitt, November 1956, #257–259, Hildebrand Gurlitt Papers, Berlin Library, Bundesarchiv (Berlin Federal Archives).

8. Letter, Rudolf Schleier to Helene Gurlitt, 12 November 1956, #409, Hildebrand Gurlitt Papers, Berlin Library, Bundesarchiv (Berlin Federal Archives).

9. Letter, Aenne Abels to Helene Gurlitt, 23 November 1956, #615, Hildebrand Gurlitt Papers, Berlin Library, Bundesarchiv (Berlin Federal Archives).

10. Letter, Benita Fräßle-Gurlitt to Cornelius Gurlitt, 19 February 1967, Gurlitt Family Private Archive, quoted in Remy, *Der Fall Gurlitt*, 405.

11. Remy, *Der Fall Gurlitt*, 408–410.

12. Letter, Cornelius Gurlitt to Helene and Benita Gurlitt, August 1959, Düsseldorf Stadtarchiv, Dusseldorf, Germany, quoted in Remy, *Der Fall Gurlitt*, 423.

13. Letter, Helene Gurlitt to Cornelius Gurlitt, 31 May 1965, Gurlitt Family Private Archive, quoted in Remy, *Der Fall Gurlitt*, 410, 411.

14. Letter, Cornelius Gurlitt to Helene and Benita Gurlitt, no date (likely September 1963), Gurlitt Family Private Archive, quoted in Remy, *Der Fall Gurlitt*, 417.

15. Letter, Cornelius Gurlitt to Helene and Benita Gurlitt, September 1961, Gurlitt Family Private Archive, quoted in Remy, *Der Fall Gurlitt*, 417.

16. Letter, Benita Fräßle-Gurlitt to Cornelius Gurlitt, 15 November 1967, Gurlitt Family Private Archive, quoted in Remy, *Der Fall Gurlitt*, 418.

17. Letter, Helene Gurlitt to Cornelius Gurlitt, 30 March 1962, Gurlitt Family Private Archive, quoted in Remy, *Der Fall Gurlitt*, 419.

18. Calendar, Cornelius Gurlitt, 9 April 1966, Gurlitt Family Private Archive, quoted in Remy, *Der Fall Gurlitt*, 424.

19. Letter, Benita Gurlitt to Cornelius Gurlitt, 14 November 1974, Gurlitt Family Private Archive, quoted in Remy, *Der Fall Gurlitt*, 428.

20. Remy, *Der Fall Gurlitt*, 427.

21. Remy, *Der Fall Gurlitt*, 427.

22. Calendar, Cornelius Gurlitt, 9 November 1971, quoted in Remy, *Der Fall Gurlitt*, 431.

23. Confidential German source in discussion with the author, spring 2014.

24. Oliver Meier, Michael Feller, and Stefanie Christ, *Der Gurlitt-Komplex: Bern und die Raubkunst* (Zürich: Chronos Verlag, 2017), 311.

25. Letter, Cornelius Gurlitt to Benita Gurlitt, November 1974, Gurlitt Family Private Archive, quoted in Remy, *Der Fall Gurlitt*, 433.

26. Remy, *Der Fall Gurlitt*, 435.

27. Remy, *Der Fall Gurlitt*, 438.

28. Remy, *Der Fall Gurlitt*, 438.

29. Customs report, 2 November 2010, quoted in Remy, *Der Fall Gurlitt*, 442.

30. "Washington Conference Principles on Nazi-Confiscated Art: 3 December 1998," US Department of State, accessed 2 December 2018, www.state.gov/p/eur/rt/hlcst/270431 .htm.

31. Remy, *Der Fall Gurlitt*, 446.

32. Author's reporting notes for the *Wall Street Journal*, November 2013.

33. Author's reporting notes for the *Wall Street Journal*, November 2013.

34. Author's reporting for the *Wall Street Journal*, November 2013.

35. "Washington Conference Principles on Nazi-Confiscated Art: 3 December 1998."

36. Marcus Walker and Mary M. Lane, "Furor over Hidden Art Is Unwelcome Distraction for German Prosecutor," *Wall Street Journal*, 10 November 2013.

37. Walker and Lane, "Furor over Hidden Art."

38. David Toren in discussion with the author, June 2018; Peter Toren (son of David Toren) in discussion with the author, November 2015.

39. Peter Toren (son of David Toren) in discussion with the author, June 2018.

40. Peter Toren (son of David Toren) in discussion with the author, June 2018.

41. Hilary Spurling, *Matisse the Master: A Life of Henri Matisse: The Conquest of Colour, 1909–1954* (London: Hamish Hamilton, 2005), 393.

42. Marianne Rosenberg (granddaughter of Paul Rosenberg) in discussion with the author, July 2018.

43. Özelm Gezer, "Die Liebe seines Lebens," *Der Spiegel* 47/2013, 127.

44. Gezer, "Die Liebe seines Lebens," 129.

45. Gezer, "Die Liebe seines Lebens," 130.

46. Gezer, "Die Liebe seines Lebens," 130.

47. "Washington Conference Principles on Nazi-Confiscated Art: 3 December 1998."

48. Peter Toren (son of David Toren) in discussion with the author, June 2018.

49. Confidential German source in discussion with the author, early 2013.

50. Author's reporting notes for the *Wall Street Journal*, May 2014.

51. Author's reporting notes for the *Wall Street Journal*, May 2014.

52. Author's reporting notes for the *Wall Street Journal*, May 2014.

53. Mary M. Lane, "Germany to Comb Museums for Nazi-Looted Art," *Wall Street Journal*, 12 February 2014.

54. Official Minutes, German Bundesrat, Sitzung (Session) 919, 14 February 2014.

55. Official Minutes, German Bundesrat, Sitzung (Session) 919, 14 February 2014.

56. Author's reporting notes for the *Wall Street Journal*, May 2014.

57. Marianne Rosenberg (granddaughter of Paul Rosenberg) in discussion with the author, July 2018

58. Mary M. Lane, "Norway Returns Looted Matisse," *Wall Street Journal*, 22 March 2014.

59. Confidential German source in discussion with the author, May 2014.

60. Author's reporting notes for the *Wall Street Journal*, May 2014.

61. Confidential Swiss source in discussion with the author, October and November 2014.

62. David Toren in discussion with the author, November 2015.

63. Peter Toren (son of David Toren) in discussion with the author, June 2018.

64. Peter Toren (son of David Toren) in discussion with the author, June 2018.

65. Peter Toren (son of David Toren) in discussion with the author, June 2018.

EPILOGUE: BUSINESS AS USUAL

1. Author's reporting notes for *Wall Street Journal*, November 2013.

2. Rein Wolfs (Kunsthalle Bonn director) in discussion with the author, March 2018.

BIBLIOGRAPHY

BOOKS

Ades, Dawn, Emily Butler, and Daniel F. Herrmann, eds. *Hannah Höch*. London: Whitechapel Gallery, 2014.

Arndt, Karl, and Peter-Klaus Schuster, eds. *Die "Kunststadt" München 1937: Nationalsozialismus und "Entartete Kunst."* Munich: Prestel Verlag, 1998.

Barron, Stefanie, ed. *Degenerate Art: The Fate of the Avant-Garde in Nazi Germany*. Los Angeles, CA: Los Angeles County Museum of Art, 1991.

Baudelaire, Charles. *Selected Writings on Art and Artists*. Cambridge: Cambridge University Press, 1981.

Beckmann, Max. *Max Beckmann: Self-Portrait in Words*. Edited by Barbara Copeland Buenger. Chicago: University of Chicago Press, 1997.

Bellon, Bernard. *Mercedes in Peace and War*. New York: Columbia University Press, 1990.

Bloch, Vitale. *Hommage à Hermann Voss*. Strasbourg: Impr. strasbourgeoise, 1966.

Blumenfeld, Erwin. *Eye to I*. London: Themes & Hudson, 1999.

Burckhardt, Carl J. *Meine Danziger Mission 1937–1939*. Munich: G. D. W. Callwey, 1960.

Christ, Stefanie, Michael Feller, and Oliver Meier. *Der Gurlitt-Komplex: Bern und die Raubkunst*. Zurich: Chronos Verlag, 2017.

Deshmukh, Marion F. *Max Liebermann: Modern Art and Modern Germany*. London: Routledge, 2016.

Ebbinghaus, Angelika, Heidrun Kaupen-Haas, and Karl Heinz Roth, eds. *Heilen und Vernichten im Mustergau Hamburg: Bevölkerungs- und Gesundheitspolitik im Dritten Reich*. Hamburg: Konkret Literatur, 1984.

Eberle, Henrik, and Matthias Uhl, eds. *The Hitler Book: The Secret Dossier Prepared for Stalin from the Interrogations of Hitler's Personal Aides*. New York: PublicAffairs, 2005.

Edsel, Robert M. *The Monuments Men: Allied Heroes, Nazi Thieves and the Greatest Treasure Hunt in History*. New York: Center Street, 2010.

Eliel, Charol S., and Eberhard Roters, eds. *The Apocalyptic Landscapes of Ludwig Meidner*. Los Angeles, CA: Los Angeles County Museum of Art, 1989.

Evans, Richard J. *The Third Reich at War*. London: Penguin Books, 2008.

———. *The Third Reich in Power: How the Nazis Won Over the Hearts and Minds of a Nation*. London: Penguin Books, 2006.

Fehr, Hans. *Emil Nolde: Buch der Freundschaft*. Cologne: M. DuMont Schauberg, 1957.

Fest, Joachim C. *Hitler: Biography*. New York: Penguin Books, 2002.

Flavell, M. Kay. *George Grosz: A Biography*. New Haven, CT: Yale University Press, 1988.

Fleckner, Uwe, Thomas W. Gaehtgens, and Christian Huemer, eds. *Markt und Macht: Der Kunsthandel im "Dritten Reich."* Berlin: Walter De Gruyter, 2017.

Fulda, Bernhard, and Aya Soika. *Max Pechstein: The Rise and Fall of Expressionism*. Boston: De Gruyter, 2012.

Gay, Peter. *Weimar Culture: The Outsider as Insider*. New York: Harper & Row, 1968.

Goebbels, Joseph. *Das Tagebuch von Joseph Goebbels, 1925/26*. Edited by Helmut Heiber. Stuttgart: Deutsche Verlags-Anstalt, 1960.

———. *Die Tagebücher von Joseph Goebbels*. Edited by Elke Fröhlich. Munich: K. G. Saur, 2004.

Grosz, George. *A Little Yes and a Big No*. New York: Dial Press, 1946.

———. *Berlin–New York*. Edited by Peter-Klaus Schuster. Berlin: Staatliche Museen zu Berlin, 1995.

———. *George Grosz: Leben und Werk*. Edited by Uwe M. Schneede. Stuttgart: Verlag Gerd Hatje, 1975.

———. *George Grosz Briefe 1913–1959*. Edited by Herbert Knust. Reinbek bei Hamburg: Rowohlt Verlag, 1979.

Grosz, George, and Wieland Herzfelde. *Die Kunst ist in Gefahr*. Berlin: Malik Verlag, 1925.

Hamann, Brigitte. *Hitler's Vienna: A Dictator's Apprenticeship*. New York: Tauris Parke Paperbacks, 2010.

Heiden, Konrad. *Der Führer*. Boston: Houghton Mifflin Company, 1944.

Herbert, Ulrich. *Hitler's Foreign Workers*. Cambridge: Cambridge University Press, 1997.

Hickley, Catherine. *The Munich Art Hoard: Hitler's Dealer and His Secret Legacy*. London: Thames & Hudson, 2015.

Hitler, Adolf. *Adolf Hitlers Drei Testamente*. Edited by Gert Sudholt. Leoni am Starnberger See: Druffel, 1977.

———, ed. *Liberty, Art, Nationhood*. Berlin: M. Müller & Sohn, 1935.

———. *Mein Kampf*. New York: Reynal & Hitchcock, 1939.

———. *Monologe im Führerhauptquartier, 1941–1944*. Edited by Werner Jochmann. Hamburg: A. Knaus, 1980.

———. *The New Germany Desires Work and Peace: Speeches by Reich Chancellor Adolf Hitler, the Leader of the New Germany*. Berlin: Liebheit & Thiesen, 1933.

———. *The Speeches of Adolf Hitler, April 1922–August 1939*. Vol. 1. Edited by Norman H. Baynes. London: Oxford University Press, 1942.

Hoffmann, Meike, and Nicola Kuhn. *Hitler's Kunsthändler: Hildebrand Gurlitt, 1895–1956*. Munich: C. H. Beck, 2016.

Iselt, Kathrin. *Sonderbeauftragter des Führers: Der Kunsthistoriker und Museumsmann Hermann Voss (1884–1969)*. Cologne: Böhlau Verlag, 2010.

Jentsch, Ralph. *Alfred Flechtheim George Grosz. Zwei deutsche Schicksale*. Bonn: Weidle, 2008.

Jetzinger, Franz. *Hitler's Youth*. London: Hutchinson, 1958.

———. *Hitlers Jugend*. Vienna: Europa Verlag, 1956.

Judin, Juerg M. *George Grosz: The Years in America (1933–1958)*. Berlin: Hatje Cantz Verlag, 2009.

Junge, Traudl. *Hitler's Last Secretary: A Firsthand Account of Life with Hitler*. New York: Arcade Publishing, 2011.

Kershaw, Ian. *Hitler: A Biography*. New York: W. W. Norton & Company, 2010.

———. *To Hell and Back: Europe, 1914–1949*. New York: Penguin Books, 2016.

Kessler, Harry. *Berlin in Lights: The Diaries of Count Harry Kessler (1918–1937)*. Edited by Charles Kessler. London: Weidenfeld & Nicholson, 1971.

Kirchner, Ernst Ludwig. *Briefwechsel 1910–1935/1938*. Edited by Wolfgang Henze. Stuttgart: Belser, 1990.

Kluy, Alexander. *George Grosz: König Ohne Land*. Munich: Deutsche Verlags-Anstalt, 2017.

Knickerbocker, H. R. *The German Crisis*. New York: Farrar & Rinehart, 1932.

Koop, Volker. *Besetzt: Französische Besatzungspolitik in Deutschland*. Berlin: BeBra Verlag, 2007.

Kreis, George. *"Entartete" Kunst für Basel: Die Herausforderung von 1939*. Basel: Wiese Verlag, 1990.

Lewis, Beth Irwin. *George Grosz: Art and Politics in the Weimar Republic*. Princeton, NJ: Princeton University Press, 1991.

Lilly, J. Robert. *Taken by Force: Rape and American GIs in Europe During World War II*. Basingstoke, UK: Palgrave Macmillan, 2007.

Linge, Heinz. *With Hitler to the End: The Memoirs of Adolf Hitler's Valet*. New York: Skyhorse Publishing, 2009.

Longerich, Peter. *Der ungeschriebene Befehl: Hitler und der Weg zur "Endlösung."* Munich: Piper Verlag, 2001.

———. *Goebbels: A Biography*. New York: Random House, 2015.

Lunn, Felicity, and Peter Vergo, eds. *Emil Nolde*. London: Whitechapel, 1995.

Marno, Anne. *Otto Dix: The Evil Eye*. Dusseldorf: Kunstsammlung Nordrhein-Westfalen, 2017.

Maser, Werner. *Adolf Hitler: Legende, Mythos, Wirklichkeit*. Munich: Bechtle, 1974.

———. *Hitler: Legend, Myth and Reality*. New York: Harper & Row, 1971.

Miesel, Victor H., ed. *Voices of German Expressionism*. Upper Saddle River, NJ: Prentice Hall, 1970.

Misch, Rochus. *Hitler's Last Witness: The Memoirs of Hitler's Bodyguard*. London: Frontline Books, 2015.

Motherwell, Robert, ed. *The Dada Painters and Poets: An Anthology*. New York: Wittenborn, Schultz, Inc., 1951.

Müller, Karl Alexander von, and Otto Alexander von Müller. *Im Wandel einer Welt: Erinnerungen 1919–1932*. Munich: Süddeutscher Verlag, 1966.

Nagorski, Andrew. *Hitlerland: American Eyewitnesses to the Nazi Rise to Power*. New York: Simon & Schuster, 2010.

Nicholas, Lynn H. *The Rape of Europa*. New York: Vintage Books, 1995.

Nolde, Emil. *Jahre der Kämpfe*. Berlin: Rembrandt Verlag, 1934.

———. *Reisen, Ächtung, Befreiung, 1919–1946*. Cologne: DuMont, 1967.

Nordau, Max. *Entartung*. Berlin: Duncker, 1893.

Paul, Jürgen. *Cornelius Gurlitt: Ein Leben für Architektur, Kunstgeschichte, Denkmalpflege und Städtebau*. Dresden: Hellerau Verlag, 2003.

Peters, Olaf, ed. *Degenerate Art: The Attack on Modern Art in Nazi Germany, 1937*. New York: Prestel, 2014.

Petropoulos, Jonathan. *Artists Under Hitler: Collaboration and Survival in Nazi Germany*. New Haven, CT: Yale University Press, 2014.

Remy, Maurice Philip, *Der Fall Gurlitt: Die wahre Geschichte über Deutschlands größten Kunstskandal*. Berlin: Europa Verlag, 2017.

Rewald, Sabine, ed. *Glitter and Doom: German Portraits from the 1920s*. New Haven, CT: Yale University Press, 2006.

Riess, Volker. *Die Anfänge der Vernichtung "lebensunwerten Lebens" in den Reichsgauen Danzig-Westpreussen und Wartheland 1939/40*. Frankfurt am Main: Universität Stuttgart, 1995.

Roth, Joseph. *What I Saw*. Edited by Michael Bienert. New York: W. W. Norton & Company, 2003.

Schlenker, Ines. *Hitler's Salon: The Große Deutsche Kunstausstellung at the Haus der Deutschen Kunst in Munich, 1937–1944*. Oxford, UK: Peter Lang, 2007.

Schmidt, Diether, ed. *Otto Dix im Selbstbildnis*. Berlin: Henschel Verlag, 1978.

Schneede, Uwe M. *George Grosz: The Artist in His Society*. Woodbury, NY: Barron's Educational Series, 1985.

Schroeder, Christa. *Er war mein Chef*. Munich: Arndt Verlag, 1985.

Shirer, William L. *Berlin Diary: The Journal of a Foreign Correspondent, 1934–1941*. New York: Alfred A. Knopf, 1941.

Sinclair, Anne. *My Grandfather's Gallery: A Legendary Art Dealer's Escape from Vichy France*. London: Profile Books, 2012.

Speer, Albert. *Inside the Third Reich: Memoirs by Albert Speer*. New York: MacMillan Company, 1970.

Spotts, Frederic. *Hitler and the Power of Aesthetics*. New York: Overlook Press, 2004.

Spurling, Hilary. *Matisse the Master: A Life of Henri Matisse: The Conquest of Colour, 1909–1954*. London: Hamish Hamilton, 2005.

Steinbacher, Sybille. *"Musterstadt" Auschwitz: Germanisierungspolitik und Judenmord in Ostoberschlesien*. Munich: K. G. Saur, 2000.

Stratigakos, Despina. *Hitler at Home*. New Haven, CT: Yale University Press, 2015.

Taylor, Frederick. *Exorcising Hitler: The Occupation and Denazification of Germany*. London: Bloomsbury, 2011.

Tooze, Adam. *The Wages of Destruction*. New York: Viking, 2006.

Tucholsky, Kurt. *Werke—Briefe—Materialen*. Edited by Mathias Bertram. Berlin: Rohwolt, 1987.

Voigt, Vanessa-Maria. *Kunsthändler und Sammler der Moderne im Nationalsozialismus: Die Sammlung Sprengel 1934 bis 1945*. Berlin: Dietrich Reimer Verlag, 2007.

Waite, Robert G. L. *Vanguard of Nazism*. Cambridge, MA: Harvard University Press, 1952.

Wismer, Beat. *Karl Ballmer, Der Maler*. Aarau: Argauer Kunsthaus, 1990.

ARTICLES

Bloch, Eduard. "My Patient Hitler." *Collier's Magazine*. 15 March 1941.

Boyer, Richard O. "1—Demons in the Suburbs." *New Yorker*. 27 November 1943.

———. "2—The Saddest Man in All the World." *New Yorker*. 4 December 1943.

———. "3—The Yankee from Berlin." *New Yorker*. 11 December 1943.

Dickson, John. "Europe's Man of Mystery!" *Chicago Daily Tribune*. 6 August 1939.

"Europe's Children." *Life*. 11 September 1939.

George, David Lloyd. "I talked to HITLER." *Daily Express*. 17 September 1936.

Gezer, Özelm. "Die Liebe seines Lebens." *Der Spiegel* 47 (2013).

Grosz, George. "Self Portrait of the Artist." *Americana Magazine*. November 1932.

Hanisch, Reinhold. "I Was Hitler's Buddy." *New Republic*. 5 April 1939.

Herzfelde, Wieland. "The Curious Merchant from Holland." *Harper's Magazine*. November 1943.

"Hitler His Own Architect: He Practices His Art on a Simple Chalet." *New York Times Magazine*. 13 October 1935.

"Hitler, Mussolini and Eden—in Retreat." *Vogue*. 15 August 1936.

Lane, Mary M. "Germany to Comb Museums for Nazi-Looted Art." *Wall Street Journal*. 12 February 2014.

———. "Norway Returns Looted Matisse." *Wall Street Journal*. 22 March 2014.

Lane, Mary M., and Marcus Walker. "Furor over Hidden Art Is Unwelcome Distraction for German Prosecutor." *Wall Street Journal*. 10 November 2013.

"Paintings by Adolf Hitler." *Life*. 30 October 1939.

Rosenfeld, Paul. "Exhibition 'Fantastic Art, Dada and Surrealism,' at the Museum of Modern Art." *New Republic*. 6 January 1937.

Simpson, Hedwig Mauer. "Herr Hitler at Home in the Clouds." *New York Times Magazine*. 20 August 1939.

"Speaking of Pictures: Jugend um Hitler." *Life*. 6 December 1937.

Strauss, Heinrich. "On Jews and German Art (The Problem of Max Liebermann)." *Leo Baeck Institute Yearbook* 2, no. 1 (January 1957): 255–269.

Van Dyke, James A. "Something New on Nolde, National Socialism, and the SS." *Kunstchronik* 65, no. 5 (May 2012).

Wilson, Edmund. "Book Review: George Grosz." *New Yorker*. 4 January 1947.

INTERVIEWS

Anonymous, 2013–2018.

Marianne Rosenberg, July 2018.

Marty Grosz, June 2018.

David Toren, November 2015, June 2018.

Peter Toren, November 2015, June 2018.

Rein Wolfs, March 2018.

ARCHIVES AND ARCHIVAL DOCUMENTS

"Collection Schloss: Archives et patrimoine." Diplomatie France, article undated, accessed 22 December 2018, diplomatie.gouv.fr/sites/archives_diplo/schloss/sommaire_ang.html.

George Grosz Archive, Houghton Library, Harvard University, Cambridge, Massachusetts.

Gurlitt: Status Report. Edited by Kunstmuseum Bern, Bundeskunsthalle. Munich: Hirmer, 2017.

Hildebrand Gurlitt Papers, Bundesarchiv Berlin, Berlin, Germany.

Kirchner Museum Davos. 1992. News release. Biography Ernst Ludwig Kirchner. Accessed 29 November 2018. www.kirchnermuseum.ch/fileadmin/Inhalte_Redaktoren/Bilder_Inhalt/E.L.Kirchner/Biography_E.L.Kirchner_english.pdf.

Monuments, Fine Arts, and Archives (MFAA), National Archives and Records Administration (NARA) / (Fold3)

Detailed Interrogation Report No. 12: Hermann Voss, 15 September 1945
Collection: Gurlitt (Gurlitt Coll.)
Official Minutes, German Bundesrat, Sitzung (Session) 919, 14 February 2014.
Toren Family Archive, New York/Washington, DC.
Vitalizing Memory: International Perspectives on Provenance Research. Washington, DC: American Association of Museums, 2005.

ILLUSTRATION CREDITS

Insert, p. 1 *Zandvoort Beach Café*, Max Beckmann, 1934
(Credit: Mick Vincenz, © Kunst- und Ausstellungshalle der Bundesrepublik Deutschland GmbH, Bonn / Artists Rights Society)

Insert, p. 1 *Leonie*, Otto Dix, 1923
(Credit Kunstmuseum Bern, Legat Cornelius Gurlitt 2014 / Artists Rights Society)

Insert, p. 1 *Love Scene*, Ernst Ludwig Kirchner, 1908
(Credit Kunstmuseum Bern, Legat Cornelius Gurlitt 2014)

Insert, p. 1 *The Dancer*, Emil Nolde, 1913
(Credit Kunstmuseum Bern, Legat Cornelius Gurlitt 2014 / Emil Nolde Estate)

Insert, p. 2 *Horse Cadaver*, Otto Dix, 1924
(Credit Kunstmuseum Bern, Legat Cornelius Gurlitt 2014 / Artists Rights Society)

Insert, p. 2 Hildebrand Gurlitt with his older sister, Cornelia
(Credit TU Dresden, Universitätsarchiv, Nachlass Cornelius Gurlitt)

Insert, p. 2 Hildebrand Gurlitt with his father, Cornelius, and sister, Cornelia
(Credit TU Dresden, Universitätsarchiv, Nachlass Cornelius Gurlitt)

Insert, p. 3 *Lamentation for the Dead*, Käthe Kollwitz
(Credit Kunstmuseum Bern, Legat Cornelius Gurlitt 2014 / Artists Rights Society)

Insert, p. 3 *Self-Portrait*, Käthe Kollwitz, 1924
(Credit: Kunstmuseum Bern, Legat Cornelius Gurlitt 2014 / Artists Rights Society)

Insert, p. 3 *Corpse in Barbed Wire*, Otto Dix, 1924
(Credit: Kunstmuseum Bern, Legat Cornelius Gurlitt 2014 / Artists Rights Society)

Insert, p. 3 *Old Woman with Cloche Hat*, Max Beckmann, 1920
(Credit: Kunstmuseum Bern, Legat Cornelius Gurlitt 2014 / Artists Rights Society)

Insert, p. 4 *Bow to the Authorities*, George Grosz, 1928
 (Credit: bpk Bildagentur / Kupferstichkabinett SMB / Art Resource,
 NY / Artists Rights Society / Estate of George Grosz)
Insert, p. 4 *Keep Your Mouth Shut and Do Your Duty*, George Grosz, 1928
 (Credit: bpk Bildagentur / Art Resource, NY / Artists Rights Society /
 Estate of George Grosz)
Insert, p. 5 *The Pillars of Society*, George Grosz, 1926
 (Credit bpk Bildagentur / Nationalgalerie, SMB / Art Resource, NY /
 Artists Rights Society / Estate of George Grosz)
Insert, p. 6 Portrait of George Grosz
 (Credit: bpk Bildagentur / Edward Hoinkis / Art Resource, NY)
Insert, p. 6 The Degenerate Art Exhibition in Munich, 1937
 (Credit: bpk Bildagentur / Zentralarchiv, SMB / Art Resource, NY)
Insert, p. 6 Emil Nolde, circa 1920
 (Credit: bpk Bildagentur / Art Resource, NY)
Insert, p. 6 A section of Emil Nolde's confiscated work, *The Life of Christ*
 (Credit: bpk Bildagentur / Art Resource, NY / Emil Nolde Estate)
Insert, p. 7 Adolf Hitler tours the House of German Art, July 1937
 (Credit: bpk Bildagentur / Art Resource, NY)
Insert, p. 7 The Gurlitt family's mansion in Dresden
 (Credit: TU Dresden, Universitätsarchiv, Nachlass Cornelius Gurlitt)
Insert, p. 8 Christopher Marinello with Henri Matisse's *Woman with a Fan*
 (Credit: Wolf Heider-Sawall)
Insert, p. 8 Max Liebermann's *Two Riders on the Beach*
 (Credit: Peter Toren)

INDEX

Mary M. Lane (b. 1987) is a nonfiction writer and journalist specializing in Western art, Western European history, and anti-Semitism. Lane received one of five Fulbright Journalism Scholarships at twenty-two years old, gained international recognition as the chief European art reporter for the *Wall Street Journal*, and published numerous exclusive Page One articles on the art trove of Hildebrand Gurlitt. Since leaving the *Journal*, Lane has been a European art contributor for the *New York Times*. She splits her time between Western Europe and Washington, DC. She can be found on Twitter @MaryLaneWSJ.

PublicAffairs is a publishing house founded in 1997. It is a tribute to the standards, values, and flair of three persons who have served as mentors to countless reporters, writers, editors, and book people of all kinds, including me.

I. F. Stone, proprietor of *I. F. Stone's Weekly*, combined a commitment to the First Amendment with entrepreneurial zeal and reporting skill and became one of the great independent journalists in American history. At the age of eighty, Izzy published *The Trial of Socrates*, which was a national bestseller. He wrote the book after he taught himself ancient Greek.

Benjamin C. Bradlee was for nearly thirty years the charismatic editorial leader of *The Washington Post*. It was Ben who gave the *Post* the range and courage to pursue such historic issues as Watergate. He supported his reporters with a tenacity that made them fearless and it is no accident that so many became authors of influential, best-selling books.

Robert L. Bernstein, the chief executive of Random House for more than a quarter century, guided one of the nation's premier publishing houses. Bob was personally responsible for many books of political dissent and argument that challenged tyranny around the globe. He is also the founder and longtime chair of Human Rights Watch, one of the most respected human rights organizations in the world.

. . .

For fifty years, the banner of Public Affairs Press was carried by its owner Morris B. Schnapper, who published Gandhi, Nasser, Toynbee, Truman, and about 1,500 other authors. In 1983, Schnapper was described by *The Washington Post* as "a redoubtable gadfly." His legacy will endure in the books to come.

Peter Osnos, *Founder*